KU-736-416

Jasper Johns'
Paintings and Sculptures
1954-1974
"The Changing Focus of the Eye"

Studies in the Fine Arts:
The Avant-Garde, No. 46

Stephen C. Foster, Series Editor

Associate Professor of Art History
University of Iowa

Other Titles in This Series

Jasper Johns'
Paintings and Sculptures
1954-1974
"The Changing Focus of the Eye"

by
Roberta Bernstein
Assistant Professor of Art History
The State University of New York
Albany, New York

UMI RESEARCH PRESS
Ann Arbor, Michigan

The lines from "Passage" and from "Cape Hatteras" from
THE COMPLETE POEMS AND SELECTED LETTERS
AND PROSE OF HART CRANE, edited by Brom Weber,
are reprinted by permission of Liveright Publishing
Corporation. Copyright 1933, © 1958, 1966 by Liveright
Publishing Corporation.

Frank O'Hara's "(Dear Jap)", "(The Clouds Go Soft)" and
excerpts from "In Memory of My Feelings" reprinted with
permission from THE COLLECTED POEMS OF FRANK
O'HARA, edited by Donald Allen, Alfred A. Knopf, Inc. ©
1971.

Ted Berrigan's "Sonnet XV" reprinted with permission from
THE SONNETS, Grove Press, Inc. and the Estate of Ted
Berrigan. © 1967.

Copyright © 1985, 1975
Roberta Merle Bernstein
All rights reserved

Produced and distributed by
UMI Research Press
an imprint of
University Microfilms International
A Xerox Information Resources Company
Ann Arbor, Michigan 48106

Library of Congress Cataloging in Publication Data

Bernstein, Roberta.
Jasper Johns' paintings and sculptures, 1954-1974.

(Studies in the fine arts. Avant-garde ; no. 46)
Revision of thesis (Ph.D.)—Columbia University,
1975
Bibliography: p.
Includes index.
1. Johns, Jasper, 1930- . 2. Art—Themes,
motives. I. Titles. II. Series.
N6537.J6B47 1985 709'.2'4 85-998
ISBN 0-8357-1601-5 (alk. paper)

To Emily, Lucy, Sarah, Jeremy and David

Contents

List of Plates

Preface

In a 1959 statement, Jasper Johns wrote: "At every point in nature there is something to see. My work contains similar possibilities for the changing focus of the eye." [1] Johns' art is a microcosm of experience and a vehicle for examining the nature of perception. His consistent questioning of basic issues concerning the nature of the art object—reality and illusion, flatness and depth, color, light, outline, etc—reflects a commitment to exploring the fundamental issues of human experience. For Johns, the eye is an extension of the mind: the sensory organ for seeing is for him, as a painter, the central vehicle for thinking and feeling as well. Visual, conceptual and emotional aspects of experience are always present in Johns' art, and his best works are the ones most intensely charged with their interaction. "The changing focus of the eye," mentioned by Johns, is a key to understanding his approach to art and the resulting range of meanings and associations that makes interpretation of his work elusive. Through changing focus, his work can present the idea of the canvas-as-object *and* the anxiety of the artist; the perception of color *and* the disorientation of the psyche. His art can be seen to focus on the nature of art itself and, at the same time, to reflect the most significant contemporary cultural values.

Johns has said: "Art is either a complaint or an appeasement." [2] He elaborated by saying that art has to do with creating a situation which motivates the use of one's energy to change one's surroundings or which somehow makes those surroundings more tolerable or pleasant; that art is related to society and the reaction of society or, rather, the individual in society. According to this definition, Johns' art can be seen as a "complaint" because it inspires and provokes us to change habits of perception, affecting the way we experience the world. His art provides a way of seeing, thinking and feeling which allows us to become more aware of our surroundings and more open to change. At the same time, his art is an "appeasement" in that it has a soothing and appealing sensuous beauty. As John Cage said about Johns: "Looking closely helps, though the paint is applied so sensually that there is the danger of falling in love." [3]

The purpose of this study is to present a detailed, comprehensive examination of the first twenty years of Jasper Johns' paintings and sculptures, from 1954 to 1974, and to establish his connection with traditions of previous art. My ideas and observations are built upon the writings of other authors who have contributed to the large body of literature on Johns. Among the important essays and monographs on Johns are those by Leo Steinberg (1962), Alan R. Solomon (1964), John Cage (1964), Max Kozloff (1969), Richard S. Field (1970, 1978) and Michael Crichton (1977).

Johns has worked extensively in all media, but he is primarily a painter in that his major artistic images and ideas emerge in his paintings. I consider his sculptures to be three-dimensional paintings in the sense that they are variations of ideas already worked out in paintings. Drawings and prints make up a large part of Johns' *oeuvre,* however, they are usually based directly on his paintings and sculptures. Johns has done only a few preparatory studies for his paintings and sculptures and these are usually intended to work out technical details such as proportions and measurements, rather than to develop an image or idea. There are some instances where new imagery appears first in Johns' graphics, and I will discuss these in the context of specific paintings and sculptures to which they are related.

The organization of the text is intended to reveal the way Johns' characteristic thematic patterns, images and pictorial devices emerge and develop. Each chapter deals with works linked by subject, theme or related motifs. For example, Chapter 1 begins with Johns' first *Flag,* 1954-55, followed by a discussion of variations on the flag motif and his other flat objects and signs dating from 1954 to 1974. In Chapter 7, I discuss works from 1962 to 1966 dealing primarily with the theme of the artist's studio. While each chapter presents a distinct aspect of Johns' art, it is important to keep in mind that most of Johns' works do not fall into clearly defined categories, and that they are inextricably related through his increasingly complex self-referential language of imagery.

My discussion of Johns' art emphasizes its artistic sources and relationship to specific traditions of past art. I have found many connections between Johns' works and traditional still life painting, expecially the *trompe l'oeil* still lifes of John F. Peto. I also examine Johns' position in the development of modern art from the time of Paul Cézanne and Cubism to Abstract Expressionism. Chapter 4 is for the most part devoted to a study of Johns' relationship to Cézanne and Marcel Duchamp, two modern "Old Masters" whom Johns once called his "teachers."[4] René Magritte is mentioned frequently to show how Johns confronts the most significant pictorial and conceptual aspects of modern art.

Johns' relationship to his contemporaries is only briefly touched upon because a thorough handling of this topic does not fall within the scope of this

study. Most significant for Johns among his contemporaries are Robert Rauschenberg, composer John Cage and choreographer-dancer Merce Cunningham, all of whom he met during 1954-55 when his first important art works were produced.[5] Rauschenberg and Johns were close friends for six years, and many aspects of their work reveal a common sensibility and similar artistic concerns. Their friendship ended during 1961-62, and the tone of emotional crisis reflected in Johns' works from that period is probably connected with that break-up. Cage and Cunningham, who also share a similar artistic sensibility with Johns, have remained close friends.

This text has been developed from my doctoral dissertation, *"Things the Mind Already Knows": Jasper Johns' Paintings and Sculptures 1954-1974*, Columbia University, 1975. Changes have been made to correct, clarify and expand the original text. References to, and information from, sources published since 1974 are included mostly in the notes; and with only a few exceptions, I have chosen not to refer to Johns' works done after 1974.

I have been interested in Jasper Johns' art since 1964, when I saw his retrospective exhibition at the Jewish Museum in New York. I met him in April 1967 and, until 1972, saw him frequently, almost on a daily basis for much of that time. Besides being a friend, I worked for him part-time while I was a graduate student during 1968-69, organizing and cataloguing his prints and cataloguing works by other artists in his collection. Many of my experiences and conversations with Johns are recorded in a journal I kept during this time. I drew upon this journal and unrecorded conversations with Johns from 1967 to 1972 for some of the information included here, as well as later conversations. Through my personal contact with Johns, I have acquired much information and gained many insights which have provided what I consider to be a sound basis for interpreting his art. This study is an attempt to share that knowledge and experience.

Acknowledgments

Professor Theodore Reff of Columbia University consistently and enthusiastically supported my choice of Jasper Johns as a dissertation topic at a time when the validity of contemporary art as an area of study for art history was still in question. I am grateful to him for that support and for the sound scholarly advice and years of guidance he gave me as my teacher. Sara Cedar Miller devoted a tremendous amount of time and energy in photographing the illustrations for my dissertation. She also helped inspire my confidence in my work and was important in encouraging me to develop the present study. Mr. and Mrs. Victor and Sally Ganz have always made their art collection available to me both for enjoyment and study. Their passion for and knowledge about contemporary art has been a great inspiration to me. I want to thank David Whitney and Mark Lancaster who read my manuscript and provided factual information and helpful suggestion; and Viki Sand who assisted me in the manuscript's final preparation. I am very grateful to Leo Castelli and the staff of the Leo Castelli Gallery for their generosity in allowing me access to their archives and for lending me photographs. I especially want to thank Maryjo Marks for her cooperation and assistance.

I could not have completed this study without the help of my close friends and family who have assisted and supported me in many different ways. I express to them my deepest gratitude.

Finally, I want to thank Jasper Johns for his friendship and art which changed my life.

List of Abbreviations

The following books and catalogues are used as sources for reproductions of works mentioned but not illustrated in the text. I have used the author's full or abbreviated name with plate or catalogue number.

Jasper Johns

Note that for Johns I also refer the reader to color reproductions of works illustrated in black and white.

Cri. Crichton, Michael. *Jasper Johns* (exhibition catalogue). New York: Harry N. Abrams and Whitney Museum of American Art, 1977.

Field Field, Richard S. *Jasper Johns: Prints 1960-1970* (exhibition catalogue). Philadelphia: Philadelphia Museum of Art, 1970; *Jasper Johns: Prints 1970-1977* (exhibition catalogue). Middletown, CT: Wesleyan University Press, 1978. (Catalogues numbered consecutively)

Koz. Kozloff, Max. *Jasper Johns.* New York: Harry N. Abrams, 1969.

Other Artists

Berg. Bergström, Ingvar. *Dutch Still Life Painting in the Seventeenth Century.* Translated by C. Hedström and G. Taylor. London: Faber and Faber, 1956.

Cam. Camfield, William A. *Francis Picabia: His Art, Life and Times.* Princeton: Princeton University Press, 1979.

Cooper Cooper, Douglas. *The Cubist Epoch* (exhibition catalogue). London: Phaidon, 1970.

Faré Faré, Michel. *La Nature Morte en France du XVIIe au XXe siècle: son histoire et son evolution.* 2 vols. Geneva: Pierre Cailler, 1962.

Forge Forge, Andrew. *Robert Rauschenberg*. New York: Harry N. Abrams, 1972.

Fra. Frankenstein, Alfred. *The Reality of Appearance: The Trompe l'Oeil Tradition in American Painting* (exhibition catalogue). Greenwich, CT: New York Graphic Society, 1970.

Gab. Gablik, Suzi. *Magritte*. Greenwich, CT: New York Graphic Society, 1970.

Mag. Rétrospective Magritte (exhibition catalogue). Brussels: Palais des Beaux-Arts and Paris: Centre Georges Pompidou, 1978-79.

Sch. Schwarz, Arturo. *The Complete Works of Marcel Duchamp*. New York: Harry N. Abrams, 1969.

Ven. Venturi, Lionelli. *Cézanne: son art—son oeuvre*. 2 vols. Paris: Paul Rosenberg, 1936.

Wil. Wilmerding, John. *Important Information Inside: The Art of John F. Peto and the Idea of Still-Life Painting in Nineteenth Century America (exhibition catalogue)*. Washington, National Gallery of Art, 1983.

Zer. Zervos, Christian. *Pablo Picasso*. Paris: Edition "Cahiers d'Art" [1951].

1

Flat Objects and Signs

Flags

Flag, 1954-55[1]

When asked about the sources of *Flag*, 1954-55 (Plate 1) (Cri. 1), Johns answers that he dreamt one night of painting a large American flag and then proceeded to do so. He has said this several times and will offer no other explanation for the appearance of this remarkable painting. However, we can see the dream as having revealed to him an image with which he could state his developing artistic ideas with clarity and conviction.[2]

The flatness of the flag enabled Johns to deal with the basic pictorial concern of representation in a new way, since it can be depicted on the flat surface of the canvas without using conventional illusionistic devices like perspective, foreshortening and modelling. Other flat subjects followed: targets, numbers, alphabets and maps, all of which have several features in common with the flag.[3] It was necessary to Johns that all these objects and signs were human-made as well as flat because, as Leo Steinberg wrote:

> The fact that they are man-made assures him that they are makable and this is the liberating discovery for the painter whose mind is both literal and contemporary: the man-made alone can be made, whereas whatever else the environment has to show is only imitable by make-believe. The position of modern anti-illusionism finds here its logical resting place. The street and the sky—they can only be *simulated* on canvas; but a flag, a target, a 5—these can be *made,* and the completed painting will represent no more than what it actually is. For no likeness or image of a 5 is paintable, only the thing itself.[4]

No previous artist dealing with representation had given up illusionism so definitively as Johns did with the *Flag* and his other flat subjects.

When we view *Flag*, 1954-55, from a distance, it looks like a real flag hanging on the wall. However, closer inspection reveals that this flag is not quite like others we have seen. It is made of canvas covered with collage and brushstrokes of paint. Because we have never been confronted with such a

hybrid object, we cannot fit it into our previously defined categories of either "flag" or "painting," although it has the expected features of each. We could use it as if it were a flag since it has all the required elements of our national symbol: the red and white stripes indicating the thirteen original colonies and the white stars on a blue field signifying the number of states (then forty-eight). But because it is also a painting, we experience it in a different way: its function changes in its new role as work of art. As a result of the ambiguity surrounding Johns' flag/painting, we are suspended in an undefined situation where our perceptions—jolted from their familiar habits—are free to change. This condition of ambiguity, challenging habits of perception, is essential to the meaning of this first *Flag* and Johns' subsequent works.

Besides being flat and man-made, the flag and Johns' other flat subjects satisfy certain other necessary conditions. They had to be common and standardized in terms of American culture, in Johns' words, "things the mind already knows."[5] Flags, targets, maps, the alphabet and numbers are known to us from childhood. They are all associated with initiation into some of our common cultural denominators: patriotism (flag), reading and writing (alphabet), arithmetic (numbers), geography (map); the target is also associated with learning a basic skill. They all evoke a specific, learned response: saluting (flag), reciting (alphabet), counting (numbers), locating (map) and aiming (target). An important part of the impact of Johns' *Flags, Targets, Alphabets,* etc. is that we no longer take these familiar objects for granted nor use them only in conditioned ways. Each painting is an occasion to expand our awareness that everything in our environment, however common or insignificant it may appear, provides a rich perceptual experience. Because the objects Johns chose are common and familiar to everyone, they are not identified with Johns' personal taste and therefore have a quality of self-detachment to them—i.e., they "belong" not only to Johns, but to everyone. It is significant, for example, that Johns chose the American flag, even though many other flags or emblems would have been suitable for his pictorial concerns. Any other flag, say of a state or another country, would reflect an obvious personal or aesthetic preference. In his initial paintings from the mid-1950s Johns wanted to steer the viewer away from becoming involved with the artist's subjective concerns as much as possible.[6]

Another necessary quality of Johns' flat subjects is that they are simple, hard-edged designs that can be easily transferred onto the canvas without any special skill or talent. Each object is, therefore, a ready-made composition, selected because it is suitable for developing a variety of pictorial ideas. The abstract configuration of the American flag is appropriate in several ways for the artistic experience Johns wants to present. One of its most important features for Johns is the unity of format and design, which gives the painting a sense of containment and self-generating logic. The internal forms of the flag pattern—the blue rectangle and the red and white bands—echo the shape of the

whole. We are used to perceiving the flag design only as a whole, but in *Flag,* 1954-55, Johns also presents it as a composition of independent geometric shapes: he divides the design into distinct sections, using three separate, but attached rectangular panels. These separate panels call attention to the painting's canvas-on-stretcher construction, so we experience it as a three-dimensional object as well as a flat surface pattern.[7]

The flag design has no hierarchy of focus: each part is of equal importance to the flag's symbolic meaning. Our eye does not rest on one focal point nor on secondary areas of special interest; rather we are encouraged to explore the entire visual field. In *Flag,* 1954-55, Johns has painted the design in a relatively uniform web of varied brushstrokes and collage, in a manner which reinforces its inherent lack of focus. The textured surface also functions to eliminate what little figure-ground distinction there is in the flag. Brushstrokes and drips of encaustic cross edges, linking the separate parts of the design, establishing that they belong to the same layer of space.

The stars are the most difficult area in the flag design in terms of figureground. Johns paints them so that they are set *in* rather than *on* the blue field. The paint and collage is built up around the stars (in *Flag,* 1954-55, each one is cut out of paper, either as a positive or negative shape), so that they are unified spatially with their surroundings while remaining distinct shapes. The star pattern has a fascinating optical effect which cancels the initial focus on the stars. After a few moments of observation we fluctuate between seeing the white stars dominant and the blue crown-shaped area between them as dominant.[8]

In terms of redefining some of the basic premises of art, Johns' *Flag* can be seen as a follow-up to Magritte's painting, *The Use of Words I,* 1928-29 (also titled, *The Treason of Images*) (Gab. 109), and its many variations. In the Magritte, a large, realistic image of a pipe is labeled with the words "Ceci n'est pas une pipe." (It is interesting, although perhaps coincidental, that one of the collage fragments in *Flag* includes the word, "pipe," in large letters.) Magritte is calling attention to the difference between a painted *image* of a pipe and the real object. Magritte wrote the following related statement about his painting, *State of Grace,* 1959 (Gab. 85):

> Painting has no thickness: thus my painting with the cigar has no perceptible material thickness, *the thickness of the cigar is in the mind.* This is not lacking in importance if a preoccupation with the truth has any importance. In fact, a painting conceived and painted with this preoccupation must have the unequivocal character of an *image.* It is not a cigar which one sees, but the image of a cigar.[9]

Johns' *Flag* offers another possibility in that he does not create an image, but rather the object itself: although you cannot smoke Magritte's pipe or cigar, you can salute Johns' flag.[10] However, Johns does make his *Flag* unequivocally

different from a real one by making sure we experience it as art. There is no illusion of the object's texture as with Magritte: we are made aware of the paint and collage as materials independent of their function in depicting the flag. Also, because Johns' painting is made up of separate panels, we experience it as an independent object in its own right, not just a flat surface, as Magritte describes it, with "no thickness."

Johns has said that he saw the Magritte exhibition at the Sidney Janis Gallery in March 1954.[11] (This was Magritte's second solo exhibition in New York; his first was in 1953 at the Iolas Gallery.) The title of the Janis Gallery exhibition was, "Magritte: Word vs. Image," and it included the *Use of Words I* and several other versions of the "Ceci n'est pas une pipe" motif. Robert Rosenblum's review of this exhibition mentioned the issue of art versus reality and other qualities of Magritte's work which would have appealed to Johns at the time:

> [Magritte] paints objects with utter detachment and matter-of-factness, but the objects themselves and the relationship between them are every bit as strange as his new principles of vocabulary and syntax ... Magritte's compositional schemes are of the simplest kind, but all the more effective for it. The lucidity and straightforwardness of his organization is not only striking visually; it enforces the disarming simplicity of his attack on the basic principles of common sense."[13]

Whether or not Johns' *Flag* was in part a conscious response to Magritte, it is important to note that Magritte was available at the time as a source of inspiration, and that Johns' works throughout his career have been involved with the same type of conceptual issues as Magritte's. During the 1960s, Johns began collecting Magritte's works, among them a drawing of the "Ceci n'est pas une pipe" motif, based on the painting *The Two Mysteries,* 1966 (Gab. 110).

Another related source for Johns' *Flag* and other flat objects is *trompe l'oeil* painting, where, as in Magritte's *Use of Words* series, attention is focused on the difference between an object and its image. At the time he painted *Flag* Johns was probably aware of the tradition of *trompe l'oeil* painting through the works of William Harnett, John F. Peto, John Haberle and other nineteenth-century American still-life painters.[14] Most *trompe l'oeil* still lifes show small, life-size objects attached to or hanging from a vertical surface, like Harnett's *Meerschaum Pipe,* 1886. Even more so than Magritte's, Harnett's pipe looks real—as if it could be lifted from the wall and smoked. However, the viewer's awareness that it is *not* a pipe, but rather a picture of a pipe is essential to the experience of the painting, raising the same conceptual issues about the relationship between art and reality as Magritte and Johns. In traditional *trompe l'oeil* still lifes, the optimum effect of "fooling-the-eye" is achieved when the objects represented are flat, e.g., the dollar bills, pictures, postage stamps, and so on in Haberle's *The Changes of Time,* 1888 (Fra. 172). Paintings of

isolated flat objects, like Harnett's *Five Dollar Bill,* 1877 (Fra. 124), come closest to presenting a visual/conceptual experience similar to Johns' *Flags* and other flat objects and signs.

The flag enabled Johns to take the ultimate step in breaking away from the Renaissance tradition of representation in art, in order to establish with absolute integrity the flatness of the picture surface and the independent nature of the painting as object. It is also important to examine Johns' works prior to the first *Flag* to understand why the flag was such a suitable subject for him at the time.

Little is known about Johns' works before *Flag*, and Johns himself is not interested in discussing his earlier works nor in trying to locate those which may still be in existence. To the contrary, when a work dating from before the 1954 *Flag* does turn up, Johns, destroys it if possible.[15] Leo Steinberg mentioned early Schwitters-like collages, which Johns did during 1952 or shortly thereafter.[16] What we can infer from these collages (none of which are known) is that since 1952 Johns appears to have been committed to a kind of painting which stresses the picture's surface rather than presenting illusions of depth. In two *Untitled* drawings from 1954, Johns establishes the reality of the surface with a dense web of strokes. In both, disk-like forms appear to emerge through the surface layer.[17]

In *Construction with Toy Piano* and *Untitled Construction*, both 1954 (Koz. 7, 8), the three-dimensional construction of the painting is emphasized as well as its surface texture. These works clearly establish Johns' relationship to the collage-assemblage tradition of modern art. In *Toy Piano*, Johns used an old, worn, wooden toy piano and covered it with collage fragments. It has the nostalgic quality of a personal souvenir, like a Schwitters collage or "Merz" construction. Leo Steinberg wrote that *Toy Piano* "has a romantic, melancholy quality about it, even a hint of self-pity."[18] Such an interpretation is difficult to validate on the evidence of *Toy Piano* alone, but I think Steinberg has intuited, from the few surviving pre-*Flag* works, qualities which would have been even more obvious in some of Johns' destroyed or missing early works. I think it is possible that at some early phase of his career, Johns' art had an overtly romantic, even sentimental quality. Johns, in part, eliminated this romantic tendency, in part, repressed it in his works from 1954 on, but it reappears in the form of a profound and complex personal statement in his works of 1961 and after.[19]

In *Untitled Construction*, a plaster cast of a face is placed in a niche below a collaged area (here, as in *Toy Piano*, most of the collage fragments are printed in German, Spanish and Italian). The presence of the enigmatic face of a sleeping (dreaming?) figure, displayed like an object on a shelf, gives the painting a disturbing, surrealist aura, characteristic of Johns' 1955 *Targets* with plaster casts. The neutrality of Johns' *Flag* enabled him to eliminate the

romantic or emotional overtones of his previous works, and its banality deflated their poetic mood. Such a distinctly American image as the flag enabled him to identify with recent developments in American art by definitively breaking away from the European sensibility of *Toy Piano* and *Untitled.*

Two other works of 1954 are closer in spirit to *Flag* and the works which followed. One is an *Untitled* grid-patterned collage on silk (Koz. 21) which, like the flag, is a geometric design made up of repeated units. The other, *Star* (Koz. 9), is made of two equilateral triangle constructions combined to form a Star of David-shaped object. Like *Flag,* it is both an object with symbolic meaning and an abstract, geometric design. Its title reinforces its interpretation as a religious symbol (Johns mentioned another work from the same period, *Cross,* which I have not seen);[20] as such, it has more emotional or personal connotations than the more neutral *Flag.*

Using the American flag as a subject enabled Johns to expand the scope of his art, so that it was innovative in terms of the most advanced art of the time, Abstract Expressionism. Johns' relationship to Abstract Expressionism is complex: his work is, on the one hand, a decisive alternative to Abstract Expressionism; on the other, it is an assimilation of some of its fundamental aspects. While his work was initially considered by many artists and critics to be a reaction against Abstract Expressionism, it can now be seen as a continuation of many of its features, as well as a transition to new modes of painting. Among Johns' favorite twentieth-century artists are Willem de Kooning and Barnett Newman, both of whom were important influences on his work.[21]

By 1954, Abstract Expressionism was recognized as an established style in New York circles.[22] There were many followers emerging, especially of de Kooning's style, and many artists were searching for alternatives to escape what they considered to be a dead end. By 1954, works of many diverse trends were exhibited in New York, with Abstract Expressionism—the definition of which was becoming more and more vague—still the dominant, though not exclusive, influence on artists.

Johns' most obvious reaction against Abstract Expressionism was in his use of recognizable subject matter in a radically new way. Because the *Flag* was so realistic, it seemed like an absolute rejection of the validity of abstract art. Figurative and other representational art was being done in avant-garde New York circles during this period, but it was generally conventional either in theme (such as the figurative paintings of de Kooning and Pollock) or handling (such as Fairfield Porter's works). Johns' flat, commonplace objects and signs, presented without illusionist devices, called into question currently accepted values by revitalizing representational subject matter as a valid alternative for innovative modern painting.

With the *Flag,* Johns was assertively breaking away from the basic tenets of expressionism, as well as abstraction. For the Abstract Expressionist "gesture" painters, including Pollock, de Kooning, Hofmann, Motherwell and Kline, the painting was a means to reveal the artist's subjective condition: the artist's feelings, thoughts and experiences were expressed through forms and colors. This subjectivism is an essential part of the meaning of the painting— the formal elements are intended to be vehicles of self-expression. The works of the color field painters—Still, Rothko and Newman—are not expressive in the same sense, but they too focus attention on the artist, as a kind of "oracle" who presents a visionary experience through his art. Johns' position of detachment was to remove himself as completely as possible from the painting so it could be experienced objectively, i.e., seen for what it was, as an independent object.

It seems that when he painted *Flag,* it was necessary for Johns to overstate his position of absolute detachment in order to affirm his rejection of what he considered to be subjective or romantic tendencies in Abstract Expressionism as well as in his own previous works. There is however, a passionate intensity in the *Flag* which comes through, changing it with a sense of repressed emotionalism, as if some very powerful forces were being held in check. As with all art, the character of the artist is mirrored in each of his or her works. But Johns—unlike the Romantics or Expressionists—takes a classical position and chooses to divert us from interpreting the work in terms of himself in order to involve us in a more universal experience of the paradoxical complexity of life, to get at a truth beyond the individual.[23]

The brushstrokes of Johns' *Flag* are painterly but controlled, and they are not meant to be interpreted in expressionist terms like those of the gesture painters. Like the Abstract Expressionist "action painters" Johns covers the entire surface with brushstrokes of equal intensity, creating a non-focused, random visual field. For artists like de Kooning and Pollock, the "all-over" surface was a way of engaging the viewer in the act of creation and the energy it involved. For Johns the surface is presented more literally as a layer covering the canvas. The activity of the brushstrokes is not meant to represent the artist's state of mind while creating the painting; it is meant to provide "possibilities for the changing focus of the eye."[24]

Johns adopted several aspects of color field painters' works in his *Flag* and subsequent paintings. First, because of the apparent simplicity of the works of Still, Rothko and Newman, there seems to be no composition in the conventional sense of an arrangement of forms on a surface. The compositional elements are minimized, so that they seem to be part of the given condition of the painting rather than an arrangement worked out by the artist. The minimal forms which do appear (for example, Rothko's rectangles and Newman's stripes) echo the picture's edges or its shape as a whole. There is little figure-ground distinction in their paintings because of the reduction of elements. Their works are meant to be perceived as a *gestalt* and it is important

that they create an immediate impact. Johns' *Flag* contained ready-made most of the features of color field painting in that its predetermined design is simple, holistic and flat.

Johns presents the flag so that there is a balance maintained between "realism" and "abstraction"—i.e., between seeing the flag as the object "flag" and as an abstract geometric configuration. While our eyes wander across the richly textured surface, we come across an embossed seal reading "United States of America . . . ", referring us back to the flag as a whole, as an object with symbolic meaning.[25]

Variations on the Flag

Throughout his career, Johns has used the American flag as a subject in all media: painting, sculpture, drawing, lithography, etching and silkscreening. It has continually played a vital role in his work and should be regarded as more than a subject important only as an initial statement. He has repeated it so many times (there are approximately twenty-five known *Flag* paintings through 1974 and numerous drawings and prints) because it has been suitable for presenting a variety of pictorial ideas and visual/conceptual experiences.

There are basically five variations Johns has used: (1) red, white and blue single flags, like the original *Flag* painting; (2) monochrome single flags, mostly in white or gray rather than the flag's standard colors; (3) single flags set in larger fields, where all the flag's edges are no longer identical with the painting's edges; (4) multiple flags where Johns repeats the flag two or three times within a single field; and (5) backwards and/or vertical flags.[26]

In all these variations and in each example within a category, the design of the flag has been preserved: the changes in each painting involve its size, medium, color, texture and/or arrangement in the pictorial field. Only in a 1955 drawing, *Flag (With 64 Stars)* (Cri. 9), is the design altered; there are eight rows of eight stars each, rather than the six rows of eight of the standard flag. In 1959 the number of stars in the American flag was changed from forty-eight to forty-nine, and again in 1960 to fifty. Johns never painted a flag with forty-nine stars, and it was not until 1965 that he painted his first flag with fifty stars, *Flags,* 1965 (Cri. 130). Since that date, he has used the flag with fifty stars (five rows of six and four rows of five) for his paintings and most of his graphics. There is only one flag painting after 1960 with forty-eight stars, *Two Flags,* 1962.

Johns has painted red, white and blue *Flags* of varying scale (most smaller than the first *Flag*) and in different materials, including encaustic and collage, encaustic, pastel and collage on gesso board, and oil on brown paper. Each one, although the same in general appearance, differs in terms of size and texture. For example, compare the 1954-55 *Flag* with a red, white and blue *Flag* of identical size from 1958. Although both are painted in encaustic, the texture of

the 1958 *Flag* is smoother because there is no collage, only one canvas (rather than joined panels) and more regularly applied brushstrokes. Also, the colors are more luminous in the later *Flag*. In 1967, Johns painted a *Flag*, which like his first *Flag*, is done in encaustic and collage on three panels. However, in this painting, there are touches of the secondary colors—green, orange and violet—which appear gradually, creating an intensely vibrant spectrum of colors.

Johns' 1960-66 *Flag* is an example of his interest in the interaction of different media. It is painted in red, white and blue encaustic and collage over a lithograph, *Flag I*, 1960 (Field 5), printed in black on white. The lithograph shows through in several areas, functioning like the newsprint collage in adding diversity to the flag's texture. From his first in 1960, all Johns' prints have been transformations of subjects which appeared initially in paintings or sculptures. The combination of painting and printmaking in one work reveals their conceptual interrelationship for Johns from this point.

It is significant that all but one of Johns' monochrome *Flag* paintings are either white or gray, both neutral tones. By using white or gray, he in effect eliminates color rather than inventing or altering it—which would be a type of distortion, like a change in design. The exception is a small *Green Flag*, 1956, in pencil and crayon, one of several monochrome green works by Johns. (There are also four *Green Targets* and one *Green Map*.) The effect of painting the flag design in monochrome is that it becomes more abstract; its parts are not so easily distinguished from one another as when each is a separate color. However, even drained of its expected colors, the flag remains a flag because of the familiarity of its design and the way Johns reinforces it by emphasizing the pattern in enough areas with brushstrokes and collage: the balance between "object" and "painting" is maintained, although more precariously than in the *trompe l'oeil* red, white and blue *Flags*.

Johns has done five monochrome *Flag* paintings (three white and two gray) and one bronze *Flag* sculpture in the format of the original 1954-55 *Flag*. In Johns' second *Flag* painting, *White Flag*, 1955 (Cri. 8), all of the flag's colors except white have been eliminated and it has been blown up to enormous scale, so that it almost disappears through lack of definition. Because it is so large— about 6½ × 12 feet—it is difficult to take in the whole pattern in one glance from a normal viewing distance. However, since we know we are looking at a flag, which we usually think of as a unified *gestalt*, we are continually referred to the painting as a whole. The brushstrokes and collage fragments are large in accordance with the size of the entire format; they are used both to build up the surface and to stress the edges of the stars and stripes, ensuring that the flag pattern remains apparent in the enormous field of white where it might otherwise be lost.

The whiteness of the *Flag* makes it at first appear empty of visual stimuli. What we are confronted with is a large, banal object which, as a familiar object in our everyday environment, is devoid of the emotional or intellectual content

usually expected in a work of art. The pervasive whiteness seems to reinforce the painting's lack of "content" or "message" in that it makes the object more difficult to perceive. White is conventionally associated with emptiness, blankness or disappearance; it also generally symbolizes purity. There is a tradition of white paintings in modern art, beginning with artists such as Whistler and Monet in the late nineteenth century. For both these artists white gave the subject represented an undefined vagueness, as it does in Johns' *Flag*. Especially in Monet's snowscapes, whiteness is associated with disappearance as tangible forms dissolve in pervasive glare or mist. Kasimir Malevich in *White on White,* ca. 1918, was the first artist to use only white in a non-objective painting. It was important to him to reduce the pictorial elements, both form and color, to a minimum in order to achieve a statement of "pure feeling," which for him was the essence of art.[27] During the early 1950s Barnett Newman, Ad Reinhardt, Ellsworth Kelly and Robert Rauschenberg did all-white paintings. Rauschenberg, in his 1951 series of *White Paintings* (Forge 5), eliminated form and color to a more extreme degree than Malevich, Newman, Reinhardt and Kelly. Each painting consists of an arrangement of separate panels painted with a uniform layer of white; there is no composition, tonal contrast or suggestion of depth. Rauschenberg thought of these paintings as receptive surfaces which would allow life to merge with art in a new way: "I always thought of the white paintings as being not passive but very—well, hypersensitive. So that one could look at them and see how many people were in the room by the shadows cast, or what time of day it was."[28] In this sense, these paintings are like "blank sheets" for Rauschenberg as a collagist: flat surfaces which allow the world to enter. They relate to John Cage's use of silence in his music and Merce Cunningham's use of silence and pause in his dance. Cage's silent piece, 4'33", performed first in 1952, is the musical equivalent of Rauschenberg's *White Paintings.* During the piece, Cage's friend, pianist David Tudor, sat at a piano without playing it—the "music" consisted of the sounds created in the environment during that span of time.[29] Cage has described Rauschenberg's *White Paintings* as "airports for the lights, shadows and particles" and wrote further: "The White paintings caught whatever fell on them; why did I not look at them with my magnifying glass? Only because I didn't yet have one? Do you agree with the statement: after all nature is better than art?"[30]

Both Rauschenberg's paintings and Cage's ideas on silence are important in understanding the sensibility underlying Johns' *White Flag.* For Johns, too, whiteness creates a situation of visual "silence" which provokes the viewer to look in a different way in order to relate somehow to the apparent emptiness. As Susan Sontag wrote in her essay, "The Aesthetics of Silence":

The notions of silence, emptiness, and reduction sketch out new prescriptions for looking, hearing, etc.—which either promote a more immediate, sensuous experience of art or confront the artwork in a more conscious conceptual way.[31]

Silence, emptiness and reduction, as they are used in the work of Rauschenberg, Cage and Johns, also involve us in a different attitude toward ✗ the way we experience reality—the idea that in terms of perception everything is as important as everything else, no matter how minimal, insignificant, even boring it may seem to be: what Sontag calls "the positivity of all experience at every moment of it."[32]

An important difference between Johns' *White Flag* and Rauschenberg's *White Paintings* is that Johns' contains its own visual "noise" in the form of painterly brushstrokes of encaustic and collage, which cover the entire surface. Paradoxically it is *full* while appearing empty, and the fullness is contained within the work itself, rather than the environment as with Rauschenberg and Cage. Johns best sums up this attitude in the final words of a statement made in 1959: "Generally, I am opposed to painting which is concerned with conceptions of simplicity. Everything looks very busy to me."[33]

In *Gray Flag,* 1957 (Koz. 33), there are none of the flag's standard colors. Rather, the entire flag is painted in gray, another neutral color Johns adopted to augment the effect of detachment which was then so important to him.[34] Though *Gray Flag* is relatively small, its scale does not alter our perception of the flag design as it does in the large *White Flag.* However, the same type of tenuous balance between abstraction and realism is created because of the use of monochrome: the flag seems to be continually on the verge of disappearing, yet it is delineated just enough so that its recognizable structure defines the surface. In 1960, Johns made a small *Flag* in sculpmetal and collage on canvas (Cri. 49). The silvery gray of the sculpmetal is similar to gray encaustic except that its surface texture is different and its metallic quality gives the painting a more manufactured look. However, in both cases brushstrokes are applied in a painterly way, giving them a hand-made look as well. The shiny metallic surface of the sculpmental *Flag* creates patterns of light and shadow resulting from the varying thickness and direction of the brushstrokes. That same year Johns did a *Flag* sculpture cast in bronze (Cri. 50), directly based on the sculpmetal painting/relief, its size and surface configuration almost identical. Like Johns' other monochromes, the bronze provides a neutral, uniformly colored surface.

Johns has painted several *Flags* set in a field, where all the flag's edges are not identical with the edges of the painting. The first example of this variation is *Flag Above White,* 1955, in which the top and side edges of the red, white and blue flag coincide with the top and side edges of the painting, while the lower edge abuts a white field added below. The addition of the white area increases the artistic potential of the original flag design. Because it is part of a pictorial space larger than itself our perception of it is altered. The white area plays an ambiguous role: it can be considered an enlarged white stripe, which extends the flag's proportions. However, our perception of the flag as a *gestalt* makes it impossible to accept such a distortion of the design, so that we see the "flag"

and the "white" as two separate adjacent areas. The white area also could be seen as part of a white ground on which the flag is painted, except that the flag and the white are painted to look like part of the same surface layer: nothing is really *on* or *under* anything else.[35]

Flag Above White with Collage (Plate 2) (Koz. 15), done the same year, is of the same size, color and proportions as *Flag Above White*. The only difference is the presence of collage, mostly newspaper fragments of various sizes and types of print. Collage dominantes the surface here more than in any other of Johns' paintings—its mention as part of the title indicates its special role. Almost the entire surface is covered with newsprint aligned vertically, horizontally and diagonally, functioning with the same diversity as brushstrokes usually do in Johns' works (here, the brushstrokes play a secondary role). As in Johns' other *Flags* with collage, the stripes are delineated by bits of paper and the stars cut out of paper. (In *Flag Above White* and other paintings without collage, the edges of the design are reinforced by brushstrokes and the stars are stencilled.) The collage materials are covered by a thin layer of encaustic so that the print is clearly visible in some places and obscured in others. Among the phrases which stand out clearly are: "Hoover commission," "If there is tragedy in this story," "Avviso Teatro," "she is small, freckled and shy," "Hey Kids! Books for Boys." The most striking collage element is the vertical row of four instant souvenir snapshots of a man staring with a straightforward blank gaze. Johns has placed the photograph so that the man's image blends with the stripes, each picture takes up the space of two stripes and is so arranged that the man's face is positioned in the white stripes. Johns has said that he found these pictures on the street, ensuring that the man is anonymous and eliminating the possibility of personal involvement on either the artist's or the viewer's part.[36] In a 1965 interview, when asked whether his collage materials had any "iconographic significance," Johns said:

> I think only in the instance say, where there are those photographs [referring to those in *Flag Above White With Collage*]—that's a very deliberate kind of thing clearly left to be shown, not automatically used but used quite consciously. But generally, whatever printing shows has no significance to me. Sometimes I looked at the paper for different kinds of color, different sizes of type, of course, and perhaps some of the words went into my mind; I was not conscious of it.[37]

In *Flag on Orange Field,* 1957 (Cri. 22), a red, white and blue flag, entirely isolated from the painting's edges, is set into the upper half of a bright orange, vertically rectangular field of dense brushstrokes of encaustic. In the same 1965 interview cited above Johns said:

> The *Flag On Orange* was involved with how to have more than one element in the painting and how to be able to extend the space beyond the limits of the image, the predetermined image... It got rather monotonous, making flags on a piece of canvas, and I wanted to add

something—go beyond the limits of the flag, and to have different canvas space. I did it early with the little flags with the white below, making the flag hit 3 edges of the canvas and then just adding something else. And then in the *Orange* I carried it all the way around.[38]

The flag clearly maintains its identity, even though it is at the same time part of the larger field. The bright orange contrasts sharply with the flag's colors, so that its edges remain visible. (This would not be the case if the field were either red, white or blue.) The brightness of the orange makes the field appear to advance optically, so that the flag seems to be set *into* the field rather than on it, as a figure on a ground. The orange also adds a sense of lushness to the painting, which contrasts with the generally restrained coloring of Johns works up to this point.

Another variation is multiple flags in a single field. The first of these is *Three Flags,* 1958 (Plate 3) (Cri. 40), where three red, white and blue flags, each on a separately stretched canvas, are placed one on top of the other.[39] Like the sculpmetal *Flag,* this work is an ambiguous object, both painting and relief sculpture at the same time. Only the smallest flag is entirely visible, yet we read the other two as complete images because of the predominating impulse to see the design as a whole. There is an irregular pattern created by the stars and stripes of different sizes, yet Johns has not altered or distorted the flag design at all. *Three Flags* proves that changes in scale do not undermine the effect of the flag's realism. Because it is a flat design it can be rendered in any size or in different sizes within one work and still maintain its *trompe l'oeil* effect. Johns has set up a situation where a reversal of conventional perspective occurs: in an illusionist painting, objects further in depth appear smallest, whereas in *Three Flags* the opposite is true since the smallest flag is closest to the viewer. Johns once mentioned that *Three Flags* was similar to Picasso's *Bather by the Sea,* 1933 (Zer. 8, 147)[40] where the same type of scale reversal occurs: the bather's breast closest to the viewer is smaller than the one behind it.

In the following year, 1959, Johns painted *Two Flags* (Koz. 48), in plastic paint, his only major work in that medium. Two flags of equal size, both in varying shades of black, gray and white, are painted one on top of the other, so that the format is a vertical rectangle made up of two horizontal rectangles. As in Johns' other monochrome *Flags,* there is a balance between seeing the flag design and losing it in the uniformly colored surface. In *Two Flags* there is also a balance between reading the surface as a unified field and seeing the two separate flags as individual objects within the field—Johns stresses the dividing line between them to make sure they remain distinct. Because the two flags are identical in size, medium and color, they look like repeated images, one a duplicate of the other. However, if the surface details are compared, the differences between them become apparent: the brushstrokes and tonality of each flag are different in any given area, and each provides a unique visual experience in terms of its painterly handling.

In 1962, Johns painted a slightly larger version of *Two Flags* in the same format, this time in oil on two joined canvases. Because these flags are painted in red, white and blue, they have a more distinctive identity as flags, and as a result there is not the same sense of a continuous field of brushstrokes as in the 1959 gray painting. We clearly see *two* flags, but Johns presents them in such a way that they also form a unified single field. The two panels are linked by brushstrokes and paint drips which continue from one flag to the other (the most obvious is a thick vertical red brushstroke near the right edge). By juxtaposing two like objects as he does in *Two Flags,* Johns focuses on sharpening our senses so that we can see subtle variations in things which seem to be the same.

Flags, 1965 (Cri. 130), also involves a comparison of two like images within the same painting, but in a different way from Johns' other multiple *Flags.* This painting's structure relates to *Flag on Orange Field,* since one of the flags is set in the upper section of a vertical field. However, another flag is added in the lower section on a separate canvas slightly above the larger surface. The upper flag is painted green, black and orange and the lower one gray, like the surrounding field. We are meant to stare at the dot in the center of the upper flag and then shift our gaze to the lower flag. As a result of the negative afterimage effect, the upper flag's complementary colors appear on the neutral surface of the lower. These turn out to be the standard colors of the flag: red being the induced complementary of green, white of black and blue of orange. Johns provides a black dot in the center of the lower flag to align the afterimage directly on the gray flag. According to Johns' conceptual framework, the green, black and orange flag could only exist as a reference to its red, white and blue complement; its colors could not have been arbitrarily selected.

In a drawing titled *Two Flags,* 1969 (Plate 4), Johns presents a different version of the multiple flag variation than had been used in his paintings. Two flags are arranged in a vertical position, adjacent, but separated by a small space. In one, the flag design is traced lightly in pencil, so that most of the surface is the blank, white page. In the other, the flag design is densely worked over in pencil, so that it appears "full" in contrast to the other which appears "empty." In both, the lower left corner of the paper is folded back, revealing another layer of paper beneath it. The layer under each flag drawing—at least what we can see—corresponds to the flag above it: the surface configuration is the same as the drawing above, but without the structure of the flag to delineate it. The bent corner invites the viewer (conceptually) to lift the drawings and turn them over. The drawings on the folds suggest that by lifting the paper the flag's reverse side would be visible. The potential for lifting the image and seeing its reverse side reminds us that the drawing is a tangible, three-dimensional object in its own right, rather than a flat surface.[41]

This drawing is the source for two paintings with vertical flags, *Flag,* 1971, in gray and *Two Flags,* 1973 (Cri. 152), in red, white and blue. The vertical orientation of the flags adds a new perceptual dimension to this now familiar Johnsian image. The flag design appears backwards in relation to its usual horizontal orientation. However, when the American flag is displayed, whether horizontally or vertically, the stars always appear in the upper left, as they appear in Johns' paintings.[42] Backwards flags appear only in Johns'etchings from *1st Etchings,* 1967-68, and *1st Etchings* (2nd State) 1967-69 (Field 75, 82). For these, Johns chose not to reverse the flag design when he prepared the etching plate and as a result the image appears backwards. Since 1960 Johns has also done several *Flag* lithographs where he drew the flag design backwards to have it come out correctly in the print. Johns' vertical *Flags* were probably in part inspired by his printmaking activity involving reversal of images, especially the etchings mentioned above.

In summary, the American flag was a subject with which Johns could initially state his basic artistic ideas, and also one that he could vary in ways which would reflect different pictorial concerns throughout his career. The flag also provided Johns with a distinctly American subject, establishing his connection with previous American art. The only straightforward depictions of isolated American flags before Johns are found in folk arts and crafts. Flags appear in several landscape or cityscape paintings of the American scene, ranging from naive folk paintings, like Terrence Kennedy's *Political Banner,* ca. 1840, to sophisticated social commentaries, like Florine Stettheimer's *Cathedrals of Wall Street,* 1939 (Plate 5). Stettheimer, one of Johns' favorite American artists, created an important precedent for Johns' and other recent artists' interest in the commonplaces of American culture.[43]

Many recent artists since Johns have used the flag either as an independent subject or as a motif in paintings and collages, e.g., Claes Oldenburg and Tom Wesselmann. "The People's Flag Show" held in 1970 at the Judson Memorial Church included works by approximately 150 artists, poets and dancers, using the American Flag as a central theme. The show was consciously political and anti-establishment, challenging "state laws restricting our use and display of the flag."[44] It is significant that Johns, the artist most associated with the flag, did not participate. Johns does not intend his *Flags* to have political meaning. He originally chose the flag because it was a commonplace object, familiar to everyone, something generally accepted as a patriotic symbol, without the political connotations it has had since the mid-1960s during the height of controversy over the Vietnam war. The one specifically political *Flag* Johns has done was an edition of posters sold to raise money for the Vietnam Moratorium Committee in 1969, using a photographic reproduction, of the green, orange and black flag from *Flags,* 1965.[45]

Targets

The painting which directly followed Johns' first *Flag,* was *Target with Plaster Casts,* 1955 (Plate 6). The target shares many features with the flag, but its unique qualities enabled Johns to explore different art ideas. The target is a more abstract image in that it can be read as a geometric pattern of concentric circles, as well as an object with a specific function. The flag, although it is also a relatively simple geometric design, is much more specifically defined as an object. The perfect radial symmetry of the target gives it a sense of evenness and regularity which goes beyond what John Cage called the asymmetrically symmetry of the flag.[46] Another important difference is that the target is based on a hierarchical arrangement of forms culminating in the bulls-eye. This gives the design a specific focus which Johns counteracts through format,color and, in his first two *Targets,* with a row of boxes filled with plaster casts. It is significant that Johns placed the circular target in a square field rather than using a shaped canvas, where the format and design would be identical, as in *Flag.* The circle-in-a-square arrangement provides a more diverse surface design: the spandrel-shaped corners contrast with the circles and draw attention away from the central focal point of the bull's-eye. Johns did not use "ready-made" colors for his *Targets;* instead he chose red, yellow and blue—the primary colors—which from this point are the basic colors of his conceptualized palette. There is no sense of distinction between figure-ground elements, because the circles of the target, like the stripes of the flag, are read as part of the same layer of space (i.e., we do not see a pattern of stripes on a ground, which we would tend to do if it were an abstract design rather than a target). The target itself appears to be set into the square field rather than on it. As in the *Flag,* the separate parts of the pattern have a tangible thickness, because of the way Johns has built up the surface: each ring is a distinct band of collage materials painted over encaustic. *Target with Plaster Casts* is a construction made of a stretcher plus a wider board on each side, which sets the painting off 3½-inches from the wall and emphasizes its presence as an independent object. The brushstrokes and collage are continued over the sides, so that the "edges" become part of the surface as well. (The brushstrokes of red encaustic continue only onto the sides of the stretcher; the construction boards are covered with collage, including figurative images, postcards and papers of various sorts, some of which are printed in foreign languages.) There is a wooden strip along the bottom of the *Target* which functions like a supporting ledge. At the top is a row of boxes with casts, indicating the literal depth of the painting/object whose surface bears the flat target design. The sources within Johns' own work for the structure of *Target* are *Construction with Toy Piano,* 1954, with its row of piano keys in the same position as the *Target*'s hinged lids, and *Untitled Construction,* 1954, with a plaster cast in a niche.[47]

There are nine boxes, each with a hinged wooden lid, which can be opened or closed. The boxes are painted in the primary and secondary colors and neutral tones, and all of them, except the empty blue one and the black one with a bone, contain plaster casts of parts of the human body. Each cast is painted the same color as the box: a purple foot, white face, red hand, pink breast, orange ear, green penis and yellow heel. The greenish-black bone is the most ambiguous fragment, since it is not specifically identifiable; however, it does suggest the female sexual organ, which is probably the reason Johns used it.[48] Because this fragmented figure is juxtaposed with the target, there is a suggestion of violence and dismemberment. At the same time, because of the way Johns presents the figure—its parts like objects on niche-like shelves—it becomes dehumanized, and the connotations of violence appear in this sense absurd: the casts are in actuality no more real than the rows of figures one aims at in a carnival shooting gallery. I refer to Johns' body fragments as figures because, even though they are incomplete, they indicate the presence of figures and relate thematically to traditions of figurative art.

The figure, which is usually considered more important than an object in the hierarchy of subject matter, here takes a secondary role: the target is larger and cannot be covered and hidden from view like the boxes containing the anatomical fragments. The target and casts are presented as different types of "images": the target/painting is a depiction of a flat object which, like the flag, can be used like the original object, so that it is not a representation in the traditional sense; the cast/sculptures are three-dimensional representations made from a real figure. By juxtaposing the target and figure, Johns is also contrasting two distinct visual experiences. The target is a symmetrical, geometric design seen as a whole in a single glance. The figure, usually seen as a whole, is incomplete and its symmetry shattered; it is presented in a serial arrangement, so that each part is perceived separately in a way which has nothing to do with the organic structure of the body. Because the body parts are seen independently, they seem more important and mysterious than if they were part of a complete figure: they even have an iconic presence, like precious religious relics.

By showing the human figure broken up and boxed in, Johns is characterizing it as unable to exist as an integrated whole, out of touch with its surroundings. Its parts are kept out of touch from each other, so that they cannot function together. The figure is cut off from its environment, either to keep itself protected or hidden or because it cannot make contact with the outside world.

Picabia's works showing targets juxtaposed with figures are precedents for and possible influences on Johns' *Targets* with anatomical fragments. In *Optophone*, ca. 1922 (Cam. 227), a female nude reclines across the bull's eye of a target-like pattern of concentric circles. The target image creates a sense of

anticipated violence. In *Spanish Night*, 1922 (Cam. 210), targets and bullet holes create an atmosphere of violence surrounding the female nude and male dancer.[49]

There are several Dada and Surrealist works with anatomical fragments which are relevant precedents for Johns' *Target*, in that they present a similar image of the isolated, alienated individual as characteristic of modern society. Some of these were probably known to Johns when he did his first works with fragments during 1954 and 1955. Several artists have used parts of mannequins and dolls in sculptural assemblages, such as Raoul Hausmann's *The Spirit of Our Time*, 1919,[50] and Alberto Giacometti's *Caught Hand*, 1932. There are a few examples of works with plaster casts of body parts before Johns': including Salvador Dali's plaster foot in *Tray of Objects*, 1936, and Marcel Duchamp's ambiguous, erotic casts, *Not a Shoe*, 1950, *Female Fig Leaf*, 1950, *Objet-Dard*, 1951, and *Wedge of Chastity*, 1954 (Sch. 331, 332, 335, 338).

Giorgio De Chirico and Magritte used anatomical fragments in several paintings, e.g., De Chirico's *Song of Love*, 1914 (Gab. 37), and Magritte's *Memory*, 1938.[51] In both, what looks like a fragment of an antique sculpture is juxtaposed to apparently unrelated common objects. These fragments, like Johns', are presented as objects, while at the same time indicating the presence of figures; in Magritte's painting the fragment even bleeds from a wound inflicted by an unknown source. Magritte's *A Night Museum* and *The Bold Sleeper*, both 1927 (Gab. 50, 54), have several features in common with Johns' *Target*. The four compartments in *Night Museum* resemble the row of boxes in Johns' painting. The hand in Magritte's painting is presented in a matter-of-fact way, juxtaposed with still-life objects. It is disturbing to see a human hand placed on a shelf as if it were an apple, but Magritte provokes us to question what we are actually perceiving in a work of art—reality or illusion. The piece of cut-out paper covering one of the compartments functions like Johns' target design to focus attention on the flatness of the picture's surface. The format of *Bold Sleeper* is strikingly similar in composition and imagery to Johns' *Target*:[52] the figure in a box-like compartment at the top, and below, a group of common objects, all three-dimensional forms (of varying degrees of roundness or flatness) which are shown embedded in the surface of a relatively flat stone slab. There is even a small painting by Magritte with a target and head fragment, *Hall of Arms*, 1926 (Mag. 9). In all these paintings, Magritte, like Johns, creates a disturbing atmosphere through the unexpected juxtaposition of figure or figure fragments and objects; and, at the same time, deals with the concept of representation in terms of flatness versus three-dimensionality and illusion versus reality.

In Johns' *Target with Four Faces* (Koz. 5), done the same year, the geometry of the target design is again contrasted with the disturbing fragmentation of the figure. This time, instead of casts of different parts of the anatomy, Johns uses only faces which appear identical (they were cast from the

same female model), but which vary slightly because they were cast at different times.[53] Like the white face in the first *Target*, they are cut off below the mouth and above the nose, but here they fit exactly into the niches, so that they seem even more confined. The most disturbing aspect of these faces is their lack of eyes. Johns ironically makes the eyes more conspicuous by their absence, as if by leaving them out he reminds us that the process of seeing is not to be taken for granted. The absence of eyes also guarantees the figure's anonymity. The device of repeating the same image four times further depersonalizes it as if it were a mass-produced item. Repetition also gives the face a more captivating quality than if presented singly. A similar effect occurs with the "four faces" in the photograph in *Flag Above White with Collage*, 1955. It is impossible to specifically interpret the figure in this *Target*. Many thoughts and feelings are evoked—isolation, depersonalization, anxiety—but the work always comes back to the object it claims to be: a target with four faces.

Magritte and Joseph Cornell are precedents and possible sources for Johns' use of multiple images of the same face. More significantly, the similarities in their works underscore the similarities between Johns and these Surrealist-rooted artists. Magritte's bowler-hatted men, like Johns' faces, are anonymous and appear to be infinitely repeatable, as in *The Month of the Harvest* (1959). In Magritte's *The Menaced Assassin*, 1926-27 (Gab. 39) three identical faces are lined up outside the back window; a fourth figure with the same face, standing by the gramophone, completes the group (this figure could also be blocking from view a fourth face at the window). The mood of violence in this Magritte painting connects it thematically with Johns' 1955 *Targets*. Cornell did several works with repeated figures, some including target-like patterns as well. For example, *Untitled (Medici Slot Machine)* 1942, resembles Johns' *Target with Four Faces* because of the serial repetition of identical faces, the juxtaposition of figure and circle, and also because the figure is enclosed in a box implying its isolation from its surroundings.[54]

Although the format, medium and color of *Target with Four Faces* are basically the same as Johns' first *Target*, it is a more unified construction. The target is exactly centered in the square, whereas in the first there is more space above the target than below. Also the target takes up more of the field, and its edges almost touch the sides of the square. The four boxes above are centered, so that the painting is vertically symmetrical. (In the first *Target* the nine boxes are not centered—the block at the right is wider than the one at the left.) Instead of individual lids for each box, there is a single hinged board, which can be closed to cover all of the boxes at once. The construction is the same type of stretcher-board combination, but there is no wooden strip along the lower edge.

A drawing, *Target with Four Faces*, 1955 (Cri. 10), done after the painting, reinforces the importance of its three-dimensional construction.

Johns shows both a front and side view. In the front view, the boxes are drawn so that their structure is clearly visible; and the side view shows the ¾-inch stretcher and the 3-inch board supporting it. The casts are indicated by the word "head" repeated in each box. This is the first time Johns used words as a substitute for objects. In a 1958 drawing he used the word "face" (Koz. 111). In 1968, Johns did a silkscreen and a poster based on *Target with Four Faces* for Merce Cunningham's Dance Company, using Cunningham's face instead of the original anonymous-looking model (Field 92).

Almost all of Johns' subsequent *Target* paintings have been single targets of the same five-ringed design, centered in a square field with no plaster casts or other objects connected with them. He did not experiment with field variations or multiple images the way he did with the *Flags.* There are only two examples of these variations, both based on *Flag* paintings: a small watercolor *Target On Orange Field,* 1957, and *Targets,* 1966 (the same format as *Flags,* 1965). In 1960, Johns did a small "blank" target in pencil, with red, yellow and blue watercolor discs and brush attached below, signed as if Johns meant it to be painted in by someone else. In several other versions of the *Target,* Johns retains the same primary color scheme as in the first two: alternating blue and yellow bands set in a red square. In each one the scale and/or medium is varied. Johns first major oil painting was a primary color *Target,* 1958 (Cri. 23). Its surface has the look of encaustic because of the restrained manner in which the brushstrokes are applied; however, it has a different textural quality from Johns' earlier *Targets:* close examination reveals that it is rough and pasty-looking, rather than waxy and smooth like encaustic. In this important transitional work, Johns consciously created ambiguity as to the medium used, whereas in his subsequent oil paintings, he used large open brushstrokes exploiting the fluidity of that medium.

As with his *Flags,* Johns did not vary the color scheme of his *Targets* for expressive or purely decorative effect. The only other multi-colored arrangement he used employs the secondary colors: orange and violet bands on a green square. This color scheme appeared first in *Targets,* 1966, where the colors, like those in *Flags,* 1965, are determined by the negative afterimage effect: after staring at the green, violet and orange target, we see the complementaries of red, yellow and blue superimposed on the neutral gray target below. The next year, Johns began a large, single, green, violet and orange *Target,* 1967-69, where the fact that the colors are complementaries of the original *Targets'* colors is as much a part of their meaning as their sensuous impact. In 1974, Johns did two *Targets,* one small and one large, using the full range of the spectrum, although the overall coloring is predominantly red, yellow and blue. In the larger *Target* (Cri. 153) Johns added three color rectangles—green, violet and orange—in the same position as the boxes in his 1955 *Targets.*

Johns has painted several monochrome *Targets* in green, gray, white and black. Through eliminating the multiple colors which clearly define the discrete bands of target, he makes the image more difficult to perceive. The same thing happens in the monochrome *Flag* paintings, but since the target design is more abstract, it comes even closer to disappearing than the flag. It can be read as a composition of concentric circles, and therefore the title plays an especially important part in preserving its identity as an object. If, for example, *Green Target* (Cri. 12) 1955 were called "Green Circles," it would take on a different meaning, without the connotation of the object/painting which is so crucial for Johns. It is significant that *Green Target* was Johns' first work to be shown in a major exhibition (1957 at the Jewish Museum); it was the only one of his paintings selected for the show, most likely because it could be viewed as an abstract painting for those who wanted to see it that way.[55]

Johns' first painting in sculpmetal was a small *Target*, done in 1958, the same year he did his first free-standing sculptures of lightbulbs and flashlights in that medium. Frank Stella, who owns this *Target*, said that Johns planned to make a sculpture based on it (like his bronze *Flag* based directly on his sculpmetal *Flag*, both 1960).[56] A note in Johns' "Sketchbooks" mentions this sculpture, which to date has not been made: "Make a target in bronze, so that the circles can be turned to any relationship."[57] The potential movement of the target design found expression in *Device Circle*, 1959, and subsequent works with moveable devices used to trace circles.

Numbers and Alphabets

Figures

Johns' first paintings of printed signs were of individual numbers in a rectangular field. In 1955, he did four number paintings: *Figures 1, 2, 5,* and *7* (Cri. 3, 4, 5, 6) in white encaustic and collage, all identical in size and format. Like all of Johns' subsequent numbers and letters, they are presented in a standardized way, so that they do not suggest his own handwriting. They are traced with stencils or made to look that way, and therefore are more objective and impersonal than numbers drawn freehand. These first *Figures* were not intended to be an ordered series. Johns said that he cannot remember the order in which they were done, and that sequence was not part of his thinking about them. He also said that he was at first going to title them "Numbers," but he decided that, like de Kooning, he wanted to have his own "figure" paintings.[58] Although on one level the title "Figure" is an ironic pun, it also reveals much about the meaning of these paintings for Johns. The irregular geometry of each number suggests the human figure—the shapes of some suggest the organic curves of the body, others are like stick figures. The number-figure has the

tactile, sensuous qualities of human figures without their emotional overtones, unlike those represented by casts in Johns' 1955 *Targets*. The title "Figure" also focuses attention on Johns' concern with figure-ground relationships.

The 1955 *Figures* are all relatively small paintings and therefore intimate; but we do not normally see a number so large or isolated as it appears in these paintings. When we do—say a number on a sign or a doorway—we look at it for specific information. In Johns' paintings, however, the number appears not in the context of daily life, but in the context of art: we look at it in a new way and it gives information of a different order than expected.

Each figure is centered in its field, the size and proportions of which are just adequate to contain it. A clear-cut figure-ground differential is set up, which Johns then breaks down by integrating the figure with its surrounding space. This unification is achieved without dissolving the number's shape. In *Figure 5*, for example, the "5" is cut out of newspaper fragments, so that it appears set into rather than on the collaged surface around it. (This is similar to the handling of the separate parts of the flag and target designs.) White encaustic is applied over the entire surface, so that the figure is not distinguished by color or texture. Brushstrokes are used to reinforce the shape of the "5" in some places, and in others brushstrokes and drips cancel out the boundary between number and surrounding field.

The most significant precedent for Johns' *Figure* paintings is Charles Demuth's *I Saw the Figure 5 in Gold*, 1928 (Koz. 3), which Johns was most likely familiar with at the time he painted his first *Figures*.[59] Both artists present a figure "5," depicted in an impersonal, standardized typeface, as the painting's main subject. Our attention is focused on something which would normally not be thought important enough or valid as a subject for a work of art. Both use the number as a flat sign which calls attention to the picture's surface like the numbers and letters in Cubist still lifes. There are, however, many differences between Johns' *Figure 5* and Demuth's painting. Unlike Johns' "5" which is painterly, Demuth's is hard-edged and clearly set apart from the surrounding Cubist-type space. Demuth repeats the "5" three times in diminishing scale, so that it creates an illusion of depth: in a typically Cubist way there is a tension between the flatness of the signs and the three-dimensional illusionist space. (The way Demuth uses the "5s" to establish three fixed levels of depth recalls Johns' *Three Flags*, 1958, except Johns creates a literal, rather than illusory pictorial space, by superimposing three flags of diminishing scale, with the smallest nearest the viewer, rather than, as in the Demuth, furthest away.) In Johns' painting the "5" is presented with no specific associations, while in Demuth's it refers to "the figure 5 in gold" on a fire engine, as described in a poem titled "The Great Figure," by his friend William Carlos Williams. Demuth was concerned with creating a visual equivalent to the poem, including the effects of movement, sound and light of the fire engine speeding "through

the dark city." Johns' "5" has no intended literary or anecdotal allusions nor spatial illusions.

All of Johns' subsequent *Figure* paintings are like his 1955 *Figures,* single numbers in a rectangular field. As with his other flat motifs, each version is different in scale, color and/or medium. His most frequently painted *Figure* to date is "4"; and he has painted all the primary numbers individually except "6" and "9" (see Appendix B). After the 1955 *Figures,* it was not until 1959 that single numbers were taken up again as a major subject. That year he painted three small *Figures*—"4," "7" and "8," and three larger ones, all the same size— "0," "4" and "8." The larger *Figure 8* (Plate 7) is Johns' first figure in color. Because of its bright color (mostly red, yellow, blue and white) and its more open expressionist type of brushwork, combined with the curvilinear shape of the "8," it takes on an especially sensuous and figurative quality, comparable to that of some of de Kooning's *Woman* paintings.

In 1960, Johns painted his largest "life-size" (6 × 4½ feet) single figure, a *Figure 5* (Plate 8) commissioned by Mr. and Mrs. Robert Scull, who chose the number. The names "Scull" and "Johns" are printed in the lower corners.[60] It is painted in black, white and gray encaustic (with a touch of violet, over collage. Its shape and proportions are different from the first *Figure 5:* the numeral is thicker and takes up more of the field, the brushstrokes are larger and more open (characteristic of Johns' change of style beginning in 1959 with works like the *Figure 8* just described), thus creating the illusion of a shallow layer of space which is counterbalanced by the flatness of the "5," the flat sign acting like a foil to the space-generating brushstrokes.

Alphabets and Numbers

The alphabet was Johns' next motif using printed signs. He did not paint individual letters, but always the complete alphabet. (He once said that he never painted single letters because people would personalize them into initials.)[61]

In his first alphabets painting, *Gray Alphabets,* 1956 (Cri. 18), Johns arranged the letters of the alphabet, painted in uniform lower case Roman type, in a grid made up of 27 × 27 rectangular units, each of which echoes the shape of the entire field. The grid unifies the surface into a single pattern, perceived as a *gestalt,* but at the same time it provides a separate "field" for each individual letter, so that each part of the pattern—each module—remains distinct. All the grid units, except the one in the upper left corner, are filled with letters arranged in their memorized sequence, "a to z." The top row and the row along the left edge each contain the twenty-six letters of the alphabet, while the others contain twenty-seven. Each row of the grid is different, always beginning and ending with the same letter. A progression is set up which runs its course to

completion, rather than being infinitely extendable, as it would if the rows were identical or if there were no blank space at the beginning. Because of the arrangement he has chosen, Johns created a closed and complete system like the designs of the flag and target. According to John Cage, Johns first saw this type of alphabet chart in a book,[62] however, like his other ready-made designs, what is significant is not the invention of the motif, which Johns consciously avoids, but the way it is transformed in an art situation.

Johns has set up the letters so that we can read them the way we were taught, in a linear sequence from left to right. But we can also read them vertically (the order is the same as it is horizontally) and diagonally, since the same letter is repeated on the diagonal (accented especially when the letters themselves have diagonal elements, like "x," "y" and "z"). Also, the painterly handling of the surface encourages a random style of looking which counteracts the ordered structure of the grid arrangement. Because Johns used monochrome, the letters do not stand out distinctly like letters (in a book, on a sign, etc.) are supposed to so that they can be clearly read, and we see them emerge and disappear as our focus shifts. They are painted so that some are clearly legible while others are obscured by brushstrokes. The difficuty in reading most of the letters encourages us to look at them more intensely than we normally would. Almost all the letters were cut out of bits of newspaper (the others were printed through stencils directly onto the canvas), so that they are actually letters made up of letters, whose function has been altered by their new use as collage.

The grid structure, first used by Johns in his 1954 *Untitled* collage gives a uniformity to the surface: it is a regular, all-over pattern, each part of which is as important to the whole as any other—there is no focus and no areas where the eye is specifically directed. The grid and repeated letters create a sense of sameness, counterbalanced by the painterly handling which transforms each unit into a unique "painting-within-a-painting."

Johns' subsequent *Alphabets* paintings have all been in the same format with lower-case letters, but varying in size, medium and color (see Appendix B). In 1968, he painted three large *White Alphabets,* all in oil and identical in scale. In each one, the letters of the alphabet were printed onto the surface with rubber stamps rather than stencils: two are printed in white on white (one with backwards letters) and one in colors on white. The only variations in format and lettering have been in one drawing and two prints. In a charcoal drawing, *Alphabet,* 1959, a single alphabet printed in upper-case letters is arranged in a square field—four rows of five letters and one of six. The units of the grid which contain it change in width to accommodate each letter. In two prints, a lithograph, *Alphabet,* and *Embossed Alphabet,* both 1969 (Field 115, 116), the letters are superimposed one on top of the other, like the previous *0 Through 9* images Johns did earlier, during 1960-61.

In 1957, Johns painted *White Numbers* and *Gray Numbers* using the same chart-like grid structure of *Gray Alphabets*. From this point, Johns preferred the "Numbers" motif, painting many more versions of it than the "Alphabets," most likely because there were only ten rather than twenty-six signs to deal with and the structure could therefore be simplified. In all of the *Numbers,* the sequence "0 to 9" is repeated twelve times. Each unit of the 11 × 11 grid contains a figure, except the one in the upper left, so that the same type of closed system is set up, with the signs shifting position in each row. The numbers, like the letters, can be read in a linear pattern in all directions, but non-linear looking is encouraged as well by the way the surface is painted.

Johns did several versions of this "Numbers" motif in white, gray and colors. In his *White Numbers,* he creates a situation of visual silence suggesting disappearance, as in his other white paintings. But these are especially minimal in their initial impact because the paint is applied sparsely, so that the canvas shows through, and there is no collage. In *White Numbers,* 1958, Johns added subtle touches of color (red, blue, yellow, orange and green) which appear only gradually as the surface is thoroughly explored, taking on an unexpected intensity because of their colorless surroundings. The eye shifts from color to color in an unstructured way, completely different from the linear ordering of the rows of numbers. (In *White Numbers,* 1959, there are a few touches of orange and blue.) Johns said that in his first *Gray Numbers,* 1957, the numbers were printed without stencils,[63] so that, in spite of the metallic-looking, neutral gray, there is a more personal hand-made quality to this painting than the ones which follow. A 1963 sculpmetal *Numbers* (Koz. 83) was used as the model for *Numbers,* 1963-69, cast in aluminum. *Numbers,* 1964, a commission for The New York State Theatre at Lincoln Center, also in sculpmetal, is Johns' largest version of this motif (12 × 9 feet) and the only one where the units of the grid are each separate panels. Included in the surface are a key (Johns' only metal-on-metal collage) and Merce Cunningham's footprint (a reference to the performing arts). The initial impact of Johns' *Numbers in Color,* 1958-59 (Plate 9) (Cri. 26), is the opposite of his monochrome white and gray numbers, where the visual "activity" at first seems to be reduced to an absolute minimum; here, brushstrokes of encaustic in the full range of Johns' palette—varying values of primaries, secondaries and neutral tones—plus collage are distributed randomly throughout the entire surface, creating a dazzling fabric of color. Johns did a *Gray Numbers* in 1958 (Cri. 25) identical in size and medium to *Numbers In Color.*

0 To 9 and 0 Through 9

In 1958, Johns painted *0-9 (0 To 9)* in white encaustic and collage (Koz. 25). The numbers are arranged in two rows, 0 to 4 and 5 to 9, so that a horizontal

field is made out of the smaller, vertically rectangular units. Each unit is handled like an individual *Figure* painting, but at the same time it is an inextricable part of the whole (like the grid modules in the *Numbers*). In 1959, Johns painted two larger versions of this motif, one in red, yellow and blue encaustic and collage (Cri. 39) and one in gray plastic paint. In 1960, he began a painting, *Numbers, 1960-65* (Koz. 30), related to a series of lithographs titled *0-9, 1960-63* (Field 17-46). This painting in encaustic on paper (mounted on canvas) was done over a proof for the first lithograph in that group, "O" (Field 27), which was the only one of the series completed in 1960.[64]

In 1960-61, Johns did eleven paintings and one sculpture where all ten numbers are superimposed on each other (Plate 10) (Cri. 57, 75-78). He titled them *O Through 9*, to indicate the process of looking through space to see them, rather than reading them in a linear sequence. This arrangement creates an illusion of shallow depth since the numbers interlace and overlap. But at the same time, they establish the flatness of the surface on which they are printed There is a cubist type of tension between three-dimensionality and flatness, but unlike the Cubists, Johns uses only flat signs, identical in scale, to create the illusion of layers of space. There is no constant focus because of the shifting clarity and obscurity of the numbers—each one is present in its entirety, yet part of one number becomes part of another, and all ten emerge and disappear as our focus changes. Because we "read" them simultaneously rather than one after the other, the hierarchical arrangement of their ordering is eliminated. As Leo Steinberg describes it, Johns is "annulling the seniority rule among numbers."[65]

The first *0 Through 9* was painted in 1960, in oil (Cri. 57). Johns used his full palette of bright colors and neutral tones. As a guide to the structure of this complicated image, Johns did a charcoal drawing (Cri. 65) where each number was traced through a stencil in such a way that the numbers are neither too obvious nor completely lost. A design of interlacing lines is formed by the outlines of the numbers, comparable in their space-generating effect to Pollock's black and white "drip" paintings, except that Johns' lines are predetermined by the subject and mechanically drawn, while Pollock's are random and exist independent of recognizable subject matter.

The next five *0 Through 9* paintings were done in 1961, all of them identical in size and medium to the first. Although the format is the same, each one is unique in that different parts of the numbers are obscured or clarified according to the way it is painted. Johns develops pictorial situations previously explored in other works, comparing the effect of color and monochrome treatments of the same image. He uses elements from other paintings, like the randomly printed color names from *False Start*, 1959, and title-signatures printed along the bottom edge, "0 Through 9 Johns 61" and "Zero Through Nine J Johns 1961." A new motif, polka dots, appears in this

series for the first time. Five smaller *0 Through 9* paintings were done in 1961, all of which vary in medium and color, including a sculpmetal version (Koz. 82). An aluminum sculpture was made from the sculpmetal painting/relief the same year. First a gelatin mold was made from the sculpmetal version; a plaster impression was taken from this; and then the surface was reworked before being cast in aluminum.[66]

Because their subject and "viewpoint" are the same, these paintings can be considered serial images, like Monet's *Rouen Cathedral* paintings. Monet depicted the effects of changing light and atmosphere conditions on the cathedral facade. For Johns, the fixed motif is the superimposed numbers, and he shows how they are affected by pictorial variations, like medium, color, texture. Both Monet and Johns used subjects which stress the flatness of the picture surface, and in both series there is a sensuous quality to the paint which, even to a large extent in the Monet, is independent of the depicted subject.[67]

Maps

Johns has painted several maps of the United States and one world map, in various sizes and media (see Appendix B). Maps can be considered his "landscapes," the way his numbers are "figures." His first *Map,* 1960 (Koz. 59), was painted in gray encaustic over a small outline map of the U.S.A., the kind a school child would be required to fill in with the names of states and their capitols.[68] In Johns' painting there are no labels to give us the kind of information we usually find in a map, and the boundaries are blurred in certain areas. The shapes of the states are not meant to convey only their identity and location, but they also have meaning as abstract patterns making up a larger design. The map is a more complicated design than the flag, target, numbers or alphabets, but like them it is one which is predetermined, fixed in format and measurable. The map particularly reflects Johns' involvement with scale and measurement from 1960 on. His first painting with a ruler was done in 1960, the same year he did his first *Map.*

Johns' next *Map,* 1961 (Cri. 74), is a large multi-colored painting. According to John Cage, Johns drew a grid on a small outline map, which was transferred on an enlarged scale to the canvas by copying the printed map freehand using the grid as a guide.[69] The map is not shown as an isolated image, rather it is continuous in all directions. Although the map of the U.S.A itself is complete and centered in the rectangular field, the map as a whole, which includes parts of Canada, Mexico and surrounding bodies of water, is a fragment, cut off at the painting's edges. Only the map's lower edge, with Johns' characteristic blank strip, is sealed off. At the other three edges words are cut off, implying continuity beyond the canvas space. However, Johns presents opposite possibilities for reading these edges: e.g., the words "Atlantic Ocean"

and "Pacific Ocean" are printed horizontally, so that they are cut off at their respective edges, *and* vertically along the edges as if to reinforce the painting's boundaries. Even though maps of the U.S.A. usually come with the surrounding territory included, I think it is significant that for his large *Map* paintings, Johns rejected the isolated outline map used for *Map*, 1960, and chose the one showing the map as a segment of a larger whole. This distinguishes the *Maps* from Johns' other earlier flat objects and signs which are always complete, closed systems. This quality of the map also makes it particularly suitable for his art from 1960 on, in which he often uses incomplete, open compositions in contrast to the complete, closed ones characteristic of his earlier work.

Johns has done everything possible to achieve a balance between legibility, so that we can see the details of the map with relative clarity, and illegibility, so that we can experience the abstract qualities of the map-as-painting. The general features of the map are easily distinguishable, especially since we are already familiar with what we are looking at, even though brushstrokes obscure the boundaries in many places. The states are all marked with their names or abbreviations, painted in letters of varying sizes and colors and printed in different directions, so that they function not only as labels but also as brushstrokes, adding texture to the surface. In several places letters are obscured by brushstrokes or drips. Johns uses brushstrokes and lettering both to establish the flatness of the surface and to create a shallow layer of space (for example, in the repeated letters of "Nevada" and "Texas," which establish separate levels of depth). In a map, color usually functions to distinguish separate areas. Instead Johns applies various values of his full palette throughout the surface, unifying the field into a large overall arena of bright color. Ruled lines have been added to strengthen the structure of the surface design.

Johns' next *Maps,* one done in 1962 and the other in 1963 (Plate 11) (Koz. 61, 62) are both large paintings identical in scale and medium (encaustic and collage). Both appear to be conscious variations on the 1961 *Map* with many details repeated. The 1962 *Map* is painted in neutral tones, with subtle touches of red, yellow and blue. Because of the more restrained coloring and handling of brushstrokes, it has a more subdued expressive quality than the previous *Map.* The way Johns uses color here to create the effect of a mood is characteristic of his ironic stance, since the subject itself is as impersonal and neutral as his other flat subjects. Most of the labels echo those of the earlier version in size and direction. (There are some changes in the lettering—larger stencils were used in several places and therefore more names are abbreviated.)

The 1963 *Map* continues the series, but this time with an even more explosive handling than the vigorous brushwork of the 1961 *Map.* Johns seems to be imitating in encaustic the fluidity of oil paint which encourages large,

open brushstrokes. The spikey brushstrokes obliterate several areas, especially near the left edge, so that only minimal legibility is maintained. The color appears to be somewhere between the brightness of the 1961 *Map* and the subdued coloration of the 1962 *Map*. The primary color rectangles, an important motif through 1968, appear for the first time here, along the painting's right edge.

Johns only did two variations on the format of the original *Map*, a large *Double White Map*, 1965, and a 1966 small *Green Map Above White*. (Both variations had been presented first in his *Flags*.)

The map is a subject which could be interpreted to have personal meaning, if certain areas were made to stand out from others. But Johns paints the map the way he paints all of his other works: each area of the surface (here, each location on the map) is of equal importance. It is interesting to note, however, that Johns began to paint maps at approximately the same time that references to specific locations appear in other works, especially references to the Carolina seacoast. There is only one work where a map appears in conjunction with an autobiographical reference. This is a proof with additions of a single map image from the lithograph *Two Maps I*, 1966, printed in white on gold paper. In the upper right is the imprint of a 1965 South Carolina license plate. At the time, Johns had a house at Edisto Beach, South Carolina, which is also his home state.

In 1967, Johns began his largest painting to date, the 15 x 30 foot *Map* (Plate 12), based on R. Buckminster Fuller's Dymaxion Air Ocean World Map. It was done for the American pavilion at the World's Fair, Expo '67 in Montreal, which was designed by Fuller. Using the Fuller map was for Johns not only a suitable extension of his vocabulary of flat subjects, but also especially appropriate for its designated setting, referring both to the pavilion's designer and to the "global" thinking implied by a world's fair. (A map of the U.S.A would have been too specifically American for Johns to use in the World's Fair setting—it would no longer be a neutral object.)

The Fuller map, first published in 1943, is an improvement over other cartographic projections, including the standard Mercator projection: "It uses spherical trigonometry dividing the surface of the earth into 20 equilateral spherical triangles radiating from the center of the earth. When these triangles are projected onto a two-dimensional plane, the result is a map with less distortion than any map known to date.... Besides offering an undistorted view of the world in the two-dimensional plane, the Dymaxion map can be assembled into an icosahedron globe (a geometric figure consisting of 20 equilateral triangles somewhat resembling a sphere)."[70] It provides a new way of seeing the earth as an interrelated whole, since the land masses are shown as one continuous continent centered around the North Pole. Thus "it is possible to view the whole earth's surface comprehensively as one great continental

archipelago lying within one world ocean." Fuller's map expresses his philosophy that "the whole world will become every man's backyard," so that we must all join together on "spaceship earth" to make the world work for every one. Johns' painting is in part meant to be an acknowledgment of his admiration for Fuller and his ideas, although Johns' attitude about the world and its future is generally skeptical, even pessimistic.[71] My evaluation of Johns as fundamentally skeptical and pessimistic comes from the time I spent with him; however, like his art, his character includes what would usually be considered mutually exclusive aspects. He has a tremendous capacity for enjoying and appreciating life which coexists with his pessimism.

The structure and certain details of Johns' *Map* directly follow those of the Fuller map. For part of the process, Johns used an opaque projector to transfer the design of the map onto the canvas sections. The whole is made up of twenty-two separate parts, mostly equilateral triangular units (the other irregular shapes result from the flattening out of the icosahedron globe, which is made up of twenty equilateral triangular planes). Johns has constructed each part from separate panels. His original intention was to hinge the panels so that they could be folded into a globe, but the scale of the map and its fragile surface would have made this process too awkward.[72]

The map image is painted continually across the surface in a manner similar to Johns' other *Map* paintings: boundaries are both clarified and obscured by brushstrokes, encaustic and collage, and names of locations are printed in stencilled letters of varying size and direction. Unlike his previous *Maps,* however, this is a complete system, not a fragment of a larger whole. The structure of the surface is different, not only because of the different pattern of the world map, but because of the disivions into separate triangular units. There is a focal point in the *World Map*—the North Pole draws attention to the map's center like the target's bull's-eye, and here it is used as a device to help unify the enormous area of the painting. This is Johns' first shaped canvas. All his works since his first *Flag* are either rectangles or squares, although sometimes with objects protruding beyond the edges. When *Map* was first exhibited in Montreal in 1967, the colors were based on those of the Fuller map: mostly orange, yellow and green, used by Fuller to indicate the earth's temperature changes, with blue for the ocean. Johns later completely repainted the original surface, transforming the colors and textural details, so that in its final state, the entire surface is subdued, mostly gray with touches of color throughout.

2

Objects and Words: 1954-1962

1954-1958

Besides flat objects and signs, Johns attached found objects to paintings and placed words in varying locations on the canvas surface. The objects and words Johns selects for his paintings are similar to his flat objects and signs, they are all familiar things, as Johns puts it, "things which are seen and not looked at, not examined."[1] The found objects are mostly common household items (drawer, coat hanger, window shade), while the flat objects are mostly schoolroom items (flag, map, numbers, alphabets). The found objects, like the flat ones, appear to have been selected, not only because they are familiar, but because they suggest a range of meanings and associations. All Johns' found objects and signs enable him to examine the nature of the art object itself.

The most significant precedents for Johns' use of found objects are Duchamp's ready-mades. However, the essential difference between Johns' works and Duchamp's ready-mades is that Johns always incorporates his objects into paintings; or if he uses ready-made designs, like the flag or target, they are completely hand-done in art materials. Johns has said he was not familiar with Duchamp's ready-mades in 1954-55 when he did his first found object paintings;[2] however, he was probably familiar with the tradition of assemblage through the work of Cubist, Dada and Surrealist artists, including Picasso, Schwitters, Miro and Cornell. Johns' paintings with found objects also reveal an awareness of traditional still-life painting in the types of objects used and their manner of presentation. The most obvious similarities are with *trompe l'oeil* still lifes and those of Cézanne and the Cubists.

The first two found objects Johns used were musical instruments: a small wooden toy piano in *Construction with Toy Piano,* 1954, and a music box in *Tango,* 1955 (Cri. 13). Both are simple toys—familiar from childhood experience—which require no special skill to play. In *Toy Piano,* the object is presented so that it forms the whole construction of the work and provides a surface for collage materials. Although its numbered keyboard is weathered and out of tune, it can still be played. Our sense of touch is provoked, engaging

us more directly in the work's physical presence. In one of the first examples of Renaissance *trompe l'oeil* illusionism, the marquetry decoration in the studiolo of the Duke of Urbino, a piano keyboard was included as a device to enhance the effect of realism (Berg. 24). In Georges Braque's Cubist still life, *Piano and Mandola,* 1909-10, the keyboard image is used to make us aware in an ironic way (like the *trompe l'oeil* nail in his *Violin and Palette*, of the same date) of the new modes of anti-illusionist depiction he is presenting (Cooper 23, 24).

The music box in *Tango* has been placed behind the canvas at the lower right so that only its winding key is visible. In the upper left,the word "Tango"—the first title Johns includes as part of a work—is painted in large capital letters on a separate canvas, suggesting tango dancing and the music associated with it.[3] The associations of the dance and music become part of the subject of the painting along with the rectangular field of bright blue encaustic and collage. The placement of the music box behind the canvas directs our attention to the painting's three-dimensional construction, since it is literally, not illusionistically, *in* the painting. This is the first work in which Johns leaves a blank strip at the bottom edge, reminding us of the canvas beneath the paint. This device is used frequently from this point.

Even though *Tango* is presented in a depersonalized manner, the title suggests that the tango may have personal associations for Johns which he does not want to reveal. The music box could have been a childhood toy, souvenir or gift with emotional significance. This quality of ambiguity is characteristic of most of Johns' found object paintings: the object is depersonalized because it is so familiar and displayed in a detached way, yet it seems possible that it has personal meaning for Johns.

It is an interesting coincidence that John Cage did a "Suite for Toy Piano" in 1948. Johns may or may not have known about this Cage piece when he did *Toy Piano,* but the choice of a toy instrument on the part of both the composer and painter reflects similar interests in investigating what is acceptable as subject matter for art. The same is true of dancer/choreographer Merce Cunningham, like Cage a close friend of Johns' from 1955. Cunningham often included movements from daily life in his dances. In "Collage II," a piece from the early 1950s, he used a number of popular dances, including the tango.

In Johns' next painting with an attached object, *Canvas,* 1956 (Plate 13)(Cri. 21), he places a smaller canvas backwards against a larger one so that its stretcher is visible. It is his only early painting that focuses attention on an object specifically from the realm of art. During the 1960s, when he used other studio objects, the canvas stretcher appears as an assemblage object in several paintings. Presenting the canvas so we are confronted with its three-dimensional construction, usually hidden from view, enabled Johns to state directly his position that the painting is an independent object. The canvas back can be seen as a surface framed by the stretcher, setting up the situation of a

painting-within-a-painting. However, the "content" of this inner painting is the same as the one that surrounds it: the gray paint which blends the surface—rectangle within rectangle—into a unified whole. The concept of a painting about nothing except itself would have ironic appeal for Johns. In this context, the following incident related by Johns in a 1966 statement is relevant to *Canvas:*

> In 1950 or '51 a painter whom I admired said that he was to have an exhibition of 8 or 10 canvases which were turned face to the wall in the kitchen where we were talking. He said that the works were very new and good, and that he would not show them to anyone before the scheduled exhibition. When he left the room, another friend looked at the fronts of the canvases and said that they had not been painted.[4]

There are at least two paintings by American *trompe l'oeil* artists, Peto's *Lincoln and the Phleger Stretcher,* 1898 (Wil. 177), and William M. Davis' *A Canvas Back,* ca. 1870 (Fra. 17) that are significant precedents for Johns' work. Both show the canvas back isolated as the main subject (although Peto and Davis depicted objects attached to the stretcher, while Johns showed only the canvas stretcher itself).[5] The purpose of these paintings, according to Alfred Frankenstein, is "to make the spectator think he is contemplating the back of a canvas—that the painting he really wants to see is on the other side."[6] While the artist "fools the eye" in this way, he also makes the viewer aware of the painting's canvas-on-stretcher construction. The essential difference between these paintings and Johns' is, of course, that Johns uses a real object not an illusionist representation of one. However, Johns' *Canvas,* like Peto's and Davis' provokes us to want to turn it over to see the front. Our impulse is likewise frustrated, since it is fixed forever in its place; because we can never know what is on the hidden side of the small canvas, it becomes an enigmatic object. The layer of gray also adds a mysterious quality, as if something were being covered over or hidden by it.

Gray Rectangles, 1957 (Cr. 36), summarizes Johns' approach to structure, composition and color in his early found object paintings. The objects in this case are not household items, but three identical rectanglar panels set into the lower section of a large square canvas. Even though these panels cannot be removed or opened, they make us aware of the painting's three-dimensional canvas-on-stretcher construction. Each rectangle has been painted a primary color (from left to right: red, yellow and blue) and then painted over with gray encaustic like the rest of the surface. Because the layer of gray initially hides the colors and makes them difficult to see, we get more involved in the process of looking than we would if they were clearly visible. As a result these "hidden" colors have a special kind of intensity once we become aware of them. As mentioned previously in connection with the *Target* paintings, red, yellow and blue is Johns' preferred palette of colors, especially during the mid-1950s.

Johns' use of the primaries is similar to Mondrian's: both use red, yellow and blue—the "classical" colors—to convey a sense of objectivity and detachment. However, Mondrian was more involved than Johns with the idea of purity which these colors suggest. For Johns the primaries provide a conceptual basis for his color choice which counteracts their sensual and emotional impact. Gray is Johns' favorite color and his most frequently used monochrome in this group of found object paintings.[7] Because gray is neutral it gives the painting a detached, restrained appearance; it also gives the surface a sculptural or mechanical look. In a 1969 interview, Johns discussed the use of gray in his early works:

> I used gray encaustic to avoid the color situation. The encaustic paintings were done in gray because to me this suggested a kind of literal quality that was unmoved or unmovable by coloration and thus avoided all the emotional and dramatic quality of color. Black and white is very leading. It tells you what to say or do. The gray encaustic paintings seemed to me to allow the literal qualities of the painting to predominate over any of the others.[8]

There are several relevant precedents for Johns' use of monochrome gray, including the tradition of *grisaille* painting, Picasso and Braque's use of gray during their analytic Cubist phase, and Magritte's "stone" paintings. In Magritte's *Memory of a Voyage III*, 1951 (Koz. 34), the entire surface, figures and objects alike, are formed from a gray stone which looks remarkably like Johns' brushstrokes from this period.

The structure of *Drawer*, 1957(Cri. 14), is based on *Gray Rectangles* painted just before (see Appendix A). Johns set a drawer front with two protruding knobs right below the center of a square field. As in *Canvas* and *Gray Rectangles,* the entire surface is covered with gray encaustic. The drawer, like the rectangles, makes us aware of the painting's construction. Although the drawer cannot be opened, we are referred conceptually to the space inside it, behind the canvas. A drawer is a container which holds objects and Johns is identifying its function with that of a painting. We refer to objects *in* a painting, usually meaning illusionistic representations of objects in space. For Johns, the painting's "contents" must be tangibly real, like the objects found in any drawer around the house. Paradoxically, Johns' *Drawer* is neither a real drawer nor an illusionistic depiction; he has included only as much of the object as we are allowed to see, and just enough to convey the idea of a drawer.

The drawer is a frequently used motif in still-life painting, and Johns' choice of it as a subject is probably, in part, a reference to its previous uses, particularly the still lifes of Cézanne and the Cubists. The most common type of still life shows objects on a table, the edge of which is in the immediate foreground, often with objects jutting out to provide a *trompe l'oeil* transition between spectator and painting. In paintings with table drawers, the drawer front locates the picture surface and the knob appears to protrude into "real"

space, inviting us to open or close it. The drawers function as devices to make the viewer conscious of the tension between the painting's flat surface and its illusionistic picture space.

From the 1880s on, Cézanne used table drawers set at different angles, wholly or partly visible, open or closed. In *Still Life with Commode,* 1883-87, for example, there is a slightly opened table drawer with a knob, partly covered with a white table cloth; in the background, the commode drawers with knobs and keyholes are prominent. In *Still Life,* ca. 1900 (Plate 14), the knob of the drawer, emphasized by its strong shadow, echoes the shape of the fruit on the table surface. Cézanne also used table drawers in some of his *Card Player* paintings. Table drawers appear in several Cubist still lifes by Picasso, Braque and Gris, functioning even more blatantly than Cézanne's to make the viewer aware of the dilemma of representing three-dimensional forms on a flat surface.

In Haberle's *A Bachelor's Drawer,* 1889, the drawer is the main subject as in Johns' painting. For both artists the drawer front establishes the flatness of the surface and suggests opening the drawer to see what is behind the surface. Haberle adds other objects to the drawer front, mostly flat pictures, tickets, bills, etc. pasted onto the drawer. There is also a hinged cigar box lid which seems to replace the drawer as a container of objects (the drawer is obviously not in use, since some of the pasted objects are placed so that it cannot be opened, the knobs have been removed, and there is no key in the keyhole). The objects attached to the drawer give us information about the life of the owner (who happens to be the artist himself), while Johns makes his drawer as generic and impersonal as he possibly can. However, like the reversed canvas, the unopened drawer coated with gray has an intriguing quality, as if Johns could be hiding something—perhaps of personal significance—from our view.

In *Book,* 1957 (Cri. 17), the object is not attached to or set into the canvas like Johns' other found objects, but rather it replaces the canvas and stretcher construction and provides the surface onto which paint is applied. The book is opened at the middle so that it is symmetrical. Its entire surface is covered with encaustic—red pages, yellow edges and blue binding. Therefore, the exposed pages cannot be read and the pages cannot be turned: it becomes "a paralyzed book," as Steinberg described it.[9] Presented in this manner, the book is transformed into a universal object: it is clearly a book, but no book in particular. In a 1965 interview, Johns says that the book was chosen because it was the shape he wanted, not because it had any personal significance for him.[10] Yet because the book's specific identity is hidden, it provokes our curiosity—like the hidden canvas and closed drawer, and becomes more of an enigmatic object than a book whose identity is clearly legible.

Although the book's expected function has been ironically altered, it still suggests the idea of reading, now in the context of a work of art. Reading a

book or a painting basically involves receiving and interpreting visual information. In a book, we read letters, words and sentences in a linear sequence. In a painting we "read" the syntax of pictorial elements (brushstrokes, colors, shapes) in a different way, depending on the structure or composition the artist devises. By using the book as a subject, Johns is calling attention to the process of visual perception. He specifically contrasts the idea of linear reading with non-linear looking, as he does in his *Alphabets, Numbers* and related works.

Like *Canvas* and *Drawer, Book* is a motif found in previous still-life painting. The most direct connection for Johns in this case is again with the American *trompe l'oeil* still-life painters, especially Harnett and Peto, who used books frequently in their paintings. In Harnett's *Writing Table,* 1877 (Fra. 25), for example, a single book appears; unlike Johns', it is seen with related objects which places it in a specific context. Like Johns', Harnett's book involves the viewer conceptually in the process of "reading" a work of art. The title of the book is an eye-fooling device, because it looks legible but is not. Also the handwritten letter is folded so that the words are upside-down and therefore more difficult to read. In Harnett's *Job Lot, Cheap,* 1878 (Fra. 27), a pile of old, used books tempts the viewer to browse; however, the titles of these books are illegible. Peto adopted this subject from Harnett and used it in several paintings. There is an emotionally suggestive quality in his *Abandoned Treasures,* 1884 (Fra. 57), because the books are obviously worn, used, and because the picture's title suggests the importance they once had . Although Johns' *Book* is presented as a generic object, like Peto's, it also could be interpreted as having hidden, personal meaning, perhaps as his or someone's "abandoned treasure."

The book has been a common still-life subject since the Renaissance, generally indicating the intellectual as opposed to the sensual.[11] In still lifes books appear often with artist's materials, to indicate that the intellectual aspect of art is as important as craftsmanship. Books also have moral implications, usually in *vanitas* still lifes, as a reminder that worldly knowledge is useless without spiritual knowledge.[12] The seventeenth-century French still-life painter Sebastian Stoskopff combined these meanings, using disguised symbolism, in his *Still Life with Open Book,* 1625 (Faré 103): One book is an artist's sketchbook; the candle, which provides the light to read the books, is also a *vanitas* symbol. Because of the composition's simplicity and its focus on the frontal, open book, and because the symbolic meaning is hidden and therefore ambiguous, this work is strikingly similar to Johns' *Book.*

Johns' next found object painting is *Newspaper,* 1957 (Plate 15), in which the double page of a standard daily newspaper is approximately centered on a slightly larger canvas which appears to frame it. The entire surface is painted with a thin layer of gray encaustic (with touches of white), so that the newsprint

is only partly visible. We can read only fragments of the page, but not in the way we normally read a newspaper. We read it in a random, non-linear way, which has nothing to do with getting information about the daily news. Newspapers, like books, appear frequently in nineteenth-century American *trompe l'oeil* still-life paintings. The newspaper is usually shown folded, either on a tabletop with other objects of leisure (pipes, mugs, books) as in Harnett's *London Times, April 9, 1880,* 1880 (Fra. 32), or in "card rack" paintings, with other relatively flat objects, as in Peto's *Old Souvenirs,* 1881 (Fra. 56). In these, the newspaper is always specifically identified with its heading and date, but the newsprint, although it looks real, is not legible. Johns keeps his newpaper's identity unknown, so that it is taken as the object "newspaper" rather than any one specific newspaper. (The words "The Advertiser... La. Wednesday" can barely be made out in the upper left corner, but it is impossible to know if this is the newspaper's name or not.) In Johns' newspaper only random words and images show through the paint: "Khruschev portrait reveals. . . ," "Quest for knowledge," "Four Corners," pictures of automobiles from an ad. These involve us, like Harnett's and Peto's *trompe l'oeil* newsprint, in looking more closely at the painting than we would if it were clearly legible.[13]

Newspaper is an art material as well as an object from the everyday environment. Johns consciously presents it both as an object and as collage in this painting. Johns has used newspaper collage frequently in his paintings since 1954; he also used fragments of pages from books, but the association of *Book* with collage is not as obvious as *Newspaper.* The source for this double use of the newspaper is Cubist collages. Picasso and Braque first used the newspaper in still-life paintings along with other objects found in the cafe setting, like bottles, glasses, pipes and musical instruments. The newspaper , usually indicated by letters from the word "journal," along with posters, labels and other items with printed signs, functions pictorially to establish the flatness of the picture's surface. Picasso and Braque soon began to use collage materials for this purpose, including newspaper. In Picasso's *Still Life with Bottle, Glass and Violin,* 1912-13 (Zer. 2, 405), for example, the word "journal" cut out of a newspaper heading represents the newspaper in the still life, another piece of newspaper has been cut into the shape of a bottle, and another is used as a textured surface on which the violin is depicted. We are presented with a conflicting situation, since the newspaper collage defines the painting as a flat surface while it functions as a surface on which three-dimensional forms are represented. In this, and other Cubist collages, the viewer is called upon to distinguish what is a "real" and what is a "false" illusion in order to understand the new relationship between art and reality which the Cubists were establishing.

Juan Gris' 1914 *The Table (Le vrai et le faux)* provokes us to think about just this distinction. (The words "Le vrai et le faux" apppear on one of the

newspaper collage fragments.) It is a significant coincidence, underscoring the visual and conceptual links between Johns' works and the Cubists, that three objects used by Johns appear in Gris' still life: newspaper, book and drawer. On Gris' "real" newspaper are depicted "false' images of a pipe and cigarettes. The book is both "real" and "false" because it is part illusionistic representation and part collage. Johns took the definitive step in breaking away from "false" illusionist images by using only "real" objects, which he then transformed into paintings.

In *Alley Oop,* 1958 (Cri. 33), the comic strip "Alley Oop" is placed in the upper section of an orange field. (Compositionally the painting is based on *Flag on Orange Field,* 1957.) Like the newspaper, the comic strip is presented both as object and as collage material. A comic strip is something to be read containing pictures as well as words. Johns disrupts its legibility by painting over the comic strip (in primary colors, also the colors of the comics), so that it cannot be read in the expected way. We can make out some of the comic's details, but, as in *Newspaper* and *Book,* we are presented with an alternative way of "reading" the surface. The comic strip would be unidentifiable if its title weren't given. It is impossible to make out the content of the episode Johns has selected, nor is there any way of knowing what, if any, significance this particular comic strip had for Johns.

Johns used comic strips as collage material, along with other newspaper fragments, in his first *Flags* and *Targets.* Because comics are a popular or "low" art form, their presence in a painting raises the issue of defining levels of importance or "seriousness" in art. While all of Johns' early works, because their subjects are common everyday things, challenge such hierarchical distinctions, *Alley Oop* focuses attention most directly on this concept in terms of art subjects. Schwitters was possibly the first artist to use a comic strip as a collage material in *For Kate,* 1947. Since the early 1950s, Rauschenberg has used comics as collage more frequently than any other artist and in many, such as *Rebus,* 1955 (Forge 177), they play a key role in the array of materials. *Alley Oop* is in Rauschenberg's collection, and it is possible that Johns did this painting in part as an acknowledgment of the importance of comics in Rauschenberg's work.[14]

The, 1957 (Cri. 15), does not contain an attached object like the other paintings in this group, but the word "the" is presented like an object set into the canvas. It is painted in large capital letters in gray encaustic (with touches of white and black) like the rest of the surface. Unlike "Tango" which relates to the music box behind the canvas, "The" appears on its own, displaced from its usual function of modifying a noun. It appears isolated as it would on a blackboard during a grammar lesson. As Johns presents it, it is rendered meaningless in terms of its expected use. However, like Johns' other objects and signs it takes on new uses within the painting. It refers us to the relationship

between verbal language and the pictorial language of a work of art. It also suggests the idea of the relationship between objects and words, which is further developed by Johns in later works where he labels objects. We are tempted to ask: "the *what?*" But we will never know what, if anything, Johns had in mind. The one object in sight is "the" *painting,* which is in all cases his essential subject.

Again in *Tennyson,* 1958 (Plate 16) (Cri. 14), an isolated word is presented like an object in a field. In this case the word has specific reference, to the well-known Victorian poet—among the few poets who would be generally familiar to everyone at that time. However, since we are given only the name, painted in the same impersonal capital letters as "the," the reference remains vague. Like Johns' other objects and words, it can be interpreted both as a commonplace of our culture, presented in a detached manner, or as a cryptic reference to Tennyson's poetry with personal significance to Johns. The word "Tennyson" associates the painting with poetry in a general way, like "Tango" with music and dance and "The" with language. Poetry has always been important to Johns, and in several later works he makes references to specific poems by other poets.

The structure of *Tennyson* is more complex than any of Johns' previous paintings. The field is made up of two vertical panels which are almost completely covered by a piece of folded canvas, with roughly cut, uneven edges. The bottom flap of this folded canvas continues around the painting's lower edge, and the upper flap ends about six inches from the lower edge. The painting's entire surface is covered with a layer of gray encaustic. There are traces of red, yellow and blue visible along the edges of the folded canvas, suggesting that the hidden sides of the folded canvas might be painted in the primary colors. This is the first time Johns uses canvas as an object in this way without the stretcher. He uses it to create actual layers of space: there are six separate canvas surfaces, four of them hidden from view. This device is another way of involving the viewer with the painting as an independent object: the canvas is not a transparent "window" nor a flat surface, but a tangible object which can be folded and used to create space in its own right.

1959-1962

After 1958, Johns elaborated the ideas developed in his previous paintings with found objects and words, continuing to explore the nature of painting-as-object. However, a significant change of style occurs at this time. He expands his palette to include a wider range of colors and tones, and his brushstrokes become more open and gestural. Johns' use of oil paint, adopted again in 1958,(Johns had used only encaustic since 1954), is an important aspect of this style change, because oil lends itself to freer handling and a wider range of color

values and tones. Johns continues to use encaustic also, but its handling usually reflects the changes coinciding with his use of oil. This major stylistic shift occurred soon after Johns' first significant public exposure in his solo exhibition at the Leo Castelli Gallery in 1958.

The changes described above were initiated in *False Start* (Plate 17) (Cri. 51) and its companion piece *Jubilee* (Cri. 52), both 1959. In *False Start*, the canvas is covered with freely applied brushstrokes of brightly colored oil paint which overlap and intersect to create a shallow layer of illusionist space. The names of the colors which appear in the painting have been stencilled on the surface, moving in various directions, overlapping and disappearing like the spontaneous-looking, gestural brushstrokes of paint. The flatness of the printed letters acts as a foil to the effect of depth created by the activated brushstrokes and varied coloration and tonality. Yet the words also appear to be part of the shallow illusionist space, either hovering above or below it. (By using the color names Johns preserves the conceptual quality of his color, even when it is applied in the most sensuous way, as in *False Start*.) The color names bring the concept of verbal language into the context of the work of art, like the words, objects and signs in Johns' other language-related paintings already mentioned. The color names, however, refer specifically to color as an essential aspect of painting focusing our attention on how color functions and is perceived in a work of art. The relationship of the words to the painted colors is purposely made ambiguous by Johns. They can be seen as labels describing the colors in the painting, mostly red, yellow, blue, orange and white, with fewer traces of green, violet, black and gray. The number of times a color name appears corresponds approximately to the predominance of that color in the painting (e.g., only the "v" of "violet" and the "c" of "black" appear). The words are not intended to label specific areas of color, although in some cases they do. There are a variety of possibilities as to how the word and the actual color are related. For example, in the upper right corner, the word "red" is printed in red on a patch of blue. At the right edge in the center, the word "red" is printed in yellow, partly submerged in an area of orange paint. We are provoked to raise questions about what we see: How does the word "red" relate to the blue and yellow it appears to be labeling? Do the letters have to be printed in red for them to indicate that color? In the lower right there is another variation: the word "blue" is printed in yellow on blue. Max Kozloff described this situation as "a tissue of conflict between what is real and what is seen."[15]

False Start summarizes the structure, composition and color of this later group of paintings with found objects and words, the way *Gray Rectangles* summarizes the earlier group. *False Start* could be a conscious variation on *Gray Rectangles*. It is as if the colors from the earlier painting have burst out of the confines of the rectangles and through the gray veil, picking up some added hues along the way. The structure of *Gray Rectangles* deals with the literal

depth of the stretched canvas, while in *False Start* there is a shallow layer of illusionist depth. Everything about the earlier work was restrained and closed: the rectangles could not be moved, each of the primary colors was contained in its own "box," the gray encaustic was applied in short, tightly connected brushstrokes. In *False Start*, the colors are set loose and appear to be celebrating their liberated condition. The painting is more open and fragmented. Words are obscured by overlapping brushstrokes and broken off at the edges, suggesting continuity beyond the actual field of the painting for the first time in Johns' work. The title "False Start" is ironic, in a typical Johnsian way, for a painting containing so many new pictorial ideas. It is the first title which is not purely descriptive of the work or an element in it. According to Johns, its source is a horse racing print, "The False Start," that he saw in the Cedar Bar.[16]

Jubilee is the "neutral" version of *False Start*. Its appearance is generally the same as the latter's, except that it is drained of the bright colors of the spectrum. Although the two paintings look identical in configuration at first glance, *Jubilee* is slightly smaller and its surface detail different. It is painted in black, white and gray with sparse touches of color (including a partially obscured design reminiscent of an American flag). The color names are printed in varying tones of gray. (The words "red," "yellow," "blue," "orange," "black" and "gray" appear several times throughout the surface; "green" and "white" appear only once; "violet" not at all.) As in *False Start*, the situation is set up where the relationship between word and color is explored, but here in the absence of actual colors to which most of the words refer. Only "black," "white" and "gray" function as labels. The others can only provoke a mental picture of the colors they signify.

In *Out the Window*, 1959 (Plate 18) (Cri. 56), Johns uses only the primary color names, "red," "yellow" and "blue," printed in the center of three horizontal panels. The words do not stand out clearly; they appear to be woven into the fabric of multi-colored brushstrokes of encaustic and collage which covers the entire surface. Johns uses the full spectrum of colors and neutral tones, about the same color range as *False Start*. The colors at first appear to be distributed at random throughout the surface, but upon closer inspection, the subtle predominance of the color labeled by its name is apparent (slightly more red in the zone marked "red," etc). Like *False Start*, *Out the Window* seems to be a variation on *Gray Rectangles*: the primary colors are again presented as Johns' favorite palette; the colors, now in the form of words, are contained in three separate rectangle compartments, although here, the rectangles make up the painting's entire field. The structure of both works is closed and symmetrical, but the bright colors and gestural brushstrokes of the later painting give it an overtly sensuous quality.

According to Solomon, the title of this painting comes from an observer's comment: "Johns' sister visited the studio and found no meaning in the 'emptiness' of the picture; she looked out at the vacant parking lot across the street, and remarked that he seemed to paint what he saw out the window."[17] However, like *False Start*, the title is related ironically to the "content" of the painting, here suggesting the idea of the painting as a "window," which Johns undermines by asserting that the painting is a concrete object, rather than a transparent plane through which things are seen.

The format of *Out the Window* is used in several later works as a basic structural motif to which other motifs are added. In most cases a landscape or seascape setting is suggested through the titles of these paintings, for example, *By the Sea*, 1961 (Cri. 79). In this painting a fourth panel was added in which Johns superimposed the primary color names. The letters are larger and stand out more clearly than those in *Out the Window*, however, they blend with the surrounding field also. The color is rich but subdued by neutral tones, mostly grays, which predominate and mute the overal effect of the coloration. The letters appear both transparent and opaque. The letters in the lower panel create ambiguous layers of space, like the numbers in the *0 Through 9* series done the same year. The color and brushstrokes create a misty effect, relating to the title—as if we were looking at a hazy seascape. The color names, like those in *Out the Window*, do not clearly label their zones; however, the letters of each word contain more of the color which it spells out than the others.

In *Highway* (Cri. 66), Johns combines the wide range of colors and open brushstrokes of *False Start* and *Out the Window* with elements from *Tennyson* and *Gray Rectangles*—a piece of collaged canvas and inset panels. The word "highway" printed in the picture's center is barely visible, because it blends with the brushstrokes of encaustic and collage fragments which cover the entire field.[18] Johns said that the title "Highway" relates to his first experience of driving a car in the dark;[19] there is a drawing titled *Night Driver*, 1960, based on the painting *Highway* confirming this explanation. Still the meaning of "highway" in the context of the painting remains ambiguous, like Johns' other words. It brings in the idea of the highway landscape, a commonplace feature of the environment. Another possible connection of the painting's "imagery" with the title is the two small rectangular panels near the bottom edge, which suggest automobile headlights. These panels function, like the ones in *Gray Rectangles*, to disrupt the surface and refer us to the painting's three-dimensional construction. The single piece of canvas collage which covers almost the entire area above the rectangles creates concrete layers of space and hidden surfaces, like the piece of canvas in *Tennyson*.

There are a few works done after *Highway* in which a folded piece of canvas collage is the painting's only attached object. In *Reconstruction*, 1959 (Koz. 51), the piece of canvas has been folded at both ends to form three equal

horizontal rectangles, which have in effect "reconstructed" the surface. This configuration creates the same format as *Out the Window* and later paintings structured into equal horizontal zones.[20]

Disappearance I, 1960 (Plate 19), and *Disappearance II*, 1961 (Koz. 44), explore the idea of layers of space created by folded canvas which "reconstructs" the pictorial field, the title referring to the sides which disappear from view as a result of the folding. The idea of disappearance has been an imporant one in Johns' works throughout his career, especially in his paintings of flat objects, such as *White Flag, Green Target, Gray Numbers*, where the images almost disappear in the monochromatic field. In *Disappearance I*, the canvas collage is folded to form a square within a square, but in such a way that it forms two horizontal rectangles as well (the format is similar to that created by folded canvas in *Tennyson*). *Disappearance II* is Johns' most refined use of canvas collage: a piece of canvas, identical in size with the picture's field, has been folded to form a diamond within a square. One surface of the canvas collage has disappeared inside the diamond-shaped "envelope." If the envelope's flaps were lifted back, they would cause the original canvas to disappear, as it does anyway when it is covered with paint. The bare strip of canvas at the lower edge calls this idea to our attention. This is the last work to date in which canvas collage is used as a found object in this way, although canvas fragments are used as collage in some later paintings. However, Johns wrote in his "Sketchbook Notes": "Do Not Combine the 4 Disappearances," indicating that others were planned, but not carried out.[21]

In *Shade*, 1959 (Koz. 39), Johns uses a common object which functions like canvas collage to create layers and multiple surfaces, some of which are hidden from view. It is based on *Reconstruction*, but in *Shade*, the object brings in meanings connected with its use in the household. Although the shade cannot be lifted, it implies a window and therefore directly refers us to the concept of the painting as a "window" to reality. In *Shade*, Johns definitively closes the "window," thereby affirming that the painting is not a transparent surface through which we see reality, but a concrete, three-dimensional object in its own right.

Magritte, in *The Human Condition I*, 1933 (Gab. 61), and related paintings, also used the window to redefine the function of the art object. The painting on the easel is shown both as a transparent surface—like the window—through which the outside landscape is seen, and also as an independent object, distinctively different from what is seen through the window. The edge of the painting is clearly visible, showing that it is a canvas-on-stretcher construction. (The curtains even suggest the possibility of closing the window.) Suzi Gablik wrote the following on Magritte which points out the connection between *The Human Condition I* and the fundamental issues of *Shade* and Johns' other works:

The ambiguity in Magritte's image suggests that something is irreconcilable in the confrontation between real space and spatial illusion. In this single image, he has defined the whole complexity of modern art—a complexity which has led to a devaluation of the imitation of nature as the basic premise of painting.[22]

Johns owns two drawings, one in gouache and one in pencil, of one of Magritte's many variations on "The Human Condition." *Shade* also recalls Duchamp's *Fresh Widow*, 1920 (Sch. 265). Duchamp used a real window and covered the panes with leather, in effect closing the window, as Johns did with his shade. Duchamp, like Johns, is probably commenting on the idea of the painting-as-window, but he is also concerned with the language pun connected with the object. It was during 1959, the year he did *Shade*, that Johns became involved with Duchamp's work, and from that date on references to Duchamp appear frequently in Johns' art (see Chapter 4).

The object in *Thermometer*, 1959 (Plate 20) (Koz. 53), sets up a direct interaction between the painting and its environment, since the column of mercury could change height according to the temperature of the room in which the painting is hanging. Because the thermometer is set between two separate panels, it is literally inside the painting. The mercury looks like a red line drawn on the surface of the canvas, dividing it in half vertically. The numbers printed along the inner edge of the adjacent panels further link the object to the rest of the field. (The thermometer itself has no numbers marked on it.) Although the thermometer actually records the outside temperature, it appears to be measuring the "temperature" of the painting. Most specifically, it calls our attention to the idea of color "temperature," since colors are conventionally described as "warm" or "cool." Because the thermometer does not, of course, respond to colors, Johns could be questioning this associative value often attributed to them. For Johns, color is to be taken literally for what it is, not for its evocative qualities. Another possible reason Johns used the thermometer was to refer to the idea of measuring (i.e., judging) a painting according to predetermined standards. (The thermometer is the first measuring device Johns used in a painting; after 1959 he frequently included rulers.) Johns could be implying that the thermometer's function is to measure the spectator/critic's reaction to the painting as "hot" or "cold"—or degrees in between.[23]

The thermometer is an object found in a few examples of *trompe l'oeil* still life, e.g., Jean Cossard's late eighteenth century-or early nineteenth-century artist's studio still life (Faré 446). It has been used as an assemblage object by several Cubist, Dada and Surrealist artists, including Malevich in *Officer of the Third Division*, 1914, Arthur Dove in *The Intellectual*, 1925, and Duchamp in *Why Not Sneeze-Rrose Selavy*, 1921 (Sch. 274).

In *Coat Hanger*, 1959 (Koz. 40), the hanger makes us aware of the technique of attaching objects to the canvas by suspending them. Like Johns'

other found objects, its expected function in the household is applied to establishing the nature of the painting-as-object. The motif of the coat hanger first appeared in a drawing of the same title done in 1958 (Cri. 34). This was an unusual reversal of procedure for Johns, since drawings almost always follow paintings. Perhaps, in this case, it was inspired by the linear quality of the object itself, since the hanger is in effect a line made concrete and three-dimensional. The same year, 1958, Johns drew *Hook* (Cri. 35) in which he depicts a painting which was never constructed. Here, too, Johns presents the idea of suspending object from the picture surface. The hanger and hook are both objects used to hold other objects. Since both are empty, they suggest that something has been removed or that something could be attached.

Hanging objects appear more tangible and accessible than ones fixed to the surface—they are free of the picture plane and seem more easily movable and removable. In most *trompe l'oeil* still lifes, objects are shown hanging from a wall or door, because this is the most effective way of making them appear to protrude into the viewer's space. Many of Johns' paintings with found objects resemble these still lifes, especially those with one or a few depicted objects. In many cases similar types of objects are used and the composition is basically the same. One striking example is a late eighteenth-century still life, *Trophée De Chasse* by J-J. Bachelier (Faré 394), showing a hook and rope hanger to which a pair of stag's antlers is attached. The rope hanger, like Johns' coat hanger, is suspended in the exact center of a vertical field, so that it hangs above the surface, casting a distinct shadow. In both works, the entire field is important: in the Bachelier, the irregularities and knots in the wooden wall lead the eye throughout the surface in a random way, like Johns' brushstrokes of black, white and gray encaustic. The point to be made in comparing Johns' painting to Bachelier's is not that Johns was necessarily familiar with this or other earlier examples of *trompe l'oeil* at the time, but rather, that his thinking about the nature of the art object coincides with that of previous artists working in this tradition.

In his next group of paintings with attached objects, beginning with *Device Circle*, 1959 (Plate 21) (Cri. 46), Johns includes objects used in making the painting as part of the completed work. They are Johns' first paintings which focus on process: the artist's activity in the studio and the tools he uses become an integral part of the work of art. These objects which Johns calls "devices" are wooden sticks, including rulers and stretcher bars, used to trace circles or parts of circles and then attached to the finished canvas.

Device Circle is Johns' only work besides *Gray Rectangles* in which a geometric shape is the painting's subject and is defined as such by its title. The "device" is a stick attached by a screw, with another screw inserted through its free end. It was used to measure out the circle's radius and to trace its circumference on a field of multi-colored encaustic and collage. Since the stick

can still be turned, the viewer can recreate the process involved in drawing the circle. The circle's center is slightly above the center of the square field allowing space for the title at the bottom. The title functions to describe the painting's subect, but it is also important independently as a visual element. The letters establish the flatness of the surface and serve as a base on which the "device circle" appears to rest. The "device" and the "circle" are parodoxically separate and the same, since in the finished painting the stick blends with the circle because it has been painted over in the same colors. The circle as an image appeared previously in Johns' *Targets*, but here it is presented as a concrete thing in its own right, rather than as part of a familiar object.[24]

Like the stick in *Device Circle*, the ruler in *Painting with Ruler and Gray*, 1960 (Cri. 73), can be rotated 360°, but since it is on a raised board, the circle it inscribes in the square field is an imaginary one. It does not function to mark the other surface, but rather to measure it. The ruler is a common object which Johns uses in the context of the work of art to refer to the idea of scale and to measure out the picture space, as if to dispell the possibility of misinterpreting the scale to be larger or smaller than the painting's 32-× 32-inch dimensions. Another function the ruler shares with the stick in *Device Circle* is to call attention to the process of making the painting. For Johns, the ruler is an essential studio tool, more so than for many other painters, since all of his works have either predetermined or symmetrically measured formats. Johns presents the ruler as a tool which was used in laying out the painting and was then included in the finished work. The wooden yardstick was cut at 32 inches to match the painting's height and width. Johns shows us the ruler's reverse side, where the numbers are printed backwards from right to left, causing an intitial confusion in orientation. The numbers are also partly obscured by paint, linking the ruler visually with brushstrokes on the canvas surface. Like the thermometer, the ruler is an object found in several collages and assemblages by previous twentieth-century artists, e.g., Dove's *Portrait of Ralph Dusenberry*, 1924, and Picabia's *Centimeters*, ca. 1924-25 (Cam. 269).

The word "gray" looks like it was found on the weathered board, although it may have been printed by Johns. Like his other color names, its function is ambiguous. It can be interpreted as labeling the color of the painting (which is almost all gray oil paint with touches of red and yellow) or the painting's colors can be interpreted as "illustrating" the word.

Directly related to *Device Circle* and *Ruler and Gray* are two paintings titled *Device*, one dated 1961-62 (Cri. 91) and the other 1962 (Koz. 68). In the first, two stretcher bars are attached with wingnuts to the side edges in the upper section of a vertical field. The stretcher bars have been used to scrape two semi-circular areas in the wet oil paint, blending the colors and creating a blurred effect which records the movement involved in this technique. In this case, the "device" was used to manipulate paint by pressing it against the canvas

within an area limited by the length of the stretcher bar (while in *Device Circle* it was used to trace only the circle's outline). The scraped semi-circles contrast with the freely rendered brushstrokes covering the rest of the surface. According to Field, "devices" such as this one "represent Johns' continued efforts to transform the limitless arena of Abstract Expressionistic space into something conceptually controlled and measurable."[25] (For example, Johns uses his stick "devices" to mark out circles while Pollack uses sticks to drip paint on canvas creating random, linear interweavings.) There is also a contrast between the shallow layer of depth created by the overlapping, spikey brushstrokes and the affirmation of flatness achieved by the stick-scraping-paint-against-surface. The title is stencilled in large letters centered neat the lower edge, reaffirming the painting's structural symmetry. The flatness and measured quality of the printed letters contrast with the brushstrokes in the lower section as the device motif does above.

In *Device*, 1962, a smaller painting, two semi-circles of scraped paint appear, again in the upper section of a vertical field. This painting appears to be a variation on *Ruler and Gray*. A board divides the space vertically, but now the yardstick has been divided to make two stick "devices" used to trace a path on the surface of gray oil paint. The scraped semi-circles appear to be wedged between the side edges of the canvas and the inner edges created by the board. The rulers literally measure out the radius of the half circle, but they bear traces of gray paint which obscure their markings. They take on a new role—that of manipulating paint—altering their usual function as instruments of measurement. The title is printed two times in large and small letters in the lower right corner. Its presence adds an asymmetrical element and creates an ambiguous multi-leveled space like the brushstrokes of paint. This appears to be Johns' first use of superimposed printing of different sized letters—a motif which he used in several works since.

Both *Device* paintings suggest that the half circle can be completed beyond the edges by rotating the "devices" a full 360°. The two semi-circles also can be considered as sections of the same circle, suggesting a spatial continuum around the painting's surface. After 1961, Johns' works are usually more open and continuous than they had previously been. The "device-half-circle" motif used in several paintings from 1961-63 opens up the picture space beyond the confines of the canvas and introduces the concept of change and movement.

The last group of works to be discussed in this chapter are those in which the canvas is pried open with small wooden balls, so that the wall behind the painting is visible. In *Painting with a Ball*, 1958 (Koz. 38), a ball was inserted, exactly in the picture's center, between two vertical panels coated with gray encaustic. By this device, the painting's three-dimensional construction becomes part of our experience of it in a way even more obvious than the inset or multiple panels, since the depth of the stretcher is revealed not only at the

edges, but within the painting itself. The wall which is the ultimate support of the painting also becomes a part of it. Again, Johns asserts that there is no illusion behind the picture's surface: what we see through the picture plane is simply and logically the wall on which it is hung.

Three studies were done before this painting. The first two date from 1957; both show three vertical panels pried apart by two balls. (In one, the panels are red, yellow and blue; in the other, they are all gray.) Johns simplified this structure, reducing the number of panels to two in *Study for Painting with a Ball*, 1958, on which the painting of the same year is based. In this drawing and in one of the 1957 studies, Johns covered the entire surface including the opening: it is as if another layer of canvas, rather than the wall, is revealed by the prying apart of the sections.

Johns' major work in this group is *Painting with Two Balls*, 1960 (Plate 22) (Cri. 63). He altered the structure as it appeared in the drawings, so that the three panels are horizontal rather than vertical, like the format of *Out the Window*, 1959. The two balls are placed next to each other, inserted between the upper two panels. Johns added metal strips joining the panels (at the side edges). At first, these look like hinges, suggesting that the panels can be opened; they actually function to seal and link the edges of the separate section and so cannot be moved. The entire surface, including the balls, is covered with the colors of Johns' characteristic spectrum palette of this period. The brushstrokes of encaustic are large and open and the collage fragments are larger than in Johns' other paintings. The illusionist space generated by the brushstrokes is contrasted with the literal depth of the stretcher revealed by the open slit. The "push-and-pull" tension of forms and colors found in much Abstract Expressionist painting is presented in contrast to the "push-and-pull" tension of real objects. The importance of this point is apparent when *Painting with Two Balls* is compared with an Abstract Expressionist work like Robert Motherwell's *Elegy to the Spanish Republic, LIV*, 1957-1961, in which oval forms are wedged between vertical bands creating a sense of tension similar to that produced by the balls in Johns' painting.[26]

The word "balls" in Johns' title is used descriptively, but it is probably also meant to be an ironic, even sarcastic, pun referring to the "masculine Mystique" that a good painting had to have "balls." Rosalind Krauss wrote the following interpretation:

> The object undoubtedly refers to the myth of masculinity surrounding the central figures of Abstract Expressionism, the admiration for the violence with which they made their attack on the canvas, and the sexual potency read into their artistic acts.[27]

The title, artist's name and date, printed along the bottom edge, function to indicate the painting's flat surface the way the balls reveal its depth. This is the first work Johns signed and dated on the front of the canvas. The

depersonalized lettering makes it seem as if the painting were a manufactured object with a printed label. Duchamp's use of impersonal printed titles and signatures in such works as the *Chocolate Grinders, No. 1* and *No. 2*, 1913 and 1914 (Sch. 197 and 213) and *Apolinère Enameled*, 1916-17 (Sch. 243) was probably a direct source of inspiration for Johns at the time. Johns' presentation of the title-signature-date motif is also similar to the type of lettering in several of Peto's *trompe l'oeil* still lifes. In his *Office Board for John F. Peto* (Wil. 154), 1904, for example, the artist's name and date are carved along the bottom edge of a wooden wall in the same type of objectified lettering as Johns'. Peto's letters are carved in an unexpected way, i.e., not into the wood, like the date, but in relief. Johns' stencilled letters are also printed in an unexpected manner, as negative rather than positive shapes. The metal "hinge" strips used in *Painting with Two Balls* are another Peto motif: he often used similar strips to join separate sections of doors, walls or frames, like the one in the upper left corner of *Jack of Hearts*, 1902 (plate 23), and *Reminiscences of 1865*, after 1900 (Wil. 182). It is possible that Johns was not yet familiar with Peto's work during 1960, but the similarity of their imagery reflects a shared concern with the awareness of the painting-as-object.

3

Sculpture

The objects Johns chose for his sculptures, like the ones he selected for his paintings, are common household and/or studio items. In his first sculpture, *Light Bulb I*, 1958 (Cri. 27), Johns recreated the exact shape of a standard light bulb, coated it with sculpmetal and set it on a base, thus distinguishing it from a real bulb.[1] This process is analogous to the transformation which occurs in Johns' paintings of flat objects and signs, where the object's design is copied, but recreated in art materials. Like the *Flags* and *Targets*, the *Light Bulb* initially has the look of a found object, because its identity as a bulb asserts itself so strongly. However, its hand-made sculptural quality is obvious upon closer inspection. Sculpmetal was a particularly suitable medium for Johns' first sculptures, although one conventionally used for model-making rather than art. It is a material made of aluminum powder in a plastic or laquer base, which can be applied with a brush, like paint, and which hardens into a stiff metallic surface. Therefore it gives the sculptures a painterly appearance similar to that of Johns' gray encaustic paintings, while providing them with a solid, sculptural look. The base is a separate but integral part of the sculpture, not a passive pedestal: its rough texture complements the smoothness of the bulb.

In *Light Bulb II*, 1958 (Plate 24), also made of sculpmetal, Johns added a socket and wire. Because there is no base, the bulb looks more like a Duchampian ready-made, taken directly from the environment and presented unaltered as a work of art. *Light Bulb II* derives from Johns' original idea for a light bulb sculpture: a hanging bulb attached to a socket and wire, as documented by a 1957 sketch. According to Johns, this piece was never made because the plaster model was too fragile and broke.[2] The hanging light bulb appears, however, as an image in two later works: the lithograph *Recent Still Life*, 1965-66, (Field 50), and the lead relief print *Light Bulb*, 1969 (Field 121). In *Light Bulb II*, the wire is broken off and we are made aware that the bulb is isolated from its source of power.

Johns did two bronze light bulb sculptures, each in an edition of four casts. In *Light Bulb*, 1960, the bulb rests on a separately cast base (there is a slight

indentation in the base where the bulb rests, as if the bulb has worn a niche). Lifting the bulb is an important part of experiencing this sculpture: since we expect a bulb to be very light, it is a disorienting sensation to feel the unexpected heavy weight of this solid bronze object. In the sculpmetal bulbs, by contrast, Johns approximated the weight of real glass bulbs. Johns involves us not only with the object's weight in a tangible way, but also its shape. When we hold the bulb it becomes a sensual, even erotic, organic shape.

One of the four casts of *Light Bulb,* 1960 (Cri. 45), was painted to simulate even more closely the appearance of a real bulb: its surface was painted gray, its tip, silver, black and gold, and Johns printed the standard label on its front end (General Electric, 100 Watt, etc.). This and Johns' other painted bronze sculptures of 1960 are more closely related to the objects they are based on than any of his other works. Johns uses this heightened *trompe l'oeil* illusionism (translated into three-dimensions) ironically, to call attention to the difference between the art object and the real object from the daily environment. Like Magritte's pipe which cannot be smoked *(The Use of Words I),* Johns' bulb cannot produce light like the object it depicts, but takes on new uses as an art image. This quality distinguishes Johns' *Light Bulbs* and other sculptures from his paintings of flat objects and signs, which are not representations of objects, but the actual objects transformed into works of art.

Bronze, 1960-61, (Plate 25) (Koz. 78), is a variation of *Light Bulb II:* the bulb, socket and wire are separated fragments displayed on a thin base marked with a grid.

Johns' *English Light Bulb* done in 1968-70 (Cri. 140) is made of sculpmetal like his first ones. It is modelled on an English light bulb, different in proportion and detail from the standard American bulb. What interested Johns especially was the bayonet fixture at the top of the English bulb. Johns said he found it while walking on a beach in North Carolina,[3] so that it can be seen as a souvenir of that experience as well as a variation on the generic light bulb motif. The bulb is set on a wire loop coated with polyvinyl chloride, raised above a rectangular base made from a can of solidified sculpmetal coated with sculpmetal.[4]

The subject Johns chose after the light bulb was the flashlight, another light-producing object, but one which does not require an outside source of power. Johns used the same standard flashlight as the model for each version.[5] *Flashlight I,* 1958 (Cri. 30), is based on a sketch done the same year. It is set on two iron bars which raise it above a wooden base coated with sculpmetal; instead of the materials indicated for the flashlight in the sketch (bronze or papier-mâché), Johns uses a real flashlight completely covered with sculpmetal. The flashlight's original metallic surface is simulated by the sculpmetal, enhancing the sculpture's initial *trompe l'oeil* effect. Because a real object was used, it is similar in concept to the found objects coated with

encaustic in Johns' paintings, especially *Book,* 1958, where the object is actually "freestanding." The flashlight is displayed with characteristic Johnsian irony, as if it were a rare, precious object, rather than a familiar, pedestrian, household item. *Flashlight II,* 1958 (Cri. 31), is made of papier-mâché, one of the material indicated in the sketch; it has a glass front, but it rests directly on a papier-mâché base. *Flashlight III,* 1958 (Cri. 32), is Johns' first plaster sculpture, although plaster casts of anatomical fragments were used in his early constructions. It too has a glass front added as a realistic detail. Its high, roughly textured base plays an important role: it suggests Michelangelo's, and later, Rodin's, technique of contrasting unfinished with polished marble to create the effect of figures emerging from formless matter. Johns seems to be making a tongue-in-cheek reference to this technique. Johns' last *Flashlight* sculpture, 1960 (Plate 26), was cast in bronze according to the design and specifications of the 1958 sketch.

The objects Johns chose for his sculptures were selected not only because they are universally familiar, but also for the artistic meanings they evoke. Both the light bulb and flashlight refer to the role of light in art. The artist must have artificial light to work by in the studio. A work of art is described in terms of its light effects or how forms are modelled in light and shadow or, in sculpture specifically, how light reflects off surfaces, creating highlights and shadows which are an important part of the work's visual impact.

Johns could also be referring to the use of found materials in modern sculpture. Electric lights were among the non-traditional materials suggested by Umberto Boccioni in his *Technical Manifesto of Futurist Sculpture* (1912). Rauschenberg was the first artist to make frequent use of electric lights and Johns' use of light bulbs and flashlights could in part be in homage to Rauschenberg's work.[6]

Johns' 1960 *Painted Bronzes* of ale cans and paint brushes are his most effective *trompe l'oeil* works. In both, the objects were cast in bronze and then painted to simulate the "real" objects. The painting is not, however, meticulously realistic; Johns leaves mistakes and traces of the artist's touch so it becomes apparent they were made by hand. In a 1965 interview Johns said in reference to his *Painted Bronzes:*

> You have a model and you paint a thing to be very close to the model. Then you have the possibility of completely fooling the situation, making one exactly like the other, which doesn't particularly interest me. (In that case you lose the fact of what you have actually done.)...I like that there is the possibility that one might take one for the other, but I also like that with a little examination, its very clear that one is not the other.[7]

Painted Bronze (Ale Cans) (Cri. 67) was, according to Johns, provoked by a comment made by de Kooning:

I was doing at that time sculptures of small objects—flashlights and light bulbs. Then I heard a story about Willem de Kooning. He was annoyed with my dealer, Leo Castelli, for some reason, and said something like, "That son-of-a-bitch; you could give him two beer cans and he could sell them." I heard this and thought, "What a sculpture—two beer cans." It seemed to me to fit in perfectly with what I was doing, so I did them and Leo sold them.[8]

It is significant that it was de Kooning's remark to which Johns responded, because much of Johns' work is in some way a reaction to the Abstract Expressionist art which de Kooning represents. The beer can subject was suitable, as Johns' points out, because it fit in with the type of objects he was using for sculptures at the time. Like the light bulb and flashlight, beer cans are familiar household objects, simple in shape and small enough to be easily held in one hand. For Johns, the cans are studio objects as well, since he used empty beer cans for mixing paint. This is documented in later works where real beer cans are included as studio tools, for example, in *Field Painting,* 1963-64, and *Studio,* 1964 (see Chapter 6). Johns used Ballantine Ale cans, most likely because the brand was a personal favorite, but also because of the simplicity of the can's label design and its bronze color, which imitates the traditional sculptor's material Johns used. The cans rest on a bronze base setting them off as art objects.

The cans were cast in bronze and the labels hand-painted so carefully that they look at first identical to real cans. Two Ballantine Ale cans were used as models, but the sculpture itself was completely remade in art materials.[9] When examined closely it is obvious that the *Painted Bronze* objects are not real cans, nor are they meant to be exact copies of them. The labels have a painterly quality and details are illegible. Johns has left a "signature" on the base in the form of a thumbprint, indicating his direct involvement in making the work, reinforcing the idea that it is a hand-made sculpture rather than a mass-produced object.

Another aspect of the sculpture is that the two cans at first appear identical, but are actually different from one another. One can is open and "empty" and the other closed and "full." The open can is slightly smaller, and its top is marked with the three-ring sign and the word "Florida"; the top of the closed can is blank. Another difference is their weight. When the cans are lifted off the base (each part is cast separately) one discovers that the open can is hollow and lightweight, the closed one solid bronze and therefore unexpectedly heavy. Johns' works have always been involved with distinguishing differences between objects which initially appear identical. *Two Flags,* 1959, was the first work in which two like objects were presented together for direct comparison, like the two ale cans in *Painted Bronze.* There is a second version of this sculpture, *Painted Bronze II,* 1960; it looks the same as the original sculpture, but differs slightly in surface detail.

The Savarin coffee can in Johns' next *Painted Bronze* sculpture (Plate 27) (Cri. 68), like the Ballantine Ale can, is an object which made its way from Johns' kitchen to his studio, where it was used to hold paint brushes. In a 1965 interview, he said that both his *Painted Bronze* sculptures were "right out of the studio. They'd been sitting there a couple of years before I noticed."[10] It was in 1960 that Johns began to included studio tools like brushes, cans and rulers in his works to refer to the studio environment and to the process of making a work of art.

This sculpture, too, is completely cast in bronze and hand-painted. The details of the Savarin can have been copied exactly; the can's edges and seams have been painted silver to imitate the look of the original can. The brush handles and can were cast separately and the handles screwed into the can. They have been painted to look like bare or stained wood, and are partly covered with traces of paint to indicate that they are used brushes. Because the can and brushes were cast and painted so accurately to look like real objects, and because the sculpture is presented with no base, it is Johns's most effective *trompe l'oeil* work. It is only when the sculpture is lifted or scrutinized closely that we realize it is not what it initially appears to be. Its colors are basically red, yellow and blue, Johns' preferred palette. Most likely the red color of the Savarin can, like the bronze of the ale cans, was a contributing factor in his decision to use it for a sculpture.

Johns' use of objects with specific brand names influenced several artists at the time, for example, Andy Warhol, who did his first Campbell soup can paintings in 1961. Although many painters and sculptors used commercial imagery during the 1960s, Johns used brand name objects only in these *Painted Bronze* sculptures and a few later works. A can is unlike a light bulb or coat hanger in that its shape alone does not tell us what it is; the label is necessary to enhance the sculpture's effect of realism and to identify it as a commonplace of our environment.

Johns did three sculptures which have to do specifically with the theme of the critic. In *The Critic Smiles,* 1959 (Cri. 62), done the year after Johns' first solo exhibition, a sculpmetal toothbrush, with four teeth replacing the bristles, is set on a sculpmetal base. The title is printed into the base with rubber stamp letters, and the words "copper" and "zinc" are printed into the brush handle. This Magritte-ian transformation of a familiar object suggests the idea of the critic smiling hypocritically with brightly polished teeth, while planning his critical attack on the artist. The idea of the artist's pain caused by the "bite" of the critic is also implied. Johns used this sculpture as an image in a 1966 lithograph of the same title (Field 54); in the print, the materials are indicated by the labels (appearing backwards) to be gold for the teeth, silver for the toothbrush handle and lead for the base. The image is hand-colored in gold, silver and aluminum metallic pigments to simulate these materials. In his 1969

lead relief print, *The Critic Smiles* (Field 118), the teeth are coated with gold, the handle with tin, and the base is made of lead.[11]

In the *Critic Sees,* 1961 (Plate 28) (Cri. 90), Johns presents another unusual juxtaposition of object and anatomy: two mouths appear behind the frames of eyeglasses encased in a brick-shaped form, the organs of sight having been replaced by those of speech. The mouths are plaster casts, both open, revealing the critic's teeth, but in one the teeth are clamped firmly together, while in the other they are partially open, as if the critic were speaking. This is in part a satirical comment on the wordiness of critics whose reviews often reveal that they have not really looked at the works they pan or praise. Johns told Max Kozloff that this sculpture was inspired by the three-minute visit of a critic to one of his exhibitions.[12] But the sculpture suggests a variety of interpretations related to different aspects of Johns' work which has consistently been involved with the relationship between art and language. In a sense we are all, as viewers of works of art, critics who are constantly faced with the dilemma of transforming what we see in art into spoken or written language in order to formulate thoughts about it and to communicate them to others. For Johns, who is always searching for new elements of a visual language which will enable us to expand our perception of reality, the organs of sight and speech are of equal importance. He manages to combine them behind an intellectual's glasses, suggesting perhaps their simultaneous operation. As Kozloff wrote: "The probability remains that they [speech and vision] are necessarily mutual reinforcements, components of an integrated function."[13]

In 1966, a variation on this motif titled *Summer Critic* was made in cement, wax and glass. In this version, the mouths are seen behind sun glasses instead of regular eye glasses. Field explains the source of this image, as related to him by Johns:

> When Johns was in Japan during the summer of 1966, it occured to him to do a summer version of *The Critic Sees.* The sunglasses are those of the critics who were at the pool instead of cloistered in their rooms for the purpose of writing (as their publishers had desired).[14]

Johns' last three sculptures are enigmatic works with figurative imagery and suggestive, if cryptic, personal associations. In *High School Days,* 1964 (Cri. 112), a plaster cast of a man's shoe is coated with sculpmetal. There is a small, round mirror on the toe with the work's title printed around it. Johns mentions the piece in his "Sketchbook Notes": "Make Shirl Hendryx's shoe in sculpmetal with mirror in the toe—to be used for looking up girl's dress. High School Days. (There is no way to make this before 1955)."[15] The nostalgia for school days, indicated in the title, fits in with the emphasis on personal memories in other works like the two *Souvenir* paintings from the same year, which also contain mirrors (see chapter 8). *High School Days,* as Alan

Solomon describes it, is about an "adolescent fantasy,"[16] however, the specific personal meaning the object had for Johns, both during his high school days and later in life when he used it as the subject for a sculpture, cannot be determined beyond the clues Johns gives us in his notes. The shoe is the same type of familiar man-made object Johns selected for other works, the only item of clothing he used until his 1972 *Untitled* painting with anatomical casts (one shows a woman's shoe, another a man's sock).

In *Subway,* 1965 (Plate 29), two knee caps, cast in plaster and coated with sculpmetal, are set in a rectangular field, each in its own distinct compartment. Johns said the source for this relief sculpture was an advertisment he saw while riding the subway. The ad showed a boy in short pants seated between a man and a woman, presumably his parents; someone had written "his" and "hers" on the boy's knees.[17] The ironic humor of the image would have appealed to Johns, and most likely personal associations are connected to the idea that a child is owned by his parents and to the conflicts resulting from the possessive aspects of the parent-child relationship.[18] *Subway* can also be interpreted more generally to imply that each individual has both a male and a female side (although this idea is presented in Johns' typically understated manner, since the knee caps are labeled as if they were objects like bathroom towels rather than parts of a human figure).

Johns' most recent sculpture is *Memory Piece,* 1970 (Plate 34). Like *Subway,* it contains an anatomical cast, in this case a foot. This sculpture, a relatively complex construction with sand-filled drawers, was conceived in 1961, and I will discuss it with related works from that year (see Chapter 5).

4

Johns' "Teachers": Leonardo, Duchamp and Cézanne

In 1959, Johns wrote the following statement published in the catalogue of the exhibition, "Sixteen Americans," at the Museum of Modern Art:

> Sometimes I see it and then paint it. Other times I paint it and then see it.both are impure situations, and I prefer neither.
>
> At every point in nature there is something to see. My work contains similar possibilities for the changing focus of the eye.
>
> Three academic ideas which have been of interest to me are what a teacher of mine (speaking of Cézanne and cubism) called "the rotating point of view" (Larry Rivers recently pointed to a black rectangle, two or three feet away from where he had been looking in a painting, and said "...like there's something happening over there too."); Marcel Duchamp's suggestion "to reach the Impossibility of sufficient visual memory to transfer from one like object to another the memory imprint"; and Leonardo's idea ("Therefore, O painter, do not surround your bodies with lines...") that the boundary of a body is neither a part of the enclosed body nor a part of the surrounding atmosphere.
>
> Generally, I am opposed to painting which is concerned with conceptions of simplicity. Everything looks very busy to me.[1]

The "three academic ideas" Johns mentioned reveal specific aspects of his relationship to Leonardo da Vinci, Marcel Duchamp and Paul Cézanne; however, the influence of each artist on Johns is much broader in scope. Cézanne is Johns' most important influence in terms of the visual aspects of his art, and Duchamp in terms of the conceptual, although it is important to keep in mind that both Cézanne and Duchamp, like Johns, were concerned with both aspects. Leonardo also balanced the visual and conceptual. Like Duchamp, he kept notebooks where he worked out and recorded artistic ideas; and like Cézanne, he was involved with exploring the nature of visual perception.

Leonardo: "his hands were not trembling"

Leonardo's idea, "Therefore, O painter, do not surround your bodies with lines...," comes from his "Treatise on Painting," an important source of inspiration for Johns' theories on art.[2] Johns has said that Leonardo is his favorite "Old Master" artist, and he has expressed admiration for Leonardo's works several times; he especially likes Leonardo's drawings in the Royal Collection.[3] When Johns was in London for a weekend he made a special trip to Windsor Castle to see Leonardo's "Deluge" drawings. He said the reason he liked these drawings in particular was "because here was a man depicting the end of the world and his hands were not trembling."[4] In one of John's "Sketchbook Notes" from the early 1960s, he used the word "deluge," probably intended as a reference to Leonardo's drawings: "An object that tells of the loss, destruction, disappearance of objects. Does not speak of itself. Tells of others. Will it include them? Deluge."[5] Leonardo's "Deluge" drawings very likely influenced several of Johns' works from 1966-67 (possibly earlier ones too) in which forms are engulfed by areas of turbulent brushstrokes. (Johns had a reproduction of one of Leonardo's "Deluge" drawings around his studio in 1967.) Johns has used reproductions of the Mona Lisa in several works as a reference both to Leonardo and Duchamp.

Duchamp: "O.K., so he invented fire, but what did he do after that?"[6]

Johns said he was not familiar with Duchamp's work when he did his first *Flags, Targets* and paintings with found objects. It was not until 1958/59, after his first one-man exhibition, when his works were labeled "neo-dada" by several critics that he read *The Dada Painters and Poets,* edited by Robert Motherwell, and became directly involved with Duchamp's art. At that time he went with Rauschenberg to see the Duchamps in the Arensberg Collection in the Philadelphia Museum of Art. He also read Robert Lebel's thorough, well-illustrated Duchamp monograph, published in 1959. By 1959, Johns had met Duchamp through the critic Nicolas Calas who brought Duchamp to see Johns' and Rauschenberg's work at their Front Street studios.[7] Johns owns a copy of the paperback book, *Lettre de Marcel Duchamp (1921) à Tristan Tzara,* published in 1958. It has a personal inscription by Duchamp to Johns, dated January 30, 1959. This could possibly be the date of their first meeting or shortly thereafter.

By 1960, Johns had begun collecting Duchamp's works,[8] and had familiarized himself further with Duchamp's ideas through reading the notes for the *Large Glass,* available in English for the first time in *The Bride Stripped Bare by her Bachelors, Even,* a typographic version by Richard Hamilton of Duchamp's *Green Box.*[9] Johns' perceptive review of this edition in the

periodical *Scrap,* 1960, reveals that his involvement with Duchamp resulted from a wide range of shared values concerning the nature of art and the artist's role. Duchamp's suggestion "to reach the Impossibility of sufficient visual memory to transfer from one like object to another the memory imprint," quoted in Johns' 1959 statement in "Sixteen Americans," was taken from the *Green Box* notes. Lebel interpreted this note in terms of the value Duchamp places on uniqueness: "For if he [Duchamp] loathes the ineluctability of law it is because his universe is ever and always that of the Unique. There is nothing ever repeated, nothing ever takes the place of anything else."[10] For Johns, too, the experience of uniqueness is essential: it is one of the most important aspects of his repeated versions of the same motif, where each time the motif appears its context and presentation are different.

Johns owns a copy of the 1934 edition of the *Green Box,* inscribed by Duchamp, who refers to Johns as the "Sibyl of Targets": "Jasper, Sibylle des Cibles, Affectueusement, Marcel 1960." In 1961, Johns did a drawing *Litanies of the Chariot.* The "Chariot" is one of the sections of the *Large Glass* and the "Litanies" a chant accompanying its movement, from the *Green Box* notes: "Slow life. Vicious circle. Onanism. Horizontal. Round trip for the buffer. Junk of life. Cheap construction. Tin, cords, iron wire. Eccentric wooden pulleys. Monotonous fly wheel. Beer professor." In the drawing, Johns printed this text with rubber stamp letters. Around the time of his initial contact with Duchamp, Johns began his "Sketchbook Notes," which are similar in style to Duchamp's *Green Box* notes.[11] Duchamp is the only artist on whom Johns has written published statements. Besides the *Green Box* review in *Scrap,* 1960, he wrote two short essays after Duchamp's death in 1968.[12] From 1959 on, Duchamp's art can be considered part of Johns' subject matter. Duchamp's objects, images and ideas are drawn upon by Johns and used as motifs in his own work.

Duchamp's ready-mades are significant precedents for Johns' paintings and sculptures of common objects. Duchamp was the first artist to present a found object itself as a work of art. He selected objects, among them a bicycle wheel, bottle rack, snow shovel or comb, and through the act of choice alone they were transformed into works of art. Johns' paintings and sculptures, such as his *Flags* and *Light Bulbs,* have the look of ready-mades because the object's ready-made design or shape was used. The essential difference, however, is that Johns' objects are all hand-made from art materials. When he uses found objects, for example in *Drawer* and *Coat Hanger,* they are always incorporated into a painting, rather than presented on their own like Duchamp's. For both artists, the object is given a new function in the context of art. Duchamp, by signing and dating an object, inscribing it, altering it with additions, displacing it from its expected location, changes its normal function and creates "a new thought for that object."[13] Johns always chooses objects which refer us to

specific qualities of the work of art, and thus the object acquires new meaning through its new use, as in *Drawer,* where the object indicates the painting's three-dimensional structure. Like Duchamp's objects, Johns' have the quality of being provocative and irreverent through their banality and lack of what is considered, in art terms, good aesthetic taste.

Duchamp's objects, although familiar and accessible to everyone, are changed into esoteric things as well once he has made them his own works of art. They have a mysterious presence, especially those with cryptic inscriptions which have no apparent connection with the object, like *Comb,* 1916, (Sch. 237), inscribed: "3 ou 4 gouttes de hauteur n'ont rien a faire avec la sauvagerie." Sidney and Harriet Janis, in an essay on Duchamp appearing in *The Dada Painters and Poets,* write: "Perhaps more than any of his contemporaries [Duchamp] has rediscovered the magic of the object and its esoteric relation to life."[14] Johns too presents the most commonplace objects in such a way that they become inscrutably ambiguous and mysterious, while retaining their identity as familiar things.

In the same 1959 statement in which he called Duchamp one of his teachers, Johns wrote: "At every point in nature there is something to see. My work contains similar possibilities for the changing focus of the eye." In his 1960 review of the *Bride Stripped Bare...,* Johns identified this quality of "changing focus" in his own work with Duchamp's. He described the *Large Glass* as "allowing the changing focus of the eye, the mind, to place the viewer where he is, not elsewhere." For both Duchamp and Johns, the type of visual and mental experience presented in a work of art should have the quality of referring the viewer to the space in which he or she is situated, rather than creating an illusion which leads the viewer somewhere else. The *Large Glass,* because it is a transparent surface, literally encompasses the surrounding space as part of itself. Johns mentions this effect of the *Glass* again in his 1968 essay: "Its cross-references of sight and thought, the changing focus of the eyes and mind, give fresh sense to the time and space we occupy, negate any concern with art as transportation."

It is significant that in both his 1960 and 1968 writings, Johns refers to Duchamp's art and its quality of "changing focus" in terms of the mind as well as the eye. For Johns it has always been essential to blend the visual and the conceptual aspects of art. Duchamp was the only 20th-century artist before Johns consistently and predominantly to assert the importance of ideas in art. Among Duchamp's statements on this issue are: "This is the direction art should turn: to an intellectual expression rather than to an animal expression. I am sick of the expression 'bête come un peintre'—stupid as a painter."[15] "Painting should not be exclusively visual or retinal. It must interest the gray matter, our appetite for intellectualization."[16] The notes for the *Glass* in the *Green Box* were Duchamp's most radically conceptual pieces (even Duchamp's

ready-mades had a visual presence which linked them with conventional sculpture). In the 1960 review, Johns commented on how the notes revealed "the extraordinary quality of Duchamp's thinking . . . the capacity for the work to contain Duchamp's huge precisions of thought-in-art." In 1968 he wrote: "Marcel Duchamp . . . moved his work through the retinal boundaries which had been established with Impressionism into a field where language, thought and vision act upon each other."

Since his first *Flag* painting, Johns has been concerned with detaching himself from his works so that they will not be experienced in traditional expressionistic terms. He found in Duchamp an artist who presented "painting of precision and beauty of indifference." In the 1960 review, Johns used this Duchamp quote (from the *Green Box*) to describe the *Large Glass,* and he wrote further: "Delight in the necessity of the artist's hand is left unexplored, as though the best operation would leave no souvenir of the surgeon." In 1911, in *Coffee Mill* (Sch. 178), Duchamp began to use mechanical forms. At this time he also eliminated bright color, using the Cubist's monochrome palette to give his works a more impersonal look. *Chocolate Grinder No. 1,* 1913 (Sch. 197), is his earliest painting identifiable as a "painting of precision and beauty of indifference" because of its hard-edged mechanical forms. The title and date are printed in gold letters on a strip of black leather, the way a commercial label would be used to identify a manufactured product; it is signed "appartenant à Marcel Duchamp," as if he wanted to make sure attention was drawn away from the fact that he made it. In *Chocolate Grinder No. 2,* 1914 (Sch. 213), the pictorial devices are simplified even further and the lines on the rollers are made of thread rather than drawn by hand. Lebel writes of this change: "Duchamp doubtless thought that in this way he would remove it still further from any resemblance to a work of art in order to achieve purely and simple a commercial formula, trademark, commercial device inscribed like an advertisement on a little glossy or colored paper."[17] Duchamp continued this depersonalized mode of painting in the *Large Glass* and other works, like *Tu m',* 1918 (Sch. 253), in which there is a picture of a pointing hand painted by a professional sign-maker hired by Duchamp. Duchamp's ready-mades are, of course, impersonal objects, in that the artist had no part in actually making them. Several are signed "[from] Marcel Duchamp" to stress that they were not made by his hand. In his writings and statements as well as his work, Duchamp has projected the aura of detachment, carrying it to an extreme in adopting a female alter ego Rrose Selavy. The stencilled-looking titles and signatures in Johns' works from 1960 on (beginning with *Painting with Two Balls*) are probably in part Duchamp-inspired.

Johns also admired Duchamp's relentless questioning of established values and constant undermining even of his own assumptions. Duchamp said: "I have forced myself to contradict myself in order to avoid conforming to my

own taste."[18] Duchamp does this with a sense of wit and irony that characterizes Johns' works as well. In his 1960 review, Johns wrote that the notes for the *Large Glass* reveal:

> Duchamp's wit and high common sense ("limit the no. of rdymades yearly"), the mind slapping at thoughtless values ("Use a Rembrandt as an ironing board"), his brilliantly inventive questioning of visual, mental and verbal focus and order (the beautiful Wilson-Lincoln system, which was never added to the glass; lose the possibility of identifying ... 2 colors, 2 laces, 2 hats, 2 forms"; the vision of an alphabet "only suitable for the description of this picture").

In 1959 Johns' works changed significantly in several ways. These changes were reinforced by and, in some cases, possibly influenced by his involvement with Duchamp, although they all have sources in Johns' own previous paintings and sculptures.

Duchamp's interest in movement was most likely a factor contributing to Johns' introduction of moving objects into his works from 1959 on. In *Device Circle*, 1959 (Plate 21), and *Painting with Ruler and Gray*, 1960 (Cri. 73), Johns used movable objects which could be rotated 360° to trace circles. These paintings could have been inspired by or intended as references to Duchamp's works where objects rotate in circles, e.g., *Bicycle Wheel*, 1913 (Sch. 205), Rotary Glass Plates, 1920 (Sch. 268). In Duchamp's *Coffee Mill* (Sch. 178), the machine's handle is shown in various stages of its circular movement. Duchamp said he regarded *Coffee Mill* as his key work because it was the first to indicate movement as an essential element in his art.[19] Johns was probably familiar with this painting at the time he did *Device Circle* and *Ruler and Gray* because there is a full-page color illustration of it on the title page of Lebel's 1959 monograph.

Johns' use of measuring devices from 1959 is also in part Duchamp-inspired, indicating another area where the interests of the two artists coincide. In his 1969 essay, called "Thoughts on Duchamp," Johns connected Duchamp's interest in movement with his questioning of standards of measurement:

> Duchamp's concern for things moving and stopped, exemplified in his work (Nude Descending, The Passage, 3 Standard Stoppages, the "draft pistons" and fixed dust in the Large Glass, the Rotoreliefs, etc.) brings into focus the shifting weight of things, the instability of our definitions and measurements.

Duchamp's *3 Standard Stoppages*, 1913-14 (Sch. 206), focuses on the idea of the instability of our definitions and measurements and relates to Johns' works with rulers. To make the *Stoppages*, Duchamp dropped three meter-long pieces of string from the height of one meter, and made templates conforming to the curve of the strings. (In the *Green Box* he wrote: "If a thread one

horizontal meter long falls straight from a height of one meter onto a horizontal plane twisting as it pleases and creates a new image of the unit of length.") Johns does not create new "images" of units of measurement, rather he presents standard measuring devices in unexpected situations where their function changes. Sometimes the numbers of the measuring scale are presented backwards and, in one case, *Screen Piece 3*, 1969, (Plate 54), the measuring device is shown twisted and distorted. Although the idea of chance, so important in Duchamp's *Stoppages* (he called them "canned chance") is not an aspect of Johns' use of rulers, both artists are questioning the idea of measurement as it is conventionally accepted.

In his 1960 review of the *Green Box*, Johns wrote about "Duchamp's curious frugality," where "The Carbon paper used to transfer the image of the Occultist Witnesses onto the glass becomes a drawing in itself." It is at this stage that Johns begins, with *Device Circle* and *Ruler and Gray*, to incorporate objects used in the process of making the work into the completed painting.

Another interest Duchamp and Johns share is in questioning the nature of language and its relation to art. Duchamp uses language in the form of inscriptions on certain ready-made, such as *Comb* or his *Anemic Cinema*, 1925-26 (Sch. 289). He also did several written pieces including *The*, 1915 (Sch. 234), a short nonsense essay in which the word "the" is replaced by an asterisk every time it occurs. Johns' painting *The*, 1957 (Cri. 15), presents the word itself isolated from any context other than the painting, so that it is, in effect, the opposite of Duchamp's *The*, where the word is made conspicuous by its absence. However, both artists present "the" so that its conventional meaning is altered and we experience it in a different way. Both artists' use of the word "the" as subject is one of many coincidences which occurred even before Johns knew about Duchamp's work.

In Duchamp's *Green Box*, there are several notes specifically about language, in which he suggests creating a new alphabet and other new language units. He writes, for example, "Conditions of a language: the search for 'prime words' (divisible only by themselves and by unity)." Johns, by contrast, uses available language elements, rather than inventing his own, for example, in his *Alphabets* and *Numbers* paintings. Another similarity of motifs involves Johns' *0 Through 9* paintings, with superimposed numbers and Duchamp's description from the *Green Box* of an inscription for the *Large Glass* using superimposed alphabetic units:

> Determine the alphabetic units (their number, form, significance . . .) represent sculpturally this inscription in movement. . . . Perhaps look for a way to obtain superimposed prints, i.e., a first print of the first unit (for instance) hyposulphite—make a second print of the second alphabetic unit superimposing itself on the first but printing only the essential without a background (the transparent background of the glass) 3rd, 4th, 5th units.

From 1959 on, Johns' use of language becomes more involved and more consciously conceptual, beginning with his color names, paintings like *False Start* and *Out the Window* (Plates 17, 18). Again, his involvement with Duchamp's art is a factor to be considered in understanding this change.

Johns once commented on how amazed he was to keep finding references to Duchamp in his work. He said this when I pointed out the map of the U.S.A. in Duchamp's *Genre Allegory*, 1943, (Sch. 319), which I had just noticed for the first time.[20] There are many examples of Johns' using Duchampian objects and motifs—some conscious references and some purely coincidental, as in the case of *The*, mentioned above. These examples include: Johns' *Book*, 1957 (Cri. 17), and the geometry textbook in Duchamp's *Unhappy Ready-Made*, 1919 (Sch. 260); *Thermometer*, 1959 (Plate 20), and the thermometer in *Why Not Sneeze*, 1929 (Sch. 274);[21] *Shade*, 1959 (Koz. 39), and the leather-covered window in *Fresh Widow*, 1920 (Sch. 265); *Coat Hanger*, 1959 (Koz. 40), and the coat rack of *Trap*, 1917 (Sch. 248); Johns' thumbprint signature in *Painted Bronze (Ale Cans)*, 1960 (Cri. 67), and Duchamp's in *Anemic Cinema*, 1925-26 (Sch. 289); the plaster breast in Johns' *Target*, 1955 (Plate 6), the wax cast in *Untitled*, 1972 (Plate 57), and the foam rubber breast on Duchamp's *Cover for the Catalogue Le Surrealisme en 1947* (Sch. 328). Other Duchampian motifs will be discussed in subsequent chapters in the context of the works in which they appear.

There are several instances, beginning with the drawing *Litanies of the Chariot*, 1961, where Johns incorporated Duchamp's work into his own. He has used the image of the Mona Lisa in three works, as a reference both to Leonardo's original portrait and to Duchamp's *L.H.O.O.Q.*, 1919 (Sch. 261). A small reproduction of the Mona Lisa appears as a collage element in the lower right corner, above Johns' initials, in *Figure 2*, 1962. An image of it appears in two *Figure 7* prints, one from the series of *Black and White Numerals*, 1968, and the other from *Color Numerals* 1968-69 (Field 101, 111). It was Duchamp who introduced the Mona Lisa as a subject for modern art by defacing it in a grafitti-like manner with moustache and goatee. Other artists who have used the Mona Lisa since, like Johns, have done so with Duchamp's version in mind. In a 1969 interview, Johns discussed the Mona Lisa image in his *Figure 7* prints, revealing the characteristic of his motifs to encompass references to various aspects of art experience:

> The Mona Lisa is one of my favorite paintings, and Da Vinci is one of my favorite artists. Duchamp is also one of my favorite artists, and he painted a moustache on a reproduction of Mona Lisa. Also, just before I came to work at Gemini someone gave me some iron-on decal "Mona Lisas" which you would get from sending in something like bubble gum wrappers and a quarter. With the decals all one has to do is iron the decal on cloth and one makes his own "Mona Lisa." I had some of these decals when I came to Gemini, and I thought I would use the Mona Lisa decal because I like introducing things which have their own quality and are not influenced by one's handling of them.[22]

Johns owns a copy of Duchamp's *L. H. O. O. Q. Shaved*, 1965 (Sch. 375), a small reproduction of the Mona Lisa pasted onto a dinner invitation, with the word "rasée" written under it. Johns used Duchamp's *Female Fig Leaf* sculpture (Sch. 328) to make an imprint on the surface in *No*, 1961 (Fig. 218), *Field Painting*, 1963-64 (Plate 43), and *Arrive-Depart*, 1963-64 (Plate 47). In each of these paintings the imprint was made with a copy of the 1961 bronze edition of Duchamp's sculpture, owned by Johns. Johns used the bottom of the sculpture to make the imprint, and the shape which appears is not obviously identifiable unless its source is pointed out.[23] The *Fig Leaf* shape is similar to the shape of the piece of bread in Johns' lead relief print *Bread*, 1969 (Field 122). Johns acknowledged this connection in a 1969 drawing in which he juxtaposed the bread shape with the *Fig Leaf* imprint. The initials in each corner—J.J., M.D., L.C. and T.W.— refer to Johns and Duchamp, to Johns' dealer, Leo Castelli and to Trevor Winkfield who first pointed out the similarity of the two shapes to Johns.[24]

Johns' painting *According to What*, 1964 (Plate 50), is an homage to Duchamp. It contains several Duchampian motifs and references to Duchamp's last oil painting, *Tu m'*, 1918. On a small hinged canvas in the lower left corner is Duchamp's profile portrait and his initials (see Chapter 8).

In 1968, Johns designed and executed the set for Merce Cunningham's dance *Walkaround Time*, based on Duchamp's *Large Glass*.[25] The following is an excerpt from my "Journal" in which I recorded details of the set making and an account of Duchamp's visit to Johns' studio to see the set for the first time:[26]

March 4, 1968 (Monday): Incredible day yesterday. Jasper called at 9:00 am to ask if I would help him with the Duchamp set (for Merce's *Walkaround Time*) which he had been working on for the past few weeks. He picked me up in a cab and we started working on the set while drinking coffee from the take out place [near David Whitney's loft, 343 Canal St., where Johns worked while he was living at the Chelsea Hotel]. The set is based on Duchamp's *Large Glass*. Jasper had silkscreens made of the separate motifs of the *Glass:* "Occulist Witnesses," "Glider," "Chocolate Grinder," "Sieves," "Bride," "Cinematic Blossoming," "Malic Moulds"; the "9 Shots" was the only image missing. [The silkscreens were based on Richard Hamilton's drawings for his copy of the *Large Glass* made for the Tate Gallery.] Each image was enlarged to correct, relative scale, except the "Occulist Witnesses" which was slightly larger. J screened the images on two sides of a plastic box [an inflatable box, made rigid by aluminum rods at the edges, the rods linked at the corners by a curved brass joint]. On one side of the box, the image was screened in black ink; on the opposite side, J painted over the screened image in black, gray, brown, white, silver or violet, approximating Duchamp's original colors. The boxes are extremely lightweight, although they take up relatively large volumes of space. J hopes the dancers will move them around the stage. He said Merce had begun choreographing the dance before J thought of using the *Glass* as a set, but since that time, Merce has had the image of the *Glass* in mind. The "Bride" is about 9' high, painted in black, gray and white with touches of violet; the bulkiest piece is the "Chocolate Grinder", painted in brown and silver.

J had arranged to pick up Duchamp at 2:00 that afternoon so he could look at the set before it was sent off to Buffalo [where *Walkaround Time* was to be performed for the first

time on March 10]. We worked on the finishing touches all morning. J painted in some black lines to strengthen the image of the "Bachelors" and "Glider." I cleaned off the plastic surface of the pieces that were already completed and filled them with more compressed air. J then spent a very long time arranging and lighting the pieces, trying to find the arrangement which would show off the set at its best. All focus was on the set: J himself was unshaven, wearing paint-splattered brown corduroys and torn sneakers. We went to lunch at a deli restaurant on 8th Street. J was nervous slightly: again, as if he wanted everything to be perfect; he was worried it might be too cold for Duchamp to want to go out—he mentioned that D disliked the cold weather.

We got a cab and went to 28 West 10th Street. J got out to get D. The first thing D said when he got in the cab was: "Canaday surely didn't know what to say about your show, so he said nothing at all!" [He was referring to the review that day in the *New York Times,* where Canaday described the people at the opening of J's exhibition at the Leo Castelli Gallery and hardly mentioned the works at all.]

D spoke with no French accent; he is short and thin and extremely casual in manner as well as dress; he was wearing a blue coat, a Russian wool cap, furry boots, corduroys, a green and brown tweed jacket with a blue vest underneath, a blue scarf with white polka dots. After spending about an hour or two in his presence, I feel that he is gentle, magnanimous, wise, sharp-minded, with a touch of naivete (similar in a way to Andy Warhol and John Cage—that kind of wonder-at-the-world quality and generosity that is naive, yet in a sophisticated framework).

It was beautiful to see J and D together. It was obvious that J admires D as a great genius of our age (Eddie Schlossberg told me that J once said D was the only genius he knew). It was also obvious that D has a tremendous respect and admiration for J, even seeming to think of him as a "son." D liked the set very much. He asked J how it was done.and what Merce was going to do with it, etc. J asked for suggestions and D said he thought some of the pieces should be suspended from the ceiling. Then J asked D about crediting and D thought J's name should be clearly mentioned since the idea was J's and he had done so much work on it. J kept insisting he didn't want his name mentioned since he wanted his role as Merce's artistic advisor to be ambiguous, but D insisted that J get credit. [The credit on the program for the first performance of the piece in Buffalo reads: "After Marcel Duchamp's *The Large Glass* in the Philadelphia Museum of Art, supervised by Jasper Johns." Even though J's name is mentioned, the credit still reveals little of the tremendous amount of work J put into the set.]

J went out to get a cab for D. While D was helping me on with my coat, he said he had a red scarf like mine, but he couln't find it. He said he and Teenie were going to Buffalo next Saturday, so I'll probably see him there. Then he's going to Canada, where he is going to play chess on stage with John Cage, the movements of the pieces producing the sounds of the concert. We dropped D off at his apartment on 10th Street, after riding through the deserted streets of the Soho area; D commented on how much he loves this area of New York, especially when it is deserted like it was on Sunday.

Cézanne: "Everything looks very busy to me."

Cézanne has been one of Johns' most important influences and inspirations. The two artists have a similar artistic sensibility, and this comes through in each of Johns' paintings, even where specific connections cannot be pointed out. Johns' first significant contact with Cézanne's work was a major exhibition at the Metropolitan Museum of Art in 1952, which included paintings, watercolors and drawings from each period of Cézanne's career.[27] In Johns'

1959 statement, he mentioned Cézanne as his teacher in connection with the concept of "the rotating point of view." This most likely refers to the way Cézanne, and the Cubists influenced by him, included simultaneous viewpoints in a single work.[28] Johns made only one other published reference to Cézanne in his 1964 "Sketchbook Notes," in a passage related to the painting *Watchman,* 1964:

> Looking is and is not eating and being eaten. (Cézanne?—each object reflecting the other.) That is there is a continuity of some sort among the watchman, the space, the objects.[29]

"Each object reflecting the other" refers to the way all the elements of a painting are linked so that each effects the way the others are perceived. For example, in Cézanne's *The Blue Vase,* ca. 1885 (Ven. 475), objects "reflect" each other through repeated shape (the ovals of the ink bottle opening, the plate and the base of the vase), linear pattern (the scalloped edge of the vase opening "reflected" in the edge of the white plate) and color (mostly blue, orange and brown).

These two references are the only published evidence of Cézanne's connection to Johns. The only direct reference to Cézanne in Johns' works to date is a small drawing after one of Cézanne's *Bathers, Tracing (after Cézanne),* 1977. However, anyone who has spent time with Johns knows how important Cézanne is to him; I have heard Johns express admiration for Cézanne's work many times. He once told me that Cézanne's *Bathers* are among his favorite works of art,[30] and another time he said that one of the people he would have most liked to have been was Cézanne (the other was the philosopher Ludwig Wittgenstein).[31] He told me he almost bought a Cézanne watercolor—a landscape—even though it would have cost him the price of one year's work. He did not get it, but then added he was glad, because it would have been destroyed in the fire at his house in Edisto, South Carolina.[32] I visited the Barnes Collection with Johns twice (in September 1969 and May 1970; he had visited it several times before) and he was most interested in the Cézannes.[33] Johns even suggested to me that I do a chapter of my dissertation on Cézanne which reconfirmed my own plans to do so. (I told him I was working on a section on Duchamp and he said I should do one on Cézanne instead.)[34]

Both Cézanne and Johns have painted many variations on single motifs, e.g., Cézanne's still lifes with apples, Mont Sainte-Victoires, Card Players, and Johns' Flags, Targets, Maps. Cézanne painted Mont Sainte-Victoire from several vantage points, altering the medium, size, color and composition so that each painting deals with a unique pictorial situation. In a letter to his son, September 1906, Cézanne wrote:

Here on the edge of the river, the motifs are very plentiful, the same subject seen from a different angle gives a subject for study of the highest interest and so varied that I think I could be occupied for months without changing my place, simply bending a little more to the right or left.[35]

Johns too alters the medium, size, color and composition of the different versions of a motif, changing the way it is seen and raising new artistic possibilities. What Theodore Reff wrote about Cézanne could apply to Johns as well:

...we cannot help being struck by the extraordinary range of effects that Cézanne could obtain solely through the manipulation of his pencil and brush, for his subject matter in these drawings is largely restricted to a few domestic objects, an occasional person or a small fragment of nature. Yet he creates in each instance a new pictorial structure, uniquely determined by its own type and distribution of parts.[36]

For both Cézanne and Johns, objectivity and self-detachment were important factors in the development of their styles and their choice of subjects. Both developed styles where each element of the painting seems under control and both artists chose mostly depersonalized subjects. However, because of the quality of control in their paintings, one feels that the artist's subjective tendencies have been repressed and transformed into something else, rather than eliminated. Their works are by no means emotionless, rather there is an extraordinary intensity of feeling which comes through even the most impersonal subjects like still lifes.[37] The controlled emotional intensity of Cézanne and Johns comes from what Reff, in describing Cézanne's *Bather with Outstretched Arms,* called the "antagonism between sensuality and restraint."[38] This antagonism or conflict occurs in all the pictoral elements of a given painting by Cézanne and Johns—color, brushstroke, composition, etc.— and creates in each work an unresolvable visual and psychological tension. The intense emotionalism of Cézanne and Johns is devoid of subjectivity in the sense of Impressionist or Expressionist art. Both artists picture universal conditions of reality in their art, rather than recording only specific, momentary experiences.[39]

Johns, like Cézanne, focuses on the basic artistic concern of representation in art, and both artists found new ways to picture the world on the flat surface of the canvas. Cézanne used traditional illusionistic devices like perspective and modelling to create a sense of three-dimensional space in his paintings and to give volume to forms in that space. But he used these devices in such a way that we are constantly made aware of the flatness of the picture's surface. Fritz Novotny wrote: "space in Cézanne's pictures is not illusory space in the ordinary sense. The picture plane contributes too much as an artistic reality to the impression produced by this treatment of space."[40] Johns carried the concept of anti-illusionist picture space, initiated by Cézanne (and further

developed by the Cubists), to what could be considered its logical conclusion by choosing subjects which are flat or by using real objects attached to paintings. Johns also emphasizes the idea of the painting itself as a concrete object. This idea is implied in Cézanne's works, but not developed to the extent it is in Johns' paintings which emerge out of the modernist tradition initiated by Cézanne and his generation.[4]

There are several pictorial devices which both Cézanne and Johns use to unify their paintings and call attention to the canvas surface. In Johns' paintings, as in Cézanne's, foreground-background (figure-ground) distinctions are rendered ambiguous or are cancelled out by "broken outlines." The clearest example of the broken outline in Johns' work is in his *Figure* paintings. For example, in *Figure 5*, 1960 (Plate 8), edges are sometimes reinforced by brushstrokes or collage and other times ignored or broken, so that the figure is unified with its surrounding field and figure and ground merge. Cézanne welds objects and figures to the surrounding space through broken outlines, e.g., the apples in *The Blue Vase* or the figure in *The Bather*, ca. 1885 (Ven. 548). Novotny wrote the following about Cézanne's outlines which could apply to Johns' outlines as well:

in the formation of this outline the isolating effect of contours is restricted to a minimum and instead the opposite effect is achieved—each object is linked to every other one and the space represented in the picture is linked to the picture plane.[42]

In Johns' 1959 statement he quoted a passage from Leonardo's "Treatise on Painting," which, in the context of this discussion, applies to both Cézanne and Johns: "(Therefore O painter do not surround your bodies with lines . . .) that the boundary of a body is neither a part of the enclosed body nor a part of the surrounding atmosphere."

Both Cézanne and Johns leave areas of canvas unpainted. Cézanne's use of patches of bare canvas, especially in his later paintings, comes from his watercolors where the whiteness of the paper creates a light, open and airy quality. In his paintings, the bare canvas creates the same effects of lightness and openness, adding color and texture to the image. Johns' use of patches of bare canvas throughout a field creates similar effects, especially in his paintings since 1962, like *Out the Window II*, 1962 (Cri. 102), where more canvas is exposed than in his previous works. However, for both artists, exposing the canvas is a device to undermine the depicted illusion of depth, to make us aware of the canvas-as-object. For Johns this concept is a more significant part of the painting's meaning than for Cézanne.

There is a similar quality to the brushstrokes and color in Cézanne's and Johns' paintings. Johns' brushstrokes resemble Cézanne's in the deliberate, controlled way they are applied: each one asserting itself as a mark on a flat surface, while at the same time participating in creating a sense of depth.

Charles Sterling, in his book on still life painting, wrote of Cézanne's brushstrokes:

> The art of Cézanne has focused attention on a fundamental truth, which preoccupied as they were with naturalism, painters had lost sight of for centuries: that each brushstroke, while contributing to build up images of natural things, also belongs to the picture surface, which it fills up in a certain manner; and that each brushstroke forms part of a certain order of lines and colors.[43]

Leo Steinberg wrote about Johns' brushstrokes:

> Johns' brushstrokes don't blend; each makes its short shape distinct in tone from its neighbor. That is the way Cézanne used to paint, in broken planes composed of adjacent values imparting pictorial flatness to things the mind knows to be atmospheric and spatial. Johns with that same type of brushwork that hovers mid-way between opaque canvas and spatial illusion, does the reverse, allowing an atmospheric suggestion to things the mind knows to be flat.[44]

For both Cézanne and Johns the brushstroke is handled as an independent element. Brushstrokes do not render the expected texture of objects, rather the texture remains uniformly that of the paint itself, and therefore focuses attention on the difference between the object itself and the object (e.g., apple or flag) "in" or "as" work of art.

Johns adopts a certain kind of brushstroke which seems to be a quotation from Cézanne. Both use an extended "M" or "W" stroke in many works. Cézanne uses it in paintings and more frequently in watercolors and drawings to define a certain area of color, often a shadow, e.g., in *Still Life with Water Jug,* 1892-93 (Ven. 749), and *Crossed Trees,* ca. 1896 (Ven. 938). This type of stroke appeared first in Johns' 1958 drawings, such as *Target* (Cri. 37) and *Black Numbers* (Cri. 38), where it is used to create a sense of depth as a foil to the flatness of the object and signs. (This type of stroke is found in the graphic work of many artists, but it is especially characteristic of Cézanne and Johns.) It also appears in many of Johns' paintings, such as *Shade,* 1959 (Koz. 39), *Two Flags,* 1959 (Koz. 48), *Device,* 1962 (Koz. 68), and *Map,* 1962 (Plate 11), where it is used as a sensuous surface marking. It adds a coil-like movement to the "activity" of the surface and seems to hover above its surrounding brushstrokes. It also functions as a decorative identification mark, like a fragment of illegible handwriting, suggesting a signature.

Cézanne's characteristic brushstroke marks an important change from his early romantic works (scenes of murder, rape, bacchanalian orgies and other erotic fantasies) through Impressionism, to his own Post-Impressionist style. It was first used in his fantasy themes of the mid-1870s to establish means to enable him to distance himself from and objectify his work.[45] The controlled brushstroke of Johns' paintings from 1955-58 also seems to have come from a

need to eliminate subjective tendencies and establish a sense of detachment. Johns' controlled brushstroke was in part a reaction to the openly expressive brushstrokes of de Kooning and other Abstract Expressionists, the way Cézanne's was partly a reaction to the spontaneous brushwork of Monet and other Impressionists. Both Cézanne and Johns change to a freer, looser, more open style of applying paint later in their careers, e.g., Johns in *False Start,* 1959 (Plate 17), and Cézanne in *Portrait of Vallier,* 1906 (Ven. 718).

Johns' monochrome gray corresponds to Cézanne's overall blue. Both artists used their preferred color to reinforce their position of detachment and to create a mood. Since 1955, Johns has used monochrome blue, green, white or gray in many paintings, e.g., *Tango,* 1955 (blue), *Green Target,* 1955, *White Flag,* 1955. Gray was first used in *Canvas,* 1956, and since that time has been Johns' most frequently used monochrome. Cézanne never painted in monochrome, but he used the color blue in such a way that it dominates the color scheme of many of his paintings. For Cézanne, blue suggests more than the descriptive color of forms and their surrounding atmosphere. It imparts a sense of objectivity and detachment. Kurt Badt wrote that Cézanne's blue "expressed the essence and essential being of things and their abiding, inherent permanence and placed them in a position of unattainable remoteness."[46] At the same time Cézanne's blue creates a melancholy mood, especially in certain Bather paintings, but also in portraits, still lifes and landscapes.[47] Johns applies his paint in such a way that it "allows an atmospheric suggestion" but his gray does not explicitly describe the atmosphere around things like Cézanne's blue. For Johns, gray is a neutral color which gives the painting a more literal or objective quality than any other color. But like blue, gray is associated with sadness (or gloominess) and Johns often used gray to suggest a mood of sadness (coldness, emotional withdrawal), especially in his 1961 paintings like *No* and *Water Freezes* (see Chapter 5). The result of using a cool or neutral color to suggest an emotional condition is that the emotionalism is perceived as repressed and hidden rather than openly revealed.

There is a conceptual quality to Cézanne's color which is, I think, unlike that of any other artist except Johns. Cézanne used the full range of the spectrum in a way corresponding to Johns' palette of the primaries and secondaries, especially as he uses them after 1958.[48] Johns' colors refer only to what is in the painting; each brushstroke is a response to another or to an internal element like the color names or assemblage objects. Cézanne's colors, on the other hand, are based on whatever he is using as a model for the painting—things external to the painting. However, Cézanne presents color so that it goes beyond its representational function, and his colors are to a large extent independent of the subject. For both Cézanne and Johns color plays a similar role—simultaneously conceptually controlled and visually sensuous— and for both it functions to unify the pictorial field, i.e., a touch of violet in one

area will be "reflected" in another area. Foreground and background are linked by color cancelling different positions in space. But color is also used to create depth. Cézanne used color to model forms, making them appear three-dimensional and solid. Johns also creates depth through color in paintings like *False Start*, 1959, but there is no modelling of any specific form or object. In both Cézanne and Johns there is a similar sense that there are hidden colors which reveal themselves gradually: the more intensely you look, the more you become aware of the rich fabric of color.

Both Cézanne and Johns present the world as seen in continuous time rather than from an ideal moment frozen in time. Cézanne captures the experience of seeing things in successive moments as well as from different viewpoints. Meyer Schapiro wrote that Cézanne

> loosened the perspective system of traditional art and gave to the space of the image the aspect of a world created freehand and put together piecemeal from successive perceptions, rather than offered complete to the eye in one coordinating glance as in the ready-made geometric perspective of Renaissance art.[49]

G.H. Hamilton in "Cézanne, Bergson and the Images of Time" wrote: "if the forms have been seen from different positions in space they can only have been so observed at different moments in time, the time of the indivisible continuous consciousness of the artist."[50] In recording the way nature is perceived in time, Cézanne is making a broader statement about human experience—the idea of continual change within the underlying order of things.

Johns' works too are involved with the concept of change and the effects of time passing. In his 1959 statement, cited at the beginning of this chapter, he writes: "At every point in nature there is something to see. My work contains similar possibilities for the changing focus of the eye." Like Cézanne, Johns presents the experience of seeing in successive moments and from "the rotating point of view." The idea of time passing is most concretely expressed in Johns' paintings with "devices," like *Device Circle*, 1959 (Plate 21), since we actually see the record of a continuous process in time. With both artists, time is incorporated into their paintings to capture what they consider to be the essence of meaning and order in nature and human experience, not to create a sense of the immediate, fleeting moment (as in Impressionist and Abstract Expressionist art).

The fundamental similarities between Johns and Cézanne are increasingly apparent the more familiar one becomes with their works.

5

"The Mood Changes"

During 1961, there is a change in Johns' works. His selection of subjects and the way they are presented reflect an emotional crisis in the artist's life. The titles alone, for example, *Liar, No, Water Freezes, In Memory of My Feelings*, indicate the change from the impersonal tone of his previous works to one which projects a restrained but intensely charged emotional condition, suggesting feelings of bitterness and anger, personal loss or emptiness. Memory becomes an important theme at this time as well. Stylistically, Johns' 1961 paintings are closer to his works before 1959 than to those of the two preceding years, since they are generally restrained in handling and subdued in color, mostly gray.

Liar, 1961 (Cri. 81), is characteristic of this change of mood. It is a study showing the details of a painting which was never made, including the various materials (wax, wood, sculpmetal) indicated by handwritten labels. The word "liar" is presented in a detached, object-like manner; it has been printed onto the surface using a hinged wooden block with raised letters. The printing block remains part of the work, like the stick in *Device Circle*. The word appears isolated, printed in impersonal lettering, like "the" or "red," "yellow" and "blue" in Johns' previous paintings. But "liar" has implications different from his other words: it comes across like a blunt, bitter accusation directed toward someone who has betrayed him. The word's impersonal presentation paradoxically increases the intensity of its emotional impact. Something central to Johns' emotional life is suggested by the word's cold ring. This interpretation is supported by a similar quality in other works done during this period.

Other possible interpretations focus attention on the nature of the art object which is always present as a theme in Johns' work. The word could be an accusation Johns is making to himself as an artist who must present something false in revealing the truth. This work in particular, because it is a study, is an image of an object, not the object itself. The materials indicated by the labels are in some case "true" (wax, sculpmetal) and in others "false" (the wood block is graphite). This issue is important also in regard to the *trompe l'oeil* aspect of

Johns' works, especially his 1960 *Painted Bronze* sculptures. One can imagine the viewer calling Johns a "liar" as it becomes clear that what he sees is not a real ale can. A.T. Gardener's observation about *trompe l'oeil* painting is relevant to Johns' works as well:

> Since the time of Apelles, one of the mainstays of the artist has been the attempt to reproduce the visual appearance of nature with such skill that illusion appears to be reality. This brings us to a paradox, for the closer the painter approaches the inscrutable abstraction of realistic truth, the nearer he comes to the deception of the painted lie.[2]

Liar could also be an accusation by Johns to the viewer-critic who looks at art without really seeing and, therefore, makes "false" judgments. This interpretation would relate *Liar* to Johns' sculptures *The Critic Smiles*, 1959, and *The Critic Sees*, 1961 (Plate 28).

No, 1961 (Cri. 80), again presents a single word as an object: its letters are made of lead and suspended from a long wire attached to the canvas with a screw eye. "No" is also printed onto the canvas in sculpmetal, and it appears a third time as a shadow cast by the lead letters. Like "liar," "no" can be interpreted as an emotional outcry: Johns' response to a personal decision which is irrevocable and reverberates deeply, touching all levels of his consciousness.

The word "no" as a subject is characteristic of the closed quality of Johns' subjects in general, like the unopened drawer and shade and the illegible book. The wire from which the letters are suspended is fixed onto the canvas so that it cannot swing freely from side to side. In both *No* and *Liar*, the words are small in proportion to the size of the field in which they are placed. They are printed in gray on gray and therefore blend with their surroundings, so that they seem to disappear. In *Liar*, the word could be covered over completely by the wooden block and hidden from view. This quality of disappearance, characteristic of many of Johns' earlier works as well, adds to the mood of negative emotional feelings. In this regard, it is significant that Johns titled two of his canvas collage paintings from 1960-61, "Disappearance" (Plate 19). These works with their closed envelopes of canvas communicate the same feelings as *No*: an emotional withdrawal with no possibility of turning back.

Johns reworked the surface of *No* during 1961 and added the imprint of Duchamp's *Female Fig Leaf* sculpture (Sch. 332) in the upper left. A bronze edition of this Duchamp sculpture (the original is plaster and dates from 1950) was issued by the Galerie Rive Droite in Paris in 1961. Johns most likely acquired his copy when he was in Paris in 1961.[3] The Duchamp sculpture is explicitly sexual in its title and suggestively erotic in shape. In the form Johns has presented it (he heated the bottom of the bronze sculpture and pressed it against the encaustic surface), it is an esoteric shape whose source would be

almost impossible to identify, if the information had not been revealed by Johns himself. The sexual meaning of the *Fig Leaf* is therefore hidden in the sense that it is not presented visually but conceptually; a relationship similar to that between the images in Duchamp's *Large Glass* and the explanatory notes in the *Green Box*. The hidden connotations of the *Fig Leaf* imprint and sexual overtones add to the circumstances surrounding the emotionally charged decision indicated by the word "no."

The process of imprinting the Duchamp sculpture could have been suggested by the words of Duchamp's *Musical Erratum,* 1913 (Sch. 196), a chance composition which was to be sung by Duchamp and two of his sisters: "To make an imprint mark with lines a figure on a surface impress a seal on wax."[4] By marking the surface of his encaustic painting with the *Fig Leaf* outline, Johns in effect carried out the instructions given in *Musical Erratum,* using one of Duchamp's own works to "impress a seal on wax." Leaving traces of objects and figures on the flat surface of the canvas becomes an important aspect of Johns' works from this point. In both *Liar* and *No,* the words are printed onto the canvas, so that we are made aware of the process involved in making the imprint. As Steinberg puts it, both *Liar* and *No* "seem to me to write a new role for the picture plane: not a window, nor an uprighted tray, not yet an object with active projections in actual space; but a surface observed during impregnation, as it receives a message or imprint from real space."[5] Duchamp's *Fig Leaf* is an impregnated message like the words "no" and "liar."

The word "no," like "liar," can be interpreted in terms of its artistic meanings as well as its emotional connotations. Field wrote: "In many ways the word NO seems to caution the observer from jumping to conclusions about the nature of what he is seeing."[6] "No" is a pun on "know," referring to the importance of the conceptual aspect of Johns' works. For John Cage, the negative response "no" evokes its opposite, setting up a dialogue: "Someone must have said YES (NO), but since we are not now informed we answer the painting affirmatively."[7]

In *Water Freezes,* 1961 (Plate 30), the idea of a negative emotional condition is again suggested. The words, marking the freezing point of a thermometer, indicate the change from water to ice, from a liquid to a solid state, from warmer to colder. They also can be interpreted as suggesting the change from an open to a closed emotional state. Johns' choice of "water freezes" rather than "ice melts" (or "water boils") corresponds to his choice of "no" instead of "yes." As in *No,* a concise and direct statement of icy hostility is projected. In *Water Freezes,* the thermometer is transformed into an instrument which measures temperament as well as temperature. The painting's gray color is important in conveying the mood of coldness indicated by the printed words; as in the other paintings from this period, Johns' use of

his preferred monochrome is even more emotionally suggestive than previously.

In *Painting Bitten by a Man,* 1961 (Plate 31), the feelings of anger and emotional pain which come through in *No, Liar* and *Water Freezes* is confirmed. A bite has been taken out of a thick layer of gray encaustic covering a small canvas. The image is simple but extraordinarily powerful. It is as if Johns had to express his anguish in a direct physical action, but without using the conventional painterly means of expressionist art. His feelings (anger, hurt, frustration) are summed up in a single gesture, presented in the form of a concrete thing, a bite. Through this "object," feelings are transferred from life to art with no intermediary of brush-in-hand.

Besides reflecting Johns' personal emotional state, this painting raises general questions about the way feelings are communicated in art. The title focuses attention on the "painting" which is bitten, rather than the bite. The painting itself is presented as the victim (of Johns' wrath?) or as a substitute victim, like a voodoo doll with pins stuck into it. The title also indicates that the bite was inflicted by a "man" who is not specifically identified. We can assume that it was the artist himself, but the title adds a distinct tone of ambiguity, as well as a sense of detachment. The bite could also be that of the spectator/critic (e.g., the one in *The Critic Sees?*) and this suggests the vulnerability of the work of art to the critic's attack; although it is the artist himself, not his work, that feels the pain of the critic's bite.[8]

In *Good Time Charley,* 1961 (Plate 32) (Cri. 85), the title is printed on a sculpmetal cup attached upside down to the canvas. Johns uses a ruler (part of a yardstick) to trace a path in the gray encaustic field. It is attached at the edge with a wingnut, so that it can be turned in an arc (like a stick in *Device Circle* and the ruler in *Painting with Ruler and Gray*), but its downward movement stops at the cup. It appears as if the ruler has knocked over the cup, like a carelessly swung arm or a reckless wheel of fortune, emptying it of its contents. Thus it is as if "Good Time Charley's" cup once full (of success? happiness? love?), is now empty—a metaphor for the changed condition of his life. In this context, the path traced by the ruler suggests the passage of time, as well as a sudden, jolting movement in the present. The sparseness of the still life, its simplicity and austerity, add to the feeling of sadness and loss which contrast ironically with the title.[9]

The idea of time passing, suggested by the ruler's path and overturned cup in *Good Time Charley,* is the subject of another of Johns' 1961 paintings, *In Memory of My Feelings—Frank O'Hara* (Plate 34) (Cri. 84). The title, printed along the bottom edge, refers to a poem by Frank O'Hara written in 1956.[10] O'Hara was a leading poet of the New York School and a well-known figure in the art world. He was a curator at the Museum of Modern Art and an art critic

who had many artist friends. Johns knew O'Hara from the late 1950s to the latter's death in 1966.

Although Johns had used a poet's name as the subject of a previous work, *Tennyson,* 1958 (Plate 16), this is the first time he referred to a specific poem and a contemporary poet. The title of the poem, "In Memory of My Feelings," implies that it is a commemoration. Using the title as an image enabled Johns to allude to his own feelings without making a direct autobiographical statement.

In the following passage of the poem, O'Hara records memories of his feelings from different phases of his life, and a state of emotional withdrawal indicating a figurative death, similar to that conveyed by Johns in paintings like *No* and *Water Freezes:*

> My 10 my 19
> my 9, and the several years. My
> 12 years since they all died, philosophically speaking.
> And now the coolness of a mind
> like a shuttered suite in the Grand Hotel
> where mail arrives for my incognito,
> whose facade
> has been slipping into the Grand Canal for centuries,
> rockets splay over a *sposalizio,*
> fleeing into night
> from their Chinese memories, and its a celebration
> the trying desperately to count them as they die.
> But who will stay to be these numbers
> when all the lights are dead?

Images of death appear throughout the poem "In Memory of My Feelings." In Johns' painting, the words "Dead Man" appear at the lower right, although the letters are only faintly visible because they blend with the surrounding brushstrokes. This is Johns' first reference to death and the only time the words "Dead Man" are used; in later works, he includes *vanitas* images in the form of imprinted skulls. (See Plates 47, 49.)

The last line of O'Hara's poem sum up the feelings of nostalgia, bitterness and death implied in the title and throughout the poem, feelings which Johns seemed to share at the time and which come through in his 1961 paintings:

> I have forgotten my loves, and chiefly that one, the cancerous
> statue which my body could no longer contain,
> against my will
> against my love
> become art,
> I could not change it into history
> and so remember it,
> and I have lost what is always and everywhere

present, the scene of my selves, the occasion of these rules,
which I myself and singly must now kill
 and save the serpent in their midst.

The format of *In Memory of My Feelings,* a horizontal rectangle with a smaller rectangle marked out in the upper left, suggests the design of the American flag; as if it is meant to be a "memory" of the original 1954-55 *Flag,* Johns' first major artistic statement.

In Memory is made up of two panels hinged together at the center, but not movable. As in Johns' other 1961 paintings, there is a sense of immobility, as if something meant to move or open up has been permanently fixed in place. A fork and spoon hang backwards from a wire attached to the canvas by a screw eye. This "device" has been swung from side to side tracing a mark on the surface. Like the ale cans and coffee can in Johns' 1960 *Painted Bronze* sculptures, they are objects which have made their way from his kitchen to his studio. Although they no longer function as eating utensils, they suggest the act of eating, which from this point is an important metaphor in Johns' work. In connection with the theme of memory and death, eating—taking food into the body where it changes into another state—suggests, by analogy, Johns' life (and art) being consumed by time, its condition irrevocably altered. The fork and spoon can be also interpreted as affirming the continuity of life, counterbalancing the references to death. O'Hara does this too, since throughout the poem he presents a display of images confirming the richness of life even in the context of the mood of sadness and the death which pervade. One of the poem's most striking lines, which I think captures the spirit of intensity in Johns' art as well, is: "Grace/to be born and live as variously as possible."

In 1967, Johns did illustrations with images of silverware for "In Memory of My Feelings," in a special edition of O'Hara's poetry, bearing the same title and issued by the Museum of Modern Art one year after his death.[11] The main, double-page illustration is a place setting, a fork, spoon and knife set in a field of gray. At the end of the poem is an illustration of a single spoon surrounded by an area of orange-brown and gray. Since Johns used silverware for the first time in the painting titled after O'Hara's poem and later in his illustration of it, there could also be a private meaning behind his association of silverware with O'Hara or the poem.

The eating utensils also have meaning in reference to looking at art. In his "Sketchbook Notes," Johns wrote the cryptic phrase: " 'Looking' is and is not 'eating' and 'being eaten.' "[12] The image is conjured up of the viewer or critic visually and verbally "consuming" the painting and, by extension, the artist, and in turn being consumed. This idea is also suggested in other 1961 works: *The Critic Sees* and *Painting Bitten by a Man.* The eating utensils in Johns'

works are then metaphors for consuming and digesting the art work. From 1961 on, Johns used forks, spoons and knives in several paintings. Their meaning is always purposefully ambiguous, and it is usually their juxtaposition with other objects and images that brings out the poetically suggestive qualities they assume in Johns' works.

Like the other objects Johns chooses for his paintings and sculptures, silverware is a motif from conventional still life, usually found with partially devoured food. There the items of silverware, usually knives, are depicted as if they were protruding into real space, provoking a more direct involvement by the viewer. Picasso is the only artist prior to Johns, however, who actually focused attention on silverware in some of his works. In his *Still Life,* 1941 (Zer. 11, 112), the knives, forks and spoons take on aggressive qualities adding to the painting's expressive effect; they also function, with the open table drawer, as *trompe l'oeil* elements. Picasso also used real eating utensils in several figurative sculptures.

The hinges joining the two panels are references to previous still lifes. Like the metal "hinge" strips in *Painting with Two Balls,* they relate specifically to nineteenth-century American still lifes, where objects are displayed on walls and doors. In *In Memory of My Feelings,* the hinges connecting the panels suggest that they can be opened like the cabinet door in Harnett's *Music and Good Luck,* 1888 (Fra. 52), for example. Although Johns uses real hinges, it is not to allow the panels to be opened to reveal what is behind them, but rather to suggest the possibility of doing so. Harnett depicts the hinges so that they appear real, like the other objects in the still life, yet in his painting too the possibility of opening the door, shown slightly ajar, is conceptual. *In Memory of My Feelings* is the first work where Johns supends objects parallel to the surface in the manner of *trompe l'oeil* artists like Harnett and Peto. It is significant that he used a coat hanger wire, since the idea of attaching objects to the canvas by suspending them was first presented in *Coat Hanger,* 1959 (Koz. 40). (The letters in *No* are also attached to coat hanger wire.) The combination of hinged panels and hanging objects reinforces the importance of *trompe l'oeil* still life as a precedent for this painting, and for Johns' work in general.

The silverware and hinges are most likely intended to be Duchampian references as well. One of Duchamp's ready-mades, *Locking Spoon,* 1957 (Sch. 343), consists of a spoon attached backwards to the door of his apartment, so it could be used as a device to open and close his lock. Although this work was not reproduced in print until 1964, Johns could possibly have seen it if he visited Duchamp's apartment.[13] Rauschenberg's use of a spoon (attached to a chain and set in a glass) in *Trophy II* (For Teeny and Marcel Duchamp), 1960-61 (Forge 72), reinforces the possibility that Johns' spoon is also a reference to Duchamp's spoon. The hinges could refer to the following note from Duchamp's *Green Box:*

Perhaps make a hinge picture. (folding yardstick, book...) develop the principle of the hinge in the displacements first in the plane second in space find an automatic description of the hinge.

In Memory of My Feelings marks a turning point in Johns' work. In it, he acknowledges the necessity of dealing with his feelings in his art: "against my will/against my love/become art." For the first time since 1955, Johns includes a reference to the human figure, ironically with the words "Dead Man." *Memory* is also the first work in which Johns refers to one of his contemporaries, in this case also a friend. O'Hara wrote the following poem in a letter to Johns in 1963:[14]

Dear Jap,

(my eyes clouded with my cold)
and from looking at lots of watermelons)

I just came back from the Poulenc Memorial Concert
a Riopelle watercolor I have had fallen off the wall
I miss my drawing which I think you are still looking at

yesterday I saw Matisse's great study for *La Danse*
today is colder, but

today I read a beautiful poem out loud
today also I felt confident by being busy
today also I missed Larry a lot

tonight the moon is not in this house
which I intend to leave

I want someday
to have a fire-escape

in 1951 I became crazy for fire-escapes
as you remember

when I think of you in South Carolina I think of my foot in the sand

do you at some strange distance
think of glass boxes full of weeds
and weeds filling bodies aromatically
and the strange distance between each blade of the eye

for Easter
John Myers says
you should have a hard-boiled egg
stuffed with ham

baked in milk
representing the desert

this would mean, I think, that summer need never come
that small insufferable things become culinary
that accidental simplicity has become a horrible law

in 1951 I never thought I would find mush around the fire-escape
(just an apprehensive thought before I go to sleep)
my brother has been bothering me a lot lately

A related work from 1961 is a study for a sculpture titled *Memory Piece (Frank O'Hara)* and signed, like the painting, "J. Johns 61." The sculpture, constructed almost ten years later in 1970 (Plate 34), was based directly on this study. A rubber cast of O'Hara's foot (made in 1961 when the study was done)[15] is centered on the inside flap of a lid hinged to the top of a wooden box construction with drawers. When the lid is closed, the foot presses against a layer of sand, so that when it is opened we see both the cast and the footprint it has made in the sand. The foot brings the image of a figure into the work. (The cast foot and the footprint are indicated in the study by the word "rubber," which labels a footprint outlined in pencil.) Johns did not reintroduce casts as a major motif in his work until 1964, but body imprints appear in several works from 1961 on. The foot is probably in part intended as a reference to Duchamp's sculpture of a painted cast sole of a foot with flies on it, titled *Torture-Morte,* 1959 (Sch. 354).

The footprint in the sand can be interpreted as a *vanitas* symbol, especially in juxtaposition with the title and the O'Hara poem to which it refers. A footprint in sand is a "memory piece" in that it is a record of someone's passage along a beach; an ephemeral record only, however, since footprints are quickly washed away by the ocean's waves. One reason why Johns identified with O'Hara at this time could be that they both spent much time at the seashore, O'Hara on Fire Island and Johns at his studio-home in Edisto Island. (From O'Hara's poem, "Dear Jap": "When I think of you in South Carolina I think of my foot in the sand.") During 1961 and after, Johns included many references to the seashore in his work, for example, one of his 1961 paintings is titled *By the Sea,* a drawing based on it is titled *Folly Beach,* a town located near Edisto on the coast. In a 1962 drawing titled *Edisto,* the imprint of a tennis shoe, like the footprint in *Memory Piece,* indicates the presence of a figure. The tennis shoe imprint is shown as if it were a three-dimensional form suspended by two wires, pulling at both ends. Movement is indicated by two arrows pointing in opposite directions, following the mark made by rubbing the sneaker from side to side against the paper surface. In the lower right corner, the outline of a scallop shell has been traced, locating the setting "by the sea."

The movable lid in *Memory Piece* is similar to those in Johns' 1955 *Targets,* which when opened reveal anatomical fragments otherwise hidden. The drawers recall Johns' 1957 painting *Drawer;* in the sculpture, however, the drawers can be opened, and they are lead-lined and filled with sand. It is in the *Memory* painting and sculpture that Johns first repeats motifs from earlier works, transformed and placed in a new context as described above (as distinguished from Johns' variations on flat objects and signs). Using his own previous imagery in this self-referential manner becomes an important aspect of Johns' work from this point.

The painting *Portrait—Viola Farber,* 1961-62 (Koz. 88, 89), is a direct variation on *In Memory of My Feelings.* Both are horizontal rectangles of approximately the same size, painted mostly in tones of gray (*Memory* in oil and *Viola* in encaustic). Both contain the same elements: a spoon, fork and wire, hinges and words; and in both Johns refers us to a contemporary artist who is also his friend. At the time Johns did Viola Farber's "portrait" she was one of the leading dancers in Merce Cunningham's Company, which Johns had been associated with since the mid-1950s. The dancer's presence is indicated by her name only, printed twice in superimposed lettering of different sizes. The name, by itself, suggests the musical instrument "viola" and the color "violet," as well as the person. There is no obvious connection between the word "Viola" and the other motifs, except that they are all aligned vertically in the right half of the painting. A small rectangular panel has been set into the canvas so that its surface is level with the rest of the field. This panel is hinged and can be unhooked and opened. In this state, the wall behind the canvas becomes part of the picture space, and the back of the panel is revealed, showing its canvas-on-stretcher construction. With this reversible panel, Johns combines the motifs he had used in his previous works to focus attention on structure: the inset panels from *Gray Rectangles,* 1957, and *Highway,* 1959, the canvas back from *Canvas,* 1956, and the open space revealing the wall in *Painting with Two Balls,* 1960. It is also, like *Memory,* a reference to Duchamp's "hinge picture" and to *trompe l'oeil* still lifes with hinged openings. One nineteenth-century American still-life painting in particular is strikingly similar to *Viola:* Haberle's *A Favorite,* ca. 1890 (Fra. 74). Haberle painted a wooden board with screws at each corner (except in the upper right, where the screw has fallen out), to which a pipe and some matches have been attached. The board frames a cigar box lid with a hinged panel cut out. A loop of string invites the viewer to open the panel, provoking curiosity about what can be found behind it. The inset panel in *Viola* functions in a similar way, except that it can actually be opened. The items of silverware in *Viola,* like the pipe and matches in Haberle's painting, establish a sense of tangible space in front of the picture surface.

The fork and spoon are bent and project out from the canvas as if they were waiting to support another object. They are connected by a taut rubber

band, suggesting a state of physical and psychological tension, which could reflect Viola's manner of dancing or perhaps, on a more personal level, Johns' feelings about her. The painting could also be an homage to Viola as an artist who captured in her dancing, the way O'Hara did in his poetry, feelings Johns could identify with at the time.

References to specific individuals occur in Johns' subsequent works. When the person is clearly identified by name, like Frank O'Hara or Viola Farber, Johns seems to be acknowledging that person as an inspiration for his own art. In some works, Johns uses initials which suggest that he is alluding either to someone whose identity he does not want to make public or that the reference is meant to remain ambiguous. For example, in *Figure 2*, 1962, Johns has stencilled the initials "T.B." in such a way that they blend with the brushstrokes and are barely visible; in two other works, he uses single letters "M" in *M*, 1962 and "H" in a 1963 *Untitled* drawing (see Chapter 6).

Besides names and initials, Johns includes the human figure as an important motif in his works from this point. Its presence is indicated by body imprints or casts of anatomical fragments and, sometimes, by photographs. The figure is never shown whole, and its identity and role in the work are never defined specifically.[16] In *Studies for Skin, I-IV*, 1962 (Plate 35), Johns presents imprints of his own head and hands in such a way that his features are not clearly defined. As a result, the subject's identity and expression have an aura of ambiguity. The fact that Johns used his own features is in itself indicative of the increasing personal quality of his work; but because he titled these works "Studies for Skin" instead of "Self-Portraits," he focuses attention on the process of making the body imprints and objectifies them.[17] The type of paper Johns used—engineer's standard form paper, like the title, also counterbalances the subjective quality of these images. Johns has filled in the appropriate sections in the printed title box in the lower right corner of each study (title, name, date—6 May—material, drawing no.) as if he were labeling a mechanical drawing. In spite of their objective aspects, these *Studies* come across most directly as portraits, reflecting a state of emotional crisis, the same sensibility expressed in the other works discussed in this chapter.

The technique Johns used is unusual: he coated his head and hands with baby oil and pressed them against the paper; when charcoal was rubbed on the paper, it was absorbed more by the oil-coated areas than the blank surface.[18] This technique was suitable to Johns, because he could depict his image on the paper's flat surface without using conventional illusionistic devices; he could present a distorted figurative image without willfully manipulating it for expressionistic effects. It also enabled him to show several views of a figure simultaneously, a new solution to the artistic problem of showing more aspects of a figure in a painting than can be seen from a single vantage point (for example, paintings of figures looking in mirrors, like Titian's *Venus with a*

Mirror, and Cubist figure paintings, especially Picasso's works combining profile and frontal views.)

Study for Skin I (Koz. 131) shows a direct frontal view of Johns' face and the side views of his head combined in such a way that his head looks stretched out and distorted. Next to the head are handprints, creating the effect of a figure pressing against a window pane, as if confined and longing to be released. Johns seems to be involved in a desperate struggle with himself or his art. Kozloff writes:

> Nowhere in Johns work has there been a more poignant effect of imprisonment, of the artist himself striving to break free from the physical limits of a work of art in to which he has willfully impregnated his own image.[19]

The lack of detail in the facial features (especially the blank area where the eyes should be), its distortion, and the blurred charcoal rubbings add to the sense of anxiety that the figure projects. All four *Studies for Skin* show a similar vulnerable, struggling image. In *Study for Skin II,* Johns' face appears as two separate profiles, rather than a stretched out continuous image; the hands are detached from the face. Since *Skin III* and *IV* do not contain handprints, the head appears even more an isolated fragment detached from the body. The charcoal rubbings not only blur the imprints, they convey a sense of urgency to obliterate the artist's features, especially in *Skin IV.*

In 1963, Johns began the lithograph, *Skin with O'Hara Poem,* completed in 1965 (Field 48) when the poem was added. The *Skin* image in this print is a close copy of *Study for Skin I,* and it is done on the same standard form paper, as the 1962 *Studies.* The position of the hands and details of the face and sides of the head vary slightly, but the expressive qualities are the same. The image takes on the melancholic and nostalgic mood of O'Hara's poem:

> the clouds go soft
> change color and so many kinds
> puff up, disperse
> sink into the sea
> the heavens go out of kilter
> an insane remark greets
> the monkey of the moon
> in a season of wit
> it is all demolished
> or made fragrant
> sputnik is the only word for "traveling companion"
> here on earth
> at 16 you weigh 145 pounds and at 36
> the shirts change, endless procession
> but they are all neck 14 sleeve 33

and holes appear and are filled
the same holes anonymous
no more conversion; no more conversation
the sand inevitably seeks the eye
and it is the same eye.

"Skin" appears in a 1962 painting, *4 The News* (Plate 36). An image similar to *Study for Skin I* was added as a collage element in the lower right corner and then worked over with charcoal so the features are barely visible. The handprint near the edge was added afterwards: it stands out clearly and it is reversed in relation to the "Skin" image. This hidden self-portrait gives the painting a distinctly personal quality and refers us to the feelings conveyed in the *Skin* studies.

Along the painting's bottom edge, Johns printed "4 the news Peto Johns 62." Peto has already been mentioned as a possible source for the metal strips and lettering in *Painting with Two Balls*, 1960 (Plate 22). In *4 The News*, a direct variation of *Painting with Two Balls*, Johns acknowledged Peto's role by including his name. Instead of the two wooden balls used in 1960 *Painting*, Johns introduces a folded newspaper between the two upper panels, as if it were prying them apart to reveal the wall behind the canvas. The upper panels are connected at the outer edges by the same type of metal strips used in the earlier work. Although the two paintings are similar structually and painted in the same medium—encaustic and collage—their color creates entirely different "moods": *4 The News* is subdued, mostly gray with touches of brown and blue, while *Painting with Two Balls* is vibrant and multi-colored.

The folded newspaper recalls Johns' *Newspaper,* 1957 (Plate 15). It is also a reference to Peto's "letter rack" paintings with folded newspapers and journals, like *Office Board, April 1885,* 1885 (Plate 37) and *Old Souvenirs,* 1881 (Fra. 56). Peto's letter racks divide up the surface into repeated units like Johns' separate panels; the objects wedged between the racks and the walls create a feeling of concrete physical tension like Johns' pried open panels. Among the objects in the rack in *Old Souvenirs* is a photograph of Peto's daughter and in *Office Board* a photograph of an unidentified man. (See also, *Jack of Hearts,* Plate 23.) These photographs may have inspired Johns to use the skin image in *4 The News.*

The title "4 The News" is also a reference both to Johns' and Peto's previous work. The number "4" recalls Johns' own *Figure* paintings. It also refers directly to a painting by Peto titled *The Cup We All Race 4,* 1905 (Plate 38), where "4" is likewise used as a pun on the word "for." This Peto painting was first brought to Johns' attention by art dealer Ileana Sonnabend who commented on its similarity to *Good Time Charley*, with its overturned metal cup.[20] Peto's title is carved on the wooden slats and the frame around them:

"the" is isolated on the left side of the frame so that it stands out as a separate word. Johns picked up this detail and incorporated it into his own painting, where "the" appears printed in large and small letters superimposed in the lower panel. This motif is also a reference to his own earlier painting, *The*, 1957.

Peto's *Cup* is strikingly similar to Johns' works up to this point, because it is relatively sparse and focuses on a single common object; also it is emotionally suggestive in the same restrained, understated way. Baur, in a 1950 article on Peto, mentions the "bare poignancy" of *The Cup We All Race 4,* and the personal reference to the artist's life which it makes.[21] *Cup,* a late work of Peto's, painted near the end of his career, conveys a feeling of nostalgia, as if the artist were reflecting on his past. Many of Peto's still lifes refer to the passing of time explicitly through such titles as "Old Souvenirs," "Reminiscences of 1865," "Abandoned Treasures," "Lamps of Other Days," as do many of Johns' titles from this period, such as, "In Memory," "Memory Piece," "Souvenir."

Peto's *The Cup We All Race 4* is an important source for motifs in several of Johns' other 1962 works. That year, he did a print—a gum arabic experiment—with Peto's name and the words "cup we all race 4" (Plate 39). It includes the imprint and outline of a hanging cup, two figure "4s" and a footprint. The cup is a reference to Peto's hanging cup, the 4s to his pun on "for," and the footprint reinforces the idea of a race, as well as alluding to the footprint in *Memory Piece.* The fact that Johns included the title, "cup we all race 4" indicated the significance of the sentence for him, as for Peto, concerning the idea of competition, achievement and reward. One of Johns "Sketchbook Notes" (before 1964) concerns this idea: "Competition as a definition of one kind of focus Competition (?) for different kinds of focus. What prize? Value? Quantity?"[22] Presenting the "cup we all race 4" as a familiar, humble object points out the futility of always searching for something beyond reach when the prize—the trophy cup—is something which was always accessible. By using a worthless tin cup as a trophy, Peto is saying that perhaps there is no special prize or reward at all for winning the race.[23]

Johns refers to Peto's *Cup* in two other 1962 paintings, *Fool's House* (Plate 40) (Cri. 98) and *Zone* (Cri. 101): in both, Johns includes an ordinary coffee cup hanging from a hook, like Peto's tin cup. In both, Johns has written the word "cup" as a label, focusing attention on the relation between the object and its name. In Peto's painting, "cup" is the only word carved on the wall on which the cup is hanging (the other words of the title are on the surrounding frame). Peto's juxtaposition of object and word appealed to Johns, because it coincided with and reinforced ideas he was developing in his own work through labeling objects (see Chapter 6). In *Fool's House,* Johns places a canvas stretcher next to the cup, alluding to the juxtaposition of cup and frame in Peto's painting.

Coffee cups are typical of objects Johns selected for his paintings and sculptures, and like the silverware, coffee cans and ale cans, they are also kitchen items. However, since they are also a reference to Peto's cup, they take on the meaning of ironic victory trophies. In *Zone* especially, this interpretation is reinforced by the legible collage fragments in the painting's lower section, which have to do with competition of some sort: "The big A... and the races too," "Koufax... too much for," "A... celebrates vote." In this same section of *Zone,* there is another collage element which clearly is a reference to Peto: a 4¢ Lincoln postage stamp [cf. Peto's *Office Board* (Plate 37), *Jack of Hearts* (Plate 23) and others]. Johns suspends his own paint brush from a chain, as if it were a trophy on display as well as a tool used in making the painting.

In the paintings discussed in the following chapter, Johns continues to develop the autobiographical aspects of his art, but more specifically in terms of his activity in the studio.

6

The Artist's Studio

By the end of 1960, Johns had used most of the objects from the artist's studio which would appear with increasing frequency in many of his subsequent works: paint brushes and cans for holding brushes or mixing paint in his *Painted Bronze* sculptures of 1960; stretcher in *Canvas*, 1956; ruler in *Painting with Ruler and Gray*, 1960; the artist's "palette" in the form of color names in *False Start* and *Out the Window*, 1959. It is in 1962, however, that Johns first used combinations of these objects in such a way that we seem to be entering the realm of the artist's studio. In this chapter, I will discuss the paintings in which Johns seems to concentrate most directly on the tools the artist uses in the studio and the space of the studio. These are *Fool's House, M* and *Zone*, 1962; *Slow Field*, 1962; *Field Painting*, 1963-64; *Untitled*, 1964-65, and related drawings; and two paintings titled *Studio*, 1964 and 1966.

In *Fool's House*, 1962 (Plate 40) (Cri. 98), the title, the choice of objects, and their arrangement suggest that we are looking at a kitchen/studio interior space and the flat surfaces—wall, floor, tabletop, shelf—used for supporting objects in these rooms. The broom, coffee cup and towel all appear for the first time in *Fool's House*. They are common household items that have made their way to the studio and taken on the function of art tools. The broom becomes a large paint brush, swung back and forth across the canvas to trace a path in the paint; the towel becomes a paint rag; the cup, a container in which to mix paint (there is a layer of black paint inside the cup). The juxtaposition of these kitchen items with a studio object—the stretcher—emphasizes a theme appearing frequently in Johns' works since 1961: the continuity of his activity as an artist with other aspects of his daily life, one blending indistinguishably into the other.

A new motif introduced in *Fool's House* is the handwritten labels pointing to the objects. The source of the painting's title is a comment made in response to the labels by one of Johns' friends who upon first seeing the painting, remarked: "Any fool knows it's a broom!"[1] However, Johns' labels are not merely redundant, rather they provoke us to examine the connection between a

word and an object—a connection usually taken for granted in our everyday use of language.

There are three possible sources for Johns' use of labels which shed light on their intended meaning: paintings by Peto and Magritte and the writings of the philosopher Ludwig Wittgenstein (1889-1951). In chapter 5, I discussed Peto's *Cup We All Race 4* (Plate 38) where the word "cup," isolated from the rest of the title, is juxtaposed to the hanging cup in the same framed-off area. The label in *Fool's House* points to a real cup and thereby, in contrast to Peto's *trompe l'oeil* cup, reinforces the fact that Johns uses real objects rather than images.

Another possible source is Magritte's paintings with objects and words, especially his *Key of Dreams* series, one of which, *The Key of Dreams,* 1936 (Gab. 114), is owned by Johns.[2] In this painting (similar to the others, except that the words are in English rather than French), three of the four words bear no apparent connection to the depicted objects except that they appear in the same framed section of the painting. Juxtaposing a horse with the label, "the door," is appropriate to Magritte because the *image* of a horse is as different from a real horse as it is from the word "door." By the same reasoning, the label "the valise" under a picture of a valise is no more or less "correct" than the others. In a 1929 essay, "Les mots et les images," Magritte wrote:

> An object never performs the same function as its name or image.... Everything tends to make one think that there is little relationship between an object and that which represents it.... In a painting the words are of the same substance as the images: one sees differently the images and the words in a painting.[3]

Johns, however, always labels his objects with the words we associate them with, underscoring the fact that he uses the objects themselves (or their imprints or outlines) rather than illusionist images.

A third source for Johns' labels is Wittgenstein's writings with which Johns became familiar shortly before *Fool's House* was painted. Johns told me he heard about Wittgenstein through his friend David Hayes from whom he borrowed Wittgenstein's *Tractatus Logico-Philosophicus* (1922); soon after he read *Philosophical Investigations* (1953).[4] Johns has since read all of Wittgenstein's published writings and several books about him. I have seen Wittgenstein's books in Johns' library and often around his studio. For Johns, Wittgenstein's investigations into "the problems of the relation of language to thought and to the world"[5] are supportive of his own investigations into the relation of art to language and thought and to the world.

Once when I visited Johns at the Chelsea Hotel (November 1967), he was reading Wittgenstein's *Zettel;* he read me the following passage which had particularly caught his attention:

What is the difference between these two things: Following a line involuntarily—Following a line intentionally?

What is the difference between these two things: Tracing a line with care and great attention—Attentively observing how my hand follows a line?[6]

Johns said that in his work he draws lines both ways, but he thought they came out better when he drew them involuntarily without consciously thinking about them.[7] This example is characteristic of the way Wittgenstein's writings stimulated Johns' thinking.

On Johns' recommendation, I have read Wittgenstein's *Blue and Brown Books, Philosophical Investigations* and *Zettel*. In each, I have found numerous passages strikingly similar to aspects of Johns' works and his "Sketchbook Notes," both in content and style of presentation. From my reading of Wittgenstein and thinking about his philosophy in relation to Johns' art, I have found that the subject grows continually richer and more complex. I will only discuss what is most directly relevant to the works examined in this chapter.

The labeled objects in *Fool's House* and related works are strikingly similar to Wittgenstein's comments about naming objects. Herbert Kohl's brief but lucid summary of the *Tractatus* begins:

The simple elements in his world can be named, but because they are primitive, basic elements they can *only* be named or pointed to. It is not possible to define them . . . Names are like labels, not like definitions. They are, properly speaking, pinned on the simple objects they name, or at best they mutely point to them . . . these names themselves have no meaning; they just are. It is only when they are combined into propositions that meaningful things about the world can be said.[8]

In the *Tractatus*, however, Wittgenstein refers to abstract concepts rather than simple objects like the ones Johns uses in his works. In his later work, *Philosophical Investigations* (in which he refutes much of his thinking in the *Tractatus*), Wittgenstein examines the process of naming objects in the following passages:

The word "to signify" is perhaps used in the most straightforward way when the object signified is marked with the sign. Suppose the tools A uses in building bear certain marks. When A shows his assistant such a mark, he brings the tool that has that mark on it.

It is in this and more or less similar ways that a name means and is given to a thing.—It will often prove useful in philosophy to say to ourselves: naming is like attaching a label to a thing.[9]

What is the relation between a name and thing named? . . . This relation may also consist, among many other things, in the fact that hearing the name calls before our mind the picture of what is named; and it also consists, among other things in the name's being written on the thing or being pronounced when that thing is pointed at.[10]

For Wittgenstein naming an object is a deceptively simple act which, when examined beneath its immediate, superficial appearance is actually a mysterious, "occult process":

> ... Naming appears as a *queer* connexion of a word with an object—And you really get such a queer connexion when the philosopher tries to bring out the relation between name and thing by staring at an object in front of him and repeating a name or even the word "this" innumerable times. For philosophical problems arise when language *goes on holiday*. And here we may indeed fancy naming to be some remarkable act of mind, as it were a baptism of an object.[11]

For Johns, too, naming an object is a "remarkable act of mind" rather than something to be taken for granted. For both the artist and the philosopher, what at first appears most simple and familiar—what we normally overlook— is the basis for the most radical insights and changes in consciousness. In another passage from *Philosophical Investigations,* Wittgenstein writes:

> The aspects of things that are most important for us are hidden because of their simplicity and familiarity. (One is unable to notice something because it is always before one's eyes.) The real foundations of his inquiry do not strike a man at all. Unless *that* fact has at some time struck him.—And this means: we fail to be struck by what is most striking and powerful.[12]

In John's pictorial language, the meaning of an object is its use in the painting: objects or words take on new meanings because their expected function is transformed in the context of the work of art. In *Fool's House,* for example, the kitchen objects assume the function of studio tools and the stretcher doubles as a frame. This aspect of Johns' art also coincides with Wittgenstein's idea that "the meaning of a word is its use in the language."[13] In the *Blue Book,* Wittgenstein writes:

> The use of the word *in practice* is its meaning. Imagine it were the usual thing that the objects around us carried labels with words on them by means of which our speech referred to the objects. Some of these words would be proper names of the objects, others generic names (like table, chair, etc.), others would only have a meaning to us in so far as we made a particular use of it.[14]

The way Johns isolates the word "use" in the title "Fool's House" (the title is printed so that the letters "use" of "house" are separated from the others on the left side of the broom handle) seems to emphasize the reference to Wittgenstein's idea of the relation of meaning to use in language.

After *Fool's House,* Johns did *M* and *Zone* which I have grouped with *Fool's House* because of the obvious similarities of the broom and paint brushes, the reappearance of the coffee cup in *Zone,* and the use of handwritten

labels.[15] All three paintings are similar stylistically too. They are mostly gray and, therefore, have a subdued quality, like Johns' 1961 works, while the brushstrokes are larger and more open. The freer handling has to do in part with the relatively large size of *Fool's House* and *Zone*, but it also indicates a change from the closed, restrained mood of paintings like *No*.

In *M*, 1962 (Plate 41) (Koz. 92), a small paint brush, price tag still attached, is suspended from the canvas by a wire and screw eye. Like the broom in *Fool's House*, the brush has been swung from side to side and has marked the surface. It is a used brush with traces of the same grays found on the canvas, indicating that it was used in making this particular painting. Like the stick in *Device Circle* and the ruler in *Ruler and Gray*, it calls attention to process, in this case the act of applying the paint to the canvas.

Hanging from a second wire attached to the brush is a pulley, an object used here for the first and only time in Johns' work. It does not function like a pulley, but as part of a "functionless" pendulum-like device. Rauschenberg used a pulley in a work titled *Studio Painting*, 1961 (Forge 193), and Johns' pulley, also used in a "studio" painting, could be in part intended as a reference to Rauschenberg's. Picabia's "functionless" machines, such as the one in an *Untitled* drawing from ca. 1918, owned by Johns (Cam. 158), are another possible source for the pulley device in *M*. Considering the number of references Johns makes to Duchamp's art throughout this period and his familiarity with Duchamp's writings, it is possible that the pulley was in part inspired by the "eccentric wooden pulleys" Duchamp lists among the "Litanies of the Chariot" in his *Green Box* notes.[16] The title, "M," repeated twice next to the pulley, reinforces the plausibility of a Duchampian reference—"M" could stand for "Marcel."

However, there is no way to determine with certainty who or what the letter "M" stands for, or even if Johns meant for it to stand for anything at all. The presence of the letter suggests several possible references, whether by intention or coincidence: "Marcel" Duchamp; René "Magritte," whom I have mentioned as a source for the labels which appear in Johns' works from 1962; Johns' friend, the dancer-choreographer, "Merce" Cunningham; "Marshall McLuhan," author of the phrase, "the medium is the message" and several books relevant to Johns' work;[17] even "Marilyn Monroe," who died in 1962 and who was the subject of a series of silkscreen paintings by Andy Warhol, begun that year, one of which Johns owns. It is possible that the reference is not to a public figure, but to a personal friend. Or that the letter "M" was chosen by a chance method of some kind.[18]

In *Zone*, 1962 (Cri. 101), a paint brush hangs from a chain, far enough in front of the canvas so that it can swing freely without touching the surface. Like the brush in *M* and the broom in *Fool's House*, it is partly covered with paint, as if it had been used to paint the canvas. The chain holding the brush is

attached by a magnet to a wooden "T" jutting out perpendicular to the top edge; above it, an "A" made of neon tubing lights up blue when the switch near the right edge is turned on.[19] By including the light switch in the picture space, Johns is inviting the spectator to participate, by literally "turning on" the painting. Johns' use of neon could have been in part inspired by another of Duchamp's *Green Box* notes:

> *Interior Lighting*...determine the luminous effects (lights and shadows) of an interior source i.e., that each is endowed with a "phosphorescence (?) and lights up like luminous advertisements not quite? Its *light* is not independent of its color.

The neon and wooden letters spell the word "at," suggesting location, like the title "Zone," without specifying any particular place. It is a short, commonly used word, like "the" and "no," presented in the painting as an independent object outside its expected context.

Johns used two panels, each clearly intended as separate "zones," but joined by overlappings at the edge where they meet. All the three-dimensional objects are attached on the upper panel, but the cup hangs below the edge and is actually in the lower one. The upper zone is painted in oil, mostly grays with touches of red, green, violet and orange. The lower is painted in gray encaustic and collage, its thick, opaque texture contrasting with the transparent, veiled quality of the upper one. Johns has marked off two areas in the lower zone, a rectangle and a square, one drawn in charcoal and the other marked by a thin layer of paint over the textured surface. There is an area of greenish-brown polka dots next to and overlapping the rectangle. The title, printed twice like "M," and Johns' initials appear in the lower corners.

In *Slow Field*, 1962, *Field Painting*, 1963-64, and *Untitled*, 1964-65, the artist's studio theme is continued with the addition of several new motifs. In all three paintings, Johns includes a conceptualized version of the artist's palette—a standard item in traditional artist's studio still lifes and interiors—by printing the names of the primary colors: red, yellow and blue. Along with the use of color names, Johns switches from gray to the full-spectrum color range of his works from 1959-60.

The primary color names appeared first in *Out the Window*, 1959, each in its own horizontal section; but in *Slow Field*, 1962 (Cri. 104), the words are printed vertically and repeated so that one row of letters is a mirror image of the other. The use of backwards lettering and other mirror image effects which now appear in Johns' art, could reflect the influence of his involvement with lithography, where images are prepared in reverse for printing.[20] Besides bringing in the palette motif and labeling the primary colors, the words function structurally as a column of letters dividing the field vertically into three equal sections. The corners of the field have been marked "LL" (lower

left), "UR," etc., as if to reinforce the correct vertical orientation, which might otherwise be confused because we expect the letters to be horizontal.

A stretcher similar to the one in *Fool's House* appears along the lower edge, but here it is part of a separate canvas attached with hinges in the lower right corner, so the stretcher is visible only when the canvas is swung open. A used brush, like the ones in *M* and *Zone,* hangs from a hook and wire attached to the upper stretcher bar. A simple outline drawing indicates where these objects are located when the small canvas is closed. In effect, we see the same objects simultaneously in two different positions. The handwritten labels point to the objects in the drawing, not to the real, assemblage objects. I think Johns does this to show that he is using the diagrammatic drawing and the labels in a similar way: to signify the presence of real objects in the painting. It is essential for Johns that the diagram depicts the objects without creating an illusionistic image; also that the details of the diagram and its location depend entirely on the real objects in the painting, i.e., the diagram would not exist independently of the real objects.

The same is true of the labeled diagram in Johns' 1963 *Untitled (Coca Cola)* drawing. The diagram's location is determined by the position of an imprint made with a real paint brush on the paper surface. Although there are no real objects in the drawing, the hanging brush, wire and screw eye are based on the objects in *M.* Johns has used a variety of media and techniques in this drawing: the brush imprint marked in paint, the diagram, measurement scale and handprint in charcoal; an area of watercolor (or graphite) brushstrokes; the letter "H" printed with stencil and green spray paint, a sprayed yellow paint spot and drip; and a red, silkscreened Coca Cola sign. Johns creates spatial ambiguity with these motifs, which on the one hand affirm the flatness of the surface and on the other seem to float in an undefined blank space. This drawing serves as a summary of Johns' pictorial vocabulary because of the range of techniques used and because of the types of motifs—labeled diagram, artist's tools, handprint, letter, brand name, "impact-drip"[21]—all of which appear in works from the early to mid-1960s.

Johns used handprints and other body imprints in previous works including the *Skin* drawings and *Diver,* 1962 (Plate 45), to create fragmented self-portraits. In this *Untitled* drawing, the handprint, though it is more like a signature than a self-portrait, also adds a personal quality, in that Johns' presence is directly felt. The artist's right hand is presented as an instrument for marking the picture surface, as in Johns' lithograph *Hand,* done the same year (Field 16). In the lithograph there are two right hands seen in reverse, with labels indicating the materials—soap and oil—used to make the imprints on the lithograph stone.

Among the first known art images are stencilled silhouettes of hands printed on cave walls during prehistoric times. Similar handprints appear in the

art of modern tribal hunting cultures, where they likewise seem to suggest magic powers associated with the hand.[22] Handprints are also frequently found in children's art, reflecting, like those in prehistoric and tribal art, a basic human impulse to mark a surface with an easily produced likeness and individual stamp of identity. Johns' handprints, in part, also stem from this same impulse to make a personalized mark on a surface, which refers us to the origins of art. Several other modern artists have used handprints in the same way, but only in isolated examples: Picasso, Miro, Man Ray, Duchamp, Hans Hofmann and Jackson Pollock.[23] Johns is the first artist to use the handprint and other body imprints as a repeated motif with a wide range of meanings.

The combination of hand, brush and ruler, used for the first time in this *Untitled* drawing, appears in several subsequent works. The juxtaposition of hand and paint brush suggests the concept of the brush as an extension of the artist's hand, and as the fundamental tool used in making paintings. In this drawing, however, the brush is not used in its expected way to paint the surface, but, like the hand, to make an imprint. The juxtaposition of hand and ruler suggests the idea that our standards of measurement were originally based on parts of the human body (hand, foot, arm). Both the hand and the ruler provide fixed reference points for determining scale. The ruler's numbers are printed backwards from right to left, and each individual number is printed backwards too.[24]

The Coca Cola sign is the first silkscreen Johns used. The fact that it is a popular brand name gives it the same quality as Johns' other found objects— something common and familiar to everyone. Also Johns may be acknowledging Andy Warhol as the artist who introduced the commercial technique of silkscreening as a medium for painting.[25] The letter "H" has the same cryptic quality as the "M" in Johns 1962 painting, and could possibly refer to the poet "Hart" Crane (see Chapter 7) or *trompe l'oeil* painters, William "Harnett" and John "Haberle." Hartnett did at least one painting with handprints, *Attention Company!*, 1878, using them, like Johns, as a device to assert the flatness of the surface. Haberle's *Slate,* ca. 1885 (Fra. 75), with its hanging piece of chalk, is close compositionally to Johns' *Untitled (Coca Cola)* drawing, *M* and *Zone.* Also like Johns' brushes, Haberle's chalk calls attention to process, because it is (conceptually) the instrument used to mark the picture's surface.[26]

Two studio drawings closely related to *Untitled (Coca Cola)* and *Slow Field* are *Wilderness I* and *II,* both begun in 1963 and completed in 1970. (The drawings date from 1963; the three-dimensional objects were added in 1970.) In both drawings, Johns again presents the hand, brush and ruler combination. In *Wilderness I* (Plate 42), a paint brush is suspended from a string attached to a clear acrylic cast of his own hand, and a 12-inch wooden ruler is placed below the lower edge. The isolated hand fragment gives a disturbing quality to the

work; the way the screw eye (holding the brush and string) pierces the hand suggests a crucifixion or stigmata image, conveying the idea of the artist's suffering as part of the creative process. At the same time, the cast is presented with objects pinned to it which makes the hand appear to be an object, too. Under the hanging brush is a labelled diagram ("brush," "screw eye," "string or wire"). There is also a labeled drawing of a stretcher and the primary color names.

Its companion drawing, *Wilderness II,* has a surface densely worked over in charcoal and gray pastel, making the elements more difficult to see—as if they are being engulfed by the darkness. A cast seen from the back wipes a framed surface with a rag. Three handprints seem to have been randomly marked on the surface. There are also what appear to be details from a self-portrait image similar to the *Studies for Skin:* in the lower right, the side of a head (imprint of ear and hair) and above it another ear. There are two drawings, one labeled, of hanging brushes, with arcs indicating their potential to swing and mark the surface. Below the lower edge is a ruler identical to the one in *Wilderness I.* Both drawings, although visually quite different—one turbulent and obscure, the other relatively static and clear—are suggestive of the artist's emotional difficulty associated with his work, possibly a crisis of creative powers or a general commentary on the artist's condition.

Field Painting, 1963-64 (Plate 43) (Cri. 111), is a direct variation on *Slow Field:* its format is the same with the primary color names printed vertically, dividing the space into thirds; the orientation of the field marked with labels (the words "upper left," "lower right," etc. are printed with small rubber stamp letters and arrows pointing to the corners). However, in *Field Painting,* Johns included a larger number of studio objects and materials used in making the painting than in any previous work. The mirror image letters are printed along the edge of two separate panels, allowing room for three-dimensional letters in neon and wood (the same materials as the "a" and "t" in *Zone*). The "r" of "red" is made of neon tubing which lights up red when the button switch device at the left is pressed.[27] The other letters are wooden and attached with hinges so they can be moved from side to side. On small magnets in some of these letters are attached: two paintbrushes, silkscreen squeegee, kitchen knife, spool of solder, chain, and two cans for mixing paint or cleaning brushes (Ballantine ale and Savarin coffee—both references to the 1960 *Painted Bronze* sculptures). The arrangement of these objects on the magnets is changeable. All are objects either used in making this particular work or found around the studio because they were used in other works.

Johns presents a range of ways of marking the painting's surface. The wooden letters appear to have been used to imprint the flat ones. Along the edge, near the upper right, is a footprint, indicating the artist's presence in the work or in the studio and also serving as a kind of signature and paint

applicator. Below is the yellow "impact-drip" similar to the one in *Untitled (Coca Cola);* next to it, the imprint of Duchamp's *Female Fig Leaf,* first used by Johns in *No* and a mark made by pressing the rim of the Ballantine ale can against the canvas. Cut off at the lower left corner is what looks like an imprint of the Savarin coffee can. In most of these works, Johns has used objects to mark the canvas by pressing them against the surface to make imprints. According to the following passage from his "Sketchbook Notes" (1964 or earlier), the use of object imprints is connected with the idea of art as a language:

> Find ways to apply paint with simple movements of objects—the hand, a board, feather, string, sponge, rag, shaped tools, comb (and move canvas against paint-smeared objects). What can this be used to mean if it were a language...? There seems to be sort of a 'pressure area' 'underneath' language which operates in such a way as to force the language to change. (I'm believing painting to be a language, or wishing language to be any sort of recognition.) If one takes delight in that kind of changing process one moves toward new recognitions, names, images.[28]

Johns did two paintings after *Field Painting,* titled *Studio,* both of which reflect the large-scale horizontal format Johns used for several works after *Diver,* 1962. The first was done in 1964 in Edisto Beach, South Carolina (Plate 44) (Cri. 119) where Johns worked part of the year from 1961-66.[29] An imprint of the screen door from his Edisto studio appears at a slight diagonal, extending beyond the lower edge of the canvas, where a separate panel has been added. Both the screen door and door frame are visible, which suggests that Johns pressed the canvas against the door to get as complete an imprint as possible. In a few spots he painted through the screening of the door to indicate its texture. As if to accent this texture, there is a pink area at the left edge where paint has been applied through a wire mesh with larger openings than the door screening.[30] A yardstick has been painted (its numerals printed with rubber stamps) alongside the door, but cut off at the lower edge. Other studio tools are the artist's primary palette in the form of color rectangles and several empty paint-covered beer cans and a stiff, used brush suspended from a wire. These objects, like the brush in *Zone,* 1962, hang like a tarnished trophy in honor of the work's completion. They seem to reflect the energy spent during the painting's creation. Between this cluster of objects and the door is a pattern of spikey forms which create the effect of a sudden burst of explosive energy; this was made by pressing a paint-coated palm leaf from a tree in Johns' yard onto the canvas.[31]

In the studio works previously discussed, the canvas space suggested the studio interior by referring to the surfaces on which objects could be placed. But in *Studio,* the presence of the door actually transforms the canvas into a fragment of the studio and the painting's large scale—12 feet across—adds to

the effect that we are looking at part of a wall. Because Johns has included objects found both inside and outside, we experience both the interior and exterior of the studio. In effect, the space behind the canvas/wall and in front of it is incorporated into the work without using any of the conventional pictorial means of rendering depth. In his typically paradoxical manner, however, Johns also negates the effect of the canvas as a wall: because the door extends beyond the edge, we are made aware that the canvas hangs on the "real" wall behind it. Also the door cannot, of course, be opened because it is an imprint, not a real door, and it is disoriented in relation to the room in which the spectator is standing. The diagonal line drawn across the canvas reinforces the sense of disorientation.[32]

Johns' use of his studio door may have been inspired in part by Duchamp's *Door: 11 Rue Larrey*, 1927 (Sch. 291), constructed as a door for two rooms in Duchamp's apartment, so that it could be both opened and closed at the same time. Like Duchamp's door, Johns' is a paradox because it is seen from the inside and outside simultaneously. Magritte did several paintings with doors, such as *Amorous Perspective*, 1935 (Gab. 80), a variation on the "inside-outside" theme presented also in *The Human Condition*, 1933, and other works with windows.[33] Rauschenberg used doors in several "combines," beginning with *Interview*, 1955 (Forge 16).

In *Studio II*, 1966 (Cri. 128), the imprint of a window appears four times, once cut off at the edge, suggesting that we are seeing only a fragment of a larger space. Although this window was bought in New York City and the painting was done in Johns' Riverside Drive apartment in New York, the studio referred to is the one in Edisto.[34] These windows function like the door in *Studio*, 1964, in transforming the canvas into a wall dividing inside from outside. The windows create a more transparent effect than the door, as if we can actually look through them; Johns has painted through wire screening, giving them the texture of screen windows. The window in the center has been opened—its lower section is raised and the grid patterns from the two sections overlap above. By using bright, light colors, mostly white and pink, Johns has created the effect of a light-filled studio interior. These windows show how Johns' concept of picture space has changed since he did his closed "window" picture, *Shade*, 1959. However, even with the sense of transparency and the relative open quality of the space, Johns uses his characteristic devices to affirm the flatness of the canvas surface.

The artist's presence in the studio is indicated by a handprint and artist's tools—a painted 12-inch ruler (upper right) and the primary color palette (along the upper edge). Although these are familiar motifs in Johns' studio vocabulary, *Studio II* differs from the previous paintings in this group because there are no three-dimensional objects: all are flat, either imprinted or hand-painted like the ruler.

Untitled, 1964-65 (Cri. 125), is a large, multi-paneled painting, containing many of Johns' studio motifs, including the hand, brush and ruler combinations. It seems to be a summarizing of the studio theme as it appeared in Johns' works since 1962. A paint-marked broom, used as a large brush to paint the canvas, hangs at the picture's right edge. Slightly below and to the left are found a blurred *Skin* drawing (see drawing, "*From Untitled Painting,*" 1964-65), and a handprint. These are repeated, with the *Skin* drawing cropped, in the left panel. Twelve-inch wooden rulers appear in all three sections. In the lower corner of the left panel is a small canvas attached with hinges like the one in *Slow Field,* except that this one reveals an empty canvas back and stretcher when closed, and a streak of smudged green paint when opened. (Johns put a brushstroke of paint on the small canvas or on the larger one and pressed the two together, creating mirror image brushstrokes.) The artist's palette appears in the form of the large color rectangles making up the three main sections of the field. The "RED" panel in the center is the same size and shape as the "BLUE" and "YELLOW" ones, but placed horizontally, rather than vertically, with a smaller, violet panel added below it. The color names are painted in large gray letters cut off at the edges, and also in letters blending with the colors of the panel.[35] There are various types of color charts repeated in each section: scraped spectrums, floating rectangles and bands of neutral tones (along the edges of each primary color panel). Overlapping the handprints in both the left and right panels are rectangular marks made by pressing the bottom of a large turpentine can against the canvas. The three black circles could be can imprints as well.

Johns' studio paintings are a continuation of the tradition of artist's studio still lifes and interiors. The types of studio objects he chooses—brushes, palettes, measuring devices, stretchers, casts—are found in traditional still lifes, such as Jean Cossard's *Trompe l'oeil* (Faré 446) and Anne Vallayer-Coster's *Attributes of the Arts,* 1769 (Faré 423); and in scenes of the artist at work in the studio, like William S. Mount's *The Painter's Triumph,* 1838. It is during the twentieth century, in the art of Picasso and Matisse, that the studio theme first becomes a major subject, developed over and over again in the artist's work. Johns, however, presents the studio theme in a new way, by using real objects or marks made by objects and suggesting a fragment of the studio, rather than representing it by traditional pictorial means. In this way he makes the physical and psychological experience of creating a work of art more concrete to the viewer than previous artists had done.

7

Diver and Related Works

Diver, 1962 (Plate 45) (Cri. 106), is the most monumental painting of a group which includes: *Passage* and *Out the Window II* (Figs. 277, 281) done in 1962 before *Diver*; and three works done soon after it, *Lands End*, 1963, *Periscope (Hart Crane)*, 1963, and *Arrive/Depart*, 1963-64. These works are related in several ways. First, they are similar stylistically. Johns uses more open and expressionistic brushstrokes than before and the structure of his compositions is looser. The pictorial elements often seem to float at random, breaking away from their expected order. As a result, the spatial atmosphere of these paintings is generally more turbulent than in previous works. Second, variations on the same motif are found in several works in the group: the scraped "device-circle," the primary color names, silverware held by wires, and body imprints. Third, these paintings generate similar emotional responses, suggesting isolation, struggle, even death. Johns expands on themes from his 1961 works, such as *In Memory of My Feelings* and *Memory Piece*, but in the *Diver* group his paint handling is expressionistic rather than restrained and his imagery more obviously suggests personal and emotional symbols and metaphors.[1]

Passage and *Out the Window II*, both 1962, are closely related to each other and provide a transition between the works discussed previously and *Diver*, *Lands End* and *Periscope*. The basic structure of all these works (except *Diver*) comes from *Out the Window*, 1959 (Plate 18) where the field is divided into three horizontal zones with one primary color name printed in each.

Passage (Koz. 97), like *Out the Window*, is made up of three separate panels joined together. It is exactly the same size as the earlier painting, however, the colors and handling of the words is different. The overall color of *Passage* is grayish-pink, but each primary color is more or less visible in the letters of its name (e.g., there is a faint trace of yellow in the "y" of "yellow" and the immediate surrounding area). Each color name is given a distinctly individual quality: each word is different in visual detail and in the way it relates to the surrounding space. This manner of presenting the color names, as complex and varied visual "events," is also characteristic of other paintings from the 1960s.

There are several variations on motifs from previous works in *Passage* besides the color names. In the upper left is the scraped "device-circle": a ruler was used to mark out a quarter circle and then left in the completed painting (the shape of the quarter circle is repeated in the lower left corner). Inside the circle segment, Johns has written the word "scrape" with arrows indicating the process of scraping the ruler back and forth; the word itself has been partially obscured by the repeated scraping action. "Scrape" is the first label Johns used to describe a process, rather than an object or color. There are also stencilled labels printed on some of the objects—"ruler," "iron," "envelope,"—a variation on the handwritten labels from *Fool's House, M* and others. The fork was used before, in *In Memory of My Feelings* and *Viola,* 1961-62, but here it is suspended horizontally, pulled by a chain at one end and a wire at the other. Like the ruler, the fork, chain and wire are raised above the surface and cast distinct shadows.

There are two new motifs, which Johns used for the first time in *Passage*: the envelope and the iron imprint.[2] The iron imprint was made by pressing a hot iron against the wax surface. This is another instance of Johns using a common household item as an art tool; the iron is particularly apt for encaustic, because one of the initial steps in preparing the medium is melting wax. The iron imprint recalls the words of Duchamp's *Musical Erratum,* "impress a seal on wax," already cited in connection with Johns' use of the *Female Fig Leaf* imprint in *No,* 1961 (see Chapter 5). Another Duchampian reference suggested by the iron is Duchamp's proposal for a reciprocal ready-made: "Use a Rembrandt as an ironing board."[3] Man Ray's ready-made of an iron with a row of tacks, *Gift,* 1921, a replica of which is owned by Johns, is another possible Dada source for this motif.

The envelope is a common still-life object possibly used here in reference to Peto's letter-rack still lifes (like the 4¢ stamp in *Zone*). The open address area indicates that it is a business envelope, but we are given no clues to satisfy our curiosity about its original contents; it is ambiguous whether there is a hidden, personal meaning. The words "Charleston, S.C." are printed in red on the ruler, upside-down and partially crossed out, but accented by the brushstroke of red paint over it and the red marks on the envelope (one of which looks like a figure "8"). This location refers us to Johns' home state and specifically the city closest to his Edisto Island studio-home. The sense that there is an autobiographical aspect to *Passage* is enhanced by the unsettling mood created by the subdued color and expressionist brushwork.

The title "Passage" suggests a change from one place or condition to another. It could in part be a reference to Duchamp's painting, *The Passage of the Virgin to the Bride,* 1912.[4] Another possible reference is to Hart Crane's poem titled "Passage."[5] Crane's poems, generally, have a sense of sadness and nostalgia similar to Frank O'Hara's, and the same kind of sensitivity to the

richness of life. Johns, I think, felt an artistic bond with Crane's poetry as he did with O'Hara's. Johns referred specifically to another of Crane's poems in *Periscope (Hart Crane),* 1963. The setting for Crane's "Passage" is near the sea ("Where the cedar leaf divides the sky/I hear the sea"), like most of Johns' paintings in the *Diver* group. The poem describes an artistic crisis, where the poet leaves his memory behind ("Sulking, sanctioning the sun,/My memory I left in a ravine") so he can experience nature directly, without translating it into art. But the experience he has brings him back to art:

> ...but the wind
> Died speaking through the ages that you know
> And hug, chimney-sooted heart of man!
> So I was turned about and back, much as your smoke
> Compiles a too well-known biography.
>
> The evening was a spear in the ravine
> That throve through very oak. And had I walked
> The dozen particular decimals of time?
> Touching an opening laurel, I found
> A thief beneath, my stolen book in hand.
>
> "Why are you back here—smiling an iron coffin?"
> "To argue with the laurel," I replied:
> "Am justified in transcience, fleeing
> Under the constant wonder of your eyes—."
>
> He closed the book. And from the Ptolemies
> Sand troughed us in a glittering abyss.
> A serpent swam a vertex to the sun
> —On unpaced beaches leaned its tongue and
> drummed.
> What fountains did I hear? what icy speeches?
> Memory, committed to the page, had broke.

Many of Johns' works since 1961, including those in the *Diver* group, deal with artistic crisis. I think Johns identified with Crane's experiences in "Passage," which is one of his major autobiographical poems.

The composition and motifs in *Out the Window II,* 1962 (Cri. 102), are basically the same as those in *Passage,* as if one painting were meant to be considered a direct variation on the other. As in *Passage,* each color name is presented in a unique manner, and the letters of the words contain traces of the colors they signify. Johns used a different stencil with spaces breaking the letters into separate parts, making them appear more loosely held together than those in *Passage. Out the Window II* is painted on a single canvas with the three zones marked out by red and yellow lines, made by plucking a paint-coated piece of string against the canvas.[6] There are quarter circles in the left corners;

the upper one is scraped by a ruler "device" and labeled with the word "scrape."
A spoon is suspended horizontally, like the fork in *Passage,* but it is pulled by
wires at both ends rather than a wire and chain, and there is a diagram of the
spoon and wire drawn on the canvas below (this diagram is in its own narrow
zone, marked out by a blue line parallel to the red one). In spite of the
similarities in the organization and details of the two paintings, their overall
effects, are very different. *Out the Window II* has a more objective quality—it
does not include suggested autobiographical associations the way *Passage*
does. The paintings are in two different media, one in encaustic and the other in
oil, and as a result the surface texture and paint handling are different (the iron
imprint is another motif from *Passage* eliminated in *Out the Window II,*
presumably because of the change of medium). *Out the Window II* reflects the
stylistic changes which appear in several of Johns' 1962 paintings: the
brushstrokes are thinner and looser and parts of the canvas are only stained
with a thin layer of paint, covered with paint drips or left completely bare.

Diver, 1962 (Plate 45) (Cri. 106) is 7 ½ by 14 feet, the largest work Johns had
done to that point, and his first attempt at the monumental, mural-sized scale
so important to the aesthetic of Abstract Expressionist painters like Pollock
and Newman. In *Diver,* Johns combines different styles, from expressionist to
hard edge. He uses assemblage objects and presents a variety of ways of
applying paint to the canvas: different types of brushstrokes and techniques,
such as staining or scraping the paint or applying it with parts of the body,
objects or stencils. The full range of hues and neutral tones are used: the first
two panels are painted predominantly black, white and gray, except for the
semi-circular color spectrum; the next three are mostly red, yellow and blue
with the secondary colors and neutral tones interspersed.

In spite of the diversity of pictorial elements in *Diver,* Johns manages to
maintain the effect of overall unity, without any elements disappearing or
losing their impact in the vast, panoramic field. He does this by creating
continuities and discontinuities, so that we see *Diver* as made up of
independent sections which are both separate from and connected to the rest of
the painting. There are five separate panels which increase in width from left to
right: the first two each measure 28 inches, the next two 36 inches, and the last
one 42 inches. Each panel is marked in the lower corners with numbers
specifying the order in which the panels are to be joined. Number "1" is printed
in the right corner of the first panel and also in the left corner of the second, and
so on until the fifth panel, where there is a "4" in the left corner, but no "5" in the
right. In the numberless corners, Johns has printed the title (far left) and his
initials and the date (far right). The figure of the diver, indicated by handprints
and footprints in the third and fourth panels, occupies a central position in the
composition and provides a conceptual focus which unifies the painting.

In the first panel of *Diver,* Johns creates an abrupt contrast between the transparent layers of thin, gray paint stained into the canvas and the semi-circle of thick, bright colors scraped onto the surface by a stretcher bar attached with a wingnut and bolt. This is the first time the "device-circle" motif is used to blend colors applied to the surface, rather than to scrape away an area of the painted surface.

The second panel contrasts with those next to it because of its distinct, hard-edge style. It is a scale of tonal values, with ten rectangular sections and part of another cut off at the bottom edge. Between the black rectangle at the top and the white one, there is a progression of increasingly lighter grays. Below the white rectangle, a scale of violet-grays begins, but it is impossible to determine its progression because we are shown only one complete rectangle and a fragment of another. The ordering of the neutral tones into geometrical units contrasts with the blending of hues in the semi-circular color spectrum in panel #1. The tonal chart at first appears smoothly painted, but closer examination reveals textured brushstrokes in each unit, especially in the sixth rectangle from the top, where two different shades of gray are applied with active brushstrokes. Also, the chart as a whole is not totally discontinuous with the rest of the painting, since it is linked to panel #3 by overlapping brushstrokes.

The other three panels appear to be a single field because the handling is similar and the edges are not defined. The colors change from predominantly red to blue to yellow, moving diagonally from lower left to upper right. The space, however, is actually divided into two: the area of the diver (panels #3 and #4) and the section with the primary color names (panel #5).

The arrangement of the color names suggests the structure of *Out the Window,* but the words seem to have shifted out of their fixed positions and now appear to be floating at random. "Yellow" is cut off at the edge, as if it were drifting out of the picture, and "blue" tilts at a near vertical position. The words function ambiguously as color labels for the surrounding multi-colored field: "red" is printed in gray, "yellow" in red, and "blue" in blue. Because certain motifs in this panel are cut off at the far edge ("yellow" and the yellow-orange square or rectangle), it seems as if the painting could continue beyond the edge. The same is true in the first panel, where the semi-circle could be completed beyond the edge. In this way, Johns implies that the painting is a fragment of a larger whole, while at the same time, the numbers connecting one panel to the other indicate that the painting is complete the way it is. (Since Johns did not number the far corners, he implies that nothing is meant to be attached.)

Near the lower edge of panel #5, there is a silverware construction similar to the fork and spoon in *Passage* and *Out the Window II:* a knife, fork and spoon are held together in a vertical position by a chain pulling to the left and two wires to the right. The objects cast shadows on the surface and bear traces

of the paint from the canvas below. One of the functions of the silverware, like other assemblage objects and body imprints, is to establish true-to-life scale in the painting. A cloth tape measure attached along the lower edge in panels #3 and #4 provides the actual standard of measurement, like the rulers and yardsticks in other works.[7]

The figure of the diver is indicated by handprints, footprints and arms (two long strips of scraped paint) placed on either side of the edge where the third and fourth panels meet, reflecting the symmetry of the body. The diver's feet touch the upper edge of the painting as if the figure were standing at the end of a diving board. The hands and arms are shown in two different positions: the upper ones are spread apart and the lower ones (near the bottom edge) are next to each other. Each hand and footprint is made up of superimposed layers suggesting several stages of the dive rather than a single position. Movement from the upper position to the lower is indicated by several arrows pointing downward on the arms. Johns has said that the figure is doing a swan dive[8] and by the positioning of the body imprints and arrows, he indicates the different stages of the dive.[9] The effect of a continuous, rapid movement is further heightened by the blurred paint in the diver's arms (probably the result of scraping with a palette knife or board). The final movement of the swan dive, the leap from the board and the spreading of the arms, is indicated by a line drawn in charcoal sweeping out in an arc, to the left of the lower set of handprints, and an arrow and lines to the right. These directional lines are not clearly visible because they are partially covered with paint. The diver's position and movements can be determined more exactly in a large, charcoal drawing, *Diver*, 1963 (Cri. 103), begun before the painting, but completed after it. The space of the diving board is marked in the drawing, whereas in the painting its presence is only implied. The hand and footprints are in the same position as in the painting and a path has been traced with arrows showing the motion of spreading the arms during the dive. In both the painting and drawing Johns has shown a three-dimensional figure moving through space, using only flat elements—body imprints, arrows, and lines. Although we see only traces of the diver and diagrammatic indications of the figure's movements, we are given enough information to follow the motions of the swan dive.

Johns was possibly inspired by Fernand Léger's *Diver* paintings, such as *Blue and Black Divers,* 1942-43, and *Red and Black Divers,* 1942. There was an exhibition, "Fernand Léger: Five Themes and Variations," at the Guggenheim Museum in 1962 which included fourteen works in different media from the *Diver* series and related works.[10] These *Divers* were based on Léger's observation of young men diving from the wharves of Marseilles. (Although Léger was inspired by male divers, the figures in his *Diver* series are female nudes.) Léger wrote about the *Divers*: "I tried to translate the character of the human body evolving through space without any point of contact with the

ground. I achieved it by studying the movement of the swimmers diving into the water from very high. . . . "[11] He showed these figures moving through space using only flattened-out forms defined by heavy black lines (in most of them he completely eliminated modelling) and patches of pure primary colors. Johns could have been influenced by Léger's *Divers* to show a figure moving through space without denying the flatness of the picture surface.

Unlike Léger's *Divers*, however, Johns' diver is isolated and fragmented. There is a sense of struggle and anxiety surrounding his plunge into the "sea" of turbulent brushstrokes which threatens to engulf him. Metaphorically, the diver could be seen as taking a leap into the unknown and there is a sense of risk conveyed. Johns' diver is similar in mood and close thematically to Cézanne's solitary male bathers, like the *Bather* in the Museum of Modern Art (Ven. 548), one of Johns' favorite Cézannes,[12] and *Bather with Outstretched Arms* (Ven. 549). Cézanne's figures are shown isolated, awkwardly posed and absorbed in tension-provoking thoughts. Johns' *Diver*, like Cézanne's *Bathers*, has an autobiographical quality and both artists' works can be considered, in part, self-portraits.[13] Johns' diver, taking the metaphorical leap into the unknown, can be interpreted in connection with his personal, emotional and artistic life.

On another level, Johns' diver could be a reference to Hart Crane, who committed suicide in 1932 by jumping into the ocean from a ship:

> Heedless of the curious glances that followed his progress along the deck, Crane walked quickly to the stern of the ship, and scarcely pausing to slip his coat from his shoulders, vaulted over the rail into the boiling wake.
>
> The alarm was general and immediate. There was a clangor of bells as the ship's engines ground into reverse; life preserves were thrown overboard; a lifeboat was lowered. Some claim they saw an arm raised from above the water and others that a life preserver turned over as though gripped by an unseen hand. But the officer in charge maintained they had only seen the white disc lifted on a sudden wave. . . . [14]

The arm in *Lands End*, 1963 (Plate 46) (Koz. 100), could be Crane's "arm raised above the water," from the above description of his suicide. This arm (repeated, superimposed handprints and a strip of scraped paint) looks like a detail of the figure in *Diver*. It stretches across the picture space, as if desperately reaching out for help, struggling like a drowning man. The title, "Lands End," could indicate any location where land meets ocean; it particularly suggests a promontory reaching into the sea.[15] The handling of the space, the expressionistic brushstrokes of mostly dark colors and the complicated presentation of the color names creates a disturbing, turbulent atmosphere, like a stormy seascape. The color names are printed in letters of three different sizes; they are superimposed and their direction reversed; letters break away from their established position and float in several levels of space. The word "red" appears with its mirror image; "yellow" is repeated in reverse

with upside down letters moving diagonally into the zone below (only the "y" and "w" are clearly visible, the other letters blend with the surrounding colors). The "u" and "e" of "blue" are cut off at the edges and seem to be moving out of the picture space. The scraped color spectrum from *Diver* is partly covered over with gray paint. There is an arrow to the right of the arm, but in contrast to the arrow in *Diver*, it points downward, reinforcing the sense that the figure is sinking into the sea. Johns juxtaposed the hand with the word "yell" from "yellow," adding the effect of sound to the figure's struggle, i.e., yelling for help. The word "yell" is isolated in the other paintings in this group: in *Passage* and *Out The Window II* by brushstrokes and in *Diver*, by cutting the word off at the edge.

 Periscope (Hart Crane), 1963 (Cri. 105), is the same size and format as *Lands End* and contains variations on the same motifs, but in *Periscope*, the paint is applied more thinly and the surface is mostly gray, creating a hazy, fog-like effect. The artist's arm has become the "device" used to scrape a spectrum of blended neutral tones. It suggests both the arm of the diver sweeping through space as he makes his dive and the arm of the drowning figure in *Lands End* (note the arrow in the same position, pointing downward). The function of the color names as labels has been reduced to the barest minimum, since there are only slight traces of color—red, orange, and green. The letters depart even more from their expected arrangement than in *Lands End*. The mirror image letters of "red" have floated off, disappearing beyond the canvas edge like the backwards "yellow." A disoriented "blue" falls away from its original position, the letter "l" is bent as if it were twisting around itself. The title "Periscope" comes from Hart Crane's poem, "Cape Hatteras," from *The Bridge*.[16] Cape Hatteras is about 250 miles from Edisto Island. The section of the poem in which "periscope" appears focuses on the theme of memory; the nostalgic mood conveyed is similar to that of Johns' works from the early to mid-1960s:

> The captured fume of space foams in our ears—
> What whisperings of far watches on the main
> Relapsing into silence, while time clears
> Our lenses, lifts a focus, resurrects
> A periscope to glimpse what joys or pains
> Our eyes can share or answer—then deflects
> Us, shunting to a labyrinth submersed
> Where each sees only his dim past reversed...[17]

Another passage from "Cape Hatteras" especially captures the mood and quality of shifting, turbulent space found in *Periscope, Lands End* and *Diver*:

> ...Space instantaneous
> Flickers a moment, consumes us in its smile:

A flash over the horizon—shifting gears—
And we have laughter or more sudden tears.
Dream cancels dream in this new realm of fact;
From which we wake into the dream of act;
Seeing himself an atom in a shroud—
Man hears himself an engine in a cloud.

Arrive/Depart, 1963-64 (Plate 47) (Cri. 114), has the emotionally charged quality of the paintings just discussed, and is also closely related to Johns' "artist's studio" paintings. The dominant image is the skull in the lower right, printed in black on white. The title is printed below it, although barely legible. The word "Depart," directly under the skull, is incomplete and cut off at the edge. Because the title is juxtaposed to the skull, it can be interpreted as alluding to birth (arrive) and death (depart). This is the first time Johns used a skull, but he used the words "Dead Man" in his 1960-61 painting, *In Memory of My Feelings* (Plate 33). In his "Sketchbook Notes" from the early 1960s, Johns wrote: "A Dead Man. Take a Skull. Cover it with paint. Rub it against canvas. Skull against canvas."[18] The theme of death pervades the entire painting, although each motif can be interpreted more objectively in terms of its artistic function. In the upper right is a handprint—a life-affirming signature—indicating the artist's presence in the work. Between the hand and the skull is the *Female Fig Leaf* imprint, perhaps meant to bring in a reference to sexuality as part of the birth/death cycle.

The skull is a common *vanitas* symbol of the "transcience of human life."[19] *Arrive/Depart* shows Johns' awareness of traditional *vanitas* still lifes, where skulls often are shown with other symbols of transcience, like candles, hour glasses, flowers (as in Barthel Bruyn the Elder's, *Vanitas,* 1524; Berg. 13); and symbols of "earthly existence," connoting knowledge, wealth, power and pleasure (as in Pieter Potter's, *Vanitas Still Life,* 1636; Berg. 143). Art tools and materials come under this latter category (e.g., H-D Lemotte's *Vanité en Trompe l'oeil,* ca. 1650; Faré 151).

Johns' most direct link to this tradition is Cézanne, who painted several still lifes with skulls throughout his career.[20] One of his favorite Cézannes in the Barnes Collection (Merion, PA) is *Young Man with a Skull* (Ven. 679), in which a melancholy boy contemplates a skull resting on a table top with books. Johns mentioned this to me when I was with him at the Barnes Collection in May 1970. It is revealing that the only comment he made after looking at the painting for a long time was how certain objects were connected by a continuous line. Typically, he brought up this visual detail rather than his reactions to the subject, even though the subject was obviously a significant reason why the painting appealed to him so much.

Several other twentieth-century artists have used skulls in still lifes, most notably Picasso, Braque, Max Beckmann and Arshile Gorky. However, Johns

was the first major contemporary artist (since 1950) to have used the skull as a *vanitas* symbol; he was the first to have used modern objects or new devices to bring the tradition of *vanitas* symbolism up-to-date.[21]

Arrive/Depart uses several objects as symbols of transcience besides the skull. Both the title and the silkscreened sign, "Handle with Care—GLASS—Thank you" (slightly below the painting's exact center), can be considered *memento mori* inscriptions, like those often found in *vanitas* still lifes.[22] The "Glass" sign suggests the fragility of human life or the work of art, supposedly the means whereby an artist achieves immortality. Johns is possibly questioning the idea that the artist lives forever through his work. The juxtaposition of skull and artist's tools—paintbrush, can imprints and palette of primary color rectangles—corroborates this interpretation. The imprint of a seashell (below the "Glass" sign) locates the setting by the sea, perhaps at Edisto.[23] In this context, the shell could be a *vanitas* symbol, like the shells frequently found in seventeenth-century still lifes, such as Lemotte's *trompe l'oeil* within a *trompe l'oeil* and Jacques Linnard's *Vanité au Papillon et Coquillage,* 1634 (Faré 30).

In the paintings discussed in this chapter, Johns developed a more elusive and poetic symbolism to express themes of isolation, struggle and death. The interpretations of his paintings continue to include a wide range of meanings and associations. It is characteristic of Johns' work that the words "Arrive/Depart" could be either a sign in a railroad station or a reference to the cycle of birth and death; or that the "diver" could be a man doing a swan dive or a metaphor for suicide.

8

According to What?

There are many similarities between *According to What,* 1964 (Plate 50) (Cri. 115), and *Diver,* 1962 (Plate 45). Both are large-scale paintings (*Diver* is 14 feet across, *What* 16 feet), containing diverse motifs, rendered in a variety of techniques and styles, spread out in a loosely organized composition. Motifs from *Diver* are repeated to *What,* including color names, charts, silverware; both contain figures, one in the form of flat body imprints, the other a three-dimensional cast.[1] Although these paintings resemble each other structurally and stylistically, their differences reflect significant changes in Johns' evolving style. The composition of *What* is less coherent than *Diver*'s; there is no single, dominating image—the figure fragment in *What* does not serve as a visual or conceptual focus like the centrally placed diver. The brushstrokes in *What* are larger and looser, and there is less detailed surface interest than in Johns' previous works (although this change began to occur earlier, especially in *Out the Window II* and *Diver*). Much of the surface has an open, airy quality created by thinly stained or smoothly applied layers of paint. Bare canvas shows through in several areas and, for the first time, Johns has left a large section of canvas blank.

Like *Diver, According to What* is the most monumental of a group of related paintings: *Watchman, Souvenir* and *Souvenir 2, Evian,* all 1964, and *Eddingsville,* 1965. *What* was planned in Johns' "Sketchbook Notes" (published in 1965) at the same time as *Watchman* and the *Souvenir* paintings. However, *What* was painted in New York in the summer and fall of 1964, while the other three were painted in Japan during the early summer of 1964.[2] *Evian* was also painted in New York, after the Japan paintings, but before *What.* These works were all painted soon after Johns' first major retrospective exhibition, held during the spring of 1964 at the Jewish Museum in New York. This could in part account for Johns' preoccupation with the theme of the spectator/critic in several of these works.

The figure in *Watchman* (Cri. 118) is a positive wax cast made from a plaster cast taken from a live model.[3] Like the plaster casts in his 1955 *Targets* and his imprinted figures (*Skin, Diver, Lands End*) the cast in *Watchman* is

fragmented and isolated. It is also upside-down, adding to its disturbing, disorienting effect.

The title implies that the figure is meant to function as a guard or lookout, but it also suggests the viewer, who is supposed to look actively and attentively at the work of art. In his "Sketchbook Notes," Johns worked out a rather elaborate scenario between a watchman and a spy; but the cryptic quality of the Notes makes it impossible to determine with certainty the function of these figures or their relation to each other:

> The watchman falls 'into' the trap of looking. The 'spy' is a different person. 'Looking' is and is not 'eating' and 'being eaten'. (Cézanne?—each object reflecting the other.) That is, there is continuity of some sort among the watchman, the space, the objects. The spy must be ready to 'move', must be aware of his entrances and exits. The watchman leaves his job & takes away no information. The spy must remember and must remember himself and his remembering. The spy designs himself to be overlooked. The watchman 'serves' as a warning. Will the spy and the watchman ever meet? In a painting named *Spy*, will he be present? The spy stations himself to observe the watchman. If the spy is a foreign object, why is the eye not irritated? Is he invisible? When the spy irritates we try to remove him. 'Not spying, just looking'—Watchman.

A possible interpretation of *Watchman* based on these Notes is that the watchman who is the seated figure is the spectator/critic; the spy who is invisible ("The spy designs himself to be overlooked.") is the artist.[4] The analogy between looking and eating suggests the idea of an active involvement on the viewer's part—visually consuming the work of art and in turn being consumed by it. The fact that the watchman is seated on a chair and also upside-down implies that he was at one time comfortable and relaxed; but now his state of rest has been disturbed and he seems to be falling through space, as if falling into the "trap of looking" mentioned in the Notes. For Johns, the work of art should be just such a disturbing force, provoking the spectator to change habits of perception. The "trap" could be the sense of danger one feels when leaving familiar territory for the unknown. The figure in *Watchman* could even be a conscious parody of Matisse's statement describing his dream of "an art of balance, of purity and serenity, devoid of troubling or depressing subject matter, an art which could be . . . a soothing, calming influence on the mind, something like a good armchair which provides relaxation from physical fatigue."[5]

All the elements in *Watchman* are related to each other visually or conceptually, as indicated in the "Sketchbook Notes" cited above: "(Cézanne?—each object reflecting the other.) That is there is continuity of some sort among the watchman, the space, the objects." The transition from cast to canvas is made by activated brushstrokes of green, orange and gray, which extend the figure by echoing its shape and help create the effect that it is

falling through space. (In another section of these Notes, Johns writes: "Break orange area with 2 overlays of different colors. Orange will be 'underneath' or 'behind'. Watch the imitation of the shape of the body.") The green and orange brushstrokes "reflect" the ready-made colors of the fabric on the chair seat. The red, yellow and blue rectangles function like color samples to illustrate the color names at the left, which are printed in gray on gray and disappear at the inner edge of the two vertical panels. Linking the lower section of the panels is a blended spectrum of neutral tones—a variation on the "device" motif which previously was used to mark out a circle segment. The stick used to scrape the paint leans against a wooden ball, slightly larger than the balls in *Painting with Two Balls, 1960* (Plate 22). The 4-inch projecting ledge recalls the indented ones in the 1955 *Targets* with casts; but it functions pictorially to establish a sense of space in front of the vertical surface, like the ledges in *trompe l'oeil* still lifes, such as Harnett's *Old Cupboard Door* and Lemotte's *Trompe l'oeil*. The objects resting on the ledge, along with the lettering, reinforce the "correct" orientation of the field, otherwise confused by the upside-down figure. A newspaper imprint (like de Kooning's in *Gotham News* and *Easter Monday,* made by pressing the newspaper against wet paint), partly covered over by the tonal spectrum, adds another kind of surface texture. In large, reversed letters, at the top of the newspaper page, is the word "Japan" locating the place where the painting was made.

Souvenir (Cri. 116) and *Souvenir 2* (Plate 48) (Cri. 117) are the same size and contain plates, flashlights and mirrors in identical positions on the canvas. The title comes from the souvenir plates Johns got in Tokyo during the summer of 1964, inscribed with his picture in black and white in one and in tinted colors in the other, and the primary color names.[6] Such inscribed dishes are common souvenirs of Japan—the kind tourists bring home as a memento of their trip. Johns decided to use them quite a while after he had first noticed them. He searched for the place he had originally seen them, which turned out to be the Imperial Hotel where he had stayed; but the same plates were available all over Tokyo.[7] This particular souvenir appealed to Johns because it suited his art at the time. It provided a way for him to present an objective self-portrait—it is the only clearly recognizable self-image to date in his art. Because his self-portrait is part of a ready-made souvenir (displayed on a shelf like an object in a store window), it has a detached effect. It is close in sensibility to Duchamp's depersonalized self-parodying portraits with photographs: *Wanted/$2000 Reward,* 1923 (Sch. 278), and *Monte Carlo Bond,* 1924 (Sch. 280). These "rectified ready-mades" may have influenced Johns' decision to include his own photograph in a painting. Johns' passport-style photograph with a straightforward, emotionally blank expression is similar to Duchamp's mug-shot photograph in *Wanted.* The placement of Johns' photo on the circular plate creates a visual effect similar to Duchamp's photo on the roulette wheel in

Monte Carlo Bond; also Duchamp's *Bond,* like Johns' plate, is a souvenir of a trip.[8]

Even though Johns' photo is *per se* impersonal, in the context of the other elements in the paintings, it takes on many moods and meanings. The title "Souvenir" brings in the theme of memory which is central to Johns work from this period. Johns could be the spy who "must remember and must remember himself and his remembering."[9] This process of remembering refers both to Johns' nostalgic mood, remembering past events in his life, and to the way he repeats motifs from previous works so that they become souvenirs of his artistic past.

The plate is a typical Johnsian household object—something from the kitchen, like the silverware, coffee cups and cans in other works. Like the silverware, it refers to the analogy between looking and eating. In this case, Johns seems to be directly offering himself as well as his art to be metaphorically consumed by the viewer. Johns has allowed himself to be more obviously and openly exposed and vulnerable than ever before. There is even the suggestion that his photograph is meant to be spotlighted by the flashlight's beam reflected by the mirror onto the plate. (See *Sketch for Souvenir,* 1964, and several later drawings where the path of light is marked out with arrows.)

The flashlight, like the plate, is a "souvenir" of Johns' past, recalling his earlier *Flashlight* sculptures. In the *Souvenir* paintings, it provides an internal light source, like candles in traditional still lifes. Because of the emphasis on memory in these *Souvenir* paintings, it is possible that Johns intended the flashlight—a contemporary version of the candle—to be interpreted, like candles in *vanitas* still lifes, as a symbol of transcience.[10]

The mirror has both a mechanical and a symbolic function. It deflects the flashlight's beam across the canvas, but it is also a *vanitas* symbol, as well as a symbol of introspection. As Field points out, it is a bicycle mirror made for looking backwards while moving forward. This reinforces the theme of memory, i.e., the idea of looking into the past, as if through Hart Crane's "periscope," deflecting us into a labyrinth, "where each sees only his dim past reversed."[11]

In *Souvenir 2,* Johns added a smaller canvas, turned around and fixed to the surface like the one in *Canvas,* 1956 (Plate 13). *Souvenir 2* was painted in oil, gray with touches of color, while the first version was done in gray encaustic. As a result, the two paintings have distinctly different surface qualities. Johns has set up an obvious situation of comparative looking: a significant part of the experience of these paintings has to do with perceiving the elements that distinguish one from the other. Since they are two separate paintings not usually seen together, this process of comparison involves remembering visual details. One of Duchamp's *Green Box* notes is particularly

relevant to the pairing of the two *Souvenirs* and, generally, to Johns' use of repeated subjects and motifs:

> identifying
> *To lose the possibility of recognizing*
> *2 similar objects*
> 2 colors, 2 laces
> 2 hats, 2 forms whatsoever
> to reach the Impossibility of
> sufficient *visual* memory
> to transfer
> from one
> like object to another
> the *memory* imprint
> —Same possibility
> with sounds; with brain facts[12]

The stencilled "2," on the canvas back next to the plate above the handwritten label, "souvenir," is probably in part an intentional reference to Duchamp's list of "2 similar objects" in the note cited above.

In 1966, Johns wrote the following statement about *Souvenir 2*, part of which I have already cited in reference to *Canvas, 1956*:

> After a concert at the Tape Center in S.F. I saw spots of reflected light moving on the wall.
> In a store window in Tokyo I saw plates upon which had been printed some photographs of Japanese baseball players, wrestlers and family groups.
> In 1950 or '51 a painter whom I admired said that he was to have an exhibition of 8 or 10 canvases which were turned face to the wall in the kitchen where we were talking. He said the works were very new and good, and that he would not show them to anyone before the scheduled exhibition. When he left the room, another friend looked at the fronts of the canvases and found that they had not been painted.
> Thinking anything could be a souvenir of something else, not specifically a self-portrait. Ego was not clear. Maybe just another way of dishing up a Johns.[13]

The Duchampian pun at the end of this statement reinforces the importance of Duchamp in the conception of the *Souvenir* paintings. "Ego was not clear" also points to Duchamp, who provided a model of the detached artist by presenting himself primarily as a vehicle for conceptual activities (as in *Wanted* and *Monte Carlo*). In his 1968 essay on Duchamp, Johns wrote: "The self attempts balance, descends. Perfume—the air was to stink of artists' egos. Himself quickly torn to pieces. His tongue in his cheek."[14] Johns' own work had, since 1961, broadened in scope to include the artist's self as subject. Duchamp was particularly important to Johns during this time in providing the conceptualized framework around which Johns' work could expand to include a personal, and even expressive, dimension.

The next painting in this group is *Evian* (Plate 49) which was named after a bar Johns went to in Tokyo during the summer of 1964, when he painted *Watchman* and two *Souvenirs*.[15] Its motifs are variations on those in previous works, but significantly transformed. The garbage can lid and imprint looks like the scraped semi-circle in *Diver* and other works with the "device-circle" motif. The back-and-forth, stop-and-start scraping action is reflected in the lid's segmented design. By completing the circle with the real lid, Johns actualizes the idea that all his "devices" could be used to trace out full circles beyond the edges, conceptually extending the picture space. The coat hanger is a reference to Johns' 1959 painting *Coat Hanger*. In *Evian*, the hanger is not suspended, but attached flat onto the surface and bent. Its original shape and position on the canvas are indicated by an outline drawing. A piece of string is suspended from the hanger emphasizing the space the hanger occupies in front of the canvas. It also reflects the paint drips on the canvas above (dripping below an area painted through wire screening). Johns' string creates an effect similar to the pieces of hanging string which provide a subtle illusion of depth in Peto's still lifes, like *Office Board* (Plate 37). The hanger and string, like most of the pictorial elements—garbage can lid, imprint (along upper edge), tonal spectrum, primary color rectangles, lead the eye to and beyond the edges of the canvas.

There is a skull image (lower left, near edge) imprinted on the canvas at an angle, in gray on gray, partly covered by a brushstroke, so that it seems to disappear into the picture space, and could easily be seen at first as a blurred area of gray paint rather than a skull. The cross over the skull draws attention to that spot on the canvas, but it also makes the image more difficult to identify. Because it is not clearly visible, it does not dominate the mood of the painting like the skull in *Arrive/Depart*, 1963-64; but it does add an important dimension to the meaning of the painting, by alluding to a connection between the Evian bar and Johns' preoccupation with death and transcience during this period. However, the rest of the motifs are thematically unrelated to the skull and offer no clues as to the reasons for this connection.[16]

In *According to What* (Plate 50) (Cri. 115), Johns uses several motifs from *Watchman, Souvenir* and *Evian:* upside-down seated figure, canvas stretcher, bent wire hanger, primary color names and rectangles. However, he eliminates any overt reference to his trip to Japan or other personal, emotional allusions, and focuses primarily on artistic concerns. The title "According to What" could refer to the standards of criteria used to judge the quality or value of a work: i.e., 'According to What' criteria do you determine whether this is good or bad (high or low) art? There is a provocative tone to this question, and even to the unfinished title itself, as if the spectator/critic were being challenged to examine the validity of his or her criteria for making value judgments. The title could also refer to the criteria used by the artist in selecting what is appropriate

for his art: i.e., 'According to What' do I determine that 'a' (object, color, imprint, etc.) is more appropriate than 'b' or 'c'...?[17] Because *What* is a summary of Johns' artistic development, done soon after his first major retrospective, it seems a particularly appropriate context for him to question his own, as well as his viewer's, artistic standards.

The first panel contains the seated "watchman," with the wax cast attached backwards so that the inside of the cast faces out. On the one hand, this makes the figure fragment more disturbing, because its insides are exposed; on the other, it is more depersonalized because it does not look as vividly real as a cast usually does. Like the figure in *Watchman,* it could be interpreted as the spectator/critic falling through space into the "trap of looking."[18]

In the lower corner of the same panel is a small canvas, hinged and hooked so that it can be either opened or closed. When closed, the canvas back and stretcher are visible, revealing the structure of the canvas-as-object and creating a painting-within-a-painting. In this framed-off area are the title, date and artist's signature. When the canvas is unhooked and opened, it reveals a labeled diagram of the canvas back and stretcher drawn on the larger canvas and the front side of the small canvas. On this small canvas is a variation of Marcel Duchamp's *Self Portrait in Profile,* his initials "M.D.," and a sprayed "impact-drip."

Johns was familiar with Duchamp's *Self Portrait in Profile* since 1959, when it appeared in Lebel's monograph (Sch. 344). Duchamp did the original version in paper, hand-torn with a metal template, in 1958, to be included in 137 numbered copies of the book; these are signed "Marcel dechivarit pour Robert Lebel." It was reproduced as the frontispiece for the regular edition of the book, in white on black on white, like Johns' copy in *What.* The *Self Portrait in Profile* appeared in two other books, closer to the date when *What* was painted: a full-scale replica of the original is included in 25 numbered copies of Ulf Linde's *Marcel Duchamp* (1963) and a color reproduction of it appears in Arturo Schwarz's *Marcel Duchamp/Ready-Mades, Etc.* (1964). Johns owns all these books and a 1959 poster with this same self-portrait done on the occasion of the publication of Lebel's monograph (Sch. 344a). Duchamp's *Self Portrait* would have appealed to Johns because it is a two-dimensional image which, like his own *Studies for Skin,* allows the figure to be presented on a flat surface, without modelling. Another Johnsian feature is the ambiguous figure-ground relationship, where the shapes can be read as both "positive" and "negative," cancelling any fixed figure-ground dichotomy.[19] Also, the torn paper technique Duchamp used in making the *Self Portrait* is another example of his "painting of precision and beauty of indifference," so admired by Johns, who wrote the following in his 1960 review of the *Green Box*: "Delight in the artist's hand is left unexplored as if the best operation would leave no souvenir of the surgeon."[20]

There are many other references to Duchamp's art and writing in *What*. Duchamp's spirit pervades the entire work, as if he were its co-author. In a 1972 interview, Johns was asked why he crossed out his signature with blue lines in a print based on the small hinged canvas section of *What*. Johns replied:

> Well, I didn't cross it out. The cross was there before I signed it, but I planned to sign it that way. I have deliberately taken Duchamp's own work and slightly changed it, and thought to make a kind of play on whose work it is, whether mine or his.[21]

The Duchampian references in Johns' works include: the small, hinged canvas which alludes to the "hinge-picture" Duchamp describes in his *Green Box* notes; the coat hanger similar to Duchamp's ready-made *Trap;* the spoon from *Locking Spoon*. The circle-in-square color chart in *What* could be a reference to the row of color samples in Duchamp's last oil painting, *Tu m'*, 1918 (Sch. 253). That work, like *According to What,* is an anthology of previously used motifs and techniques, loosely arranged in a large-scale picture space.[22] Duchamp's title, like Johns', is ambiguous, because it can be completed in several ways. Both artists set up a paradoxical situation in their painting by creating illusions of depth which they then undermine by establishing the canvas as a flat surface and independent object. Both Duchamp and Johns counter spatial illusions by adding real objects and surface imprints. For example, Duchamp paints the row of color samples in perspective, but "attaches" them to the canvas with a real bolt. Johns' color chart is flat, but it appears to be both over and under elements around it; in order to affirm the flatness of the chart's design, Johns included the metal template used to print it (jutting out below the edge). Another play on illusion and reality in *Tu m'* is the painted rip, held together by real safety pins, with a real bottle brush poking through it from behind the canvas. The newspaper in *What* looks like collage but is actually silkscreened onto the canvas.

Duchamp's use of shadow imprints in *Tu m'* would have appealed to Johns, because it is an important precedent for his own use of object imprints. In Duchamp's painting, only one object casting shadows, the bottle brush, is actually present in the work; the others are represented by records of their shadows painted onto the canvas surface. In *What,* the objects casting shadows—the figure and chair, the aluminum letters, and the hanger, wire and spoon—are actually in the painting. However, Duchamp's *Self Portrait* is presented as a shadow cast on the canvas, like the cork screw, bicycle wheel and hat rack in *Tu m'* (from Johns' "Sketchbook Notes": "Profile? Duchamp? Distorted as a shadow?"). Johns' version of the Duchamp self-portrait shows a string or wire attached to the top, indicating that the "real" portrait is actually hanging in front of the canvas, possibly swinging back-and-forth, so that what we see in the painting is its shadow. Since the portrait in itself is a flat object

based on a shadow imprint (silhouette), Johns' mode of presenting it seems at first redundant, but actually serves to make us aware of the many levels involved in translating life into art.[23]

In *What* Johns presents three versions of his conceptualized palette: first, the primary color rectangles along the edges of the right panel; and second, the primary color names based directly on those in *Field Painting, 1963-64*. Here, however, the hinged, three-dimensional letters are made of cast aluminum rather than neon and wood, and they are not used to support objects. The letters of "blue" are bent, as if they were beginning to break apart; the printed "e" to the left is twisting around in space, recalling the letters in *Periscope, 1963*. The words interact with the surrounding brushstrokes of color—mostly red, yellow and blue; each word is painted predominantly in the color it spells out. The third color chart, aligned parallel to the color names, is used for the first time in *What*. Johns explained the sequence of colors in a 1971 interview:

> They are just circles in squares. The squares are treated as a value, a kind of progression from white to black; the colors are a spectrum progression—yellow to orange, then it skips. To explain that: yellow, green, blue, violet, red, orange are right out of the spectrum, but adding and subtracting—yellow plus blue equals green; minus yellow equals blue; plus red equals violet; minus blue equals red; plus yellow equals orange; plus black equals brown; minus orange equals black; plus white equals gray; minus black equals white. The only place where there is any disturbance in the order is with the brown, which always seems to me to be a separate color. The value scale went from white through gray to black and then from dark to light again by adding a violet.[24]

Although this chart has been logically determined and arranged in a fixed order, it seems to be breaking apart, like the letters of "blue." In some places, brushstrokes from adjoining panels overlap the chart, and the violet unit seems to have shed a layer which has floated off into the neighboring space. The white unit projects below the edge and the metal template is bent like the aluminum letters to its left and the wire hanger to its right. It is as if these metal objects were being pulled by shifting magnetic forces.

The color names, charts and rectangles are linked by the diagonal path of newsprint made by repeating the same newspaper page, in black on white, with a silkscreen. Because it looks like a real newspaper, it functions like collage to emphasize the flatness of the surface, even while it participates in creating the illusion of depth: the overlapping brushstrokes and circle-in-square chart seem to be above the surface, and everything covered over by the newspaper seems below the surface. The newspaper is another reference to one of Johns' early object paintings, *Newspaper, 1957*, but it is significant that here he uses a silkscreen of the newspaper rather than the thing itself. It is the imprint of an imprint, like the newspaper page in *Watchman* and the copy of Duchamp's *Self Portrait*. All three are images of flat objects and therefore they are not "true"

(real objects), but paradoxically, neither are they "false" (illusions). The newspaper in *What* was printed so that the words read vertically and backwards (like the color names), although they are mostly illegible anyway because the page is unclearly printed. Like the illegible *trompe l'oeil* newspaper clippings in Harnett's and Peto's paintings, we expect the real thing but are confronted with a different order of reality. Compositionally the newspaper in *What* functions like the diagonal lines in *Studio* and *Evian* to unify the space and to disorient the picture space in relation to the edges of the canvas. The bent hanger is an upside-down version of the one in *Evian,* and it is accompanied by an outline drawing indicating its original shape. The attached wire and spoon "hang" upside-down appearing to defy gravity, like the seated figure in the upper left corner.

In *What,* as in his other mural-scale paintings, Johns creates a sense of discontinuity by incorporating a number of diverse elements which initially do not appear related. The visual and conceptual continuities Johns sets up emerge during extended viewing of the work. The emphasis on the independent elements in *What* was underscored by Johns in a 1971 series of lithographs titled, *Fragments—According to What,* depicting key details of the 1964 painting: *Leg and Chair, Bent Blue, Hinged Canvas, Bent U, Bent Stencil* and *Coathanger and Spoon* (Field 136-142).[25]

The same fragmented, disorienting world is presented in *Eddingsville,* 1965 (Plate 51) (Cri. 120), another large-scale compendium of diverse styles and motifs. Large areas of the surface are painted white or whitish-gray, making the space appear even more open and airy than in *What* or any previous painting. The upside-down seated "watchman" appears to be falling or floating through space, partly engulfed by the cluster of brushstrokes around him. We see only the figure's lower leg, presented in this instance as a flat image, possibly made by imprinting a cast or a leg onto the canvas. The leg is painted in flesh-like color and surrounded by a black area which creates the effect of a shadow cast by the leg (although the black overlaps the leg in places). On either side of the section with the leg and painterly brushstrokes are hard-edged color charts. Along the left edge is a row of rectangles which look like color samples; these repeat the colors in the circles in the chart in *What* except in reversed order (from top to bottom: white, gray, black, brown, orange, red, violet, blue-black, green and yellow). To the right, there are two circle-in-square units which look like an enlarged detail or fragment of the chart in *What,* except that the colors are different: the top unit is red in a yellow square (graded into green) and the bottom, green in a blue square. This chart seems to be floating or falling, like the "watchman."

The three-dimensional objects at the right edge appear set apart from the rest of the painting: an attached cluster of found objects similar to the hanging cans and brushes in *Studio,* 1964. A group of small household and studio

objects—a seashell, ice cube tray, beer and popcorn cans, glue jar, sponge and fork—is wedged between a wooden yardstick and cast arm, held together by a wingnut in the center and nuts and bolts at the ends. This assemblage is hinged at the edge and can be moved out and back to extend beyond the canvas. These objects provide fixed standards for determining scale in the painting; the parallel placement of ruler and arm reminds us that our standards of measurement were originally determined by the length of body parts. The metal objects and sponge pressed between the ruler and cast are bent out of shape. The hook hanging from the beer can suggests that another object could be attached; it is the only pictorial element, other than the paint drips, that establishes which way the painting is to be hung. Like the color chart at the extreme left, the group of objects is aligned with the edges and, therefore, provides a stabilizing element in contrast to the off-kilter ones, including the diagonal line linking one edge to the other.

The shell is the only sandwiched object which is not manufactured. It indicates that the setting is by the sea, confirmed by the title, "Eddingsville," the name of a small island near Edisto. Johns told me that Eddingsville has been almost completely eroded by hurricanes. He said it was an historical spot where Lafayette had a fancy picnic with red carpets laid on the beach. Johns and some friends once recreated this historical event with their own elegant "champagne picnic" there.[26]

Johns uses a photographic image of the group of objects in *Eddingsville* in a lithograph titled, *Pinion,* 1963-66 (Field 49). The photograph was printed in red, yellow and blue, blended to look like a continuous color spectrum. He added a twisted wire to the empty hook. These objects appear to overlap an area with labeled body imprints—hands, feet and knee—made by a figure crouching on the lithographic stone. The figure could be considered as a self-portrait revealing the artist contained within his art work. The body imprints in *Pinion* were done at approximately the same time as the *Skin* image in the lithograph, *Skin with O'Hara Poem,* 1963-65 (Field 48), where the figure likewise seems contained or even confined within the picture space. The title "pinion" suggests the idea of someone bound or constrained, unable to move freely or escape.

9

Works From 1966-1974

Johns' works since 1966 do not form a coherent group stylistically or thematically, but there are similar motifs and pictorial concerns which unite them. I have divided this chapter into sections dealing with related works. First, *Passage II*, 1966, and the lithograph and painting *Decoy*, 1971; *Decoy* is in part a reworking of a photographically reproduced section of *Passage II*. Second, a group of paintings Johns worked on during the fall and winter of 1967-68, exhibited together at the Leo Castelli Gallery during February-March 1968: *Harlem Light, Screen Pieces 1, 2* and *3*, and *Wall Piece*. Third, *Voice*, 1964-67 and *Voice 2*, 1967-71. The final works I will discuss in detail are *Untitled*, 1972, *Corpse and Mirror*, 1974, and *Scent*, 1973-74.

In his works since 1966, Johns continues to use familiar motifs, such as can imprints, rulers and silverware. *Passage II* and *Untitled*, 1972, contain casts of the human figure, the latter showing a more overt expressive quality than any of Johns' previous figure fragments. Johns introduces several new motifs and techniques in this group of works. The stone wall or flagstones appears for the first time in *Harlem Light*, 1967, and the stripes or hatchings in *Untitled*, 1972. Both motifs are significantly different from anything which had appeared in Johns' works before. In several paintings since 1967, Johns used silkscreened photographs of objects rather than assemblage objects; the resulting ambiguities of scale become an important focus of pictorial inquiry when there are no "real" objects to establish scale within the painting.

Passage II and Decoy

In *Passage II*, 1966 (Plate 52) (Cri. 124), Johns combines elements from his artist's studio paintings and the "According to What" group. It is not apparent why Johns titled this painting "Passage II." It does not relate directly in style or motifs to the original 1962 *Passage;* rather, it is closer in style and color to *Out the Window II*, 1962. The upside-down "watchman" is presented in the form of a wax cast which, like the flat leg in *Eddingsville*, 1965 (Plate 51), is actually a fragment of a fragment. In this instance, Johns shows both legs of the seated

figure and attaches them to the canvas with a bolt piercing the ankles.[1] This pinioned figure/object is juxtaposed to motifs involving artistic concerns, including color, structure and space. The names of all the colors of the spectrum, from red to violet, lead the eye in a zig-zag path across the canvas from the lower left to the upper left. The three-dimensional letters, attached to a projecting ledge, are made of neon tubing and wood; the others were stencilled onto the canvas surface. The neon "red" lights up red, like the "r" in *Field Painting*, 1963-64, but there is no control switch in the work; instead, the transformer and wires for the neon light are exposed and become one of the elements of the assemblage. The word "red" is repeated in printed lettering on the canvas. The hinged wooden letters cast shadows on the canvas or the wall, depending on their position. They can be manipulated to spell out words within words (by raising certain letters and lowering others): "rag," "ran," "range," "yell." They also spell out the sentence: "redo an eye"—a statement which reinforces the idea that the work of art should challenge the spectator/critic to change familiar habits of perception. In his 1966 lithograph *Passage I* (Field 57) based on a photographic reproduction of *Passage II*, Johns has arranged the letters along the ledge so they read "Redo an eye," except the "n" of "an" is slightly out of place.[2] The word "yellow," cut off at the lower right corner, bends inward and is continued in flat letters printed backwards on the canvas. The backwards lettering follows a diagonal path across the picture space, until the middle of the word "blue" where "u" and "e" twist around, altering the course of the backwards letters and correcting their orientation.

In the upper right corner of the field, there is a complex variation on the canvas-within-a-canvas motif. Two small canvases, one red and the other yellow, are placed in a section set off from the rest of the space by a narrow ledge. A string hangs from the ledge, casting shadow on the canvas below. Both small canvases have a blue mark made by pressing the canvases together, surface against surface, so that one mark is a mirror image of the other (cf. *Untitled*, 1964-65). The red canvas is attached with hinges and can be lifted up to reveal the canvas back and stretcher.

There are imprints made with studio objects, a coffee can and a rectangular turpentine can. A small segment of the latter is cut off at the right edge and completed at the left edge, as if the space were continuous around the canvas (the same effect is created by the title of *Fool's House*, 1962). Below the bent letters of "blue" are two small circle imprints made to look like they are seen from conflicting perspective viewpoints.

The lithograph, *Decoy*, 1971 (Field 134), contains direct references to the following works by Johns: the painting *Passage II*, 1966; the lithograph *Passage I*, 1966;[3] the sculpture *Painted Bronze (Ale Cans)* 1960; and *1st Etchings*, 1967-68 and *1st Etchings (2nd State)*, 1967-69 based on Johns' sculptures (Field 71-90). Because of these diverse references to works in

different media, *Decoy* is Johns' most overtly complex image to date. Its importance and uniqueness are confirmed by the painting based on it (Plate 53)—a reversal of his usual procedure where print follows painting.[4]

The most immediate source for *Decoy* is the lithograph *Passage I,* which is based on the painting *Passage II. Passage I* contains all the motifs from the painting *Passage II,* presented as flat images. The left half of the painting was reproduced photographically in the print, while the right half was redone by hand. Johns used the same photoplate (the lithographic plate with the photograph of the left half of *Passage II*) in the lithograph *Decoy,* but it is positioned vertically rather than horizontally. The only details of the right half of *Passage I* which appear are the color names. The other elements are presumably hidden by the engulfing area of black, which is an expanded version of the black area in *Passage I.* This dark, painterly area adds an ominous tone to the print, which contrasts with the lyrical effect of the light green appearing at the top edge and emerging through the layer of black in several places.[5]

The color names follow the same irregular path as in *Passage II* and the lithograph *Passage I,* but in a vertical direction. In *Decoy,* however, the backwards letters ("owgreenbl") appear to float above the surface, reversing the spatial layering of the *Passage* painting and lithograph. Also, the "word spectrum" in *Decoy* is cut off so that it looks like it continues beyond the edges, where it could follow an unpredictable, convoluted path through space.

Intruding into the space at the center of *Decoy* is a photograph of a Ballantine ale can, printed in gold to simulate the bronze-colored surface of the original object. This particular can was used as a model for one of the cans (the closed one) in Johns' *Painted Bronze,* 1960.[6] The photograph is sharply printed and creates the effect of a relatively deep, niche-like space through the positioning of the can (with the label only partly visible, leading our eye around the can) and its clearly defined shadow. But the illusion of reality created by the photograph is contradicted by the hand-written instructions: "reduce to 4¾″ (front of can)." The photograph has in fact been reduced so that the can is 4 ¾ inches—the size of a real ale can. However, the photograph of *Passage II* has been reduced so that the cast of legs is less than life-size, and no longer establishes correct scale as it did in the painting. The ale can, therefore, is the only element which serves as an accurate source of scale—the "proportional control" between the pictorial world and the world outside the work of art.[7] The surface marks from the left half of *Passage II* appear in *Decoy.* The scale changes make the coffee can imprint look the size of a beer or ale can. Only the small segment of the turpentine can imprint appears (upper edge). In *Passage II,* the turpentine can imprint suggests spatial continuity around the picture space, while in *Decoy* this visual "event" is hidden because we see only one part

of the turpentine can imprint; the same spatial continuum is implied by the color names cut off at the edges.

The lower section of *Decoy* functions in many ways like the predella of an altarpiece, separate from, but at the same time related to, the primary scene above. The cancelled photoengravings from *1st Etchings (2nd State)* are aligned along the lower edge in such a way that they appear to be part of a continued spectrum of images like the word spectrum above. They are photographic reproductions of Johns' sculptures and reliefs in bronze and aluminum, on which the *1st Etchings* were based. Across these pale gray images runs a blended spectrum line (red, orange, yellow, green, blue) which "illustrates" the color spelled out above. In the center of this line, a hole is punched through the paper revealing the lithograph as an object in its own right, and literally puncturing the illusions of depth displayed on its surface.

The painting *Decoy*, 1971 (Plate 53) (Cri. 146), was begun while the print was being completed; however, Johns told me that all the print's details had been previously determined.[8] The transformation from lithograph to painting adds another step to the already complicated history of images which make up *Decoy*. The painting closely follows the print, but there are conscious changes in scale, detailing and surface texture (due to the different media). The photographic images from the lithograph are reproduced in the painting by silkscreening, a technique Johns has used in several paintings since 1967-68.[9] The details of *Passage II* are returned to their original, life-size scale, while the ale can, now painted aluminum and gold, is blown up to larger than life. The photoengravings from *1st Etchings* are replaced by silkscreened photographs of four of Johns' bronze sculptures which are repeated like the pictures along the bottom edge of the print. The color spectrum line was made by plucking a string against the canvas. And there is a hole, like the one in the print, but here, surrounded by a brass grommet—the only real assemblage object in the painting.[10]

In each of these versions of *Decoy*, Johns presents a complicated arrangement of images which requires us to look beyond superficial appearances. Perhaps this "decoy" is meant to lure the unwary viewer into the "trap of looking." The fragmented figure in *Decoy*—the seated spectator/critic—has an even more ambiguous role than in *Watchman*, because here it is part of the "decoy" as well as a victim of the "trap."

Harlem Light, Screen Pieces, Wall Piece

The title of *Harlem Light*, 1967 (Plate 54) (Cri. 129), comes from the flagstone motif in the left panel. This motif is based on Johns' memory of a wall painted to look like red, black and gray stones which he saw while driving through Spanish Harlem. When Johns returned to Harlem to look for the wall so he

could photograph it and copy it, he could not find it and assumed it had been demolished.[11] An important aspect of the rock wall motif is that it remains close to its source as a street art image. It is a kind of decorative, unsophisticated art, not self-conscious about being art. Brought into the context of Johns' complex and, by this point in his career, highly developed vocabulary, it seems at first out of place, injecting a new and unsettling element of art-not-yet-become-art. However, Johns' choice of this motif could have been, in part, based on its similarity to images found in the work of other artists, like the rock wall in several of Magritte's paintings, e.g., *The Proper Meaning IV*, 1928-29 (Plate 58). (Since this Magritte is in the collection of Robert Rauschenberg, it would have been familiar to Johns firsthand.) Johns' wall also suggests the configuration of shapes in de Kooning's paintings of the late 1940s, such as *Attic*, 1949, and a group of related enamel on paper "Black and White Abstractions," from 1950-51, one of which Johns owns.

The stone or flagstone wall, as Johns has presented it, is a relatively uncomplicated pattern in a simple red, black and white color scheme.[12] Like Johns' *Flags* and *Targets* it is a found image which has an immediate impact and can be grasped instantaneously by the viewer. Unlike the *Flags* and *Targets*, however, the wall is not a regular, geometric design; nor is it presented as a complete, contained object. Another distinction is that a stone wall is not a flat object like a flag but a three-dimensional construction. Although Johns presents only the wall's surface pattern, he creates the effect of a real wall by making the stones appear to be imbedded into the surface. For several of the stones he used silk—a material which would not be expected to imitate the look of stone. The silk has been cut into varied stone shapes and then pressed onto the canvas, so that the wet paint moves to the edges forming a ridge as if it were cemented. Johns' choice of silk as a material could have to do in part with his use of silkscreening in works of this period.

The stone wall contrasts with the other two panels in *Harlem Light* to the extent that it seems at first to exist independently of them. Its pictorial qualities are strikingly different. The wall is a pattern of defined shapes fitted tightly together, creating the effect of a solid, impenetrable surface; the rest of the painting consists of diverse elements loosely arranged and set in a multi-leveled, open and airy-looking space. The connection between these two distinct areas seems to be that they both establish the painting as a wall. The window imprint in the right panel, like the door and window imprints in Johns' earlier *Studio* paintings from 1964 and 1966 (Plate 44) (Cri. 128), transforms the canvas into a wall dividing inside from outside. Thus the two areas establish the painting as an actual fragment of the environment (wall fragment), as well as an object (painting) hanging on a wall.

The type of window used in *Harlem Light* is similar to, but slightly different from, the gridded windows in *Studio II*, 1966. It is opened, like the

one, second from the left, in *Studio II;* it is tilted and extended beyond the canvas edge, like the door in *Studio,* 1964. It has the same transparent quality as the earlier imprints, and similar spatial ambiguities are created by the surrounding brushstrokes and textured areas painted through wire screening. Here, the idea of the light-filled studio interior is underscored by the word "light" in the painting's title.

Other artist's studio motifs are found in the right-hand section of *Harlem Light.* In the center panel there are three color blocks revealing the full range of the spectrum. The top block is red, the next one yellow-orange-green, and the lower one green-blue-violet. The blocks are separated by orange, green and violet lines (the violet line is along the bottom edge of the lower block). The lower block tilts over the edge of the right panel, as if in response to the diagonal line which seems to tip it in that direction. Next to it, on the open window, is an empty rectangle which seems to have floated away from its original position on the color chart. Assemblage objects have been eliminated. There is a can imprint (in the lower color block) and two 12-inch rulers—one painted along the right edge in the upper right corner (like the ruler in *Studio II*) and one silkscreened in the center panel, appearing to be suspended in mid-air. Besides indicating the picture's scale, these rulers reaffirm the vertical orientation of the field.

In *Harlem Light,* then, Johns further develops the theme of the artist's studio and also elaborates upon the idea of the painting as a wall. The off-kilter arrangement of forms and the abrupt discontinuities give the painting an ambiguously unsettled quality, characteristic of his works since *Diver,* 1962.

After *Harlem Light,* Johns did a series of six paintings, each titled "Screen Piece," 1967-68. *Screen Pieces 1, 2,* and *3* (Plate 55) (Cri. 131, 132) are identical in size and were exhibited together at the 1968 Castelli show. *Screen Pieces 4, 5* and *6* are smaller and were done later in 1968. The title refers to silkscreening, as well as painting through wire screens to provide a subtle but richly textured surface. In these paintings, for the first time in Johns' work, objects appear only in the form of silkscreened photographs. The main image in all the *Screen Pieces* is a fork and spoon hanging from a long wire, with the words "fork should be 7″ long" written along side and arrows pointing to the fork. In *Screen Pieces 1, 2, 3* and *5* there are also silkscreened images of rulers. All the paintings are in oil, mostly gray with touches of color. The silkscreening of the fork and spoon motif, done in black, covers the entire surface with small, raised dots which enrich its painterly texture.

This motif is taken from Johns' painting, *Voice,* 1964-67 (Plate 56), where a real fork and spoon are suspended from an unbent wire coat hanger. The intermediary step in transforming the objects from *Voice* to the silkscreened reproductions in the *Screen Pieces* is the lithograph, *Voice,* 1966-67 (Field 59). The lithograph includes a photographic reproduction of the hanging fork and

spoon from the painting *Voice;* and it was in the process of preparing the photoplate for this print that the image appearing in the *Screen Pieces* occurred. Johns wrote instructions on the photograph so that the objects would be enlarged to life-size for the print. For the *Screen Pieces,* Johns had a silkscreen made from this photograph, incorporating the instructions as part of the image, and thus focusing our attention on the idea of scale and measurement.[13]

In the *Screen Pieces,* the image has been enlarged to over life-size, so that the fork is about 12 inches long. The discrepancy between the size of the fork in the painting and what it *should be* makes us aware that we are looking at a photographic image of an object rather than the thing itself or its imprint. In this way, Johns' words function like Magritte's "Ceci n'est pas une pipe," in his *Use of Words* series. However, there are essential differences between Magritte's pipe and Johns' fork: Magritte's is a traditionally painted image of an object; Johns' is a photographic reproduction. Most important, Johns' use of a picture of a fork was dependent upon the appearance of the fork as an assemblage object in one of his previous works. Likewise, Johns' use of the ale can photograph in *Decoy* is predicated on the fact that the ale can was used as a model for one of his sculptures. A crucial function of Johns' photographed image is that it refers us to his previous art bringing with it memories and associations from those works.

The rulers in *Screen Pieces 1* and *2* serve as standards of measurement by which we can determine the actual size of the fork image which *should be,* but *is not* 7 inches long. Although the rulers, like the forks, are silkscreened photographs, we can use them—at least conceptually—as real objects, because they provide an accurate standard of measurement. In the first *Screen Piece,* 1967, the foot-length ruler is in the upper right corner, surrounded by an area of beige brushstrokes which partly obscures its details. In *Screen Piece 2,* 1968, the ruler is centered along the upper edge; to either side are extensions which look like identical rulers with no markings. At first the image looks like a yardstick divided into three sections painted red, yellow and blue.[14] The silkscreened ruler in *Screen Piece 3,* 1968, is a yardstick which appears to be suspended in space and twists like the letters of "blue" in *Passage II;* this is the first time one of Johns' rulers is bent out of shape and its scale of measurement distorted.

Near the upper left corner of *Screen Piece 3,* Johns silkscreened the title page and adjoining blank page of a book of poems by Ted Berrigan, *The Sonnets* (1967).[15] There are many aspects of *The Sonnets* which would have appealed to Johns at this time, but I think the most important was the way the poems were conceived as a series. They are all written in the sonnet form and certain lines reappear in different poems, sometimes fragmented or slightly altered. Two of the poems, "Penn Station" (p. 18) and "Sonnet XXI" (p. 25),

are made up of identical lines rearranged. Johns' *Screen Pieces* are likewise the same format, and contain motifs which are repeated in each version. Johns was reading *The Sonnets* in November 1967, when he was beginning work on his *Screen Pieces,* and I think these poems reaffirmed or possibly inspired the idea of a closely related series of paintings.

Another feature of Berrigan's poems relevant to the *Screen Pieces,* and other of Johns' works, is their collage effect. Lines seem to be fragments of thoughts, remembrances or images juxtaposed seemingly at random; for example, "Sonnet XV" (p. 20):

> In Joe Brainard's collage its white arrow
> He is not in it, the hungry dead doctor.
> Of Marilyn Monroe, her white teeth white-
> I am truly horribly upset because Marilyn
> and ate King Kong popcorn, "he wrote in his
> of glass in Joe Brainard's collage
> Doctor, but they say "I LOVE YOU"
> and the sonnet is not dead.
> takes the eyes away from the gray words,
> *Diary.* The black heart beside the fifteen pieces
> Monroe died, so I went to a matinee B-movie
> washed by Joe's throbbing hands. "Today
> What is in it is sixteen ripped pictures
> does not point to William Carlos Williams.

This poem makes sense when the first and last lines are read in sequence, then the second and second to the last, etc. Johns was reading "Sonnet XV" when I visited him one evening in November 1967 at the Chelsea Hotel where he was living at the time. He had just discovered this order and read the poem to me. He then read other poems from Berrigan's *Sonnets,* choosing favorite lines, several of which I cite below.[16]

There are reflections on the creative process in *The Sonnets,* which are thematically relevant to Johns' art: e.g., "Everything turns into writing/ I strain to gather my absurdities into a symbol" (XLV); "(to cleave to a cast-off emotion—Clarity! Clarity!)" (LXXI); "I'll break/My staff bury it certain fathoms in the earth/ And deeper than did ever plummet sound/ I'll drown my book." (LXXXVIII). There are references to art, like "Harum-scarum haze on the Pollock streets" (XIX); allusions to Duchamp which have the same cryptic quality as Johns' Duchamp references: "a man/ Breaks his arm so he sleeps' he digs/In sleep half silence and with reason" (XXXVIII); "in advance of the broken arm" (XLI); "signs a shovel and so he digs" (LXXXVIII). Gertrude Stein, one of Johns' favorite authors, is mentioned in the following line: "For everything comes to it/ gratuitously like Gertrude Stein to Radcliffe" (LII). "Sonnet LV" (p. 54) is dedicated to Frank O'Hara; the first

line is a quote from his poem, "In Memory of My Feelings": "Grace to be born and live as variously as possible." In Berrigan's poems, as in O'Hara's, there are many references to friends, lovers and autobiographical events. Alluding to particular poets and poems, even through a name or title only, enabled Johns to bring personal associations and feelings into his own work indirectly through the intermediary of poetry.

The silkscreened fork and spoon motif and the flagstones appear together in *Wall Piece,* 1968 (Cri. 136). Its predominant whiteness gives it the quality of unpainted plaster making the whole painting appear more literally like a wall than *Harlem Light,* although the picture space shifts from open and airy to impenetrable and flat. The title emphasizes the importance of the wall as subject of a number of works especially since the 1964 *Studio* painting. The fork and spoon motif has been silkscreened in violet, and it seems to be engulfed by a misty atmosphere. Several surface markings affirm the flatness of the canvas: a long brushstroke (to the right of the fork and spoon), a violet patch painted through a wire screen and a sprayed blotch of orange. The stone wall is a detail of the upper two-thirds of the wall in *Harlem Light.* It has been turned ninety degrees, so that the upper edge of the wall in *Harlem Light* becomes its right edge in *Wall Piece.* It is painted in the same technique and colors, with some variation in the surface markings. In *Wall Piece* the silk used in making some of the rocks in the right panel alludes to the silkscreening process used in the left one. Along the right edge of the wall are the color blocks—red, yellow and blue overlaid with white—which look as if they were meant to be continued beyond the edge.

Voice and *Voice 2*

Voice (Plate 56), the source for the fork and spoon motif in the *Screen Pieces* and *Wall Piece,* was begun in 1964; during the spring of 1967, its surface was completely reworked and the position of the word "voice" shifted.[17] The fork and spoon in *Voice* are part of a "device" connected by wires to a stick at the other end. The stick has scraped a path in the gray encaustic surface and is about to erase the word "voice." The hanging silverware and the piece of rope seem to provide the downward pull which causes the stick to move. Since the fork and spoon suggest the idea of "oral intake" and the word "voice" the idea of "oral output,"[18] Johns seems to be presenting them as opposing forces within the painting.

The word "voice" is similar to Johns' other isolated words, like "no," "Tennyson," and "the." It is painted in gray on gray so that it blends into the field, and its letters are small in relation to the field as a whole. However, in spite of its understated visibility, the mood and meaning of the whole painting are dominated by its presence. Like Johns' other words, it is presented with no

verbal context and its resulting ambiguity leaves open the possibility of many interpretations. The word itself suggests the idea of an uttered sound, without specifying the nature of the sound or who is making it. Usually the word "voice" is associated with a person talking, and, as such, it can have the quality of a certain mood (a sad or happy or bitter voice) or it can be a way of identifying a particular person. (We speak of recognizing a voice.) "Voice" can also refer to any sound considered a vocal utterance (the voice of the sea, of nature, of one's conscience). Perhaps in Johns' work it implies the "voice of the artist" or the "voice of the painting" which attempts to communicate in the non-verbal language of art. However, the attempt at communication is in the process of being thwarted because the "voice" is about to be obliterated.[19]

Voice recalls Johns' paintings of 1961 in mood and style. The surface is densely painted in relatively uniform gray and the handling is restrained, as in his earlier works. The imagery is sparse and isolated as if in a void. The scraping away of "voice" suggests the idea of a condition changing from "positive" to "negative," as in *Disappearance, No, Good Time Charley* or *Water Freezes.* (Note the word "ice" in "voice.") The hanging fork and spoon first appeared in *In Memory of My Feelings,* where they were juxtaposed to the words "dead man." In both works, the fork and spoon bring in the idea of consumption of food, implying a state of irrevocable change.[20]

Voice 2, 1967-71 (Cri. 147), was begun in the fall of 1967, around the same time as the group of paintings exhibited at the Leo Castelli Gallery in February 1968;[21] it is related to them, as well as to *Voice,* 1964-67. The style of *Voice 2* is characteristic of many of Johns' other large-scale works since 1962: the pictorial elements are fragmented and seem to shift in a vast arena of ambiguous, multi-leveled space.

The dominant motif is the title "Voice 2," painted in large, two-foot-high letters across the bottom edge of three separate panels.[22] The letters are cut off at the inner edges, providing a visual link from panel to panel, unifying them in spite of the gaps between them. The "v" is split at the two far ends of the painting, suggesting that the space is continuous around the canvas, or that we are seeing only part of a repeated continuum (like the letters and row of photographs in *Decoy*). Each letter is handled differently, but they are all either changing position or breaking apart. The "i" sheds a layer which begins to drift upwards, as if following the path of the "o" which disappears beyond the upper edge. A layer peels off the "c," bending away from the original letter; a line with arrows marks the point where the layers are still attached. The lower section of the "2" looks like a solid, three-dimensional form, and the "v" next to it seems to cast a slightly distorted shadow. In the first version of *Voice,* the word is barely "audible" because it blends into the large field of gray. But in *Voice 2,* it creates the effect of a loud sound, impossible to ignore. Like the first "voice,"

however, it is disappearing—not silenced in one fell swoop, but disintegrating or fading out gradually.

Voice 2 contains the hanging fork and spoon from *Voice* in the form of the silkscreened image from the *Screen Pieces*. Johns silkscreened the image several times, both horizontally and vertically, but only fragments are visible because the surface was painted over many times. Fragments of the flagstones are found in the painting also, but these are covered over so that only the outlines of the stones are visible. There is a large imprinted shape in the upper right, resembling the shape of the stones and the imprint of Duchamp's *Female Fig Leaf*. It was made with a metal chair frame which Johns used because it suggested these other shapes. The entire surface is rich with varied markings and textures, including can imprints, areas painted through wire screens of different sizes and the small raised dots from the silkscreened images.

The overall color of the painting is subdued, but there are traces of bright colors. (At one stage each of the panels was painted predominantly in a primary color.) Each panel is divided in half—vertically, horizontally or diagonally—by a line with arrows at either end. The arrows indicate that the panels can be turned upside-down. Johns has specified that the panels can be rearranged. (Instructions that they can be combined in any order are given with listed information about the work.) While working on the painting, he continually varied the arrangement of the panels. Once I saw the "diagonal" panel turned upside down and placed at the left rather than right end of the painting. Another time, the panels were arranged so that the central letters in each spelled out the exclamation: "O 2 C" (i.e., "oh, to see").[23]

Untitled, 1972, *Corpse and Mirror,* and *Scent*

Untitled, 1972 (Plate 57) (Cri. 148), is Johns' first painting since *Passage II,* 1966, to include three-dimensional objects and casts. The wax casts of anatomical fragments are the most unusual and disturbingly provocative in his work to date. This figurative panel contrasts with the other three, which are based on decorative patterns with none of the overt emotional connotations of the fragments. However, since the individual panels do not seem to "fit together," the painting as a whole, like the cast fragments, has a tension-provoking, disjunctive quality.

The striped pattern used in the left panel appears here for the first time in Johns' work. Like the flagstones, it becomes an important motif for subsequent works.[24] The design consists of bundles of stripes which look like cross-hatchings, painted green, orange and violet against a white ground (with red, yellow and blue showing through the white). The stripes or hatchings (as Johns himself calls them) are arranged so that they create an optical illusion of depth and vibrating movement when stared at. Johns said that this motif came from a

design he saw painted on a car which drove past him on the Long Island Expressway. He had seen it a few years before, so that what appears in the painting is his recollection of the design, adapted to his own spectral color scheme (he could not remember the colors of the original). Johns said this pattern could look either very sophisticated like a Matisse, or very simple like street art, and that, while it was probably closer to the latter, he wanted it to be neither.[25] The hatchings, like the flagstones, bring another element of art-not-yet-become-art into Johns complex, interwoven *oeuvre*. Johns' stripes suggest art images, too. They recall the striped patterns in some of Matisse's paintings, and there is a striking similarity between Johns' design and the patterning in the final version of Picasso's *Women of Algiers,* 1955 (Zer. 16, 360).[26]

The flagstones have by this time become part of Johns' vocabulary of images and bring into this painting recollections of their use in previous works. The second panel is approximately the same detail of the wall as the one that appears in *Wall Piece*. It is painted in the same technique, using silk for several stones, and the same color scheme. (Some stones have slightly different shapes and the surface markings are different.) The panel next to it looks like a different segment of the same wall (shifted slightly from left to right). It is painted in encaustic and its surface is coarser, with the edges of the stones cut out of the surface layer. The wall is painted over a dark layer which can be seen through some of the white stones. Two surface markings stand out: a large lavender-pink brushstroke (near the center) and an iron imprint linking the wall with the casts panel near the lower edge. Johns worked on the painting with the panels placed in various positions and traces of the rearrangements appear in the completed work.[27] In the completed painting the panels are arranged in a fixed order, not meant to be interchangeable like those in *Voice 2*.[28]

The right-hand panel, which Johns' calls "casts," is painted in pinkish-brown encaustic (flesh color) with traces of color from the attached boards. Each of the seven boards has a cast attached, and is marked with a number (one to seven) and the letters "l" and "r," establishing its left–right orientation in the field. These stencilled labels are printed in each color of the spectrum and gray. Although the boards are marked as to position and sequence, they appear to criss-cross the space at random.

The casts are almost all parts of a woman's body.[29] They are numbered in the following order: #1 (red—refers to color of stencilled number and letters on the board; the casts are all naturalistically colored—face in profile (no eyes); #2 (blue)—foot and hand, foot stepping on black sock, hand next to it on floor; #3 (gray)—buttock; #4 (yellow)—torso with breast and navel; #5 (green)—feet crossed at ankles, with green shoes; #6 (violet)—back of leg, calf and heel; #7 (orange)—knee (the knee and the face are raised on smaller boards attached to the larger ones). The most puzzling fragment is the one with the hand, foot and

sock. It is the only one which shows part of the environment and implies an event, but it does not reveal a specific setting for what is actually happening or whether there are one or two figures involved. However, since the foot is stepping on a man's sock, the presence of a male figure is implied and the setting could be the bedroom where a sock on the floor would most likely be found. Like Johns' other fragmented figures indicated by casts and imprints, including the "diver" and the "watchman," this nude figure is anonymous and its specific role in the work undefined. Because of the way the human body is broken up in the 1972 painting, and the manner in which the fragments are displayed, its impact is more disturbing and violent than in previous works.

The casts in *Untitled* are most obviously comparable to those in Johns' 1955 *Target with Plaster Casts* (Plate 6). (The fact that Johns used silkscreened target images with the casts at one stage substantiates this connection.)[30] Both show nude figures, the earlier one male, the latter one mostly female. The casts in the 1972 painting are generally taken from larger segments of the body, and therefore they form a more complete figurative image. The body parts in the 1955 *Target* are all easily recognizable (except for the ambiguous black bone), while the casts in *Untitled* show less conspicuous details of anatomy, some of which are not at first clearly identifiable. The casts in the *Target* are displayed in a matter-of-fact manner, like objects on a shelf, while those in the later work are attached to the boards in such a way that they suggest a crucifixion, adding to the mood of violence.

There are striking similarities between the details in Johns' painting and those in Magritte's paintings with walls and figurative elements such as *The Proper Meaning IV* (Plate 58) (already discussed jn connection with Johns' first use of the flagstone motif), and *The Lost Woman*, 1927-28 (Mag. 56). In *Proper Meaning*, the female figure and her emotional condition are represented by the words, "femme triste" placed in an irregularly shaped "canvas." This "sad woman" leans against a stone wall with a wooden board in front of it. In *Lost Woman*, a female figure is shown embedded in a stone wall, surrounded by fragmented hands. As in Johns' painting, the juxtaposition of wall and figure is unexpected and the mood is erotic in a disturbingly violent way. Johns' use of fragmented figures since 1954 has been rooted in Surrealism, and it is the conceptualized surrealism of Magritte which is closest to Johns' sensibility. This explains the striking similarities of imagery—stone walls, boards, object-like figure fragments—found in so many of their works. The erotic female nude in Duchamp's *Given: 1. The Waterfall/2. The Illuminating Gas*, 1946-66 (Sch. 392), seen through a hole broken into a stone wall, is also similar in imagery and mood to Johns' 1972 *Untitled* painting.[31]

The link with Surrealism via the mood and imagery of the fragmented figure in *Untitled* is underscored by the title of one of Johns' next major paintings, *Corpse and Mirror*, 1974 (Plate 59) (Cri. 162). The word "corpse" is a

reference to the Surrealist's art game called "Exquisite Corpse," "in which a collective drawing [or phrase] is accomplished as each player works on a piece of paper that is folded under step by step."[32] The name is derived from the first such game which resulted in the following phrase: "The exquisite—corpse—shall drink—the young—wine." One well-known example, from the collection of the Museum of Modern Art in New York, is a figurative drawing by four artists—Yves Tanguy, Joan Miro, Max Morise and Man Ray, done in 1926-27.[33]

Johns' reference to the game has to do in part with technique and in part with the psychological suggestiveness resulting from the random juxtaposition of imagery occurring in the "Exquisite Corpse" drawings. The word "corpse," besides alluding to the Surrealist game, interjects the theme of death like the words "Dead Man" in *In Memory of My Feelings,* 1961, and the skull imprints in *Arrive/Depart,* 1963-64, *Evian,* 1964. Closer in date to *Corpse* are a 1971 *Skull* drawing and an *Untitled (Skull)* screenprint, 1973 (Field 172), both using skull imprints. The title "Corpse" also could refer to the dismembered figure in *Untitled,* 1972. The connection to that painting is further suggested by the iron imprint and pink brushstroke found in each.[34]

Johns' process coincides with the Surrealists' folded paper game in that he painted the three sections of the left panel (in oil) independently, without reference to each other. He then painted a mirror image (in encaustic) of the left side on the right.[35] The way the hatchings meet at the horizontal edges of the six divisions and along the vertical division between the left and right sides of *Corpse,* look like the folded seams of paper used in the Surrealist *Exquisite Corpses.*[36] The use of three separate, but interconnected horizontal sections used to make up a vertical field goes back to *Out the Window,* 1959 (Plate 18). In *Corpse,* Johns joins two vertical panels to make up a larger horizontal one; he uses the hatchings painted in black and white, rather than the primary color names to articulate each section.

In *Scent,* 1973-74 (Plate 60) (Cri. 161), Johns uses the hatchings in the secondary colors like those in the left panel of *Untitled.* In this painting, the hatching design is the sole image. Johns presents what appears to be a continuous design with elements repeated at random; however, upon closer examination it is revealed to be a carefully worked out arrangement of varied and related patterns. The three-paneled painting is actually divided into nine vertical sections, which Crichton describes as follows:

> ...the elements which abut the junctions between canvases are always identical. Only the middle element of each canvas is unique. In other words, if the three vertical elements of the first canvas were labeled ABC, the second canvas would be CDE, and the third EFA. The possibility that the canvas could be rearranged is clearly indicated.[37]

Furthermore there are four "secret squares" approximately 72 by 72 inches that can be made up of panel groupings: ABCCD, BCCDE, CDEEF, DEEFA.[38] As Hess described this painting: "What at first seemed an incomprehensible mass of tangling parallel lines resolves itself into a structure of fugal implication."[39]

Scent is Johns' only major work through 1974 to consist entirely of abstract patterns, with no words, objects or object imprints included.[40] The painting's title becomes crucial in bringing in associations and references which mark this important turning point in Johns' career, ushering in a series of paintings, prints and drawings dominated by the hatching image. "Scent" refers generally to the sense of smell. (It recalls for me the part in Johns' 1968 essay on Duchamp where he writes: "Perfume. The air was to stink of artists egos.")[41] More specifically, "scent" like "decoy" refers to the hunt, particularly the idea of tracking down the object being hunted. Most significantly perhaps, "Scent" is intended to be a reference to Jackson Pollock's final painting of the same title.[42] Its use by Johns conjurs up the emotional intensity of Pollock's art, life, creative struggle and tragic death. It also underscores this work's connection to Pollock's abstract all-over style made famous through his drip paintings done between 1947 and 1953. It is the work and artistic stance of Pollock and other Abstract Expressionists which Johns' art—so clearly imagistic and so coolly detached—was seen to contradict when initially exhibited in the 1950s.

Yet twenty years after his first *Flag* painting was conceived, it seems possible and even appropriate that Johns would pay homage to Pollock. Johns' *Scent*, with its predetermined design reflects his continued commitment to maintaining a strong, conceptual focus in his work and a stance of self-detachment. However, throughout his career, Johns has developed a personal vocabulary for incorporating an expressive dimension in his art. The mature artist, working a generation after Pollock's death, can acknowledge his identification with aspects of the Abstract Expressionist sensibility from which he emerged, because of his extraordinary achievement in opening up new directions for contemporary art.

Appendix A

Chronological List of Johns' Paintings and Sculptures 1954-1974

In 1970, Johns arranged a file card catalog of his paintings and sculptures in chronological order based on his memory of the sequence in which they were done. I was with Johns when he determined this chronological arrangement, although I did not record the exact date in my "Journal." In the following list, Johns' paintings and sculptures are grouped separately according to year. The information includes date, title, medium and dimensions in inches (except for paintings of flat objects and signs; their dimensions are given in Appendix B).

PAINTINGS

1954
Untitled Construction; oil and collage with plaster cast; 26¼ x 8¾ x 4
Untitled; oil and collage on silk; 8⅞ x 8⅞
Star; encaustic on canvas with glass and wood; 22⅝ x 19¾ x 1⅞
Construction with Toy Piano; graphite and collage with toy piano; 11 x 9 x 2

1955
Flag; 1954-55; encaustic and collage
Target with Plaster Casts; encaustic and collage with plaster casts
White Flag; encaustic and collage
Target with Four Faces; encaustic and collage with plaster casts
Flag Above White; encaustic
Flag Above White with Collage; encaustic and collage
Figure 1; encaustic and collage
Figure 2; encaustic and collage
Figure 5; encaustic and collage
Figure 7; encaustic and collage
Green Target; encaustic and collage
Tango; encaustic with music box; 43 x 55

1956
Gray Alphabets; encaustic and collage
Canvas; encaustic on wood and canvas; 30 x 25

Flag; encaustic
Green Target; encaustic and collage

1957
White Numbers; encaustic
Gray Numbers; encaustic
Gray Rectangles; encaustic; 60 x 60
Drawer; encaustic on canvas and wood; 30½ x 30½
Gray Flag; encaustic
Flag; pastel and collage on gesso board
Study for Painting with Two Balls; encaustic on paper; 19 x 25¼
Book; encaustic on book on wood; 10 x 13

1957
Flag; oil on brown paper
Numbers; oil on paper
Gray Target; encaustic
Target; encaustic on board
Figure 4; encaustic and collage
Flag (On Birth Announcement); oil on paper with ribbon
Newspaper; encaustic and collage; 27 x 36
Flag on Orange Field; encaustic
The; encaustic; 24 x 20

1958
Gray Target; encaustic
0 to 9 (0-9); encaustic and collage
Target; encaustic and collage on paper
White Target; encaustic and collage
Target; sculpmetal
Flag on Orange Field II; encaustic
Gray Numbers; encaustic and collage
White Numbers; encaustic
Flag; encaustic
Green Flag; encaustic and collage on board
Target; oil; collection of the artist
Three Flags; encaustic
Tennyson; encaustic and canvas collage; 73½ x 48¼
Painting with a Ball; encaustic; 31½ x 24½
Alley Oop; oil and collage on cardboard; 23 x 18
White Numbers; encaustic
White Flag; 1955-1958; encaustic and collage
White Target

1959
Numbers in Color; 1958-1959; encaustic and collage
Alphabets; encaustic and collage
Figure 4; encaustic and collage
Figure 8; oil
Figure 8; encaustic and collage

Figure 0; encaustic
Figure 4; encaustic and collage
0-9 (0-9); encaustic and collage
Device Circle; encaustic and collage with wood; 40 x 40
Reconstruction; encaustic and canvas collage; 60 x 44
False Start; oil; 67¼ x 54
Jubilee; oil; 60 x 44
Highway; encaustic and collage; 75 x 61
Out the Window; encaustic and collage; 54½ x 40⅛
Thermometer; oil on canvas with thermometer; 51¾ x 38½
Shade; encaustic on canvas with shade; 52 x 39
Small Numbers in Color; encaustic on wood
Two Flags; plastic paint
Coat Hanger; encaustic on canvas with hanger; 27¾ x 21¼
White Numbers; encaustic
Black Target; encaustic and collage; destroyed by fire

1960
Black Target; oil on paper
Painting with Two Balls; encaustic and collage on canvas with objects; 65 x 54
Flag; sculpmetal and collage
0 through 9; oil
Figure 5; encaustic and collage
Painting with Ruler and Gray; oil and collage on canvas with objects; 32 x 32
Disappearance I; encaustic and canvas collage; 40½ x 40½
Map; encaustic on paper on canvas
Target; pencil on board with objects
White Flag; oil and collage on paper
Small False Start; encaustic and collage on board; 21¾ x 18¼
Figure 3; oil
Figure 7; oil

1961
Green Target; encaustic and collage
Water Freezes; encaustic on canvas with thermometer; 31 x 25¼
O Through 9; (gray; "O through 9 Johns 61"); oil
O Through 9; (black and white); oil
O Through 9; (color; "Zero through Nine J Johns 61"); oil
O Through 9; (color; polka dots); oil
O Through 9; (color names); oil
O Through 9; sculpmetal
O Through 9; oil on paper
O Through 9; (black and white); oil on paper
O Through 9; (polka dots); encaustic on paper
O Through 9; encaustic, plastic paint and collage on paper
Figure 3; sculpmetal and collage
Entr'acte; encaustic and collage; 36¼ x 24¾
Map; oil
By the Sea; encaustic and collage; 72 x 54½
Target; encaustic and collage

Fountain Pen; encaustic on plaster and wood; 7¼ x 5½
Liar; encaustic, pencil and sculpmetal on paper; 21¼ x 17
In Memory of My Feelings—Frank O'Hara; oil on canvas with objects; 40 x 60
Disappearance II; encaustic and canvas collage; 40 x 40
No; encaustic, collage and sculpmetal on canvas with objects; 68 x 40
Good Time Charley; encaustic on canvas with objects; 38 x 24
Painting Bitten by a Man; encaustic; 9½ x 6⅞
Small Gray Numbers; 1959-61; encaustic; 5 x 3½

1962
O to 9 (0-9); (revised 1962); plastic paint
Iron; encaustic on wood; 9¾ x 7⅛
Device; 1961-62; oil on canvas with wood; 72 x 48¼
Device; oil on canvas with objects; 72 x 36
4 The News; encaustic and collage on canvas with object; 65 x 50
Fool's House; oil on canvas with objects; 72 x 36
Portrait—Viola Farber; 1961-62; encaustic on canvas with objects; 48 x 62
Zone; encaustic, oil and collage on canvas with objects; 60 x 36
Paregoric; oil and collage; 14½ x 20½
Alphabets; oil on paper on canvas
Passage; encaustic and collage on canvas with objects; 54 x 40
Out the Window II; oil on canvas with objects; 72 x 48
Two Flags; oil on canvas
Gray Painting with Spoon; encaustic on canvas with objects; 26 x 20
Small Map; oil on board
Map; encaustic and collage
Figure 2; encaustic and collage
Diver; oil on canvas with objects; 90 x 170
Slow Field; oil on canvas with objects; 72 x 36

1963
Land's End; oil on canvas with wood; 67 x 48
Periscope (Hart Crane); oil; 67 x 48
Numbers; sculpmetal
Map; encaustic and collage
Figure 2; encaustic and collage
Figure 1; sculpmetal and collage

1964
Arrive/Depart; 1963-64; oil; 68 x 51½
Field Painting; 1963-64; oil on canvas with objects; 72 x 36¾
Numbers; sculpmetal
Watchman; oil on canvas with objects; 85 x 60
Souvenir; encaustic on canvas with objects; 23¾ x 21
Souvenir 2; oil on canvas with objects; 23¾ x 21
Gastro; encaustic on paper on canvas
Evian; oil on canvas with objects; 50 x 68½
According to What; oil on canvas with objects; 88 x 192
Studio; oil on canvas with objects; 73½ x 145

1965
Numbers; 1960-65; encaustic on paper on canvas
Untitled; 1964-65; oil on canvas with objects; 72 x 168
Eddingsville; oil on canvas with objects; 68 x 122½
Double White Map; encaustic and collage
Flags; oil
Map; charcoal and oil
Flag; encaustic and collage

1966
Passage II; oil on canvas with objects; 59¾ x 62½ x 13
Targets; encaustic and collage
Flag; 1960-66; encaustic on paper on canvas
Studio II; oil; 70 x 125
Green Map; metallic powder and hyplar on paper on canvas

1967
Voice; 1964-67; oil on canvas with objects; 96¼ x 69¼
Untitled; 1965-67; oil on canvas with objects; 73¾ x 100
Flag; encaustic and collage
Harlem Light; oil and collage; 78 x 178
Screen Piece; oil; 72 x 50
Figure 4; encaustic and collage

1968
Screen Piece 2; oil; 72 x 50
Screen Piece 3; oil; 72 x 50
Wall Piece; oil and collage; 72 x 110½
White Alphabets; oil
White Alphabets; oil and collage
White Alphabets; oil
Screen Piece 4; oil; 50¾ x 34
Screen Piece 5; oil; 50¾ x 34

1969
Target; 1967-68

The following is a list of Johns' paintings from 1970 through 1974:

1970
Figure 4 (4 Leo); encaustic and collage

1971
Map (based on R. Buckminster Fuller's Dymaxion Air Ocean World Map); 1967-71
Voice 2; 1967-71; oil and silk collage; 3 panels each 72 x 50, to be hung in any sequence 6" apart,
 72 x 162.
 Decoy; oil on canvas wtih brass grommet; 72 x 50
 Flag; oil and collage; 26 x 17

1972
Untitled; oil, encaustic and collage on canvas with objects; 72 x 192
Decoy II; oil on canvas with brass grommet; 47 x 29½

1973
Two Flags; encaustic and oil

1974
Target; encaustic and collage
Target; encaustic and collage
Corpse and Mirror; encaustic, oil and collage; 50 x 68½
Scent; 1973-74; oil and encaustic; 72 x 126¼

SCULPTURE

1958
Light Bulb I; sculpmetal; 4½ x 6¾ x 4½
Light Bulb II; sculpmetal; 8 x 3 x 4
Flashlight I; sculpmetal over flashlight and wood; 5¼ x 9⅛ x 3⅞
Flashlight II; papier mâche and glass; 8 x 3½ x 3
Flashlight III; plaster and glass; 5¼ x 3¾ x 8¼

1959
The Critic Smiles; sculpmetal; 1⅝ x 7¼ x 1½

1960
Light Bulb; bronze (4 casts); 4¼ x 6 x 4
Flashlight; bronze and glass; 4⅞ x 8 x 4½
Painted Bronze (Ale Cans); painted bronze; 5½ x 8 x 4¾
Painted Bronze (Ale Cans) II; painted bronze; 5½ x 8 x 4¾
Painted Bronze (Paint Brushes); painted bronze; 13½ x 8 diameter
Flag; bronze (4 casts); 12 x 9
Bronze (Light Bulb, Socket, Wire on Grid); bronze (4 casts); 3½ x 11½ x 6¼

1961
The Critic Sees; sculpmetal on plaster with glass; 3¼ x 6¼ x 2⅛
0 Through 9; aluminum (4 casts); 26¼ x 20

1964
The Critic Sees II; sculpmetal on plaster on glass; 3¼ x 6¼ x 3⅛
High School Days; sculpmetal on plaster with mirror; 12 length

1965
Subway; sculpmetal on board; 7⅞ x 9⅞ x 3

1966
Summer Critic; cement, wax and glass

1969
Hat Form; sculpmetal and wood hatblock; 10 x 8 x 10

1970

English Light Bulb; 1968-70; sculpmetal, wire and polyvinyl chloride; base 4⅞ x 3⅛
Memory Piece (Frank O'Hara); wood, lead, rubber, sand and sculpmetal; 6¾ x 5¼ x 13—
closed; 5½ x 29½ x 6⅝—open.

Appendix B

List of Paintings of Flat Objects and Signs

I. **FLAGS**
 A. *Red, White and Blue Single Flags*
 1. *Flag*, 1954-55, encaustic, oil and collage, 41½ x 60¾
 2 *Flag*, 1956, encaustic, 11½ x 16½
 3. *Flag*, 1957, pastel and collage on gesso board, 14½ x 18¼
 4. *Flag*, 1957, oil on brown paper, 12 x 17
 5. *Flag*, 1958, encaustic, 41½ x 60¾
 6. *Flag*, 1965, encaustic and collage, 8 x 11½
 7. *Flag*, 1960-66, encaustic on paper on canvas, 17½ x 26¾
 8. *Flag*, 1966, encaustic and collage, 48 x 60 (destroyed by fire)
 9. *Flag*, 1967 encaustic and collage, 33⅛ x 56
 B. *Monochrome Single Flags*
 1. *White Flag*, 1955, encaustic and collage, 78 5/16 x 120¾
 2. *White Flag*, 1955-58, encaustic and collage, 52½ x 78¾
 3. *White Flag*, 1960, oil and collage on paper on canvas, 18 x 26½
 4. *Gray Flag*, 1957, encaustic, 26 x 38
 5. *Flag*, 1960, sculpmetal and collage, 13 x 19¾
 C. *Single Flags in Larger Fields*
 1. *Flag Above White*, 1955, encaustic, 22 x 19
 2. *Flag Above White with Collage*, 1955, encaustic and collage, 22 x 19
 3. *Flag on Orange Field*, 1957, encaustic, 66 x 49
 4. *Flag on Orange Field*, 1957, watercolor on canvas*
 5. *Flag (On Birth Announcement)*, 1957, oil on paper with ribbon, 3 x 3⅞
 6. *Flag on Orange Field II*, 1958, encaustic, 54 x 36¼
 D. *Multiple Flags in a Single Field*
 1. *Three Flags*, 1958, encaustic, 30⅞ x 45½ x 5 (three levels)
 2. *Two Flags*, 1959, plastic paint, 79½ x 58¼ (gray)
 3. *Two Flags*, 1962, oil, 98 x 72
 4. *Flags*, 1965, oil, 72 x 48 (with raised canvas)
 E. *Vertical Flags*
 1. *Flag*, 1971, oil and collage, 26 x 17
 2. *Two Flags*, 1973, encaustic and oil, 52 7/16 x 69 9/16

II. **TARGETS**
 1. *Target with Plaster Casts*, 1955, encaustic and collage with plaster casts, 51 x 44 x 3½

2. *Target with Four Faces*, 1955, encaustic and collage with plaster casts, 29¾ x 26 x 3¾
3. *Green Target*, 1955, encaustic and collage, 60 x60
4. *Green Target*, 1956, encaustic and collage, 9¼ x 9¼
5. *Gray Target*, 1957, encaustic, 12 x 12
6. *Target*, 1957, encaustic on board, 7½ x 7½ (red, yellow, blue)
7. *Gray Target*, 1958, encaustic, 42 x 42
8. *Target*, 1958, encaustic and collage on paper, 13¾ x 13¾ (red, yellow, blue)
9. *White Target*, 1958, encaustic, 29⅞ x 30
10. *White Target*, 1958, encaustic and collage, 41⅝ x 41⅝
11. *Target*, 1958, sculpmetal, 12⅛ x 10¾
12. *Green Target*, 1958, encaustic and collage on board, 8½ x 8½
13. *Target*, 1958, oil, 36 x 36 (red, yellow, blue)
14. *Black Target*, 1959, encaustic and collage, 54 x 54 (destroyed by fire)
15. *Black Target*, 1959-60, oil on paper, 15⅜ x 15⅜*
16. *Target*, 1960, pencil on board with objects, 6¾ x 4⅝ (brush with watercolor discs)
17. *Green Target*, 1961, encaustic and collage, 10 x 10
18. *Target*, 1961, encaustic and collage, 66 x 66
19. *Targets*, 1966, encaustic and collage, 72 x 48
20. *Target*, 1967-69, oil and collage, 61½ x 61½ (orange, green, violet)
21. *Target*, 1974, encaustic and collage, 16 x 16
22. *Target*, 1974, encaustic and collage, 61¼ x 53¼

III. NUMBERS AND ALPHABETS
A. *Figures*
1. *Figure 1*, 1955, encaustic and collage, 17½ x 14 (white)
2. *Figure 2*, 1955, encaustic and collage, 17½ x 14 (white)
3. *Figure 5*, 1955, encaustic and collage, 17½ x 14 (white)
4. *Figure 7*, 1955, encaustic and collage, 17½ x 14 (white)
5. *Figure 4*, 1957, encaustic and collage, 3¼ x 3
6. *Figure 4*, 1959, encaustic and collage, 9 x 6
7. *Figure 8*, 1959, oil, 1959, oil 10 x 8 (black and white)
8. *Figure 8*, 1959, encaustic and collage, 20¼ x 15⅛ (color)
9. *Figure 0*, 1959, encaustic, 20¼ x 15⅛
10. *Figure 4*, 1959, encaustic and collage, 20 x 15
11. *Figure 5*, 1960, encaustic and collage, 72 x 54 (black and white)
12. *Figure 3*, 1960, oil, 11⅛ x 8 (black and white, painted on both sides)
13. *Figure 7*, 1960, oil, 10 x 8 (black and white)
14. *Figure 3*, 1961, sculpmetal and collage, 27 x 21
15. *Figure 2*, 1962, encaustic and collage, 51½ x 41½
16. *Figure 1*, 1963, sculpmetal and collage, 5¼ x 4
17. *Figure 2*, 1963, encaustic and collage, 18 x 14
18. *Figure 4*, 1967, encaustic and collage, 53⅜ x 41½ (white)
19. *Figure 4*, 1970, encaustic and collage, 50¾ x 35¾ (gray)
B. *Alphabets and Numbers*
1. *Gray Alphabets*, 1956, encaustic and collage, 66 x 49
2. *Alphabets*, 1959, encaustic and collage, 12 x 10½ (color)
3. *Alphabets*, 1962, oil on paper on canvas 34 x 24
4. *White Alphabets*, 1968, oil, 50¾ x 34
5. *White Alphabets*, 1968, oil and collage, 50¾ x 34

6. *White Alphabets*, 1968, oil, 50¾ x 34 (reverse lettering)
7. *White Numbers*, 1957, encaustic, 34 x 28⅛
8. *Gray Numbers*, 1957, encaustic, 28 x 22
9. *Numbers*, 1957, oil on paper, 8 x 5¾
10. *Gray Numbers*, 1958, encaustic and collage, 67 x 49½
11. *White Numbers*, 1958, encaustic, 67 x 49½
12. *White Numbers*, 1958, encaustic, 28 x 22
13. *Numbers in Color*, 1958-59, encaustic and collage, 67 x 49½
14. *Small Numbers in Color*, 1959, encaustic on wood, 10 3/16 x 7 3/16
15. *White Numbers*, 1959, encaustic, 53¼ x 49
16. *Small Gray Numbers*, 1959-61, encaustic, 5 x 3½
17. *Numbers*, 1963, sculpmetal, 58 x 44
18. *Numbers*, 1964, sculpmetal, 110 x 85 (121 panels)

C. *0 To 9 and 0 Through 9*
1. *0 To 9 (0-9)*, 1958, encaustic and collage, 12¾ x 23 (white)
2. *0 To 9*, 1959, encaustic and collage, 20½ x 35½ (color)
3. *0 To 9*, 1959 (revised 1962), plastic paint, 20½ x 35½
4. *Numbers*, 1960-65, encaustic on paper on canvas, 17 x 13
5. *0 Through 9*, 1960, oil, 72 x 54 (color)
6. *0 Through 9*, 1961, oil, 54 x 45 (gray; "0 through 9 Johns 61")
7. *0 Through 9*, 1961, oil, 54 x 45 (black and white)
8. *0 Through 9*, 1961, oil, 54 x 45 (color; "Zero through 9 J Johns 61")
9. *0 Through 9*, 1961, oil, 54 x 45 (colr; polka dots)
10. *0 Through 9*, 1961, oil, 54 x 45 (color names)
11. *0 Through 9*, 1961, sculpmetal, 27 x 21
12. *0 Through 9*, 1961, oil on paper, 31 x 23½
13. *0 Through 9*, 1961, oil on paper, 33¾ x 20 (black and white)
14. *0 Through 9*, 1961, encaustic on paper, 34 x 28½ (polka dots)
15. *0 Through 9*, 1961, encaustic, plastic paint and collage on paper, 25¾ x 20

IV. **MAPS**
1. *Map*, 1960, encaustic on paper on canvas, 8 x 11
2. *Map*, 1961, oil, 78 x 123½
3. *Small Map*, 1962, oil on board, 6 5/16 x 10⅜
4. *Map*, 1962, encaustic and collage, 60 x 93
5. *Map*, 1963, encaustic and collage, 60 x 93
6. *Double White Map*, 1965, encaustic and collage, 90 x 70
7. *Map*, 1965, charcoal and oil, 43¾ x 70¼
8. *Green Map*, 1966, metallic powder and hyplar on paper and canvas, 23¼ x 17¾
9. *Map*, 1967-71 (based on R. Buckminster Fuller's Dymaxion Air Ocean World Map), encaustic and collage, 186 x 396

Appendix C

Summary of Biographical Data and Exhibitions

Jasper Johns was born in Augusta, Georgia, on May 15, 1930 and his childhood was spent in rural South Carolina. His parents were living in Allendale, South Carolina, at the time he was born, but the nearest hospital was in Augusta. Johns' parents divorced when he was very young and he lived with various relatives in South Carolina during his childhood, including his grandparents and Aunt Gladys.

After a year studying at the University of South Carolina, Columbia, Johns came to New York in 1949, living on Long Island for awhile before moving to Upper Manhattan. He attended art school briefly and was soon drafted into the army. He was in the army from 1950-52, stationed in Fort Jackson, South Carolina, and then Japan. In 1952 he returned to New York City and lived mostly in Lower Manhattan during the 1950s (East 8th Street and Avenue C, Pearl Street, Front Street).

His first major works date from 1954, when he began his first *Flag* (toward the end of that year). Other paintings of flat objects and signs (*Targets, Numbers, Alphabets*) and paintings with attached objects (*Tango, Canvas, Drawer*) followed directly after the *Flag* during 1955-57. Johns did his first sculptures, *Light Bulbs* and *Flash Lights*, in 1958.

During 1954-55, Johns met Robert Rauschenberg, John Cage and Merce Cunningham, all of whom became close friends and artistic associates. During the early to mid-1950s, Johns supported himself by working in a bookstore, and, with Rauschenberg, designing window displays for department stores, including Bonwit Teller and Tiffany and Co.

In 1957, Johns met Leo Castelli and shortly thereafter, in 1958, had his first solo exhibition at the Leo Castelli Gallery. Before 1958, Johns had exhibited works in a few group shows: *Construction with Toy Piano*, 1954, at the Tanager Gallery in 1954; *Flag (with 64 Stars)*, 1955, at the Poindexter Gallery in 1955; and *Green Target*, 1955, at the Jewish Museum in 1957. Since 1958, he has exhibited regularly at the Leo Castelli Gallery and his works have

been exhibited in numerous solo and group exhibitions in galleries and museums all over the world.

There have been several retrospective exhibitions of Johns' works: in 1960 at the Columbia Museum of Art in South Carolina; in 1964 at the Jewish Museum in New York and the Whitechapel Gallery in London; in 1965 at the Pasadena Museum in California; during 1977-78, a retrospective exhibition organized by and held at the Whitney Museum of American Art traveled to museums in Cologne, Paris, London, Tokyo and San Francisco. A major exhibition of Johns' drawings sponsored by the Arts Council of Great Britain traveled to various museums and galleries in England during 1974-75.

In 1960, Johns began making prints at Tatyana Grosman's Universal Limited Art Editions workshop in West Islip, Long Island. Since that time, he has made almost 300 prints in a variety of media, mainly at U.L.A.E. and Gemini, G.E.L. in Los Angeles, but at many other workshops as well. In 1970, major exhibitions of Johns' prints were held at the Philadelphia Museum of Art and the Museum of Modern Art in New York. Since 1970 there have been many exhibitions of Johns' lithographs, etchings and screenprints.

During most of the 1960s, Johns lived and worked both in New York, in an apartment on Riverside Drive at 105th Street, and in Edisto Island, South Carolina. Johns' house in Edisto, acquired in 1961, was destroyed by fire in November 1966. In 1968, Johns moved to a building on East Houston Street in New York, which he converted into a home and studio.

In 1961, Johns made his first trip to Europe: he went to Paris on the occasion of an exhibition of his work at the Galerie Rive Droite and a performance of one of John Cage's pieces in which he and other artists participated. Since then, he has been to London several times and has traveled to Paris to work on his collaboration with Samuel Beckett, *Foirade/Fizzles*, 1975-76. Johns also has made two trips to Japan, during the summer of 1964 and the summer and fall of 1966.

Since 1973, Johns has been a director of the Foundation for Contemporary Performance Arts, for which he has organized fund-raising exhibitions. From 1967-1975 he was artistic advisor to the Merce Cunningham Dance Company. In 1973, Johns was elected a Member of the National Institute of Arts and Letters. In 1978 he received the City of New York Mayor's Award of Honor for Arts and Culture.

Presently Johns lives in the country outside New York City and in the French West Indies.

1. Jasper Johns. *Flag*, 1954–55

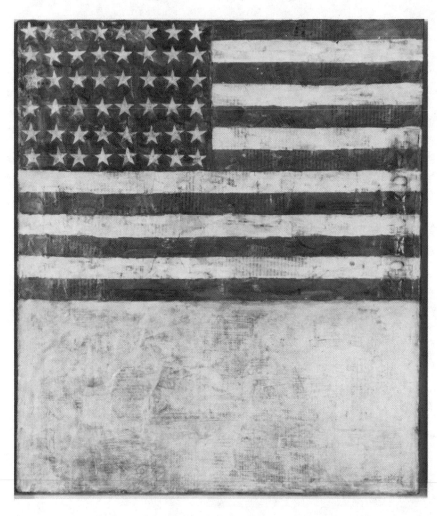

2. Jasper Johns, *Flag Above White with Collage*, 1955

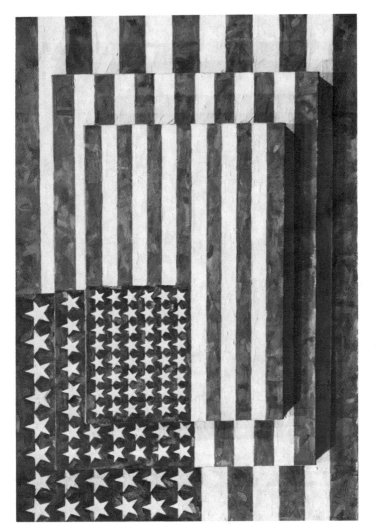

3. Jasper Johns, *Three Flags*, 1958

4. Jasper Johns, *Two Flags*, 1969

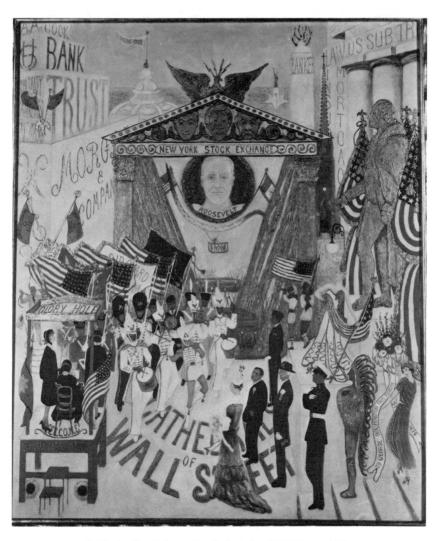

5. Florine Stettheimer, *The Cathedrals of Wall Street,* 1939

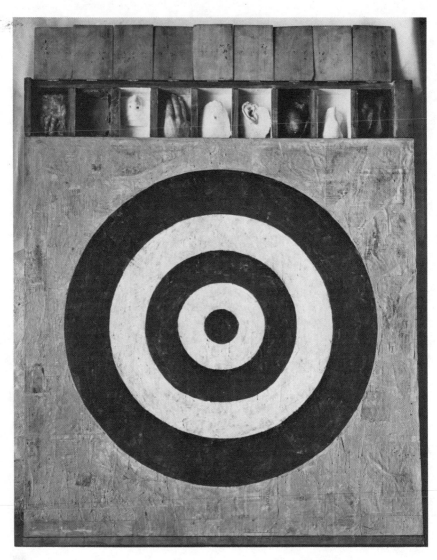

6. Jasper Johns, *Target with Plaster Casts*, 1955

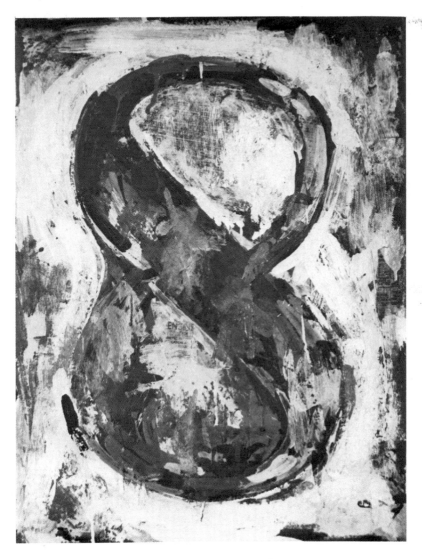

7. Jasper Johns, *Figure 8,* 1959

8. Jasper Johns, *Figure 5,* 1960

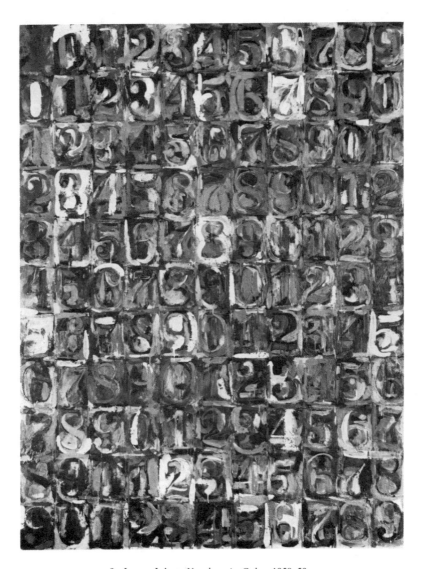

9. Jasper Johns, *Numbers in Color*, 1958–59

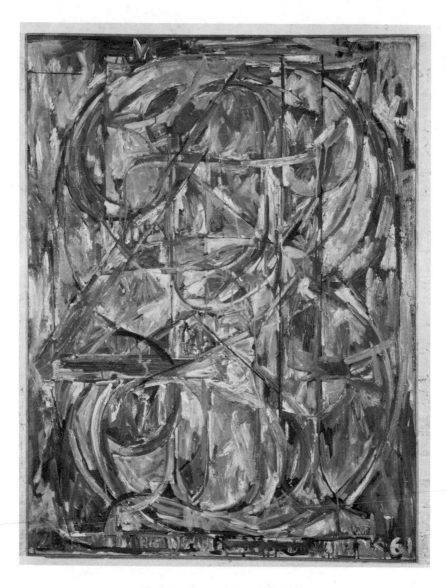

10. Jasper Johns, *0 Through 9*, 1961

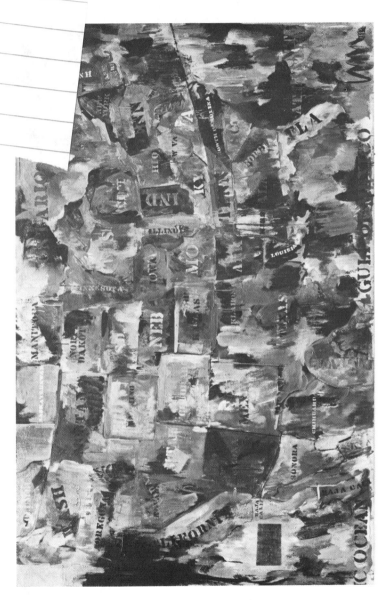

11. Jasper Johns, *Map*, 1962

12. Jasper Johns, *Map* (based on R. Buckminster Fuller's Dymaxion Air Ocean World Map), 1967–71

13. Jasper Johns, *Canvas,* 1956

14. Paul Cézanne, *Still Life*, ca. 1900

15. Jasper Johns, *Newspaper*, 1957

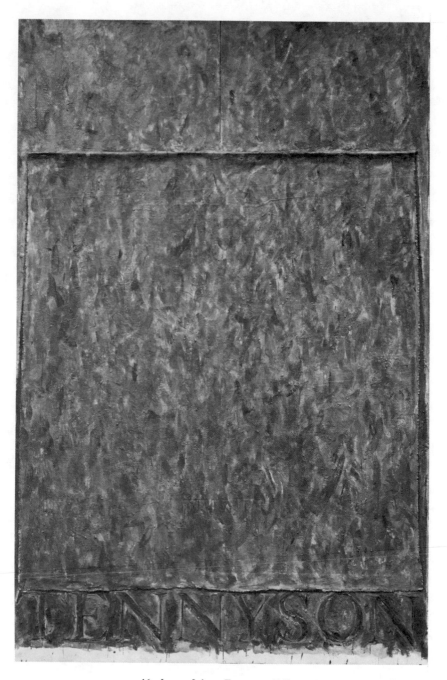

16. Jasper Johns, *Tennyson*, 1958

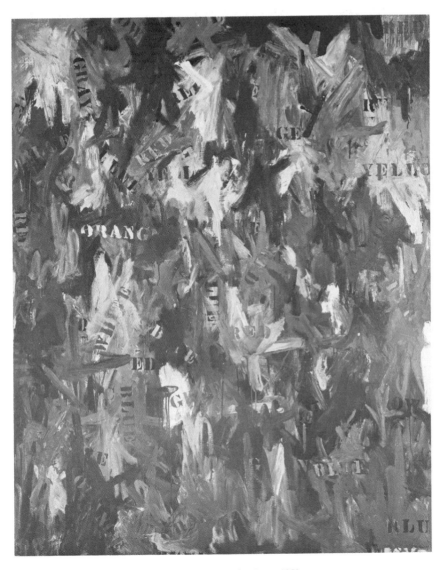

17. Jasper Johns, *False Start*, 1959

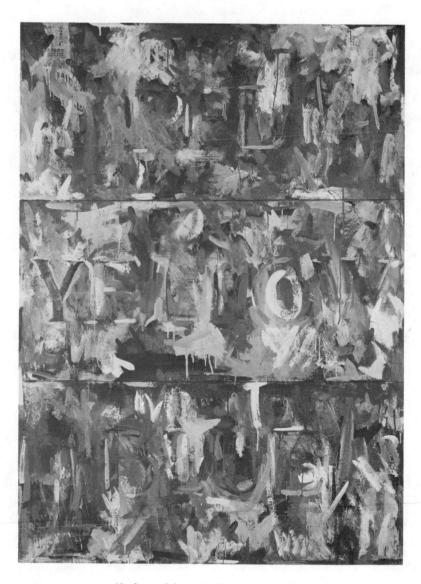

18. Jasper Johns, *Out the Window*, 1959

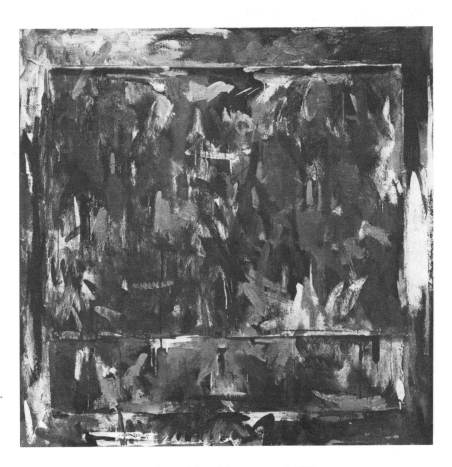

19. Jasper Johns, *Disappearance I*, 1960

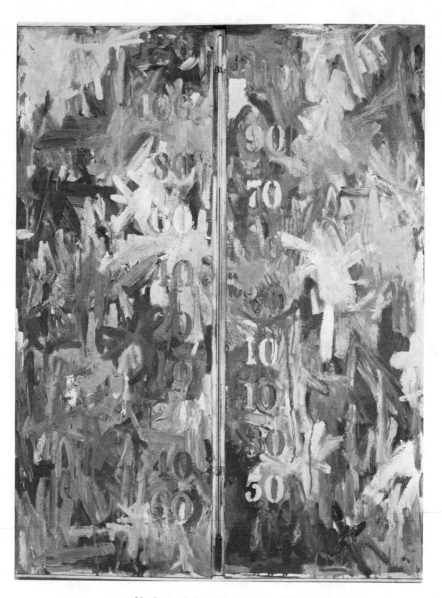

20. Jasper Johns, *Thermometer*, 1959

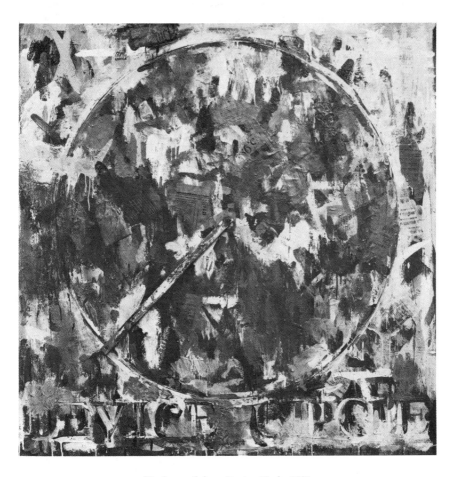

21. Jasper Johns, *Device Circle,* 1959

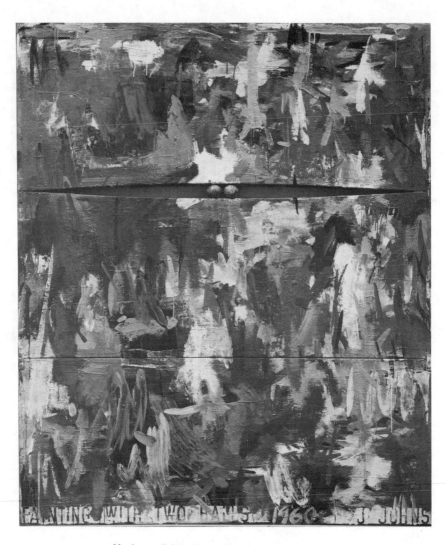

22. Jasper Johns, *Painting with Two Balls*, 1960

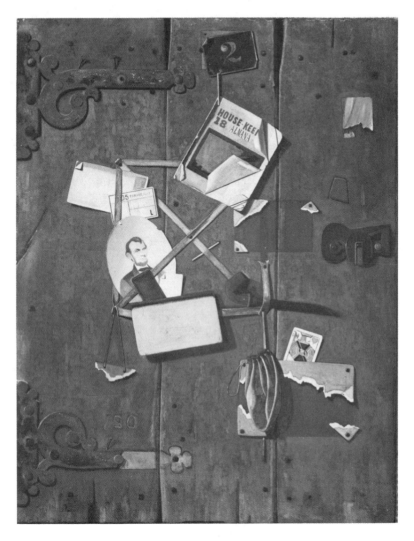

23. John F. Peto, *Rack Painting with Jack of Hearts,* 1902

24. Jasper Johns, *Light Bulb II*, 1958

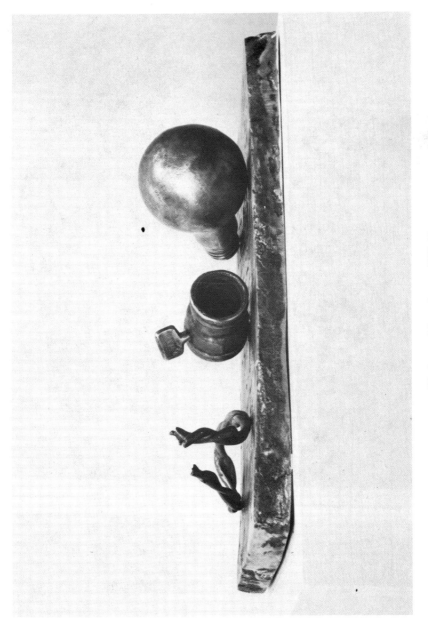

25. Jasper Johns, *Bronze*, 1960–61

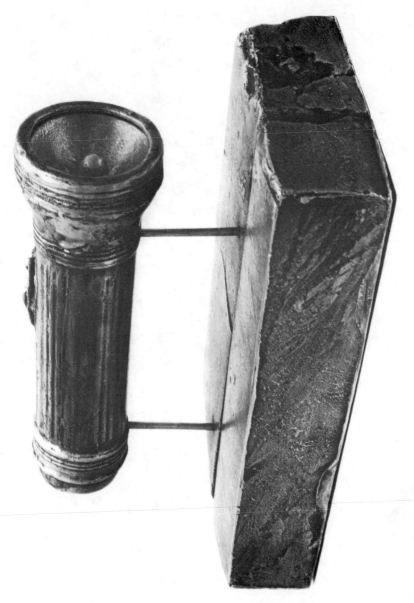

26. Jasper Johns, *Flashlight*, 1960

27. Jasper Johns, *Painted Bronze,* 1960

28. Jasper Johns, *The Critic Sees*, 1961

29. Jasper Johns, *Subway*, 1965

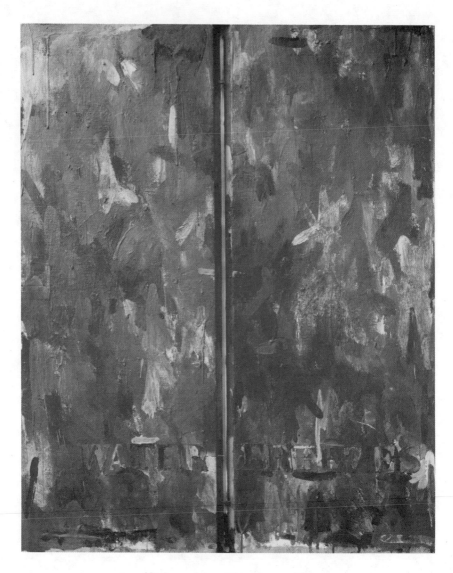

30. Jasper Johns, *Water Freezes,* 1961

31. Jasper Johns, *Painting Bitten by a Man*, 1961

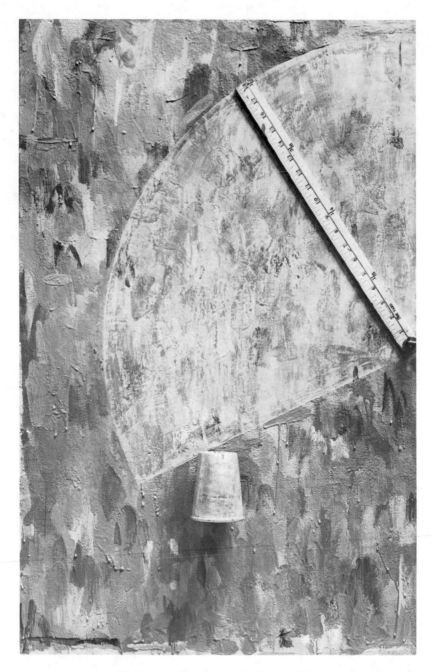

32. Jasper Johns, *Good Time Charley*, 1961

33. Jasper Johns, *In Memory of My Feelings—Frank O'Hara*, 1961

34. Jasper Johns, *Memory Piece (Frank O'Hara)*, 1961–70

35. Jasper Johns, *Studies for Skin I, II, III and IV*, 1962

36. Jasper Johns, *4 The News*, 1962

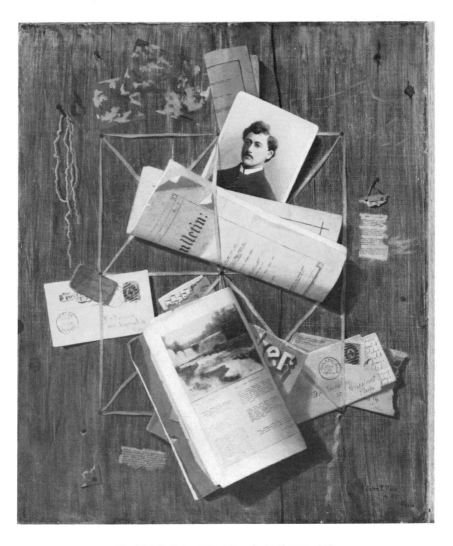

37. John F. Peto, *Office Board, April 1885*, 1885

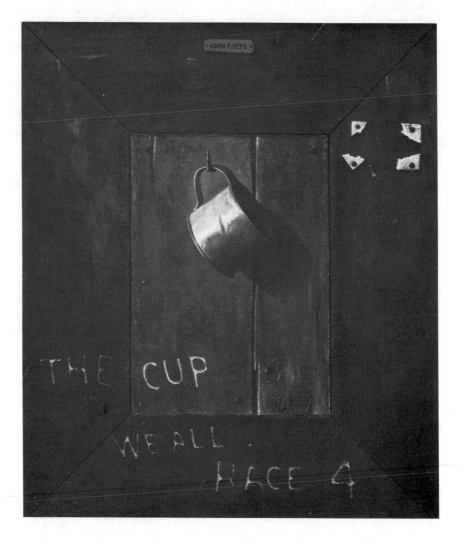

38. John F. Peto, *The Cup We All Race 4,* ca. 1900

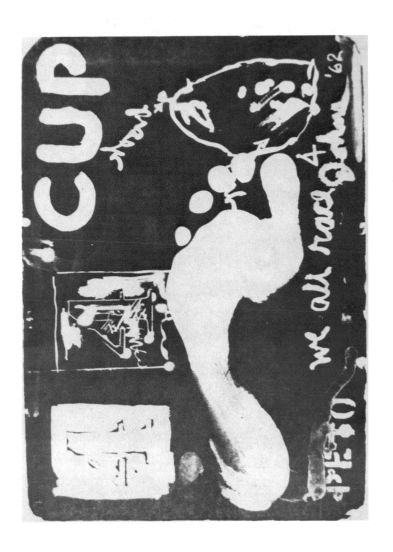

39. Jasper Johns, *Cup We All Race 4*, 1962

40. Jasper Johns, *Fool's House*, 1962

41. Jasper Johns, *M*, 1962

42. Jasper Johns, *Wilderness I*, 1963–70

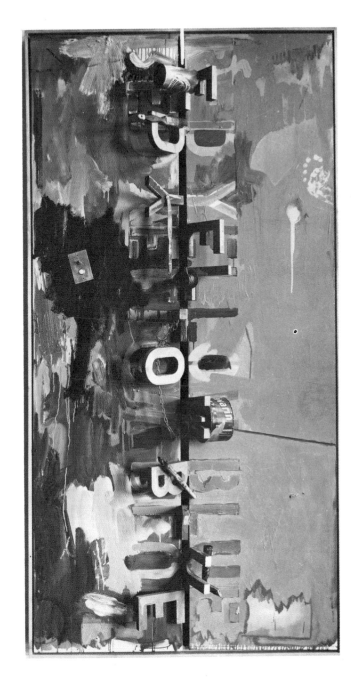

43. Jasper Johns, *Field Painting*, 1963–64

44. Jasper Johns, *Studio*, 1964

45. Jasper Johns, *Diver*, 1962

46. Jasper Johns, *Lands End*, 1963

47. Jasper Johns, *Arrive/Depart*, 1963–64

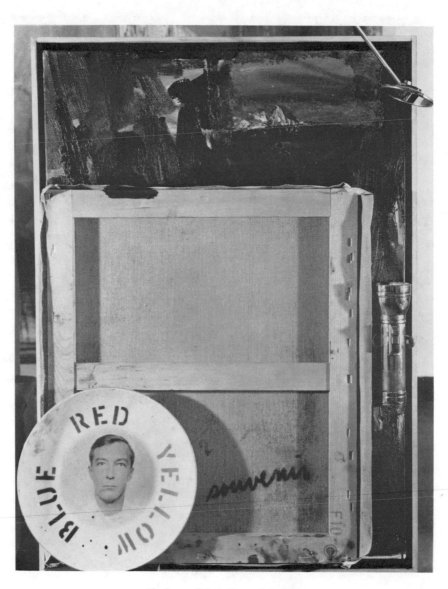

48. Jasper Johns, *Souvenir 2,* 1964

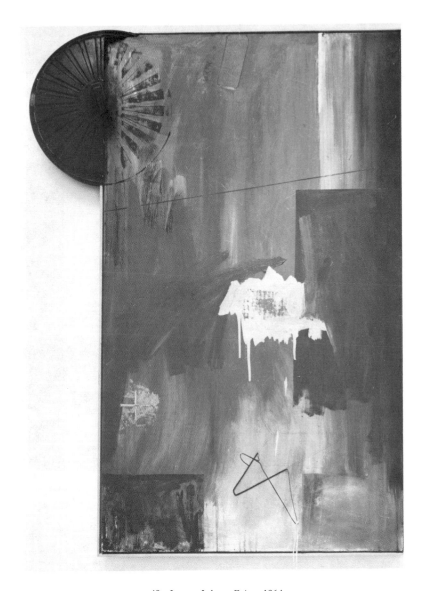

49. Jasper Johns, *Evian,* 1964

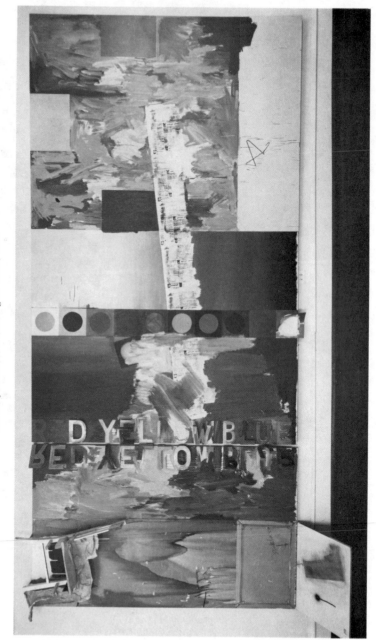

50. Jasper Johns, *According to What*. 1964

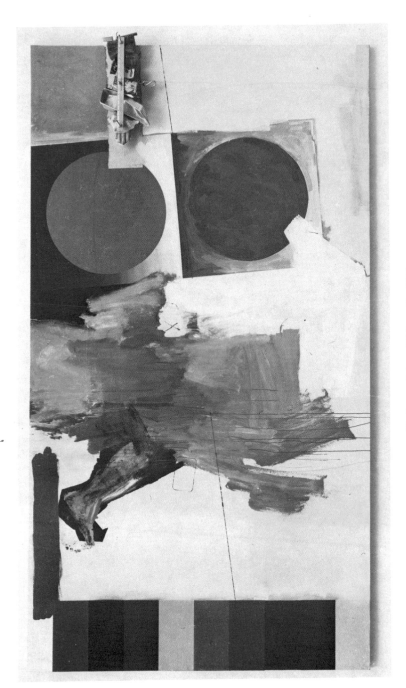

51. Jasper Johns, *Eddingsville*, 1965

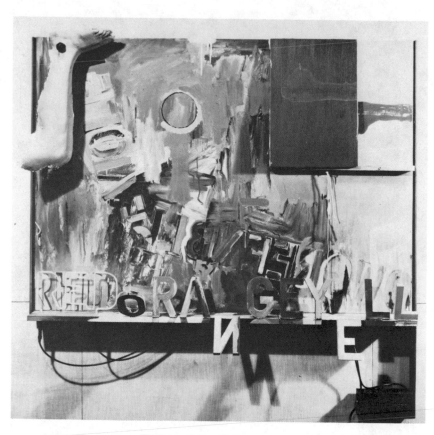

52. Jasper Johns, *Passage II*, 1966

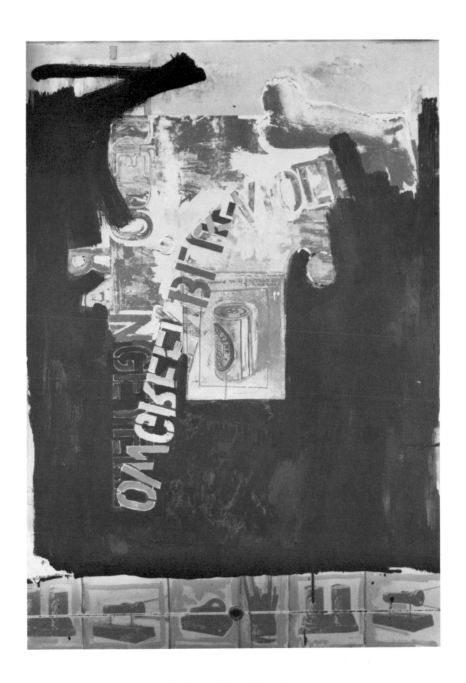

53. Jasper Johns, *Decoy,* 1971

54. Jasper Johns, *Harlem Light*, 1967

55. Jasper Johns, *Screen Piece 3*, 1968

56. Jasper Johns, *Voice,* 1964–67

57. Jasper Johns, *Untitled,* 1972

58. René Magritte, *The Proper Meaning IV*, 1928–29

59. Jasper Johns, *Corpse and Mirror*, 1974

60. Jasper Johns, *Scent*, 1973–74

Notes

Preface

1. Jasper Johns, [Statement], *Sixteen Americans,* exhibition catalogue, ed. Dorothy C. Miller (New York: Museum of Modern Art, 1959), p. 22.

2. Roberta Bernstein, unpublished "Journal": October 15 and November 5, 1967.

3. John Cage, "Jasper Johns: Stories and Ideas," in *A Year from Monday: New Lectures and Writings* (Middletown, CT: Wesleyan University Press, 1969), p. 83. (Originally published in *Jasper Johns,* exhibition catalogue, New York: The Jewish Museum, 1964).

4. Johns, [Statement], *Sixteen Americans,* p.22.

5. Calvin Tomkins in *Off the Wall: Robert Rauschenberg and the Art World of Our Time* (New York: Penguin Books, 1980) discusses Johns, Rauschenberg, Cage and Cunningham and the circumstances of their meeting and relationship to each other.

Chapter 1

1. Until about 1977 Johns' first *Flag* was dated 1954 by the Museum of Modern Art in New York and in the published literature. The dating has since been revised. According to Johns, the *Flag* was begun in 1954 and completed in 1955. The painting was damaged in Johns' studio in 1956 and repairs were made during that year (some collage fragments are dated 1956). See Joan Carpenter, "The Infra-Iconography of Jasper Johns," *Art Journal,* 36, no. 3 (Spring 1977): 224. Michael Crichton, *Jasper Johns,* exhibition catalogue, (New York: Harry N. Abrams and Whitney Museum of American Art, 1977), uses the date 1955.

2. Alan R. Solomon, "Jasper Johns," in *Jasper Johns,* exhibition catalogue (New York: Jewish Museum, 1964), p. 6, mentions the flag dream. I have heard Johns mention this dream a few times in unrecorded conversations. The revelation of Johns' initial, generative work in a dream is similar to the way solutions to problems or changes in thinking usually occur to creative individuals. Thomas S. Kuhn, *The Structure of Scientific Revolutions* (Chicago: University of Chicago Press, 1970), pp. 121-22, writes that major changes in scientific thinking occur "not by deliberation and interpretation, but by a relatively sudden and unstructured event like the gestalt switch. Scientists then often speak of the 'scales falling from the eyes' or the 'lightning flash' that 'inundates' a previously obscure puzzle, enabling its components to be seen in a new way that for the first time permits its solution. On other occasions the relevant illumination comes in sleep. . . . "

3. Leo Steinberg, "Jasper Johns: The First Seven Years of His Art," in *Other Criteria: Confrontations with Twentieth-Century Art* (New York: Oxford University Press, 1972), pp. 26-48 (originally published in *Metro*, nos. 4/5, May 1962, and by George Wittenborn, New York, 1963), lists and discusses the following eight qualities which Johns' flat subjects have in common. (1) Whether objects or signs, they are man-made things. (2) All are commonplaces of our environment. (3) All possess a ritual or conventional shape, not to be altered. (4) They are either whole entities or complete systems. (5) They tend to prescribe the picture's shape and dimensions. (6) They are flat. (7) They tend to be non-hierarchic, permitting Johns to maintain a pictorial field of leveled equality, without points of stress or privilege. (8) They are associable with sufferance rather than action.

4. Ibid., pp. 22-28.

5. Ibid., p. 31.

6. Johns has throughout his career maintained a stance of self-detachment about his work. In a 1973 interview he said: "I have attempted to develop my thinking in a way that the work I've done is not me." See Vivien Raynor, "Jasper Johns," *Art News*, 72, no. 3 (March 1973): 20-22. However, there is a significant change from 1961 on, when emotional conditions and sometimes specific autobiographical references play a central role in many of Johns' works.

7. The three panels are: (a) the blue star field, (b) the area of stripes next to it, and (c) the area below running the entire width of the flag.

8. Steinberg, p. 44, writes: "The red and white stripes do not—as in a normal striped pattern—form a figure-ground hierarchy. They are, in their familiar symbolic role, wholly equivalent. In other words, the alternation of red and white stripes in the American flag is much flatter than similar stripes on a T-shirt would be. As for the stars on the blue ground, here, as in all situations threatening a figure-ground differential, Johns employs all his techniques to cancel the difference."

9. Suzi Gablik, "René Magritte," *Artforum*, 4 no. 4 (December 1965): 31.

10. Steinberg, p. 42, writes: "You can't smoke Magritte's painted pipe, but you can throw a dart at a Johns target, or use his painted alphabets for testing myopia."

11. Roberta Bernstein, "An Interview with Jasper Johns," in *Fragments: Incompletion and Discontinuity*, ed. Lawrence D. Kritzman (New York: New York Literary Forum, 1981), p. 287.

12. *Magritte: Word vs. Image*, exhibition catalogue (New York: Sidney Janis Gallery, 1954).

13. Robert Rosenblum, "Magritte's Surrealist Grammar," *Art Digest*, 28, no. 12 (March 1954): 32.

14. Johns could have known the works of the late nineteenth-century American still-life painters through Alfred Frankenstein's book, *After the Hunt: William Harnett and other American Still Life Painters*, originally published in 1953, the year before Johns' first *Flag* was begun. There was a Peto exhibition (fifty-one paintings, his first solo exhibition) at the Brooklyn Museum in 1950, which Johns may have seen. Alfred Frankenstein, "Fooling the Eye," *Artforum*, 12, no. 9 (March 1971): 32-35, reproduces a Johns' painting (*M*, 1962) along with examples of American *trompe l'oeil* still life, but does not discuss Johns' work. Barbara Rose, "Decoys and Doubles: Jasper Johns and the Modernist Mind," *Arts*, 50, no. 9 (May 1976): 68-73, discusses some aspects of Johns' relationship to Harnett, Peto and Haberle.

15. Steinberg, p. 52. Crichton, p. 26, writes that one day in 1954 Johns destroyed all his works in his possession.

16. Steinberg, p. 21.

17. Calvin Tomkins, *Off the Wall: Robert Rauschenberg and the Art World of Our Time* (New York: Penguin Books, 1980), p. 111, writes that Johns did "a series of drawings in 1954 that both Rauschenberg and Cage greatly admired, polished lead drawings of potatoes, but so black it was hard to make out the image." These two *Untitled* drawings from 1954 are possibly from or related to this series.

18. Steinberg, pp. 52-53.

19. Mark Stevens with Cathleen McGuigan, "Super Artist: Jasper Johns, Today's Master," *Newsweek* (October 24, 1977): 79, reproduces an ink drawing by Johns, *Idiot,* ca. 1952, which has a sentimental, humanizing quality. Other early works may be related in mood to Picasso's Blue or Rose period paintings or Walt Kuhn's clown paintings, which Johns has told me he admires (unrecorded conversations with the artist).

20. Bernstein, unpublished "Journal": May 30, 1970. (Hereafter cited as "Journal" with date of entry.) Crichton, p. 26, mentions that *Star* was Johns' first commission. Johns' friend Rachel Rosenthal, after seeing his painting *Cross,* said she would buy it if it were a Jewish star. Johns then did *Star* and Rosenthal bought it.

21. "Journal": December 25, 1968. I asked Johns who his favorite contemporary artists were and he mentioned de Kooning and Newman along with Duchamp and Picasso.

22. Irving Sandler, *The Triumph of American Painting: A History of Abstract Expressionism* (New York: Frederick A. Praeger, 1970), p. 2, writes that by 1952 "the main tendencies in Abstract Expressionism had been established and accepted at least by the artists themselves."

23. Ad Reinhardt's purist theories are relevant to the classicizing aspect of Johns' work. Sandler, p. 232, writes that Reinhardt's goal was to create "an extreme, classicizing abstract art whose predetermined, schematic and repetitive form was impersonal and impassive." However, as Sandler points out, in spite of Reinhardt's anti-romantic theorizing, his works have a romantic quality characteristic of the entire Abstract Expressionist milieu.

24. Jasper Johns, [Statement], in *Sixteen Americans,* exhibition catalogue, ed. Dorothy C. Miller (New York: Museum of Modern Art, 1959), p. 22.

25. Carpenter: 224, in discussing Johns' use of collage in *Flag,* 1954-55, does not mention the embossed seal (nor the word "pipe" mentioned earlier), but other relevant collage materials including an outline map of the United States.

26. See Appendix B for a list of all Johns' *Flag* paintings in each category. Richard S. Field, "Jasper Johns' Flags," *Print Collector's Newsletter,* 7, no. 3 (July-August 1976): 69-77, provides a survey of Johns' *Flags* which includes some of the points I bring up in my discussion, and his own list of *Flag* categories.

27. Kasimir Malevich, "Suprematism," in *Theories of Modern Art: A Source Book by Artists and Critics,* ed. Hershel B. Chipp (Berkeley and Los Angeles: University of California Press, 1971), p. 341.

28. Tomkins, "Robert Rauschenberg," in *The Bride and the Bachelors* (New York: Viking Press, 1965), p. 203.

29. Tomkins, "John Cage," *Bride,* pp. 118-119.

30. John Cage, "On Robert Rauschenberg, Artist and His Work," in *Silence* (Cambridge, MA: M.I.T. Press, 1967), pp. 102, 108.

31. Susan Sontag, *Styles of Radical Will* (New York: Dell, 1969), p. 13.

32. Ibid., p. 10.

33. Johns, [Statement], *Sixteen Americans*, p. 22.

34. See discussion of Johns' *Gray Rectangles*, 1957, in Chapter 2.

35. Steinberg, p. 41.

36. Unrecorded conversation with the artist. After *Flag Above White with Collage*, Johns eliminated any obvious connection between the flag motif and figure. However, in 1965 he did a small red, white and blue *Flag* in which he again used four souvenir snapshots; this time he used pictures of his friend Suzi Gablik, for whom he did the painting.

37. Walter Hopps, "An Interview with Jasper Johns," *Artforum*, 3, no. 6 (March 1965): 34. Carpenter: 221-27, points out the variety of Johns' collage materials in some of his early works and makes a convincing case that many were consciously chosen for their personal or artistic references. She focuses primarily on Johns' hidden collage revealed by infrared photography, in *Flag*, 1954-55, *Target with Four Faces*, 1955, and *Green Target*, 1955. She does not discuss Johns' use of collage in *Flag Above White with Collage* or *Newspaper*, 1956, both of which specifically focus on collage as subject.

38. Hopps: p. 36.

39. See Crichton, pp. 35-6, where Johns discusses the specially made canvas stretchers for this painting, and his "moral conflict about whether to paint the covered portions." He painted the covered areas in gray.

40. Unrecorded conversation with the artist.

41. "Journal": April 3, 1970. Johns and I were discussing Barbara Rose's "The Graphic Work of Jasper Johns: Part I," *Artforum*, 8, no. 7 (March 1970): 39-45. In her essay, Rose writes that "paper *is* surface and surface alone." Johns made a strong point of saying that this was wrong—for him. Pieces of paper with bent corners appear frequently in *trompe l'oeil* still lifes where they function, as in Johns' drawing, to provoke the viewer to experience the paper as a tangible object.

42. Conversation with Johns' assistant, Mark Lancaster, May 1984. See also Field: pp. 74-75.

43. Unrecorded conversation with the artist. Henry Geldzahler, *American Painting in the Twentieth Century* (New York: Metropolitan Museum of Art, 1965), p. 216, writes the following about Stettheimer: "Paintings that seemed merely eccentric during the artist's lifetime have turned out to be prophetic of a concern with Americana that is shared by a number of painters in the nineteen-sixties."

44. "People's Flag Show," poster for exhibition at the Judson Memorial Church, New York, November 1970.

45. Johns has said he "cares about what goes on politically" ("Journal": July 6, 1967), but he does not except on rare occasions, take sides on political issues or participate in protest events or exhibitions. Moira Roth, "The Aesthetic of Indifference," *Artforum*, 16, no. 3 (November 1977): 46-53, sees Johns' stance of "neutrality, passivity, irony and often negation" rooted in the politics of his formative years, particularly the McCarthy period when Johns did his first *Flag*. She views Johns' art and attitude "in the Cold War context in order, first, to understand

the art itself, and second, to explain, at least in part, the bizarre disjunction of art and politics that emerged in the 1960s." She groups Johns with Duchamp, Cage and Rauschenberg as the most influential artists who espoused the Aesthetic of Indifference in the 1950s and 1960s.

46. Cage, "Jasper Johns: Stories and Ideas," in *A Year from Monday: New Lectures and Writings* (Middletown, CT: Wesleyan University Press, 1969), p. 77.

47. Crichton, p. 30, writes about the relationship of the construction of this *Target* to *Toy Piano:* "... he originally intended the hinged doors to be keys, attached to wires that ran behind the canvas. When you pressed one of the trapdoor 'keys' a sound would issue from the canvas-target. But Johns abandonned this idea when he couldn't think of a suitable hidden mechanism for making sound."

48. Johns told me that *Target with Plaster Casts* was rejected from the 1957 exhibition, "Artists of the New York School: Second Generation," at the Jewish Museum, New York. He said that someone on the selection committee suggested that if the *Target* were to be shown, some of the boxes should be closed to make the piece more "mysterious." Johns interpreted this to mean the boxes with the penis and the bone that looked like female genitalia were considered offensive and that the piece would be acceptable only if they were hidden from view. ("Journal": March 6, 1970.)

49. Johns could have seen Picabia's *Spanish Night* in the 1953 "Dada" exhibition at the Sidney Janis Gallery. William A. Camfield, *Francis Picabia,* exhibition catalogue (New York: Solomon R. Guggenheim Foundation, 1970), p. 123, mentions the connection between the "erotic targets" in *Spanish Night* and the work of several contemporary artists including Johns. William S. Rubin, *Dada, Surrealism, and their Heritage,* exhibition catalogue (New York: Museum of Modern Art, 1968), p. 29, illustrates Picabia's *Optophone* and Johns' *Target* side by side, but does not compare them in his text. See also Robert Pincus-Witten, "On Target: Symbolist Roots of American Abstraction," *Arts,* 50, no. 8 (April 1976): 84-91, who discusses Johns' *Targets* in relation to Duchamp's work. He writes the following on Picabia: "Sexual aggression is surely embedded in such a direct functional connection as the one Picabia makes between target and sexuality."

50. This work was also in the 1953 "Dada" exhibition at the Sidney Janis Gallery, at that time titled, *Wooden Dada Head.*

51. This painting is reproduced in James Thrall Soby, *René Magritte,* exhibition catalogue (New York: Museum of Modern Art, 1965), p. 37.

52. Max Kozloff, "Division and Mockery of the Self," *Studio International,* 179, no. 918 (January 1970): 11, illustrates Magritte's *Bold Sleeper* and Johns' *Target* on the same page, but Kozloff compares the Magritte with Rauschenberg's *Bed,* 1955, not with Johns' painting.

53. Solomon, p. 9. Tomkins, *Off the Wall,* p. 138, says that Rachel Rosenthal had been the model for earlier casts, e.g., *Untitled Construction,* 1954, but she had moved by the time Johns did *Target with Four Faces* and another friend, Fance Stevenson, was the model.

54. In Bernstein, "Interview," *Fragments,* p. 287, Johns says that he saw his first Cornells about the same time he saw his first Magrittes, in 1954. See Kynaston McShine, ed., *Joseph Cornell,* exhibition catalogue (New York: Museum of Modern Art, 1980), for reproductions of *Medici Slot Machine,* 1942 (plate 117) and other related Cornells.

55. Tomkins, *Off the Wall,* p. 140, quotes Leo Castelli on his reaction to *Green Target* during his first viewing of Johns' work: "I saw it as a green painting, not even a target.... A green painting with collage elements. I was thunderstruck." Johns told me that originally *Target with Plaster Casts, White Flag,* 1955, and maybe *Tango,* 1955, were to be in the 1957 Jewish

Museum exhibition, but they were all rejected and *Green Target* was chosen instead. ("Journal": March 6, 1970.)

56. Conversation with Frank Stella, Fall 1973.

57. Cage, "Jasper Johns," p. 180.

58. "Journal": April 3, 1970.

59. Johns could have seen Demuth's *Figure 5 in Gold* at the Metropolitan Museum of Art during the early 1950s. It was acquired by the Museum in 1949, the year Johns moved to New York.

60. Robert Scull told me in a conversation, Fall 1972, that he chose "5" because it was the family's lucky number.

61. Unrecorded conversation with the artist.

62. Cage, "Jasper Johns," p. 81.

63. Unrecorded conversation with the artist.

64. This series of lithographs—three portfolios of ten prints each—was Johns' most elaborate use of the "0 to 9" arrangement in two horizontal rows, in this case combined with single figures. Each of the ten prints is related to the others as part of an ordered sequence, since the same stone was reworked and used for each: i.e., the stone for "0" was used for "1," with the "0 to 9" motif remaining the same in both. Johns' *Black and White Numerals*, 1968 (Field 94-103) were also conceived as a series, "0 to 9," but each is seen as an independent figure, and each was done on a separate stone. *Color Numerals*, 1968-69 (Field 104-113), were mostly done using the same stones as the black and whites; they are related to each other as a series by the color bands which are arranged in a systematic progression from one print to the next.

65. Steinberg, p. 52.

66. *Three Generations of Twentieth-Century Art: The Sidney and Harriet Janis Collection of the Museum of Modern Art*, exhibition catalogue (New York: Museum of Modern Art, 1972), p. 148.

67. There was an exhibition, "Claude Monet: Seasons and Moments," at the Museum of Modern Art, March-May 1960, which Johns may have seen; it included several of Monet's serial images, including six *Rouen Cathedral* paintings.

68. Crichton, p. 45, writes that Rauschenberg gave Johns a schematic map of the United States and Johns painted over it. Rauschenberg had used maps as prominent collage elements in several works, including *Small Rebus*, 1956 (Forge 209).

69. Cage, "Jasper Johns," p. 76. In *Small Map*, 1962, a transfer grid is visible through the layer of encaustic.

70. This and the following quotations are taken from an essay accompanying a 1967 edition of Fuller's "Dymaxion Air Ocean World Map."

71. During a conversation with Johns, when he was working on the *World Map* he told me he thought Fuller was a "genius" but "too optimistic." See also Rolf-Dieter Herrmann, "Johns the Pessimist," *Artforum*, 16, no. 2 (October 1977): 26-33.

72. Unrecorded conversation with the artist.

Chapter 2

1. Max Kozloff, *Jasper Johns* (New York: Harry N. Abrams, 1969), p. 15.

2. Johns has said this several times. In a conversation, November 15, 1974, he confirmed to me that he was not familiar with Duchamp's work until after his first solo exhibition which was held at the Leo Castelli Gallery in 1958. (See Chapter 4 for a detailed discussion of Johns and Duchamp.)

3. Michael Crichton, *Jasper Johns,* exhibition catalogue (New York: Harry N. Abrams and Whitney Museum of American Art, 1977), p. 30, notes that the music box originally played "Silent Night," but Johns altered it to make abstract plinking sounds. This information was first cited in "His Heart Belongs to Dada," *Time,* 73 (May 4, 1959): 58.

4. Charlotte Willard, "Eye to I," *Art in America,* 54, no. 2 (March-April 1966): 57.

5. Barbara Rose, "Decoys and Doubles: Jasper Johns and the Modernist Mind," *Arts,* 50, no. 9 (May 1976): 72-73, reproduces Peto's *Lincoln and the Phleger Stretcher* and discusses it as a precedent for the painting as object in Johns' work.

6. Alfred Frankenstein, *The Reality of Appearance: The Trompe l'Oeil Tradition in American Painting,* exhibition catalogue (Greenwich, CT: New York Graphic Society, 1970), p. 54.

7. Johns has told me several times that gray is his favorite color. In a conversation, November 15, 1974, he said that he had heard about psychological tests showing that people who prefer gray are more emotionally repressed than people who prefer other colors.

8. Joseph E. Young, "Jasper Johns: An Appraisal," *Art International,* 13, no. 7 (September 1969): 50.

9. Leo Steinberg, "Jasper Johns: The First Seven Years of His Art," in *Other Criteria: Confrontations with Twentieth-Century Art* (New York: Oxford University Press, 1972), p. 19.

10. Walter Hopps, "An Interview with Jasper Johns," *Artforum,* 3, no. 6 (March 1965): 34.

11. Michel Faré, *La Nature Morte en France du XVIIe au XXe siècle: son histoire et son evolution,* vol. 1 (Geneva: Pierre Cailler, 1962), p. 107.

12. Ibid., p. 110.

13. Later, in *4 The News,* 1962, Johns makes a direct reference to Peto's use of newspaper by including a folded newspaper wedged between panels. (See Chapter 5.)

14. Roberta Bernstein, "Rauschenberg's *Rebus,*" *Arts,* 52, no. 5 (January 1978): 138-141, discusses Rauschenberg's involvement with the relationship between words and images and his breaking down of hierarchies between "high" and "low" art. The title "Rebus," chosen by Johns, reinforces the focus on the interplay of words and images in the painting and its importance in both artists' works at the time.

15. Kozloff, p. 27.

16. Hopps, p. 36.

17. Alan R. Solomon, "Jasper Johns," in *Jasper Johns,* exhibition catalogue (New York: Jewish Museum, 1964), p. 13.

18. John Cage, "Jasper Johns: Stories and Ideas," in *A Year from Monday: New Lectures and Writings* (Middletown, CT: Wesleyan University Press, 1969), p. 79, writes: "Once when I

visited him he was working on a painting called *Highway*. After looking at it, I remarked that he had put the word right in the middle. When I left he painted over it so that the word, still there, is not legible."

19. Solomon, p. 13.

20. See E.B. Hennings, "*Reconstruction:* A Painting by Jasper Johns," *Bulletin of the Cleveland Museum of Art,* 60, no. 8 (October 1973): 234-241.

21. Cage, p. 80.

22. Suzi Gablik, *Magritte* (Greenwich, CT: New York Graphic Society, 1970), p. 75.

23. Johns' first sculpture on the theme of the critic, *The Critic Smiles,* was done in 1959. After 1959, Johns did several works dealing with the subject of the spectator/critic.

24. Johns did studies for three, possibly four "Devices," all of which may have been planned in 1959 before or right after *Device Circle* was made. (I have seen these drawings in Johns' collection.) One study is basically the same in format as the completed *Device Circle*, but the circle is exactly centered in the square and the title is not included. Another "Device" study shows two half circles drawn by two sticks attached at the center of the side edges. This design is the basis for *Device*, 1961-62 (Cri. 91), and *Device*, 1962 (Koz. 68). In both studies it looks as though a pencil is stuck through a hole at the end of the sticks to do the marking. In another study, what looks like a pencil is left in the completed work after it has been used to draw a line dividing the square field in half vertically. A fourth study (not labeled "Device" like the others, but done on the same kind of paper, probably at the same time) shows a diamond set into a square field (like the folded canvas in *Disappearance II*) with what appears to be moveable sticks along the edges. It is, however, impossible to figure out from this study (like the others only drawn as sketches) how these are meant to work.

25. Richard S. Field, *Jasper Johns: Prints 1960-1970,* exhibition catalogue (Philadelphia: Philadelphia Museum of Art, 1970).

26. Crichton, p. 47, notes that Johns intended to make the painting by joining the panels together and then pushing the balls in between them. However, this did not work and Johns had two custom-made stretchers constructed. This technique, then, does create an illusion, but of a different kind than Motherwell's. Johns himself says: "In the painting now there is no tension. It's all illusion." (Crichton, p. 68, no. 67) However, this is just the type of ambiguity Johns cultivates in his work, because of the way it calls the nature of the object into question.

27. Rosalind Krauss, "Jasper Johns," *Lugano Review II,* 1, no. 2 (1965): 97, n. 20.

Chapter 3

1. Johns said the shapes of his 1958 sculpmetal-coated *Light Bulbs* were built up with various small objects; he said he could not remember what the objects were, but probably nails were among the materials used. (Roberta Bernstein, unpublished "Journal": March 6, 1970. Hereafter cited as "Journal" with date of entry.)

2. Unrecorded conversation with the artist.

3. "Journal": March 6, 1970. Johns' assistant, Mark Lancaster, told me in a conversation, May 1984, that he had pointed out to Johns the difference between English and American light bulbs. When Johns found an English bulb on the beach in North Carolina, he made the sculpture for Lancaster, whose name is on the base.

4. "Journal": March 6, 1970. Polyvinyl chloride is a material Gary Stephan (who worked for Johns in 1970) was using for his paintings at the time. Johns was intrigued by the qualities of the material and decided to use it in this sculpture.

5. Johns always uses standardized objects, so that his personal taste is not an obvious part of the meaning of his works. However, in a 1965 interview (David Sylvester, "Interview," in *Jasper Johns Drawings,* exhibition catalogue, London: Arts Council of Great Britain, 1974, pp. 7-8), Johns talked about the model for his *Flashlight* sculptures: "...I had this image of a flashlight in my head and I wanted to go buy one as a model. I looked for a week for what I thought was an ordinary flashlight, and I found all kinds of flashlights with red plastic shields, wings on the sides...and I finally found one that I wanted. And it made me very suspect of my idea, because it was so difficult to find this thing I had thought was so common. And about that old ale can which I thought was very standard and unchanging, not very long ago they changed the design of that...it turns out that actually the choice is quite personal and is not really based on one's observations at all." Also cited in Max Kozloff, *Jasper Johns* (New York: Harry N. Abrams, 1969), pp. 31-32.

6. Roni Feinstein, "New Thoughts for Jasper Johns' Sculpture," *Arts,* 54, no. 8 (April 1980): 149. Feinstein also argues that Johns' early sculptures are erotic objects directly influenced by Duchamp.

7. Walter Hopps, "An Interview with Jasper Johns," *Artforum,* 3, no. 6 (March 1965): 36.

8. G.R. Swenson, "What is Pop Art? Part II: Jasper Johns," *Art News,* 62, no. 10 (February 1964): 66.

9 Johns told me that one of the original ale can models was lost or stolen; he still has the closed one. ("Journal": May 13, 1973.) A photograph of the model for the closed ale can appears in Johns' lithograph and painting, *Decoy,* 1971 (Plate 53) (Field 134).

10. Hopps: 36. In Michael Crichton, *Jasper Johns,* exhibition catalogue (New York: Harry N. Abrams and Whitney Museum of American Art, 1977), p. 43, Johns says: "Doing the ale cans made me see other things around me, so I did the Savarin can. I think what interested me was the coffee can used to hold turpentine for brushes—the idea of one thing mixed with another for a purpose."

11. In Crichton, p. 42, Johns says the following about *The Critic Smiles:* "I had the idea that in society the approval of the critic was a kind of cleansing police action. When the critic smiles it's a lopsided smile with hidden meanings. And of course a smile involves baring the teeth. The critic is keeping a certain order, which is why it is like a police function. The handle has the word 'copper' on it, which I associate with police. I imagined the sculpture to be done in various metals—base lead, handle silver and teeth gold."

12. Kozloff, p. 10. See also Crichton, p. 48.

13. Ibid.

14. Richard S. Field, *Jasper Johns: Prints 1960-1970,* exhibition catalogue (Philadelphia: Philadelphia Museum of Art, 1970). Johns did a print, *Summer Critic* (Field 55), that same year, first published in Shuzo Takiguchi, *To and From Rrose Selavy,* selected works of Marcel Duchamp, with special contributions: A Self-Portrait in Profile by Marcel Duchamp and Works by Shusaku Arakawa, Jasper Johns and Jean Tinguely (Tokyo: Rrose Selavy, 1968). In this version, the word "mouth" is silkscreened onto green acetate, indicating the casts of mouths in the sculpture. An embossed print of *The Critic Sees* (Field 68) was done the next year, 1967, with "mouth" printed on clear acetate.

15. John Cage, "Jasper Johns: Stories and Ideas," in *A Year from Monday: New Lectures and Writings* (Middletown, CT: Wesleyan University Press, 1969), p. 17.

16. Alan R. Solomon, *Jasper Johns: Lead Reliefs* (Los Angeles: Gemini, G.E.L., 1969).

17. Trevor Winkfield, [Back Cover], *Julliard* (Leeds, England: Winkfield, Winter 1968-69).

18. Johns' parents were divorced when he was a young child, and he lived with various relatives and sometimes with his mother and stepfather. He seems to have had less contact with his father. Cage, p. 78, writes: "[Johns] went to college for a year and a half in Columbia [South Carolina] where he lived alone. He made two visits during that time, one to his father and one to his mother."

Chapter 4

1. Jasper Johns, [Statement], *Sixteen Americans*, exhibition catalogue, ed. Dorothy C. Miller (New York: Museum of Modern Art, 1959), p. 22.

2. See Leonardo da Vinci, *Treatise on Painting*, trans. A. Philip McMahon, intro. by Ludwig H. Heidenreich (Princeton: Princeton University Press, 1956).

3. Roberta Bernstein, unpublished "Journal": July 6, 1967. (Hereafter cited as "Journal" with date of entry.) From the same "Journal" entry: "In a shopping center [in Norfolk, Virginia, on our way back to Nags Head, North Carolina] we saw a three-dimensional, life-size version of Leonardo's *Last Supper* in wax, exhibited in a trailer truck. Johns remarked: 'My favorite painter in my favorite medium!' The only other Old Master artists I have heard Johns express admiration for are Dürer and Grünewald."

4. Max Kozloff, *Jasper Johns* (New York: Harry N. Abrams, 1969), p. 38.

5. John Cage, "Jasper Johns: Stories and Ideas," in *A Year from Monday: New Lectures and Writings* (Middletown, CT: Wesleyan University Press, 1969), p. 75. Kozloff, p. 38, pointed out the possible connection between this Note and Leonardo's *Deluge* drawings.

6. Johns, "Duchamp," *Scrap*, no. 1 (December 23, 1960): 4.

7. The above information can be found in Kozloff, p. 24 and Rosalind Krauss, "Jasper Johns," *Lugano Review II*, 1, no. 2 (1965): 84. Johns' relationship with Duchamp has been discussed by many authors since Kozloff's "Johns and Duchamp," *Art International*, 3, no. 2 (March 1964): 42-45.

8. Johns owns the following works by Duchamp: *The Bride Stripped Bare by Her Bachelors, Even (The Green Box)*, 1934 (Sch. 293); *From or by Marcel Duchamp or Rrose Selavy (The Box in a Valise)*, original edition 1941 (I do not know which edition Johns has) (Sch. 332); *A l'Infinitif (The White Box)*, 1967; *Female Fig Leaf*, bronze edition, 1 of 10 (unnumbered), issued by Galerie Rive Droite, 1961 (Sch. 332); *Objet-Dard (Dart-Object)*, painted bronze, edition 6/8, issued by Galleria Schwarz, 1962 (Sch. 335); *Wedge of Chastity*, bronze and dental plastic, edition 7/8, issued by Galleria Schwarz, 1963 (Sch. 338); *Bouche-Évier*, stainless steel edition, AP IV, issued by International Collector's Society, 1967 (Sch. 371); "*Pulled at Four Pins*," etching, edition 91/100, 1964 (Sch. 372); *L.H.O.O.Q. Shaved*, 1965 (Sch. 375); *The Chess Players*, etching, edition 36/50, 1965 (Sch. 380); *Self-Portrait in Profile: Marcel Duchamp La Hune, 1959*, poster edition 8/40 (Sch. 350); "*A Poster Within a Poster*" (Pasadena Art Museum), edition of 20 signed copies, 1963 (Sch. 363); *Cover for the Catalogue Le Surrealisme en 1947* (Sch. 328); *Cover for View (New York), Marcel Duchamp Number, V, No. 1 (March 1945)* (Sch. 322); *Cover for Transition (New York), No. 26 (Winter 1937)* (Sch. 302). Johns has possibly acquired other works by Duchamp since I made this list

in 1970. Johns also owns many books and catalogues on Duchamp and several posters not included in the above list.

9. Marcel Duchamp, *The Bride Stripped Bare by her Bachelors, Even,* a typographic version by Richard Hamilton of Marcel Duchamp's *Green Box,* trans. George H. Hamilton (New York: Wittenborn and Company, 1960).

10. Robert Lebel, *Marcel Duchamp,* trans. George H. Hamilton (New York: Paragraphic Books, 1967), p. 30.

11. Kozloff, "Johns and Duchamp:" 43, writes: "Like Duchamp, Johns now writes notes and suggestions to himself, which, if they stop short of programming, imply very well that verbal ideas shade his whole mode of imagery."

12. Johns, "Marcel Duchamp (1887-1968): An Appreciation," *Artforum,* 7, no. 3 (November 1968): 6; and "Thoughts on Duchamp," *Art in America,* 57, no. 4 (July-August 1969): 31. I will cite passages from these in the text.

13. Marcel Duchamp, Beatrice Wood and H.-P. Roche, "The Richard Mutt Case," *The Blind Man/P.B.T.* (New York), No. 2 (May 1917).

14. Sidney and Harriet Janis, "Marcel Duchamp: Anti-Artist," in *The Dada Painters and Poets: An Anthology,* ed. Robert Motherwell (New York: Wittenborn, Schultz, 1951), p. 315.

15. James J. Sweeney, "Eleven Europeans in America: Marcel Duchamp," *Museum of Modern Art Bulletin,* 13, nos. 4-5 (1946): 21.

16. Cleve Gray, "The Great Spectator," *Art in America,* 57, no. 4 (July-August 1969): 21.

17. Lebel, p. 32.

18. Janis, p. 307.

19. Ibid., p. 309.

20. "Journal": May 1, 1967.

21. Kozloff, "Johns and Duchamp:" 44, mentions these first two examples.

22. Joseph E. Young, "Jasper Johns: An Appraisal," *Art International,* 13, no. 7 (September 1969): 53.

23. For a more thorough discussion of this motif, see Chapter 5.

24. Unrecorded conversation with the artist.

25. See James Klosty, ed., *Merce Cunningham* (New York: E.P. Dutton & Co., 1975), pp. 84-86, 190-193.

26. I have added explanations in brackets to clarify the "Journal" text.

27. Conversation with the artist, November 15, 1974.

28. In his 1959 statement, Johns connects Cézanne and Cubism. While I concentrate on Cézanne in this chapter, throughout the text I discuss Johns' connections to Cubism. Johns has acknowledged Picasso specifically as an artist he admires. He has done two prints in homage to Picasso: *Cups 4 Picasso,* 1972, and *Cup 2 Picasso,* 1973 (Field 167, 168).

29. Johns, "Sketchbook Notes," *Art and Literature,* 4 (Spring 1965): 185.

30. "Journal": July 6, 1967.

31. Unrecorded conversation with the artist.

32. "Journal": December 25, 1967.

33. "Journal": September 19, 1969 and May 24, 1970.

34. "Journal": June 17, 1970.

35. Basil Taylor, *Cézanne* (New York: Paul Hamlyn, 1970), p. 21.

36. Theodore Reff, Cézanne: The Logical Mystery," *Art News,* 58, no. 2 (April 1963): 29.

37. Ibid., p. 30. Reff writes: "Probably the most moving aspect of the current exhibition [Cézanne's watercolors at Knoedler's] is its revelation of Cézanne's ability to charge an entirely insignificant bit of landscape or group of humble objects with the intensity of his feelings."

38. Reff, "Cézanne's *Bather with Outstretched Arms," Gazette des Beaux-Arts,* 6th ser., 59 (March 1962): 180.

39. Kurt Badt, *The Art of Cézanne,* trans. S.A. Ogilvie (Los Angeles: University of California Press, 1965), p. 214, writes: "For what Cézanne aimed to do was to state a truth about the world which lies around man, and not just about his own subjective feelings and experiences." Forrest Williams, "Cézanne and French Phenomenology," *The Journal of Aesthetics and Art Criticism,* 12, no. 4 (June 1954): 481, writes: "The ultimate achievement of Cézanne, an objectivity without the sacrifice of personal vision, is especially striking if one keeps in mind the magnitude of his subjective tendencies and thus appreciates the even greater magnitude of the objective victory within himself."

40. Fritz Novotny, *Cézanne* (New York: Phaidon, 1948), p. 8.

41. See the discussion of Johns' *Drawer,* 1957, and Cézanne's still lifes with drawers, Chapter 2.

42. Quoted in Badt, p. 51.

43. Charles Sterling, *Still Life Painting from Antiquity to the Present Time,* trans. J. Emmons (New York: Universe Books, 1959), p. 104.

44. Leo Steinberg, "Jasper Johns: The First Seven Years of His Art," in *Other Criteria: Confrontations with Twentieth-Century Art* (New York: Oxford University Press, 1972), p. 22.

45. Reff, "Cézanne's Constructive Stroke," *Art Quarterly,* 25, no. 3 (Autumn 1962): 214-227.

46. Badt, p. 82.

47. Reff, "*Bather with Outstretched Arms,"* p. 173, writes: "The pervasive blue coloring of this canvas . . . enhances its atmosphere of sadness and revery."

48. See Badt, p. 43, for a discussion of Cézanne's technique of using color.

49. Meyer Schapiro, *Cézanne* (New York: Harry N. Abrams, 1952), p. 10.

50. George H. Hamilton, "Cézanne, Bergson and the Image of Time," *Art Journal,* 16, no. 1 (Fall 1956): 8.

Chapter 5

1. In 1970, when Johns was arranging a chronological listing of his works, he commented, "the mood changes," when he got to 1961—the year he did the works discussed in this chapter.

(See Appendix A.) 1961 is the year after his first retrospective exhibition at the Columbia Museum of Art in South Carolina; the year he got his studio on Edisto Island, South Carolina; and the year his close friendship with Rauschenberg drifts apart. What is important about the works from this period, however, does not revolve around the specific details of Johns' life, but rather his shift to incorporating intense feelings as a subject in his art.

2. Albert Ten Eyck Gardener, "Harnett's *Music and Good Luck*," *The Metropolitan Museum of Art Bulletin*, 22, no. 5 (January 1964): 165.

3. There was a solo exhibition of Johns' work at the Galerie Rive Droite, June 13 to July 13, 1961. Johns' trip to Paris is documented in two works: *Floral Target* and *15' Entr'acte*, both 1961. In the watercolor *Floral Target*, Johns included the program for a performance on June 20, 1961 of John Cage's *Variations II* played by pianist David Tudor; Johns, Rauschenberg, Jean Tinguely and Niki de Saint-Phalle each contributed works to the event. Besides the program, Johns included the bill for the flowers presented at the end of the concert and the card of the flower shop from which they were purchased. The painting, *15' Entr'acte*, was shown to the audience during the program's fifteen-minute intermission. Done in the style of Johns' other works from 1961 (discussed in this chapter) and using the word "entr'acte," which suggests an interruption of activity, this painting fits in with the mood of emotional withdrawal characteristic of *No* and *Water Freezes*. A possible source for Johns' painting is René Clair's film, *Entracte*, 1924, shown during the intermission of the ballet, *Relâche*. One of the well-known scenes from this film shows Duchamp and Man Ray playing chess.

4. *Musical Erratum* was translated in the 1960 edition of Duchamp's *The Green Box* reviewed by Johns in *Scrap*, no. 1 (December 23, 1960): 4.

5. Leo Steinberg, "Jasper Johns: The First Seven Years of His Art," in *Other Criteria: Confrontations with Twentieth-Century Art* (New York: Oxford University Press, 1972), p. 51.

6. Richard S. Field, *Jasper Johns: Prints 1960-1970*, exhibition catalogue (Philadelphia: Philadelphia Museum of Art, 1970).

7. John Cage, "Jasper Johns: Stories and Ideas," in *A Year from Monday: New Lectures and Writings* (Middletown, CT: Wesleyan University Press, 1969), p. 76.

8. *Painting Bitten by a Man* also suggests the idea of the artist as self-critic. Barbara Rose in "Decoys and Doubles: Jasper Johns and the Modernist Mind," *Arts*, 50, no. 9 (May 1976): 69, argues that "The content of Johns' art is posited above all on the act of self-criticism."

9. *Good Time Charley* is similar to John F. Peto's *The Cup We All Race 4*, 1905 (Plate 38). The similarity was pointed out to Johns after he did this painting. He then did several works which consciously refer to the Peto painting, including *4 The News*, 1962 (Plate 36), discussed later in this chapter.

10. Donald Allen, ed. *The Collected Poems of Frank O'Hara* (New York: Alfred A. Knopf, 1971), pp. 252-257. O'Hara's "In Memory of My Feelings" was first published in *In Memory of My Feelings, A Selection of Poems by Frank O'Hara*, Bill Berkson, ed., (New York: Museum of Modern Art, 1967).

11. Berkson, ed., *In Memory of My Feelings*, 15.

12. Johns, "Sketchbook Notes," *Art and Literature*, 4 (Spring 1965): 185.

13. Arturo Schwarz, *The Complete Works of Marcel Duchamp* (New York: Harry N. Abrams, 1969), p. 531, notes that *Locking Spoon* was on the door of Duchamp's apartment at 37 East 58th Street which he occupied until 1960.

14. Allen, ed. *Poems of Frank O'Hara*, pp. 470-471.

15. Field; confirmed in conversation with Johns' assistant, Mark Lancaster, May 1984.

16. See Roberta Bernstein, "Jasper Johns and the Figure: Part One: Body Imprints," *Arts*, 52, no. 2 (October 1977): 142-144.

17. See Michael Crichton, *Jasper Johns*, exhibition catalogue (New York: Harry N. Abrams and Whitney Museum of American Art, 1977), pp. 49, 69, n.79. *Studies for Skin* were done in connection with a project conceived in 1962 to cast an entire head from a live model and make a rubber mask from that cast, which would in turn be laid out on a flat surface and cast in bronze. The project was never completed.

18. Max Kozloff, *Jasper Johns* (New York: Harry N. Abrams, 1969), p. 47.

19. Ibid.

20. Unrecorded conversation with the artist.

21. John Baur, "Peto and the American Trompe l'Oeil Tradition," *Magazine of Art*, 43, no. 5 (May 1950): 183. See also John Wilmerding, *Important Information Inside*, exhibition catalogue (Washington: The National Gallery of Art, 1983), pp. 164-165.

22. Cage, p. 81.

23. Johns used a takeoff on the Peto title later in two lithographs done in homage to Picasso: *Cups 4 Picasso*, 1972 and *Cup 2 Picasso*, 1973 (Field 167, 168). In these the cup formed by the outlines of the Picasso profiles are chalices resembling trophy cups.

Chapter 6

1. Alan R. Solomon, "Jasper Johns," in *Jasper Johns*, exhibition catalogue (New York: Jewish Museum, 1964), p. 16.

2. In Chapter 1, I discuss Magritte as a possible influence on Johns at the time he painted his first *Flag* and *Target* paintings in the mid-1950s. During the early 1960s, Johns started collecting Magritte's work and he now owns one painting and several drawings and sketches. Johns told me that he acquired Magritte's *Key of Dreams*, 1936, after he had painted *Fool's House*, possibly the next year in 1963. (Conversation with the artist, November 15, 1974.)

3. Suzi Gablik, *Magritte* (Greenwich, CT: New York Graphic Society, 1970), pp. 138-140.

4. Conversation with the artist, November 15, 1974. Rosalind Krauss, "Jasper Johns," *Lugano Review II*, 1, no. 2 (1965): 97, n.22, writes that Johns' initial enthusiasm for Wittgenstein came late in 1961, when he heard the following story about the philosopher. The story is from Norman Malcolm, *Ludwig Wittgenstein: A Memoir* (New York: Oxford University Press, 1958, 1967), pp. 51-52: "Once after supper, Wittgenstein, my wife and I went for a walk on Midsummer Common. We talked about the movements of the bodies of the solar system. It occurred to Wittgenstein that the three of us should represent the movements of the sun, earth and moon, relative to one another. My wife was the sun and maintained a steady pace across the meadow; I was the earth and circled her at a trot. Wittgenstein took the most strenuous part of all, the moon, and ran around me while I circled my wife, Wittgenstein entered this game with great enthusiasm and seriousness, shouting instructions at us as he ran. He became quite dizzy and restless with exhaustion." Peter Higginson, "Jasper's Non-Dilemma: A Wittgensteinian Approach," *New Lugano Review*, 8/9 (Fall 1976): 53-60, discusses *Fool's House*, 1962, and several other works by Johns in relation to Wittgenstein's writings. He stresses that it is Wittgenstein's later work, as presented in *Philosophical Investigations*,

rather than his earlier philosophy as presented in *Tractatus,* which is "sympathetic to Johns' own vision."

5. Herbert Kohl, *The Age of Complexity* (New York: Mentor Books, 1965), p. 46.

6. Ludwig Wittgenstein, *Zettel* (Oxford: Blackwell, 1967; Berkeley: University of California Press, 1970), p. 120e, #583.

7. Roberta Bernstein, unpublished "Journal": November 29, 1967. (Hereafter cited as "Journal" with date of entry.)

8. Kohl, p. 47.

9. Wittgenstein, *Philosophical Investigations,* trans. G.E.M. Anscombe (Oxford: Basil, Blackwell and Mott: 1953, 1958), p. 73, #15.

10. Ibid., p. 18e, #37.

11. Ibid., p. 19e, #38.

12. Ibid., p. 50e, #129.

13. Ibid., p. 20e, #43: "For a *large* class of cases—though not for all—in which we employ the word 'meaning' it can be defined thus: the meaning of a word is its use in the language." In the same passage, Wittgenstein goes on to say: "And the *meaning* of a name is sometimes explained by pointing to its bearer."

14. Wittgenstein, *The Blue and Brown Books* (Oxford: Blackwell, 1958; New York: Harper & Rowe, 1965), p. 39.

15. In determining the chronology of these works (see Appendix A), it seemed to be important to Johns that *Fool's House* came before *M* and *Zone;* i.e., that the broom led to the paint brushes and not the other way around.

16. Marcel Duchamp, *The Bride Stripped Bare by her Bachelors, Even,* a typographic version by Richard Hamilton of Marcel Duchamp's *Green Box,* trans. George H. Hamilton (New York: Wittenborn and Company, 1960). In another version of "Litanies," titled "Exposé of the Chariot," Duchamp lists "crude wooden pulley." Johns 1961 drawing, *Litanies of the Chariot,* documents his familiarity with this Duchamp note.

17. McLuhan's most well-known book, *Understanding Media,* was not published until 1964. However, Johns could have read McLuhan's *Gutenberg Galaxy* (1962) or *The Mechanical Bride* (1951) before he painted *M.*

18. It is significant in this regard that John Cage titled one of his books, *M* (1973), as the result of a chance operation using the *I Ching* with the twenty-six letters of the alphabet. In a conversation August 1972, Cage told me the title of his as-yet-unpublished book and pointed out the coincidental references to "Merce," "Marcel," "McLuhan" and other artists and friends. I asked him if he knew of Johns' painting with the same title: he said he didn't remember it, but that he was delighted with the additional coincidence. Richard S. Field, *Jasper Johns: Prints 1970-1977,* exhibition catalogue (Middletown, CT: Wesleyan University Press, 1978), p. 36, no. 41, suggests the double "M" in *M* may be a pun on Duchamp's painting *Tu m',* i.e., "Two M."

19. There is also a button on the side edge of the painting slightly above the location of the switch. The painting is set into a wooden box-frame providing space behind the canvas for the batteries and wires for the neon light. Johns provided the following instructions for operating the light: "Battery Operation: ON—switch down, press button; OFF—switch up. Line

operation (110 volts AC): ON—plug in, switch up, press button; OFF—switch down. Undesirable operation: Charge battery—switch down, plug in, light on; charge time = operation time."

20. Max Kozloff, *Jasper Johns* (New York: Harry N. Abrams/Meridian Books, 1974), p. 24.

21. Field, *Jasper Johns: Prints 1960-1970*, exhibition catalogue (Philadelphia: Philadelphia Museum of Art, 1970).

22. Andreas Lommel, *Prehistoric and Primitive Man* (New York: McGraw-Hill, 1966), p. 27.

23. Kozloff, *Jasper Johns* (New York: Harry N. Abrams, 1969), p. 44, n. 28, mentions Hofmann, Duchamp and de Kooning as artists who used the handprint motif before Johns. Johns was probably familiar with most, if not all, of these precedents for the use of handprints. I think, however, that the most direct sources for Johns' use of handprints are Pollock in *Number One*, 1948 (which Johns could have seen in the Museum of Modern Art in New York) and Duchamp (one reproduced in the catalogue for the exhibition, "Surrealist Intrusion in the Enchanter's Domain," held at the D'Arcy Galleries, New York, November 28, 1960 to January 14, 1961, and the other in the March 1945 edition of *View* (owned by Johns).

24. The numbers are printed backwards on the yardstick in *Painting with Ruler and Gray*, 1960. In several prints with rulers the orientation and the numbers are reversed because of the technique, e.g., the lithographs, *Hatteras*, 1963 (Field 15), and *Ruler*, 1966 (Field 56). In both *Figure 7* lithographs from *Black and White Numerals* and *Numerals in Color*, 1968-69 (Field 101, 111), there is a hand-drawn ruler like the one in the *Untitled* drawing, along the lower edge. In these prints the numbers are backwards, but are oriented from left to right. In one, there is a handprint near the ruler.

25. Johns may have borrowed this silkscreen from Warhol. In his next work with a silkscreen, *Arrive/Depart*, 1963-64 (Plate 47), he used a silkscreen Warhol had used in one of his paintings (see Chapter 7).

26. Alfred Frankenstein, "Fooling the Eye," *Artforum*, 12, no. 9 (March 1971): 32-35, reproduces Haberle's *Slate*, ca. 1897, next to Johns' *M*, 1962, but does not discuss either work.

27. There are instructions for operating the light, similar to those for *Zone*.

28. Solomon, p. 19.

29. See Ugo Mulas et al., *New York: The New Art Scene* (New York: Holt, Rinehart and Winston, 1967), pp. 152-154.

30. This method of texturing the surface was used in *Arrive/Depart*, 1963-64 (Plate 47), and *Evian*, 1964 (Plate 49), and used frequently in later works, especially the *Screen Piece* series, 1967-68 (Plate 55).

31. Unrecorded conversation with the artist.

32. The diagonal line motif, appearing frequently in Johns' works from the mid-1960s, was used first in *Fool's House*, 1962 (Plate 40). Besides disrupting the painting's vertical/horizontal axes, it is used as a unifying device.

33. Gablik, pp. 97-98.

34. Conversation with the artist, November 15, 1974. Johns' house in Edisto was destroyed by fire in November 1966, when he was in Japan; among the works destroyed was *Untitled (Window)*, 1966.

35. The visual and conceptual color scheme is further complicated by the words "blue" appearing on the yellow panel and "yellow" on the blue. The red, yellow and blue letters are painted with shadows creating an illusion of depth. This effect is further developed in *Voice 2*, 1967–1971.

Chapter 7

1. The *Diver* group is similar stylistically to many works in the artist's studio group, and Johns used many of the same motifs in each. I have distinguished the paintings in each group mainly on the basis of what seems to be the predominant theme, as well as their obvious interrelationships in terms of direct variations on specific structural details and motifs.

2. Johns did a small painting, titled, *Iron*, 1962, with a labeled iron imprint made on a wooden surface covered with encaustic.

3. Johns mentioned this reciprocal ready-made in his 1960 review of Duchamp's *Green Box* in *Scrap*, no. 1 (December 23, 1960): 4.

4. Richard S. Field, *Jasper Johns: Prints 1960-1970*, exhibition catalogue (Philadelphia: Philadelphia Museum of Art, 1970), mentions this too.

5. Brom Weber, ed., *The Complete Poems and Selected Letters and Prose of Hart Crane* (Garden City, NY: Anchor Books, 1966), pp. 21-22.

6. Johns described this process to me in connection with a later work, *Decoy*, 1971. (Conversation with the artist, September 1972.)

7. The only other time Johns used a tape measure was in *Gray Painting with Spoon*, 1962, where a spoon is attached to the top edge by a magnet, and a tape measure fragment, partly obscured by paint like the one in *Diver*, is attached upside-down along the lower edge.

8. Conversation with the artist, Spring 1968.

9. The upper handprints could correspond to the initial stage of the dive, where the feet are together and the arms are resting by the diver's side, or to other stages where the hands are spread apart; and the lower, to stages where the hands are together, including the position right before leaving the board.

10. According to Johns' chronology, *Diver* was painted at the end of 1962 (see Appendix A), and therefore after the Guggenheim exhibition which was held from February 28 to April 29, 1962. Also, Johns could have seen Léger's *Divers* in other exhibitions in New York during the 1950s and early 1960s. For example, *Red and Black Divers*, 1942, and a small gouache, *The Divers*, 1942, were exhibited at the Sidney Janis Gallery, December 5 to January 7, 1961. *The Divers II*, 1942-43, is in the collection of the Museum of Modern Art.

11. Katherine Kuh, *Léger* (Urbana: University of Illinois Press, 1953), p. 55.

12. Roberta Bernstein, unpublished "Journal": July 6, 1967.

13. Theodore Reff, "Cézanne's *Bather with Outstretched Arms*," *Gazette des Beaux-Arts*, 6th Ser., 59 (March 1962): 172, writes that the bather is a projection of Cézanne and "his own solitary condition." I think Johns' diver is partly a projection of himself and his emotional condition at the time.

14. Philip Horton, *Hart Crane: The Life of an American Poet* (New York: Viking Press, 1957), p. 302. Johns owns a copy of this book. I think Johns' interest in and identification with Crane during this period, 1962-63, had to do with aspects of the poet's life, including his difficult family background, interest in the relationship of poetry and art, homosexuality, alcoholism and his death by suicide, as well as his poems.

15. Johns told me he was not referring to a specific location when he titled this painting. (Conversation with the artist, November 15, 1974.) Michael Crichton, *Jasper Johns* (New York: Harry N. Abrams, 1977), p. 50, writes that Johns said the painting was given that title "because I had the sense of arriving at a point where there was no place to stand."

16. Weber, ed., *The Complete Poems... of Hart Crane*, pp. 88-95. The same year, 1963, Johns did a lithograph titled, *Hatteras* (Field 15), based on *Periscope* and an *Untitled (Periscope)* drawing (Cri. 108).

17. Alan R. Solomon, "Jasper Johns" in *Jasper Johns*, exhibition catalogue (New York: Jewish Museum, 1964), p. 21, cites this passage from Crane's "Cape Hatteras" in connection with *Periscope*, and mentions its autobiographical associations for Johns: "The poem describes Johns' country, the Carolina coast, but more than this one senses a subjective response to the poet's anguish, for some deep personal reason. His reserve about himself (which has been respected here), masks a profound vulnerability; one wonders about his own submersed labyrinth, how he sees his own dim past reversed, like the words in the painting."

18. John Cage, "Jasper Johns: Stories and Ideas," in *A Year from Monday: New Lectures and Writings* (Middletown, CT: Wesleyan University Press, 1969), p. 74. It is characteristic of Johns to focus on the details of imprinting the skull, rather than on the theme of death. The Note reflects an attitude of detachment, as if the skull were like any of his other, more emotionally neutral, common objects.

19. See Ingvar Bergström, *Dutch Still Life Painting in the Seventeenth Century*, trans. C. Hedström and G. Taylor (London: Faber and Faber, 1956), p. 154. The categories of *vanitas* still life mentioned below are Bergström's.

20. Skulls appear in Cézanne's still lifes either with other objects like a book, candle and flowers, a pitcher or fruit, or alone. See Lionelli Venturi, *Cézanne: son art—son oeuvre*, vol. 2 (Paris: Paul Rosenberg, 1936), plates 61, 68, 151, 753, 758, 759.

21. Since the mid-1970s a number of artists have used the skull in the *vanitas* still-life context, including Audrey Flack and Jim Dine.

22. Johns used this "Glass" sign in one other painting, *Target*, 1967-69. The silkscreen was borrowed from Andy Warhol who had used it in a 1962 painting, titled *Glass—Handle with Care*. The "Glass" sign could also be a reference to Duchamp's *Large Glass* and other works on glass, which in the *Green Box* notes he calls "delays in glass."

23. The drawing, *Edisto*, 1962, also has a shell. Solomon, p. 22, states that *Arrive/Depart* was begun at Johns' Edisto studio.

Chapter 8

1. Although Johns' figures are fragmented and only partially represented they are, I think, intended to be seen as figures. Max Kozloff, *Jasper Johns* (New York: Harry N. Abrams, 1969), p. 33, refers to the figurative motifs in Johns' later works as "personnage fragments."

2. Jasper Johns, "Sketchbook Notes," *Art and Literature*, 4 (Spring 1965): 185-192; reprinted in John Russell and Suzi Gablik, *Pop Art Redefined*, exhibition catalogue (New York: Frederick A. Praeger, 1969), pp. 84-85. All other passages from Johns' "Sketchbook Notes" cited in this chapter are from this source. Michael Crichton, *Jasper Johns*, exhibition catalogue (New York: Harry N. Abrams and Whitney Museum of American Art, 1977), p. 51, writes that Johns began sketches for *Watchman, Souvenir* and *What* during a month spent on Oahu, Hawaii, in 1964 before arriving in Japan.

3. Richard S. Field, *Jasper Johns: Prints 1960-1970,* exhibition catalogue (Philadelphia: Philadelphia Museum of Art, 1970), states that the Japanese critic Shuzo Takiguchi was the model for the cast; however, Johns told me in conversation (September 1972) that this was not true, though he did not say who was the model. *Watchman* is the first painting since his 1955 *Targets* in which he used a cast. He used plaster casts of mouths in his sculpture, *The Critic Sees,* 1961 (Plate 28), and made a cast of Frank O'Hara's foot for *Memory Piece (Frank O'Hara)* (Plate 34), another sculpture, planned in 1961 but not completed until 1970 (see Chapter 3).

4. Field, also thinks that the watchman is the spectator and the spy is the artist.

5. Henri Matisse, "Notes of a Painter (1908)," in *Matisse on Art,* ed. Jack D. Flam (New York: E.P. Dutton, 1978), p. 38.

6. The original photograph was in black and white. Johns used the photograph itself as a collage element in a drawing, *Souvenir 2,* 1966.

7. Field.

8. These Duchamp images were known to Johns at least since Robert Lebel's 1959 monograph on Duchamp, but they were available as sources closer to the time the *Souvenirs* were painted. *Wanted* was reproduced as a poster for Duchamp's 1963 retrospective at the Pasadena Art Museum *("A Poster Within a Poster")*; Johns owns one of the numbered edition of this poster, acquired at the time of the exhibition. *Monte Carlo Bond* was reproduced in color on the cover of *Marcel Duchamp Ready-Mades, Etc.,* published in 1964. Johns owns a copy of this book.

9. Field equates the painting *Spy,* mentioned in the "Sketchbook Notes," with *Souvenir.*

10. The reference to traditional still-life symbolism also could have been intended in Johns' earlier *Flashlight* and *Light Bulb* sculptures (see Chapter 3.)

11. See discussion of *Periscope (Hart Crane),* 1963, in Chapter 7. Field, *Jasper Johns: Prints 1970-1977,* exhibition catalogue (Middletown, CT: Wesleyan University Press, 1978), p. 36, n.44, mentions that the word "No" is hidden behind the plate in *Souvenir.* This further connects *Souvenir* to the mood and themes of Johns' previous works and is another reference to one of his own past works, *No,* 1961.

12. This Duchamp note is cited by Field, *Jasper Johns: Prints 1960-1970,* in his discussion of the lithograph, *Souvenir,* 1970. Kozloff, *Jasper Johns* (New York: Harry N. Abrams/Meridian Books, 1974), p. 23, writes that Johns mentioned this Duchamp reference to Field in connection with *Souvenir.* Johns quoted part of this note in his statement in *Sixteen Americans,* exhibition catalogue, ed. Dorothy C. Miller (New York: Museum of Modern Art, 1959), p. 22, and in his review of Duchamp's *Green Box* in *Scrap,* no. 1 (December 23, 1960): 4.

13. Charlotte Willard, "Eye to Eye," *Art in America,* 54, no. 2 (March-April 1966): 57. Crichton, p. 51, discusses the origin of the idea for the spotlight effect in *Souvenir* at a John Cage concert while in San Francisco en route to Hawaii and Japan: "...Johns saw a spot of light moving over the ceiling of the darkened hall. He eventually determined that this was coming from a woman's compact mirror. The light, mirror and reflected spot made him think, 'That will be in my next painting.'"

14. Johns, "Marcel Duchamp (1887-1968): An Appreciation," *Artforum,* 7, no. 3 (November 1968): 6.

15. Conversation with the artist, November 15, 1974. Johns described it to me as a "vulgar" bar. He thought the name of the bar was somehow connected to the bottled spring water "Evian." Johns also did a small painting, *Gastro*, 1964, on a coaster from Gastro, an "intellectual's" bar in Tokyo.

16. This is the last skull imprint to appear in a painting before 1974. However, Johns did a 1971 drawing and 1973 lithograph (Field 172), where a single skull imprint is the main image.

17. Stephan Bann, *Experimental Painting: Construction, Abstraction, Destruction, Reduction* (New York: Universe Books, 1970), p. 117, suggests the following interpretation: "'According to What' criteria can we operate the transition from the surrounding world to the particular world of the painting?" The title is such that it could be completed in a variety of ways changing its interpretation, like Duchamp's *Tu m'* mentioned below in connection with this painting.

18. According to Field, *Jasper Johns: Prints 1960-1970*, the model for the cast in *What* was Olga Kluver. In John Coplans, "Fragments According to Johns: An Interview with Jasper Johns," *Print Collector's Newsletter*, 3, no. 2 (May-June 1972): 30, Johns says the following about this cast: "The first time I used this kind of element was in Japan, in a painting called *Watchman* (1964), in which I did a section of a figure seated in a chair. It was used with the realistic or imitative surface shown forward. After I finished the painting, I invited various people to come and look at it. My Japanese friends all went up against the painting to look behind to see how it was made. So when I made this painting, which I already had in mind, I turned it the other way to show the back of the cast, as it were, or the inside of the cast rather than the outside."

19. This idea is further explored in *Cups 4 Picasso*, 1972, and *Cup 2 Picasso*, 1973 (Field 167, 168), also done in homage to another twentieth-century "Old Master," where the Picasso profiles and chalice are read as either figure or ground.

20. Johns, *Scrap*: 4. Johns did a die-cut stencil board print, *M.D.*, 1974 (Field 193), for which he may have used the template prepared for the Duchamp profile in *What*. This print, commercially executed under the supervision of Hiroshi Kawanishi, is a perfect example of the quote just cited. See Field, *Jasper Johns: Prints 1970-1977*, p. 96.

21. Coplans, p. 31.

22. The relationship between *According to What* and *Tu m'* has been discussed by many authors, including Max Kozloff, Michael Crichton and Barbara Rose.

23. In Coplans, p. 30, Johns explains the technique used for copying the Duchamp *Self-Portrait*: "I took a tracing of the profile, hung it by a string and cast its shadow so it became distorted and no longer square. I used that image in the painting. There is in Duchamp a reference to a hinged picture, which of course is what this canvas is." See also Field, *Jasper Johns: Prints 1970-1977*, p. 72.

24. Coplans, pp. 29-30.

25. Roberta Bernstein, "An Interview with Jasper Johns," in *Fragments: Incompletion and Discontinuity*, ed. Lawrence D. Kritzman (New York: New York Literary Forum, 1981), pp. 288-289.

26. Conversation with the artist, November 15, 1974.

Chapter 9

1. Richard S. Field, *Jasper Johns Prints: 1960-1970,* exhibition catalogue (Philadelphia: Philadelphia Museum of Art, 1970), writes that art critic Barbara Rose was the model for this cast.

2. Johns pointed out the sentence "Redo an eye" after I mentioned to him that I noticed words within words in the lithograph *Passage I* (unrecorded conversation). The color names in *Field Painting,* "redyellowblue," also contain words within words, which can be spelled out by the hinged letters. Max Kozloff, *Jasper Johns* (New York: Harry N. Abrams, 1969), plate 102, illustrated the detail with the word "dye." However, because the letters in *Field Painting* are vertically arranged, they are not as easily read as those in *Passage II,* and not as important to the meaning of the painting.

3. There is a lithograph, *Passage II,* 1966 (Field 58), printed from the same plate and stones as *Passage I,* except it is printed in white on black paper.

4. The lithograph *Decoy* was originally conceived in 1967, when Johns made a working proof which included the left half of the lithograph *Passage I* and a photograph of an ale can. These elements were partially enclosed by a large black area and combined in the same way they appear in the completed print. When the project was taken up again in 1971, it was entirely reworked on one stone and eighteen plates. The plates were printed on a hand-fed, off-set lithography proofing press which allows for more spontaneity than the conventional press Johns had used in the past, since images do not have to be reversed on the plates and proofs can be taken more quickly. I saw the early working proof mentioned above at Universal Limited Art Editions, West Islip, Long Island, when I was working on the catalogue essay for the exhibition, "Jasper Johns' *Decoy:* The Print and the Painting," held at the Emily Lowe Gallery, Hofstra University, Hempstead, L.I., September 15-October 15, 1972.

5. Similar areas of black appear in two 1967 prints, *Voice* (Field 59) and *Watchman* (Field 60). I think the surface handling in these works and the sense it creates of an engulfing mass was inspired by Leonardo da Vinci's *Deluge* drawings. (See Chapter 4.)

6. Conversation with the artist, September 1970.

7. Stephan Bann, *Experimental Painting: Construction, Abstraction, Destruction, Reduction* (New York: Universe Books, 1970), p. 116, uses "proportional control" to describe the function of objects, specifically rulers, in Johns' paintings in terms of establishing real scale.

8. Conversation with the artist, September 1972.

9. Johns used silkscreens of printed signs in his 1963 *Untitled (Coca Cola)* drawing and in *Arrive/Depart,* 1963-64 (Plate 47). However, photographic reproductions like those in *Decoy* were first used in prints during 1966-67, *Pinion,* 1963-66, *Passage I* and *II,* and *Voice,* 1966-67. This led to the use of silkscreened photographic images in paintings beginning with the *Screen Pieces* in 1967-68 (Plate 55).

10. There is a second version of both the print and the painting *Decoy.* The lithograph *Decoy II,* 1971-73 (Field 169), is a reworking of the stone and plates used for the original lithograph. The painting, *Decoy,* 1972, is approximately the same size as the lithograph, and along the bottom edge, Johns has used silkscreens of the cancelled photoengravings from *1st Etchings* which appear in the lithographs.

11. Roberta Bernstein, unpublished "Journal": October 15, 1967. (Hereafter cited as "Journal" with date of entry.) Johns told me this story when he was working on *Harlem Light.* I walked into his studio (at the time he was working in a loft at 343 Canal Street) and was astonished to

see him working on an image which appeared so different from anything he had done before. The story of the source of the flagstones motif is mentioned in many published sources, including *Art Now: New York,* 1, no. 4 (April 1969). In Michael Crichton, *Jasper Johns,* exhibition catalogue (New York: Harry N. Abrams and Whitney Museum of American Art, 1977), pp. 54-55, Johns is quoted as saying that the original wall was red, black and gray. Johns also emphasizes the importance to him that it was a found image: "If I could have traced it I would have felt secure that I had it right. Because what's interesting to me is the fact that it isn't designed, but taken. It's not mine."

12. This motif has come to be referred to as "flagstones." Johns himself uses "flagstones" in titling his prints based on *Untitled,* 1972, which use the stone wall image. Flagstones are flat and the word makes a pun on Johns' signature subject, the American flag.

13. Although the *Screen Pieces* were done before *Decoy,* 1971, both were planned around the same time in 1967; the photoplate of the ale can with instructions, "reduce to 4 ¾"...", was done in 1967.

14. Around this time Johns found or was given a red, yellow and blue folding yardstick, advertising the name of a liquor store.

15. Ted Berrigan, *The Sonnets* (New York: Grove Press, 1967). I refer to various poems from this book below, citing page numbers in the text.

16. "Journal": November 29, 1967.

17. "Journal": April-May 1967, Johns was working on *Voice* in his Riverside Drive apartment. *Voice* was exhibited at the Leo Castelli Gallery in a group show in September 1967. A photograph exists of the first version of *Voice* from 1964.

18. Field.

19. Among the phrases in Picabia's *Untitled* drawing, ca. 1918, owned by Johns, is "my voice is strangled." Although the words in the drawing are in French, and Johns does not read French, there is an English translation attached to the back of the drawing's frame.

20. Field in his discussion of *Voice,* mentions the idea of consumption as "obliteration" or, he writes, "at the very least it implies change and this process is at the root of Johns' eating simile."

21. "Journal": December 1967.

22. The lithograph *Voice,* 1966-67 (Field 59), provides the visual transition between the words "voice" as they appear in the two paintings. In the print, the letters are larger in proportion to the rest of the field and they are aligned along the bottom edge as they were in the 1964 version of *Voice.* Johns said, half-jokingly, that he didn't like the lithograph *Voice,* because it was too "dramatic" and looked like it was a Sunday School book cover suggesting the "Voice of God." ("Journal": September 15, 1967.)

23. "Journal": December 10 and December 25, 1967. Crichton, p. 58, reproduces *Voice 2* with the panels combined in three different arrangements and suggests that: "This is the equivalent of having the three canvases bent into a circle...."

24. In fact, the stripes or hatchings, as Johns himself refers to them, become the dominant image for his paintings from 1974-1984.

25. "Journal": July 2, 1972. The stripe pattern is also similar to the design on the ceilings of the basement of Johns' house (originally a bank) on East Houston Street. In fact, the design is a common one, used to decorate many types of objects. The story of the origin of Johns'

hatchings design has been published in several sources, including Crichton, p. 59, and is discussed and interpreted at length; for example, see Rosalind Krauss, "Jasper Johns: The Functions of Irony," *October*, 2 (Summer 1976): 91-99.

26. Picasso's *Women of Algiers* is in the Collection of Victor and Sally Ganz, who are collectors of Johns' works as well as Picasso's. Johns has seen the Picasso several times during social visits to the Ganz home. Both Victor Ganz and I independently noticed the similarity between the stripes in Picasso's painting and Johns' hatchings. Another painting with a stripe pattern similar to Johns' hatchings is Edvard Munch's *Between the Clock and the Bed*, 1940-42, which has become an important reference in Johns' works since about 1980. Several of his works are titled after the Munch. Krauss, "The Functions of Irony" pp. 91-99, mentions the relationship of Johns' hatchings to Picasso's works from 1907-8 with crosshatching strokes and to the all-over composition characteristic of much modern art, including Pollock's drip paintings. See also Field, *Jasper Johns: Prints 1970-1977*, exhibition catalogue (Middletown, CT: Wesleyan University Press, 1977), p. 53, n.23, for a summary of several authors comments on Johns' hatchings.

27. "Journal": March-August 1972. Mark Lancaster (conversation, May 1984) pointed out to me that the flagstones are arranged to create two overlapping squares, measured at the point where the edges of the repeated elements occur.

28. Johns has used the painting *Untitled*, 1972, as the basis for many prints. In *Fizzles (Foirades)*, 1975-76, Johns did a series of etchings showing the panels arranged in four different combinations (Field 219-222). In the lithograph, *Four Panels from Untitled 1972 (Grays and Black)*, 1973-75, Johns emphasizes the continuity of the painting from edge to edge by showing part of the hatchings panel connected to the casts panel, and the casts connected to the hatchings (Field 198-201).

29. According to several of Johns' friends I talked to around the time he was working on the painting, at least three different models were used for the casts, including Marion Javits and Barbara Rose. Thomas B. Hess, "Polypolyptychality," *New York Magazine*, 6, no. 8 (February 19, 1973): 73, writes that the piece contains "bits and pieces of four or five friends." Mark Lancaster (conversation, May 1984) told me that two female and two male models were used.

30. The figure panel went through several distinct changes as Johns was working on the painting, some of which I saw and recorded in my "Journal": (1) blank canvas ripped in two places revealing stretcher bar and wall behind canvas (March 10, 1972); (2) some casts made (May 13, 1972); (3) Johns replaced the torn canvas with another blank, brown canvas and silkscreened two white targets on it, one whole and one cut off at the lower edge (June 7, 1972); (4) boards with anatomical fragments attached to canvas over targets, bits of colored paper marking each board (June 8, 1972) (5) targets covered over with layer of encaustic in bright colors; I said to Johns it reminded me of *Painting with Two Balls*, 1960; he said it reminded him of the colors in *By the Sea*, 1961; (6) canvas now painted in gray encaustic; numbers and letters stencilled on boards (July 2, 1972); (7) canvas painted beige (August 1972).

31. Roni Feinstein, "Jasper Johns' *Untitled* (1972) and Marcel Duchamp's *Bride*" *Arts*, 57, no. 1 (September 1982): 86-93, emphasizes the connection between Johns' painting and Duchamp's *Large Glass* and *Given*. . . . She reproduces and discusses Magritte's *Lost Woman*, citing my dissertation," 'Things the Mind Already Knows': Jasper Johns' Paintings and Sculptures 1954-1974," (Columbia University, 1975) as the source.

32. Hess, "On the Scent of Jasper Johns," *New York Magazine*, 9, no. 6 (February 9, 1976): 66.

33. See Crichton, p. 61.

34. The iron imprint and pink brushstroke were first used by Johns in *Passage*, 1962, one of his earliest works to include autobiographical associations.

35. Hess, "Scent:" 66, and Crichton, p. 61.

36. Field, *Jasper Johns: Prints 1970-1977*, p. 31, discusses the junctures between sections of hatchings in Johns works from this period. He writes: "The space in these areas seems to bend or be enfolded into the picture surface itself; although it is immediately countered by the relative flatness of the overall design pattern and the literal flatness of every single brushstroke."

37. Crichton, p. 62. Hess, "Scent:" 65-67, was the first to point out this structure.

38. Hess, "Scent:" 66.

39. Ibid., p. 67.

40. See Barbara Rose, "Jasper Johns: Pictures and Concepts," *Arts*, 52, no. 3 (November 1977): 148-149, for a discussion of Johns' paintings with hatchings as "pseudo abstractions—impersonations of an abstract style."

41. Jasper Johns, "Marcel Duchamp (1887-1968): An Appreciation," *Artforum*, 7, no.3 (November 1968): 6.

42. Hess, "Scent:" 67. Hess also mentions that Pollock's *Scent* was once owned by Johns' dealer, Leo Castelli, and thus a work to which Johns would have had direct access.

Selected Bibliography

Monographs, Catalogues, Articles, Essays, Interviews and Statements on and by Jasper Johns

Ashbery, John. "Brooms and Prisms." *Art News,* 65, no. 1 (March 1966): 58-59, 82-84.

Bernstein, Roberta. Unpublished "Journal." 1967-1972.

_____. [Introduction] and Robert Littman [Notes]. *Jasper Johns' Decoy: The Print and the Painting* (exhibition catalogue). Hempstead, New York: The Emily Lowe Gallery, Hofstra University, 1972.

_____. "Johns and Beckett: *Foirades/Fizzles.*" *Print Collector's Newsletter,* 7, no. 5 (November-December 1976: 144-145.

_____. "Jasper Johns and the Figure: Part One: Body Imprints." *Arts,* 52, no. 2 (October 1977): 142-144.

_____. "[Review of] *Jasper Johns: Prints 1970-1977* by Richard S. Field." *Art Journal,* 39, no. 4 (Summer 1980): 329-331.

_____. "An Interview with Jasper Johns." In *Fragments: Incompletion and Discontinuity,* pp. 279-290. Edited by Lawrence D. Kritzman. New York: New York Literary Forum, 1981.

_____. "[Review of] *Jasper Johns Working Proofs* by C. Geelhaar and *Jasper Johns Prints: 1977-1981.*" *Print Collector's Newsletter,* 13, no. 1 (March-April 1982): 27-29.

Cage, John. "Jasper Johns: Stories and Ideas." In *Jasper Johns* (exhibition catalogue), pp. 21-26. New York: Jewish Museum, 1964; reprinted in *Jasper Johns* (exhibition catalogue), pp. 26-35. London: Whitechapel Gallery, 1964; reprinted in John Cage. *A Year from Monday: New Lectures and Writings,* pp. 73-85. Middletown, CT: Wesleyan University Press, 1969.

Carpenter, Joan. "The Infra-Iconography of Jasper Johns." *Art Journal,* 36, no. 3 (Spring 1977): 221-227.

Coplans, John. "Fragments According to Johns: An Interview with Jasper Johns." *Print Collector's Newsletter,* 3, no. 2 (May-June 1972): 29-32.

Crichton, Michael. *Jasper Johns* (exhibition catalogue). New York: Harry N. Abrams and Whitney Museum of American Art, 1977.

Feinstein, Roni. "New Thoughts for Jasper Johns' Sculpture." *Arts,* 54, no. 8 (April 1980): 139-145.

_____. "Jasper Johns *Untitled* (1972) and Marcel Duchamp's *Bride.*" *Arts,* 57, no. 1 (September 1982): 86-93.

Field, Richard S. *Jasper Johns: Prints 1960-1970* (exhibition catalogue). Philadelphia: Philadelphia Museum of Art, 1970.

_____. "Jasper Johns Flags." *Print Collector's Newsletter,* 7, no. 3 (July-August 1976): 69-77.

_____. *Jasper Johns: Prints 1970-1977* (exhibition catalogue). Middletown, CT: Wesleyan University Press, 1978.

Forge, Andrew. "The Emperor's Flag." *The New Statesman,* 68, no. 1761 (December 11, 1964): 938-939.

ᐱ Fuller, Peter. "Jasper Johns Interviewed I." *Art Monthly,* no. 18 (July-August 1978): 6-12.

_____. "Jasper Johns Interviewed II." *Art Monthly,* no. 19 (September 1978): 5-7.

Gablik, Suzi. "Jasper Johns's Pictures of the World." *Art in America,* 66, no. 1 (January-February 1978): 62-69.

Geelhaar, Christian. *Jasper Johns Working Proofs* (exhibition catalogue). London: Petersburg Press, 1980.

Goldman, Judith. [Introduction]. *Foirades/Fizzles* (exhibition catalogue). New York: Whitney Museum of American Art, 1977.

_____. "Echoes—To What Purpose?" In *Jasper Johns: Prints 1977-1981* (exhibition catalogue). Boston: Thomas Segal Gallery, 1981.

Hennings, E.B. "*Reconstruction:* A Painting by Jasper Johns." *Bulletin of the Cleveland Museum of Art,* 60, no. 8 (October 1973): 234-241.

꙰ Herrmann, Rolf-Dieter. "Johns the Pessimist." *Artforum,* 16, no. 2 (October 1977): 26-33.

_____. "Jasper Johns' Ambiguity: Exploring the Hermeneutical Implications." *Arts,* 52, no. 3 (November 1977): 124-129.

Hess, Thomas B. "Polypolyptychality." *New York Magazine,* 6, no. 8 (February 19, 1973): 73.

_____. "On the Scent of Jasper Johns." *New York Magazine,* 9, no. 6 (February 9, 1976): 65-67.

Higginson, Peter. "Jasper's Non-Dilemma: A Wittgensteinian Approach." *New Lugano Review,* 8/9 (Fall 1976): 53-60.

꙰ Hopps, Walter. "An Interview with Jasper Johns." *Artforum,* 3, no. 6 (March 1965): 32-36.

Johns, Jasper. [Statement]. In *Sixteen Americans* (exhibition catalogue), p. 22. Edited by Dorothy C. Miller. New York: Museum of Modern Art, 1959; reprinted in Barbara Rose, ed. *Readings in American Art Since 1900: A Documentary Survey,* pp. 165-166. New York: Frederick A. Praeger, 1968.

_____. "Duchamp." *Scrap,* no. 1 (December 23, 1960): 4.

_____. "Sketchbook Notes." *Art and Literature,* 4 (Spring 1965): 185-192; reprinted in John Russell and Suzi Gablik, *Pop Art Redefined* (exhibition catalogue), pp. 84-85. New York: Frederick A. Praeger, 1969.

_____. "Marcel Duchamp (1887-1968): An Appreciation." *Artforum,* 7, no. 3 (November 1968): 6; reprinted in Anne D'Harnoncourt and Kynaston McShine, eds. *Marcel Duchamp* (exhibition catalogue), pp. 203-204. New York: Museum of Modern Art; Philadelphia: Philadelphia Museum of Art, 1973.

_____. "Thoughts on Duchamp." *Art in America,* 58, no. 4 (July-August 1969): 31.

_____. "Sketchbook Notes." In Trevor Winkfield, ed. *Julliard,* pp. 25-27. Leeds, England: Winkfield, Winter 1968-69.

_____. "Sketchbook Notes." *Art Now: New York,* 1, no. 4 (April 1969).

Johnson, Ellen H. "Jim Dine and Jasper Johns: Art about Art." *Art and Literature,* 6, (Autumn 1965): 128-140; reprinted in Ellen H. Johnson. *Modern Art and the Object,* pp. 171-176. New York: Harper and Row, 1976.

꙰ Kaplan, Patricia. "On Jasper Johns' *According to What.*" *Art Journal,* 35, no. 3 (Spring 1976): 247-250.

Kozloff, Max. "Johns and Duchamp." *Art International,* 8, no. 2 (March 1964): 42-45.

_____. *Jasper Johns.* New York: Harry N. Abrams, 1969.

_____. *Jasper Johns.* New York: Harry N. Abrams/Meridian Books, 1974.

Krauss, Rosalind. "Jasper Johns." *Lugano Review II,* 1, no. 2 (1965): 84-113.

_____. "Jasper Johns:The Functions of Irony." *October,* 2 (Summer 1976): 91-99.

Kuspit, Donald B. "Personal Signs: Jasper Johns." *Art in America,* 69, no. 6 (Summer 1981): 111-113.

Masheck, Joseph. "Sit-in on Johns." *Studio International,* 178, no. 916 (November 1969): 193-195.
———. "Jasper Johns Returns." *Art in America,* 64, no. 2 (March-April 1976): 65-67.
Olson, Roberta J.M. "Jasper Johns—Getting Rid of Ideas." *Soho Weekly News,* 5, no. 5 (November 3, 1977): 24-25.
Perrone, Jeff. "Jasper Johns' New Paintings." *Artforum,* 14, no. 8 (April 1976): 48-51.
Porter, Fairfield. "The Education of Jasper Johns." *Art News,* 62, no. 10 (February 1964): 44-45, 61-62.
Raynor, Vivien. "Jasper Johns." *Art News,* 72, no. 3 (March 1973): 20-22.
Robertson, Bryan. [Introduction]. *Jasper Johns* (exhibition catalogue). London: Arts Council of Great Britain, 1978.
Rose, Barbara. "The Graphic Work of Jasper Johns: Part I." *Artforum,* 8, no. 7 (March 1970): 39-45.
———. "The Graphic Work of Jasper Johns: Part II." *Artforum,* 8, no. 9 (September 1970): 65-74.
———. "Decoys and Doubles: Jasper Johns and the Modernist Mind." *Arts,* 50, no. 9 (May 1976): 68-73.
———. "Jasper Johns: Pictures and Concepts." *Arts,* 52, no. 3 (November 1977): 148-153.
Rosenberg, Harold. "Jasper Johns: Things the Mind Already Knows." *Vogue,* 143, no 3 (February 1, 1964): 174-177, 201-203; reprinted in Harold Rosenberg. *The Anxious Object: Art Today and Its Audience,* pp. 177-184. New York: Horizon Press, 1964.
Rosenblum, Robert. "Jasper Johns." *Art International,* 4, no. 7 (September 1960): 75-77.
Shapiro, David. "Imago Mundi." *Art News,* 70, no. 6 (October 1971): 40-41, 66-68.
Solomon, Alan R. "Jasper Johns." In *Jasper Johns* (exhibition catalogue), pp. 5-19. New York: Jewish Museum, 1964; reprinted in *Jasper Johns* (exhibition catalogue), pp. 4-25. London: Whitechapel Gallery, 1964.
———. *Jasper Johns Lead Reliefs.* Los Angeles: Gemini, G.E.L., 1969.
Steinberg, Leo. "Jasper Johns." *Metro,* nos. 4/5 (May 1962); revised for *Jasper Johns.* New York: George Wittenborn, 1963; further revised for "Jasper Johns: The First Seven Years of His Art." In *Other Criteria: Confrontations with Twentieth Century Art,* pp. 17-54. New York: Oxford University Press, 1972.
Stevens, Mark, and Cathleen McGuigan. "Super Artist: Jasper Johns, Today's Master." *Newsweek* (October 24, 1977): 66-79.
Swenson, G.R. "What is Pop Art? Part II: Jasper Johns." *Art News,* 62, no. 10 (February 1964): 43, 66-67.
Sylvester, David. "Interview." In *Jasper Johns Drawings* (exhibition catalogue), pp. 7-19. London: Arts Council of Great Britain, 1974.
Tillim, Sidney, "Ten Years of Jasper Johns." *Arts,* 38, no. 7 (April 1964): 22-26.
Whitney, David. [Introduction]. *Johns, Stella, Warhol* (exhibition catalogue). Corpus Christi: Museum of South Texas, 1972.
Young, Joseph E. "Jasper Johns: An Appraisal." *Art International,* 13, no. 7 (September 1969): 50-56.

Other Sources Consulted

Allen, Donald, ed. *The Collected Poems of Frank O'Hara.* New York: Alfred A. Knopf. 1971.
Alloway, Lawrence. *American Pop Art* (exhibition catalogue). New York: Collier Books and Whitney Museum of American Art, 1974.
Badt, Kurt. *The Art of Cézanne.* Traslated by S.A. Ogilvie. Los Angeles: University of California Press, 1965.
Bann, Stephan. *Experimental Painting: Construction, Abstraction, Destruction, Reduction.* New York: Universe Books, 1970.

Barker, Virgil. *American Painting: History and Interpretation.* New York: Macmillan Co., 1950.

Baur, John. "Peto and the American Trompe l'Oeil Tradition." *Magazine of Art,* 43, no. 5 (May 1950): 182-185.

Bergström, Ingvar. *Dutch Still Life Painting in the Seventeenth Century.* Translated by C. Hedström and G. Taylor. London: Faber and Faber, 1956.

Berkson, Bill, ed. *In Memory of My Feelings: A Selection of Poems by Frank O'Hara.* New York: Museum of Modern Art, 1967.

Bernstein, Roberta. "Rauschenberg's *Rebus.*" *Arts,* 52, no. 5 (January 1978): 138-141.

Cage, John. "On Robert Rauschenberg, Artist and His Work." *Metro,* no. 2 (May 1961); reprinted in John Cage. *Silence.* Middletown, CT: Wesleyan University Press, 1961; 2nd ed. Cambridge, MA: M.I.T. Press, 1967.

Camfield, William A. *Francis Picabia* (exhibition catalogue). New York: Solomon R. Guggenheim Foundation, 1970.

_____. *Francis Picabia: His Art, Life and Times.* Princeton: Princeton University Press, 1979.

Cooper, Douglas. *The Cubist Epoch* (exhibition catalogue). London: Phaidon, 1970.

Da Vinci, Leonardo. *Treatise on Painting.* Translated by A. Philip McMahon. Introduction by Ludwig H. Heidenreich. Princeton: Princeton University Press, 1956.

Duchamp, Marcel, Beatrice Wood and H.-P. Roche. "The Richard Mutt Case." *The Blind Man/P.B.T.* (New York), no. 2 (May 1917).

_____. *The Bride Stripped Bare by Her Bachelors, Even.* A typographic version by Richard Hamilton of Marcel Duchamp's *Green Box.* Translated by George H. Hamilton. New York: Wittenborn and Company, 1960.

Faré, Michel. *La Nature Morte en France du XVIIe siècle: son histoire et son evolution.* 2 vols. Geneva: Pierre Cailler, 1962.

Fernand Léger: Five Themes and Variations (exhibition catalogue). Master Series, no. 1. New York: Solomon R. Guggenheim Museum, 1962.

Forge, Andrew. *Rauschenberg.* New York: Harry N. Abrams, 1972.

Frankenstein, Alfred. *After the Hunt: William Harnett and Other American Still Life Painters, 1890-1900.* Berkeley and Los Angeles: University of California Press, 1953 and 1969.

_____. "Harnett, Peto and Haberle." *Artforum,* 4, no. 2 (October 1965): 27-33.

_____. "American Art and American Moods." *Art in America,* 54, no. 2 (March-April 1966): 76-87.

_____. *The Reality of Appearance: The Trompe l'Oeil Tradition in American Painting* (exhibition catalogue). Greenwich, CT: New York Graphic Society, 1970.

_____. "Fooling the Eye." *Artforum,* 12, no. 9 (March 1971): 32-35.

Gablik, Suzi. "René Magritte." *Artforum,* 4, no. 4 (December 1965): 30-33.

_____. *Magritte.* Greenwich, CT: New York Graphic Society, 1970.

Gardner, Albert Ten Eyck. "Harnett's Music and Good Luck." *The Metropolitan Museum of Art Bulletin,* 22, no. 5 (January 1964): 157-165.

Geldzahler, Henry. *American Painting in the Twentieth Century.* New York: Metropolitan Museum of Art, 1965.

_____. "Numbers in Time: Two American Paintings." *The Metropolitan Museum of Art Bulletin,* 23, no. 8 (April 1965): 295-299.

Gombrich, E.H. *Art and Illusion: A Study in the Psychology of Pictorial Representation.* 4th ed. London: Phaidon, 1972.

Gray, Cleve. "The Great Spectator." *Art in America,* 57, no. 4 (July-August 1969): 20-27.

Greenberg, Clement. "Post-Painterly Abstraction." *Art International,* 8, nos. 5-6 (Summer 1964): 63-65; revised for Henry Geldzahler. *New York Painting and Sculpture: 1940-1970* (exhibition catalogue), pp. 360-371. E.P. Dutton & Co. and Metropolitan Museum of Art, 1969.

_____. "After Abstract Expressionism." *Art International,* 6, no. 8 (October 1962): 24-32.

Hamilton, George Heard. "Cézanne, Bergson and the Image of Time." *Art Journal,* 16, no. 1 (Fall 1956): 2-12.

Hopps, Walter, Ulf Linde and Arturo Schwarz. *Marcel Duchamp Ready-Mades, Etc. (1913-1964).* Paris: Le Terrain Vague, 1964.

Horton, Philip. *Hart Crane: The Life of an American Poet.* New York: Viking Press, 1957.

Janis, Sidney and Harriet. "Marcel Duchamp: Anti-Artist." In *The Dada Painters and Poets: An Anthology,* edited by Robert Motherwell, pp. 306-315. New York: Wittenborn, Schultz, 1951.

Klosty, James, ed. *Merce Cunningham.* New York: E.P. Dutton & Co., 1975.

Kohl, Herbert. *The Age of Complexity.* New York: Mentor Books, 1967.

Kuh, Katherine. *Léger.* Urbana: University of Illinois Press, 1953.

Kuhn, Thomas S. *The Structure of Scientific Revolutions.* Chicago: University of Chicago Press, 1970.

Lebel, Robert. *Marcel Duchamp.* Translated by George H. Hamilton. New York: Grove Press, 1959; New York: Paragraphic Books, 1967.

Lippard, Lucy. *Pop Art.* New York: Frederick A. Praeger, 1966.

Lommel, Andreas. *Prehistoric and Primitive Man.* New York: McGraw-Hill, 1966.

Magritte: Word vs. Image (exhibition catalogue). New York: Sidney Janis Gallery, 1954.

Malcolm, Norman. *Ludwig Wittgenstein: A Memoir.* New York: Oxford University Press, 1958, 1967.

Malevich, Kasimir. "Suprematism." In *Theories of Modern Art: A Source Book by Artists and Critics,* pp. 341-346, edited by Hershel B. Chipp. Berkeley and Los Angeles: University of California Press, 1971.

Matisse, Henri. "Notes of a Painter (1908)." In *Matisse on Art,* pp. 35-40. Edited by Jack D. Flam. New York: E.P. Dutton, 1978.

McShine, Kynaston, ed. *Joseph Cornell* (exhibition catalogue). New York: Museum of Modern Art, 1980.

Meyer, Leonard B. "The End of the Renaissance." *The Hudson Review,* 16, no. 2 (Summer 1963): 169-183.

Motherwell, Robert ed. *The Dada Painters and Poets: An Anthology.* New York: Wittenborn, Schultz, 1951.

Mulas, Ugo, et al. *New York: The New Art Scene.* New York: Holt, Rinehart, and Winston, 1967.

Novak, Barbara. *American Painting of the Nineteenth Century: Realism, Idealism and the American Experience.* New York: Frederick A. Praeger, 1969.

Novotny, Fritz. *Cézanne.* New York: Phaidon, 1948.

Paz, Octavio. *Marcel Duchamp or the Castle of Purity.* Translated by D. Gardner. London: Cape Goliard, 1970.

Pincus-Witten, Robert. "On Target: Symbolist Roots of American Abstraction." *Arts,* 50, no. 8 (April 1976): 84-91.

Reff, Theodore. "Cézanne's *Bather with Outstretched Arms.*" *Gazette des Beaux-Arts,* 6th Ser., 59 (March 1962): 173-190.

_____. "Cézanne's Constructive Stroke." *Art Quarterly,* 25, no. 3 (Autumn 1962): 214-227.

_____. "Cézanne: The Logical Mystery." *Art News,* 58, no. 2 (April 1963): 28-31.

Retrospective Magritte (exhibition catalogue). Brussels: Palais des Beaux-Arts; Paris: Centre Georges Pompidou, 1978-79.

Rose, Barbara. "Dada Then and Now." *Art International,* 7, no. 1 (January 1963): 22-28.

_____. "The Second Generation: Academy and Breakthrough." *Artforum,* 4, no. 1 (September 1965): 53-63.

Rosenblum, Robert. "Magritte's Surrealist Grammar." *Art Digest,* 28, no. 12 (March 1954): 16, 32.

Roth, Moira, "The Aesthetic of Indifference." *Artforum,* 16, no. 3 (November 1977): 46-53.

Rubin, William S. *Dada and Surrealist Art.* New York: Harry N. Abrams, 1968.

————. *Dada, Surrealism and Their Heritage* (exhibition catalogue). New York: Museum of Modern Art, 1968.

Russell, John, and Suzi Gablik. *Pop Art Redefined* (exhibition catalogue). New York: Frederick A. Praeger, 1969.

Sandler, Irving. *The Triumph of American Painting: A History of Abstract Expressionism*. New York: Frederick A. Praeger, 1970.

Schapiro, Meyer. *Cézanne*. New York: Harry N. Abrams, 1952.

Schwarz, Arturo. *The Complete Works of Marcel Duchamp*. New York: Harry N. Abrams, 1969.

Soby, James Thrall. *René Magritte* (exhibition catalogue). New York: Museum of Modern Art, 1965.

Sontag, Susan. *Styles of Radical Will*. New York: Dell, 1969.

Steinberg, Leo. "Contemporary Art and the Plight of its Public." *Harper's Magazine*, 224, no. 1342 (March 1962): 31-39; reprinted in Leo Steinberg. *Other Criteria: Confrontations with Twentieth-Century Art*, pp. 3-16. New York: Oxford University Press, 1972.

Sterling, Charles. *Still Life Painting from Antiquity to the Present Time*. Translated by J. Emmons. New York: Universe Books, 1959.

Surrealist Intrusion in the Enchanter's Domain (exhibition catalogue). New York: D'Arcy Galleries, 1960.

Sweeney, James J. "Eleven Europeans in America: Marcel Duchamp." *Museum of Modern Art Bulletin*, 13, nos. 4-5 (1946): 19-21.

Taylor, Basil. *Cézanne*. New York: Paul Hamlyn, 1970.

Three Generations of Twentieth-Century Art: The Sidney and Harriet Janis Collection of the Museum of Modern Art (exhibition catalogue). New York: Museum of Modern Art, 1972.

Tomkins, Calvin. *The World of Marcel Duchamp 1887-1968*. 2nd ed. New York: Time-Life Books, 1972.

————. *The Bride and the Bachelors*. New York: Viking Press, 1965.

————. *Off the Wall: Robert Rauschenberg and the Art World of Our Time*. New York: Penguin Books, 1980.

Venturi, Lionelli. *Cézanne: son art—son oeuvre*. 2 vols. Paris: Paul Rosenberg, 1936.

Weber, Brom, ed. *The Complete Poems and Selected Letters and Prose of Hart Crane*. Garden City, New York: Anchor Books, 1966.

Willard, Charlotte. "Eye to Eye." *Art in America*, 54, no. 2 (March-April 1966): 49-59.

Williams, Forrest. "Cézanne and French Phenomenology." *The Journal of Aesthetics and Art Criticism*, 12, no. 4 (June 1954): 481-491.

Wilmerding, John. *Important Information Inside: The Art of John F. Peto and the Idea of Still-Life Painting in Nineteenth Century America* (exhibition catalogue). Washington: National Gallery of Art, 1983.

Wittgenstein, Ludwig. *Philosophical Investigations*. Translated by G.E.M. Anscombe. Oxford: Basil, Blackwell and Mott, 1953, 1958.

————. *The Blue and Brown Books*. Oxford: Blackwell, 1958; New York: Harper & Row, 1965.

————. *Zettel*. Oxford: Blackwell, 1967; Berkeley: University of California Press, 1970.

Zervos, Christian. *Pablo Picasso*. Paris: Edition "Cahiers d'Art," [1951].

Index

Grandma 4pm